WITHDRAWN

WILLIAM GLACKENS

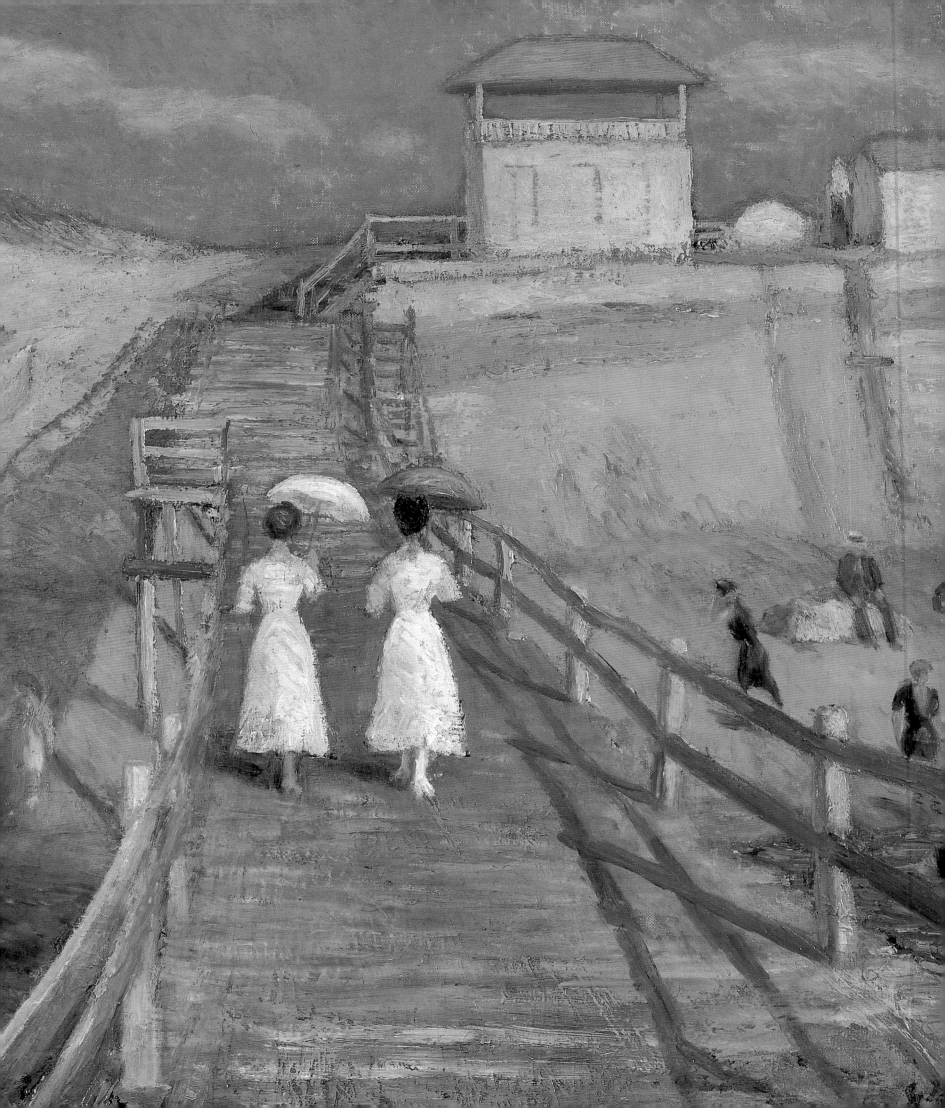

WILLIAM GLACKENS

TEXT BY
William H. Gerdts

ESSAY BY
Jorge H. Santis

MUSEUM OF ART ◆ FORT LAUDERDALE

ABBEVILLE PRESS ◆ PUBLISHERS
NEW YORK ◆ LONDON ◆ PARIS

Jacket front:
Detail of plate 97, THE ARTIST'S DAUGHTER IN CHINESE COSTUME, 1918

Jacket back:
Plate 81, SLEDDING, CENTRAL PARK, 1912

Frontispiece:
Detail of plate 70, CAPE COD PIER, 1908

Unless otherwise indicated, all works are in
The Glackens Collection, Museum of Art, Fort Lauderdale, Florida

EDITORS: Mary Christian and Nancy Grubb
DESIGNER: Nai Chang
PRODUCTION EDITOR: Owen Dugan
PRODUCTION MANAGER: Lou Bilka

Text copyright © 1996 Museum of Art, Fort Lauderdale. Compilation—
including selection of text and images—copyright © 1996 Abbeville Press and
Museum of Art, Fort Lauderdale. All rights reserved under international
copyright conventions. No part of this book may be reproduced or utilized in
any form or by any means, electronic or mechanical, including photocopying,
recording, or by any information storage and retrieval system, without
permission in writing from the publisher. Inquiries should be addressed to
Abbeville Publishing Group, 488 Madison Avenue, New York, NY 10022.
The text of this book was set in Adobe Garamond.
Printed and bound in Singapore.

First edition
2 4 6 8 10 9 7 5 3 1

Library of Congress Cataloging-in-Publication Data
Gerdts, William H.
William Glackens / text by William H. Gerdts: essay by Jorge H. Santis
p. cm.
Includes bibliographical references and index.
ISBN 1-55859-868-5
1. Glackens, William J., 1870–1938. 2. Artists—United States—
Biography. 3. Glackens, William J., 1870–1938—Catalogs.
4. Glackens, Ira. 1907– —Art collections—Catalogs. 5. Art—
Florida—Fort Lauderdale—Catalogs. 6. Museum of Art (Fort
Lauderdale. Fla.)—Catalogs. I. Santis, Jorge H. II. Title.
N6537.G485G47 1996
759.13—dc20 95-38383

OVERSIZE
N
6537
.G485
G47
1996

CONTENTS

THE GLACKENS COLLECTION

◆

Jorge H. Santis

FOREWORD

In 1986, the Trustees of the Museum of Art, Fort Lauderdale, an institution which had existed in a storefront since its founding in 1958, built a grand new facility in the downtown area. An architectural masterpiece designed by Edward Larrabee Barnes, it is one of the largest museums in the state of Florida.

Building the new facility was an especially bold step since the collection was not yet of real significance. However, over the past years, undoubtedly because of the beauty of the building, the museum has attracted many exciting gifts. The most spectacular of these has been Ira Glackens's donation of his father's collection. It brings to South Florida works of great quality and important historical interest. It also gives the museum's collection true distinction in the field of American art. Glackens's reputation has been on the rise in recent years and works of his have more than once been featured in large exhibitions of paintings of the period. Increasingly he is seen as one of America's great colorists and paint handlers.

The Museum of Art and indeed all of South Florida are grateful to Mr. C. Richard Hilker and Jorge Santis, curator of the collection, who worked diligently to secure this gift. Also, the museum is honored to have Professor William H. Gerdts, one of the foremost scholars of American art, write an essay on William Glackens for this book which features the museum's collection. The museum is also grateful to the Sansom Foundation and Abbeville Press for their wholehearted support of this project.

Dr. Kenworth W. Moffett
Director, Museum of Art, Fort Lauderdale

7

ACKNOWLEDGMENTS

First and foremost, I would like to offer my thanks to Kenworth W. Moffett, director, and Jorge H. Santis, curator of the collections at the Museum of Art, Fort Lauderdale, and to C. Richard Hilker, director of the Sansom Foundation, for inviting me to write this study of William Glackens. While Glackens was an artist with whose work I was familiar, I have now come to a new understanding and appreciation of his significance for the history of American art and a greater recognition of his central role in that history—a role that was recognized by many critics, writers, and fellow artists during his lifetime.

I owe special gratitude to Carole Pesner and Katherine Kaplan of the Kraushaar Galleries in New York, and to John Surovek of Palm Beach, Florida—the dealers who represent the Glackens estate. Susan Conway of Washington, D.C. generously made the Glackens Archives in her possession available, and without them this study would not have been possible in the form it has taken. Nancy I. Glendinning, now Dr. Nancy Davenport, was extremely generous is sharing her 1965–66 Master's thesis on Glackens. Sallie D. Sanders of the Inventories of American Painting and Sculpture of the Smithsonian Institution; Judy Throm at the Washington offices of the Archives of American Art; and Cathy Stover and Nancy Malloy at the New York office of the Archives contributed significantly to my research. And I owe a great debt to Claire Grandpierre, my research assistant on this project, whose intelligent pursuit of critical and bibliographic leads has been exemplary.

Others who have offered significant assistance include Alejandro Anreus, Richard H. W. Brauer, Margi Conrads, Dr. David Dearinger, Amy Ellis, Stuart Feld, Dr. Linda Ferber, Dr. Barbara Dayer Gallati, Elizabeth H. Hawkes, Patricia Junker, Emily Kass, Dr. Elizabeth Kornhauser, William Lang, Janet J. Le Clair, Cheryl Leibold, Nannette V. Maciejunes, Dr. Nancy Mowll Mathews, Julie Mellby, Dr. Ellen Miles, Dr. Marc Miller, Dr. Elizabeth Milroy, Alan Moore, Heather B. Nevin, Kathleen O'Malley, Dr. Lisa Peters, Louise D. Polan, Rachel L. Rampa, Cynthia Roznoy, Daniel Schulman, Ralph Sessions, Patricia Watkinson, Helena E. Wright, Dr. Rina Youngner, and Dr. Judith Zilczer.

My associates at Abbeville Press have, as always, facilitated my task here, and in that regard, I offer special recognition to editor Mary Christian.

Finally, I acknowledge with great pleasure my gratitude to Nancy Grubb, my editor at Abbeville Press, for her superb professionalism, and to my wife, Abigail, for her sustained support, and as in so many past projects, my appreciation to both these esteemed women for their wit and understanding.

WILLIAM H. GERDTS

WILLIAM GLACKENS

LIFE AND WORK

◆

WILLIAM H. GERDTS

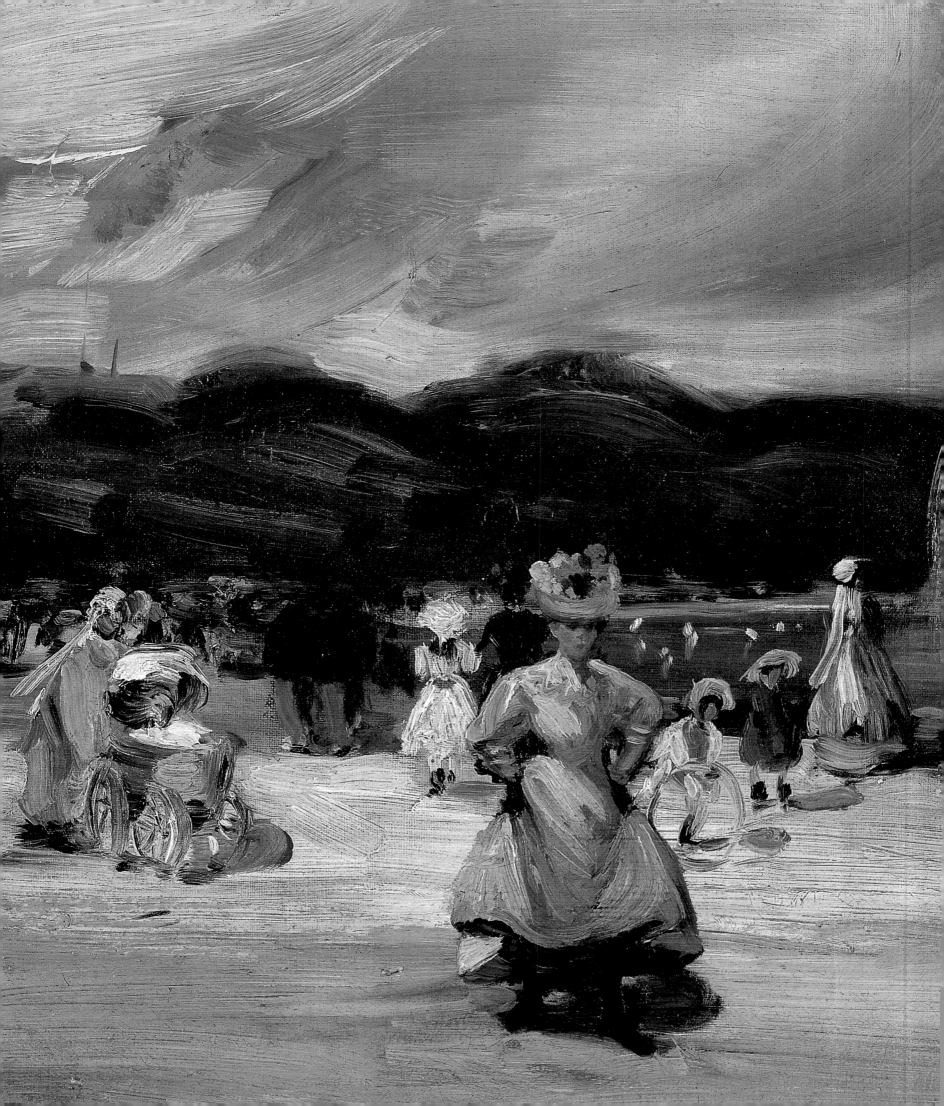

1
EARLY LIFE AND TRAVELS

William Glackens was born on March 13, 1870, at 3214 Sansom Street in Philadelphia; his early years in that city would provide him with an educational and artistic heritage that would be crucial to his mature artistry. The son of Samuel Glackens, an employee of the Pennsylvania Railroad, and his wife, Elizabeth Cartright Finn Glackens, William had two siblings: an older sister, Ada, and an older brother, Louis.[1] William first attended the Northwestern School on the corner of Race and Carlyle Streets in Philadelphia, and then he followed Louis to Central High School, studying there from 1885 to 1890.[2]

Central High School had long been a breeding ground for the city's artistic talents. The school was a progressive institution, with a drawing curriculum that had been established in 1840 by the distinguished painter Rembrandt Peale. The most eminent artistic alumnus before Glackens was Thomas Eakins, who had attended Central High School a generation earlier, graduating in 1861, having been fastidiously inculcated with drawings skills that stood him in good stead during his entire career. Not surprisingly, a few years later Glackens led his associates John Sloan, George Luks, and Everett Shinn in admiration of Eakins's art, along with that of Winslow Homer, and in the future Glackens would refer to Eakins as "a genius."[3]

Glackens's skills as a draftsman were nurtured at Central, where he made tight, precise, and correct drawings as illustrations for a mathematics textbook and for a dictionary,[4] though the vivid calligraphy he later developed was worlds apart from these early illustrations and from Eakins's methodical drawings. Glackens and a schoolmate, under the pseudonyms "Gracie and Kafoodle," also prepared an illustrated story, the "Cruise of the Canoes," the manuscript of which is still extant (Glackens Archives, Susan Conway Gallery, Washington, D.C.). One of Glackens's schoolmates at Central was his future friend and associate John Sloan; equally significant for his future was another fellow pupil, the future art patron Albert C. Barnes, who also entered the school in 1885 and graduated a semester before Glackens.

After graduation Glackens traveled to Florida with some friends, a trip whose only artistic results were a couple of landscape studies in oils—one of a palm tree and one entitled *Florida Swamp* (Samuel Vickers collection, Jacksonville, Florida) (the two may, in fact, be identical).[5] He designed the cover of the May 1891 *The Fern Leaf* (plate 1)—published in Philadelphia by Charles W. Edmonds. One of the artist's earliest published illustrations, and signed with his nickname "Butts," it depicts a conventionally idyllic though quite sensuous young woman among the ferns in a wooded bower—much in keeping with contemporary figurative illustration but very different from the newspaper

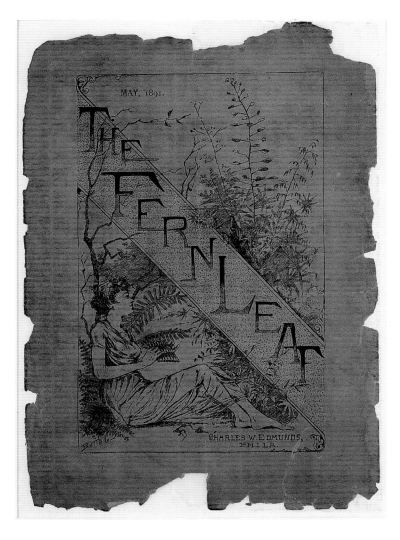

1. COVER OF "THE FERN LEAF," MAY 1891
Lithograph on green paper, 10½ x 7½ in.

work that Glackens was then beginning to undertake. Utilizing his talents as a draftsman and following in the footsteps of his brother (who worked for *Puck* in New York), William Glackens signed on as an artist-reporter at the *Philadelphia Record* in 1891 (see plate 2). His signed illustrations were reproduced there beginning that March; a year later he left for a position on the *Philadelphia Press*, under the art directorship of Edward W. Davis (father of the future painter Stuart Davis). He was joined there the following year by Everett Shinn, and then by George Luks in 1894 and by Sloan in 1895; this association would be crucial to the new urban realism that culminated in the establishment of The Eight with their joint exhibition held in New York City in 1908.

Newspaper illustration had been popularized by Joseph Pulitzer when he took over the *New York World* in 1883, and by the early 1890s most dailies contained pictures. The *Press* led the field in Philadelphia, though until 1892 its artists were generally copying photographs.[6] From that year on, however, fires, strikes, accidents, trials, suicides, and murders were the order of the day for the artist-reporters at the *Press*.[7] Glackens was particularly remembered for one assignment for the *Press* when he stood on a reporter's shoulders, wriggled through a small win-

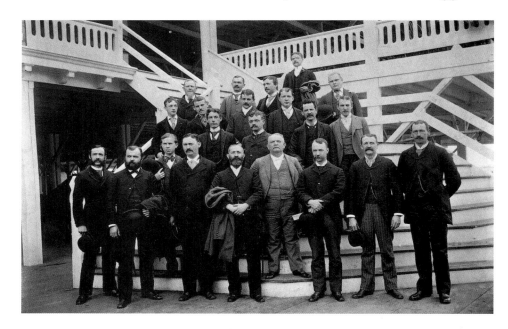

2. The staff of the *Philadelphia Record*, c. 1891–92
William Glackens is on the far left, second from the top.

3. Students at the Pennsylvania Academy, c. 1894. William Glackens is in the middle row, second from the left. Three to the right of him, in the white bow tie, is Maxfield Parrish.

dow to get into a room, locked by the police, where a murder had taken place, and landed in a pool of the victim's blood.[8] Glackens's professional artistry, aided by a prodigious memory, thus emerged in the world of practical experience rather than solely in the confines of art school. Glackens and his colleagues were especially inspired by the graphic modes of the celebrated European illustrators George Du Maurier and Charles Keene.[9]

Meanwhile, Glackens also enrolled in night classes at the Pennsylvania Academy of the Fine Arts in 1892 (see plate 3). There he studied along with Sloan under Henry Thouron, instructor in composition, and briefly with Thomas Anshutz; he remained for two years.[10] Sloan introduced Glackens to Robert Henri, who became a close friend and a significant figure in Glackens's artistic career. Henri, recently back from three years of intensive study in Paris, was continuing to take classes at the Academy while teaching at the Phila-delphia School of Design for Women. In 1893 Sloan, Glackens, and their colleagues organized the Charcoal Club (see plate 4), which met twice a week to work from the nude model, with Henri giving criticism; after half a year the club was dis-banded, due both to the arrival of summer and to the depression of that year.[11] In the company of

4. Photograph of "Gypsy" Novello, model for the Charcoal Club, 1893
Delaware Art Museum, Wilmington; Sloan Archives

Sloan, Glackens had begun painting landscapes in the countryside around Philadelphia at least as early as the summer of 1892 and possibly even 1890.[12] His *Philadelphia Landscape* (plate 5), painted in 1893, is one of his earliest oils, and its vivid painterly approach to the urban landscape is a harbinger of his later interpretations of Paris and New York. Despite the currency that the

5. PHILADELPHIA LANDSCAPE, 1893
Oil on canvas, 17¾ x 24 in.

Impressionist movement was gaining at the time in the United States (though less in Philadelphia than in New York), *Philadelphia Landscape* is more tonal than coloristic, reflecting James McNeill Whistler's impact on Glackens; in 1899 Glackens was noted as considering Whistler and Edouard Manet the great artists of the century.[13] In 1894, with Sloan's help, Glackens also undertook to depict the local landscape in a group of etchings, a medium that Sloan had previously explored; Sloan recalled preparing his etching *The Schuylkill River* that year, "with William Glackens beside me, absorbing his first and only lesson in etching."[14]

In the summer of 1893 Henri assumed leadership of the group of young illustrators of the Philadelphia press, who met at his studio at 896 Walnut Street. From the fall of 1894 through the spring of 1895 Glackens and Henri shared a studio at 1717 Chestnut Street; both artistic discussion, as a sort of sequel to the Charcoal Club's activities, and lively theatricals, in which Glackens participated, took place there (see plate 6).[15]

Glackens had already spent a weekend with Henri in New York City in April 1894, where presumably he painted *The Brooklyn Bridge* (now lost), which was shown at the Pennsylvania Academy's

6. William Glackens presenting an entr'acte at "An Evening at 806 Walnut Street," c. 1894

sixty-fourth annual exhibition—the first public display of his art. The picture was praised in the *Philadelphia Public Ledger:* "Highly successful, its effect being convincing. It is interesting to note that it hangs in the same place as did Whistler last year. While it would be rash to compare it with the master, it is pretty sure to be more popular."[16] Glackens also submitted two other now-unlocated paintings, *The Cathedral* and *Portrait,* but these were not accepted for the show; in 1894 he also produced caricature works for the *Fake Exhibition* at the Academy.[17]

Factory Scene (plate 7) is another rare early picture, dating possibly from 1895.[18] It depicts a row of industrial buildings, with the emphasis on the tall smoking chimneys, and constitutes a precursor both to the gritty scenes of urban life associated with the future Ashcan School and to the industrial imagery that would become so prevalent in the United States beginning in the 1920s. *Autumn Landscape* (plate 8), also from this period, is a figurative piece, with women and children dancing in a park to music provided by male musicians, including a harpist; here the overall amber tone and lyrical mood justify the *Ledger* critic's suggestion of a Whistlerian association in Glackens's early paintings.

In June 1895 Glackens—along with his fellow Philadelphia painters Elmer Schofield, Augustus Koopman, and Colin Campbell Cooper plus the newlywed sculptor Charles Grafly and his wife— accompanied Henri to Paris; for all but Glackens, the youngest of the artists, this was a return visit to the French capital. Glackens thus joined the vast contingent of American art students and tyros who traveled to the French capital, beginning in the years immediately after the Civil War, to establish their professional credentials. Unlike the great majority of these (including all of his traveling companions, who had studied at the Académie Julian in the late 1880s and early 1890s), Glackens did not enter any of the popular art schools, nor did he seek private instruction from any of the renowned French artist-teachers.

These Philadelphia artists were not in Paris long, before Henri proposed a bicycle trip to Belgium and Holland. That August he, Glackens, and Schofield, and possibly the Canadian painter James Wilson Morrice, toured the galleries in Brussels, Antwerp, The Hague, Rotterdam, and Amsterdam, attracted especially by the work of Rembrandt and even more by that of Frans Hals. Glackens's painting reached full maturation soon after the friends returned to Paris that autumn. There the lessons of Frans Hals were merged with the inspiration offered by the work of the Impressionists from the Gustave Caillebotte bequest, which went on view in the Musée du Luxembourg in February 1896, while Glackens and Henri were in Paris.[19] Glackens had already admired Manet's work at an exhibition at Durand-Ruel's New York gallery in March 1895, and in Paris, Manet became an idol for both Americans; Henri would later be referred to as the "American Manet."

Glackens and Henri remained extremely close, renting studios near one another, visiting the Louvre and Luxembourg museums, and enjoying the friendship of the painter Morrice.[20] During their fifteen months in Europe, Glackens and Henri also painted in the countryside around Fontainebleau, but they concentrated on scenes in Paris and the suburb of Charenton, painting with dark, dramatic colors applied vigorously in slashing brushstrokes.

7. FACTORY SCENE,
c. 1895
Oil on canvas, 18 x 24 in.
Delaware Art Museum,
Wilmington;
gift of Helen Farr Sloan

8. AUTUMN LANDSCAPE,
c. 1893–95
Oil on canvas, 25 x 30 in.

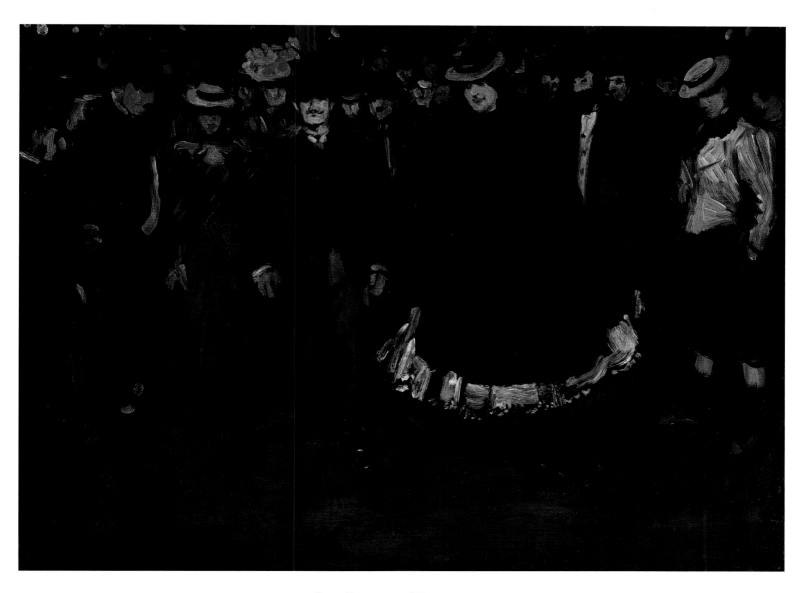

9. BAL BULLIER, NO. 1, C. 1895
Oil on canvas, 23⅞ x 32 in.
Daniel J. Terra Collection, 1.1995; Courtesy of Terra Museum of American Art, Chicago

While Glackens's technique bespoke seventeenth-century Baroque masters such as Hals and Diego Velázquez, his subject matter was drawn from Manet, Edgar Degas, and Henri de Toulouse-Lautrec: scenes of Parisian streets, theaters, and cafés, peopled by couples enjoying the freedom of modern urban nightlife. *Bal Bullier, No. I* (plate 9) depicts a couple in the famous dance hall in Montparnasse; the woman's wide skirt slightly indecorously reveals her white petticoat while she enjoys the gaze of a variety of male and female spectators.[21] The work, which was illustrated in *Bookman* in May 1900 and was perhaps the earliest oil by Glackens to

be reproduced, suggests comparison with Manet's *Ballet Espagnol* (1862; Phillips Collection, Washington, D.C.).[22]

Outdoor Theatre, Paris (plate 10), of probably the same time, is another scene of Parisian amusement, with women on a stage dancing, perhaps the can-can, clad in more suggestive costumes and exhibiting a good deal more abandon. The vermilion structure and warm yellow glow of the theater lights add to the seductiveness of the scene. One of the most exuberant and striking of Glackens's Paris scenes is *Circus Parade* (plate 11).[23] It is another night scene, with figures in theatrical

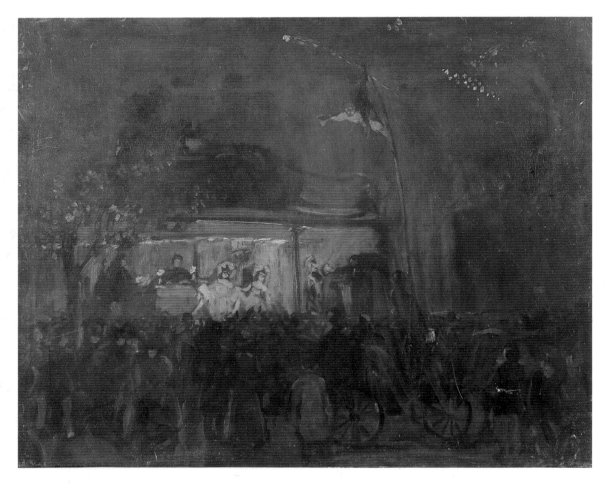

10. Outdoor Theatre,
Paris, c. 1895
Oil on canvas,
25¾ x 31¾ in.
Kraushaar Galleries,
New York

11. Circus Parade,
c. 1895
Oil on canvas, 24 x 32 in.
Kraushaar Galleries,
New York

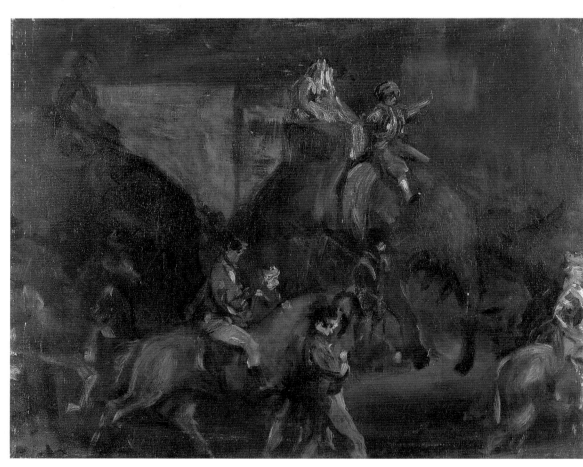

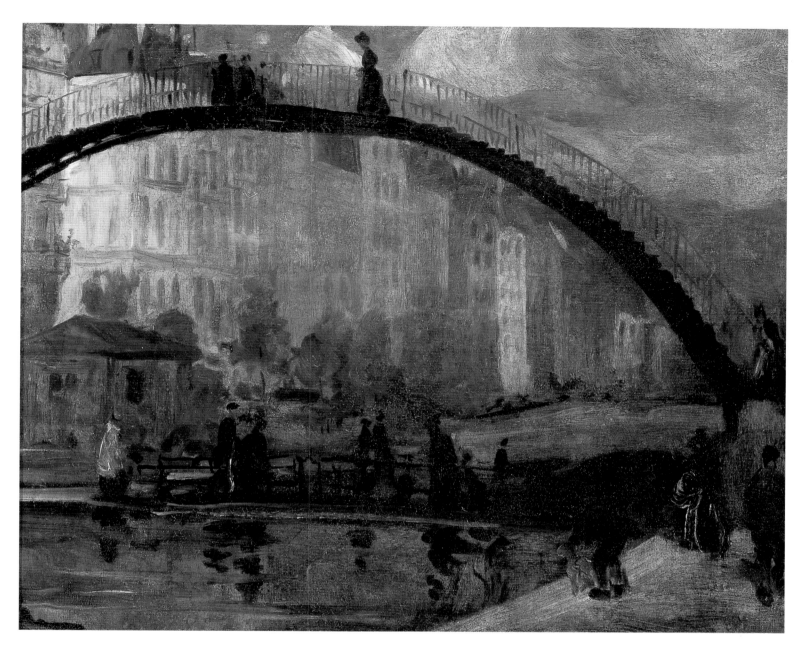

12. LA VILLETTE, 1895
Oil on canvas, 25 x 30 in.
Carnegie Museum of Art, Pittsburgh;
Patrons' Art Fund

costume riding on horses and elephants, their exotic dress constituting brilliant flashes of color against the dark animals and the nocturnal setting. These works introduce Glackens's fascination with the world of entertainment, which he would sustain back in America.

One of Glackens's most unusual compositions of this period is *La Villette* (plate 12), which shows a cast-iron pedestrian bridge arching over a water-way, against a backdrop of tall Parisian buildings. La Villette was then a commercial section in north-eastern Paris, with open-air livestock markets and slaughterhouses, but Glackens has transformed this rather sordid reality into a parklike setting, and what may have been industrial and tenement buildings look more like fashionable apartments.[24] Interestingly, Glackens's etching of the same theme shows a much more gritty background of factories

13. Sailboats,
Luxembourg Gardens,
c. 1895
Oil on canvas, 25¾ x 32 in.
Kraushaar Galleries,
New York

14. In the Luxembourg,
c. 1896
Oil on canvas, 16 x 19 in.

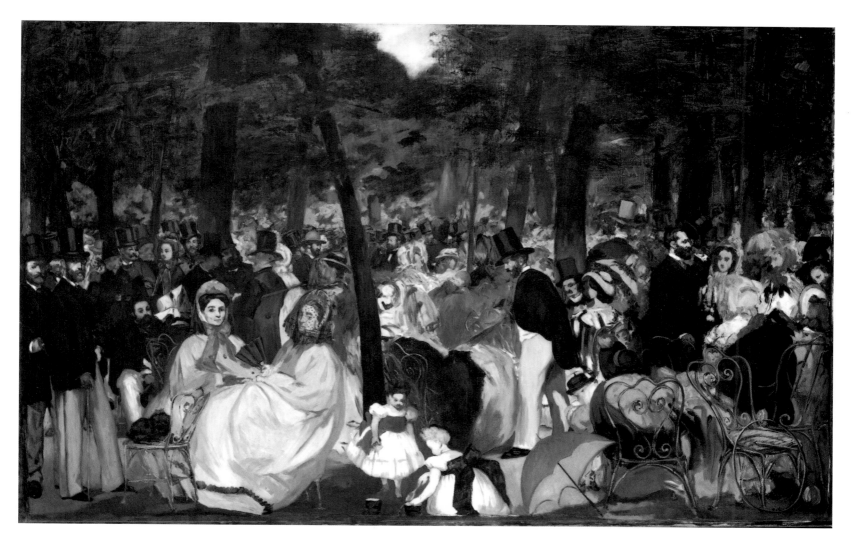

15. Edouard Manet
LA MUSIQUE AUX TUILERIES, 1862
Oil on canvas, 30 x 46½ in.
National Gallery, London

and commercial life. In the painting, adults tend children playing at the water's edge—a favorite motif of the artist's that he developed at this time and that found its fullest expression in the series of paintings he created of Luxembourg Gardens, including *Sailboats, Luxembourg Gardens* (plate 13) and *In the Luxembourg* (plate 14). These paintings seem partly indebted to Edouard Manet's *La Musique aux Tuileries* (plate 15); Glackens would have seen this painting in the spring of 1895 at the Manet show at Durand-Ruel's gallery in New York, just before Glackens left for France. Manet's is a brighter scene, and though more crowded it is also more sedate, with the activities of children far less

emphasized.[25] Henri, too, painted Luxembourg Gardens, and his Parisian pictures of these years, such as *The Storm—La Rue* (private collection), are extremely close to Glackens's.

In the Luxembourg shows children playing with hoops and sailing miniature boats in the basin, while a nurse at the left attends an infant in a per-ambulator. The most prominent figure is the un-accompanied woman with an elaborate flowered hat, hitching up her skirts and striding purpose-fully toward the viewer. *Sailboats, Luxembourg Gardens,* a darker painting, situates the viewer almost in the middle of the pond among the miniature boats, with children and adults on the

16. Quatorze Juillet, 1895–96
Oil on canvas, 25¼ x 30¼ in.

distant walkway watching the informal regatta. Both of these pictures bear comparison with a slightly earlier painting by the renowned American painter William Merritt Chase, *The Lake for Miniature Yachts* (c. 1890–91; Peter G. Terian collection), which Glackens could well have known from its illustration in *Harper's Weekly*.[26] One of Glackens's paintings of the Luxembourg Gardens was shown in 1896 at the Salon of the Société Nationale des Beaux-Arts; this may have been *In the Luxembourg.*

One of the grittiest of Glackens's Parisian pic-

tures is *Quatorze Juillet* (plate 16), a night scene with celebrating figures densely packed in front of the glowing windows of a café. Both old and young are dancing in the streets, figures larger and more individually characterized than most that appear in his Paris scenes. They seem to represent all strata of society, from top-hatted gentlemen to rough working men in smocks and stout women in aprons—a far cry from most French scenes celebrating Bastille Day.[27]

Almost all of Glackens's Parisian pictures emphasize the casual pleasures of city life. An exception

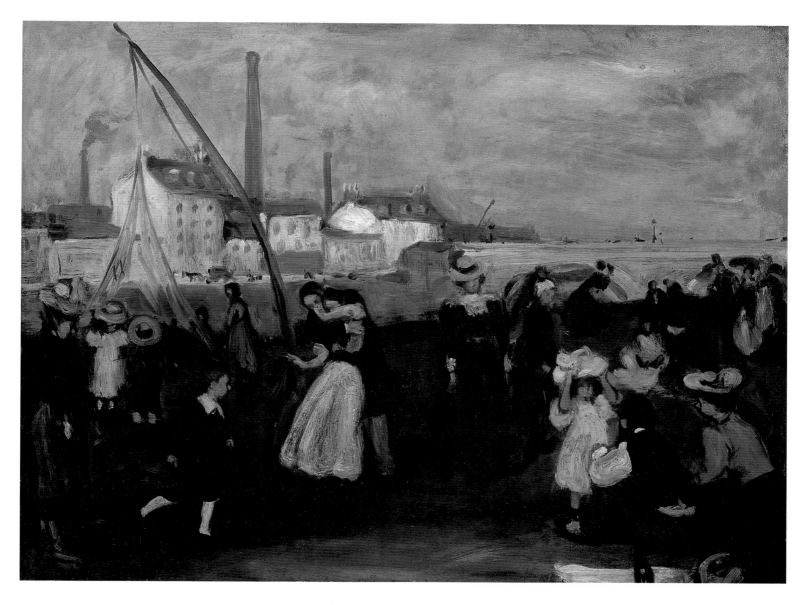

17. ON THE QUAI, C. 1895–96
Oil on canvas, 23⅞ x 32 in.
Valparaiso University Museum of Art, Valparaiso, Indiana; Sloan Fund Purchase

to this is *On the Quai* (plate 17)—a rather mysterious scene of violent confrontation set against an industrial background. The picture's date has been debated, with the scholar Paul Shakeshaft opting for 1905–6, during the artist's second visit to Paris. But both Ira Glackens and Antoinette Kraushaar (the artist's son and longtime dealer) strongly upheld an 1895 date for the work, and the dark palette and rather summary forms of both figures and buildings do seem to conform to the earlier period. Shakeshaft has identified the location of the scene as the port of Dieppe, with the quai du Hable on

the right bank of the Arques River in the foreground, looking across to a tobacco factory on the quai de la Marne and the rue Aguado.[28]

As in other of Glackens's 1895–96 paintings, the artist purposefully emphasized a variety of participants in *On the Quai:* a number of well-dressed boys and girls as well as adults of both genders and various ages, and judging by their costumes, of diverse social and economic status. These figures, positioned both singly and in small groups, appear unconnected, reflecting perhaps the isolation of modern life. What they do have in common is their apparent unconcern

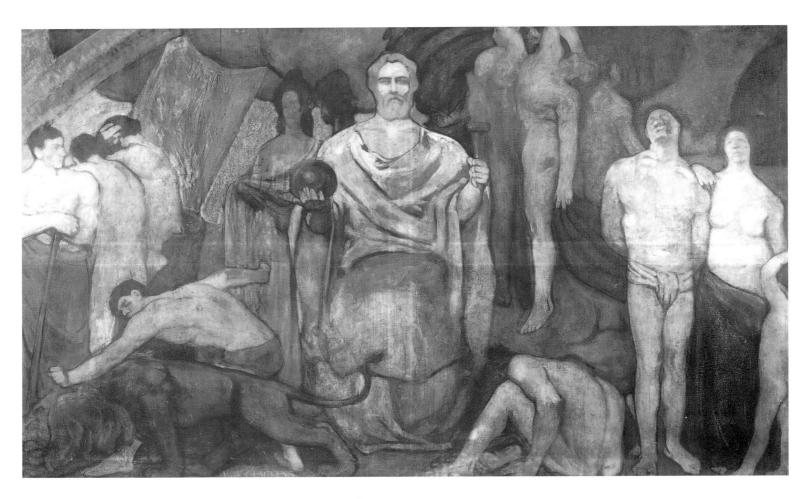

18. Science, 1896–97
Oil on canvas, 77½ x 127½ in.
The Pennsylvania Academy of the Fine Arts, Philadelphia;
Commissioned by the Pennsylvania Academy

about the scene of physical violence at the center of the painting, where a young woman struggles against the aggressively passionate embrace of a black frock-coated male. It is a scene that suggests the world of art illustration and that seems a fore-runner to some of Glackens's own narrative work, such as his 1912 illustration *There Was a Short Struggle That Brought Nell up against the Wall.*[29]

Glackens returned to Philadelphia from Paris in the autumn of 1896. He exhibited again in the Pennsylvania Academy annual that December, showing two French pictures: one of his scenes in the Luxembourg Gardens and *Head of a French Girl.* Glackens's first significant work on his return to his native city, which also constituted his final engagement there, was the creation of two murals—*Science* (plate 18) and *Calliope* (de-

stroyed)—for the lecture room at the Pennsylvania Academy of the Fine Arts. These were two of a series of twenty-two paintings assigned to twelve artists who had studied at the Academy—primarily students of Thouron, who supervised the project. Though referred to as murals, they were, like the great majority of such decorative schemes of the period, paintings done not directly on the walls but on canvas that was then attached to the surface of the room.

The project was completed by April 1897, but its starting date is uncertain.[30] It is possible that Glackens had gone to France with some idea of studying the possibilities, both technical and inter-pretive, for mural work; Sloan was already at work on his Academy murals by the time Glackens re-turned from Paris.[31] The instructions that Thouron

had prepared for Sloan are extant, and presumably these same guidelines were issued to Glackens. The color was to combine richness with delicacy, with yellows and greens prevailing. Full-size figures were not to exceed nine and a half feet, and Thouron called upon Sloan to recognize flatness as "one of the essential qualities of good mural painting," with simplified modeling and firm contours.[32]

These last directions suggest as models the mural work of the great French artist Pierre Puvis de Chavannes, a painter much admired at the end of the century both in France and in the United States. Indeed, much allegorical decoration in America, including almost all of the Academy murals, was inspired by Puvis. Glackens's multi-figure composition of heroic nudes for *Science* is no exception, though it is exceptional in his oeuvre. Glackens no doubt encountered Puvis's paintings while in Paris; the murals in Saint Geneviève (1877–79), the Sorbonne (completed 1889), and the Hôtel de Ville (completed 1894) were cultural monuments he surely would have visited. Henri, who especially admired the Sorbonne murals, would have led Glackens toward Puvis as would

have the Philadelphia illustrator Henry McCarter, who had studied with Puvis. Glackens would also have seen a group of Puvis's murals painted for the Boston Public Library when they were exhibited at the Salon of the Société Nationale des Beaux-Arts in 1896.

Although the friezelike composition and emphasis on nudity in *Science* show the undeniable impact of Puvis's art, Glackens's individual figures also exhibit Michelangelesque heroic power and stress, suggesting that the young American searched the past as well as the present for the components of his monumental allegory, though his intent and the identification of his specific figures is lost today. The mural *Calliope* was one of nine single figures of the muses, placed between the other thirteen murals; all nine were garbed in white draperies and treated "in a more severely decorative manner."[33] Except for his poster-mural *Russia* (plate 107), prepared many years later, in the autumn of 1918, Glackens was not to undertake so vast and imaginative a project again, though in 1900 he was quoted as wanting to do "big work"—"portraits and murals and church decoration."[34]

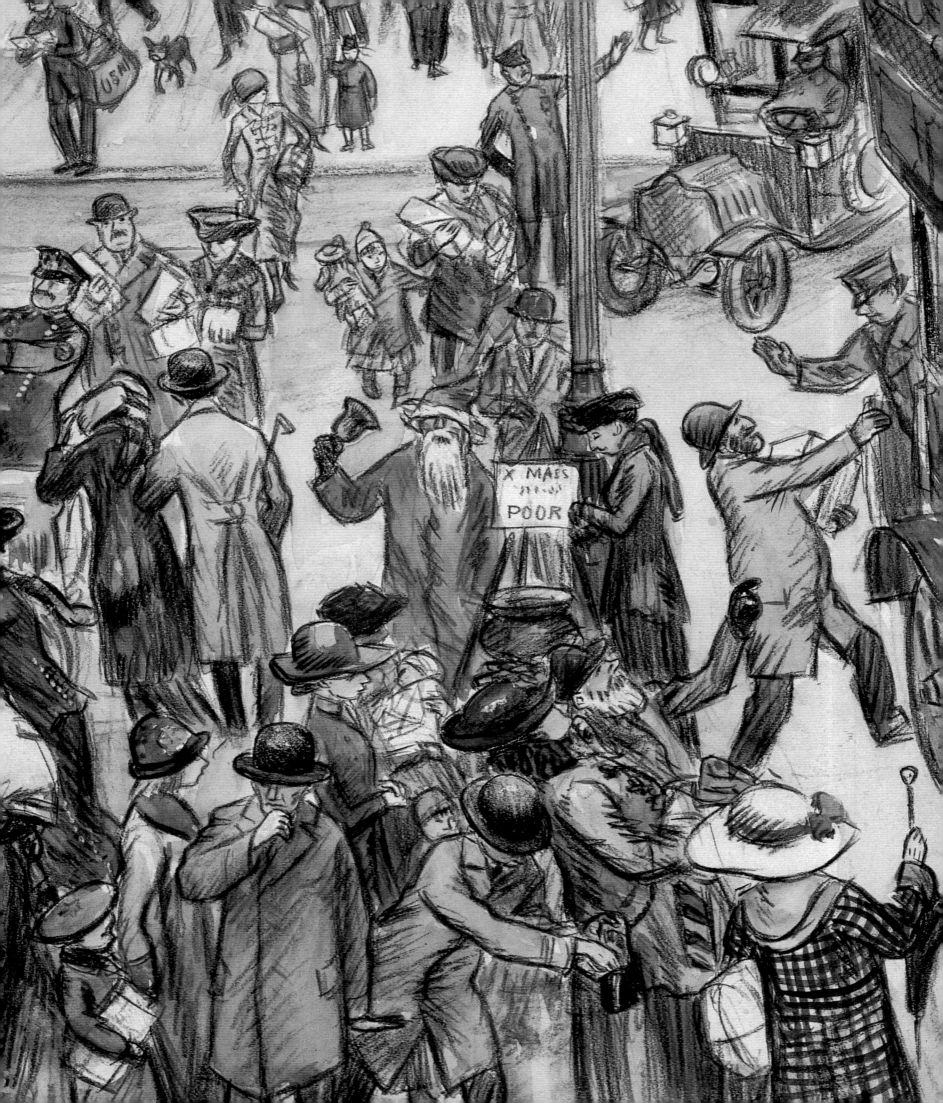

2
THE ILLUSTRATOR

By the end of 1896 Glackens had moved to New York City. There he resumed his earlier career as a newspaper illustrator, now on the *New York Sunday World*—a position obtained through his fellow Philadelphian George Luks, who had joined the newspaper in April 1896. At first he and Luks roomed together, but Glackens soon rented a studio in the Holbein Studio Building at 139 East Fifty-fifth Street.[1] Like Luks, Glackens created cartoons for the *World;* he was immediately followed there by Everett Shinn. After six weeks on the *World,* Glackens switched to a rival newspaper, the *New York Herald,* as an illustrator-reporter.[2] The exodus of the Philadelphia illustrator-reporters to New York was brought about by the availability of opportunities there in the newspaper empires of the great publishers: Joseph Pulitzer, owner of the *World;* William Randolph Hearst, of the *Journal;* and James Gordon Bennett, who owned both the *Herald* and the *Telegram.*

Glackens returned to the *World* at the beginning of 1898, again doing work for the comics section, but this time he initiated a series featuring a group of kids called the Merry-Go-Rounders; this lasted a little over a month. Glackens's final drawing for the *World* appeared on May 1, 1898—an illustration for a story about tenement evictions.[3] In the meantime, he had maintained some ties with Philadelphia; the triumphant return of Admiral George Dewey and his fleet to New York was celebrated in the *Philadelphia Public Ledger* on October 2, 1899, with an illustration by Glackens entitled *The Land Parade in New York—Tenth*

Pennsylvania Regiment Passing in Review before Admiral Dewey.[4]

Glackens remained with the two New York newspapers for only two years. As early as 1897, probably recognizing the imminent domination of newspaper illustration by photography, he broadened his scope by illustrating for *McClure's Magazine,* starting with seventeen illustrations for Rudyard Kipling's story "Slaves of the Lamp," which appeared in *McClure's* in August 1897.

It was in *McClure's* that Glackens's most celebrated illustrations appeared, those related to the Spanish-American War. On February 15, 1898, the American battleship *Maine* was blown up in Havana Harbor, with 266 casualties, and two months later the United States was at war with Spain. Glackens was soon sent to Tampa, Florida, to meet the news correspondent Stephen Bonsal and create "illustrations telling of the departure, voyage and arrival, and subsequent work and fights of the U.S. troops in Cuba."[5] After sketching soldiers waiting to go to the front, Glackens traveled with Bonsal to Cuba in mid-June to cover the war; Glackens entered Santiago on June 19.[6] His illustrations were first published on October 1898, accompanying Bonsal's "The Fight for Santiago: The Account of an Eye-Witness," followed in December by Bonsal's story "The Night after San Juan"; the articles also included photographs taken by Bonsal.[7] Glackens's earliest Spanish-American War illustration had previously appeared in *Munsey's Magazine,* in June 1898, and in March, April, and May of the following year his illustrations

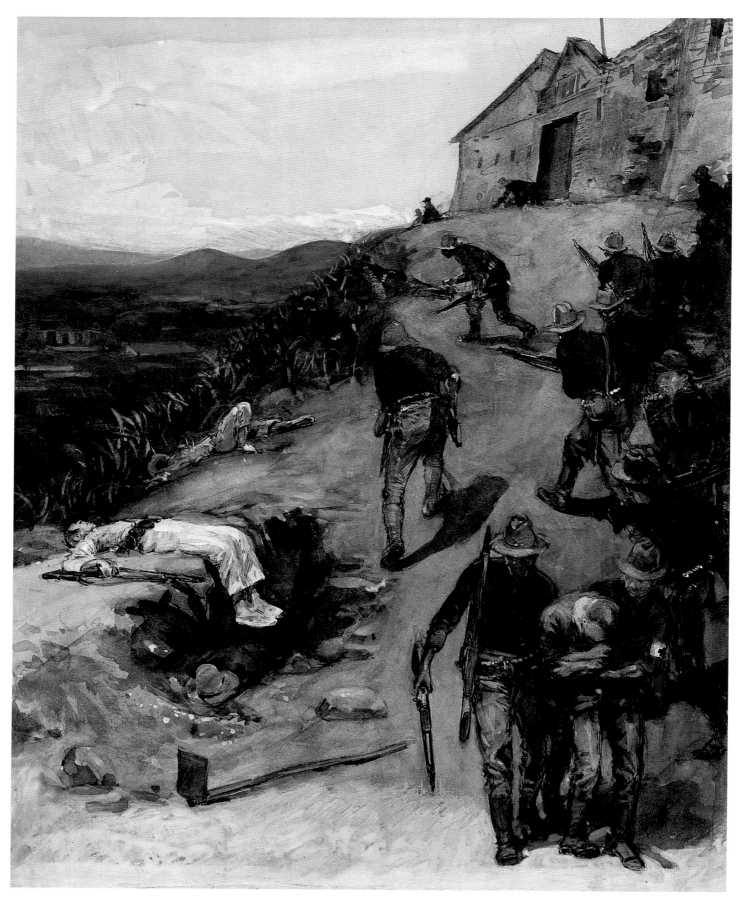

19. THE NIGHT AFTER SAN JUAN, 1898
Watercolor, pen and black ink on paper, 16 x 13 in.

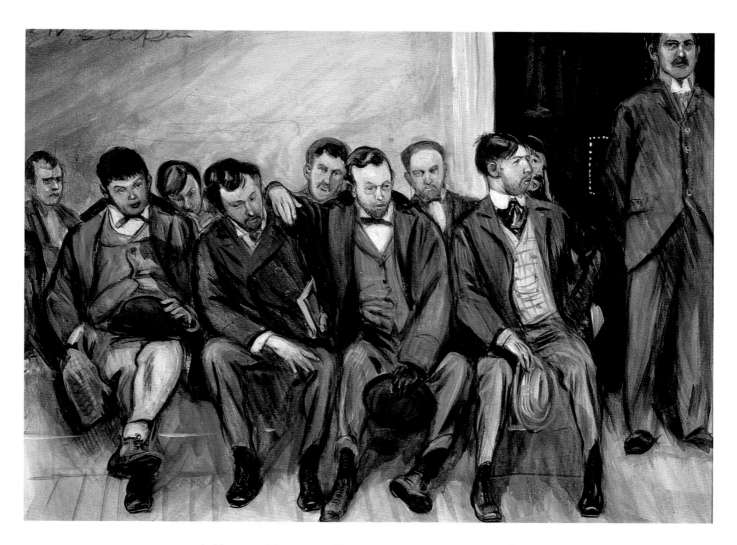

20. A Young Doctor, Especially during the Growth
of His First Beard, Is Invariably a Music Lover, 1900
Gouache on paper, 8½ x 11½ in.

accompanied three parts of Richard Titherington's series "Our War with Spain" in that periodical. The abrupt end of the war left about half of the finest among his forty-three or more Cuban drawings unpublished, such as *The Night after San Juan* (plate 19).[8]

This series was Glackens's last as an artist-reporter; from this point on, his illustrations were freelance assignments for fiction. He capitalized immediately on his recent experience, selling to *McClure's* two pieces related to the Spanish-American War, which were used to illustrate stories by Stephen Crane that appeared in February and July 1899. From then on, Glackens illustrated stories by many different authors in various magazines, though remaining a favorite illustrator at *McClure's* through 1910.

Typical of Glackens's work for *McClure's* were the seven illustrations that appeared there in June 1900, illustrating Marion Hill's story "A Tune in Court: A Story of the Italian Quarter in San Francisco." No longer dependent upon firsthand observation—Glackens had no need to travel to San Francisco for this assignment—he relied on the story itself to provide pictorial inspiration. That allowed him to exercise his mastery of anatomy and especially his penetrating ability to depict distinctive types, as in his expert gouache, preparatory to the illustration *A Young Doctor, Especially During the Growth of His First Beard, Is Invariably a Music Lover* (plate 20). Compared to illustrations by many of his colleagues, Glackens's figures are frank and unidealized. Forbes Watson, later editor of

Arts, recalled: "Years ago I remember Albert Sterner speaking of the complaints that used to come to the McClure magazine because Glackens' illustrations were not sweet enough. They were too real, too original, too fresh and amusing to appeal to a public saturated with false illustration."[9]

Glackens's illustrations subsequently appeared in many other periodicals, such as *Century, Collier's Weekly, Cosmopolitan, Harper's Bazar, Harper's Weekly, Putnam's Monthly,* the *Saturday Evening Post* (where his illustrations appeared in ninety-one stories between October 1902 and December 1912), and *Scribner's.*[10] Indeed, Glackens achieved renown more quickly as an illustrator than as a painter, with numerous articles at the turn of the century touting his abilities.[11] In addition, he joined Henry McCarter and Maxfield Parrish in the *Special Exhibition of Works by Three Philadelphia Illustrators* in January 1900 at Philadelphia's Plastic Club. Everett Shinn, himself a draftsman of tremendous ability, ventured the opinion "William J. Glackens is the greatest draughtsman this country has produced."[12] This sentiment was echoed by the painter Gifford Beal, who wrote, "I first think of Glackens as a great illustrator, perhaps the greatest we ever had."[13]

Glackens may sometimes have begrudged the time required for his commercial illustrations, but that was nevertheless what paid the bills—at least during his early years in New York. Having provided his first book illustrations in 1895, for George Nox McCain's *Through the Great Campaign with Hastings and His Spellbinders* (Philadelphia: Historical Publishing Company), he subsequently illustrated thirteen more books between 1899 and 1913, including three by the popular writer Paul de Kock. For these, his drawings were reproduced photomechanically, with original etchings also bound in the volumes, presumably to make them more salable.[14] Glackens's final book illustrations appeared in 1913 in *A Traveler at Forty* (New York: Century Company) by Theodore Dreiser, who had become a staunch champion of those artists, including Glackens, who were later identified as the Ashcan School. These illustrations, too, had

appeared previously that year, with Dreiser's serialized text, in *Century* magazine.

Glackens's most consistently incisive urban realism is found not in his oil paintings but in his graphic work—especially his later drawings, many of which were prepared for magazines. There are many thematic crossovers between Glackens's illustrations and his paintings, but there are also aspects of them that remain quite distinct. Whereas Glackens's fascination with images of poverty and with some of the more sordid aspects of urban life is bountifully apparent in his illustrations, it seldom found expression in his oil paintings. Unlike his slightly younger contemporary George Bellows, for instance, Glackens never portrayed in oils the more tawdry and violent aspects of boxing, but he did create a marvelously powerful wash drawing, *Boxing Match* (Arthur G. Altschul collection, New York)—one of several illustrations of the sport that he designed for H. R. Durant's short story "A Sucker," published in *Cosmopolitan* in 1905.[15]

Given that the artist's published illustrations number over a thousand, a thorough analysis of them is far beyond the scope of this essay. His graphic style is probably most identified with an incisive linear mode, in which long, straight or sinuous lines are combined with short staccato dashes. There is, however, an immense diversity to the modes he employed. Everett Shinn provided what is probably the best description of Glackens's varied graphic styles, distinguishing between his newspaper and his magazine work.[16] In the former, Glackens employed strong black pen-and-ink lines, later substituting a fine, pointed sable brush for the pen. In his magazine work, made to be reproduced as halftones, he achieved a greater range of tonalities by using wash and tempera, charcoal and carbon pencil, accented with Chinese white or with watercolor or pastel (his instinct for color constantly reasserted itself). And Shinn noted his preference for red chalk when investigating the nude.

Something of the spirit of Glackens's illustrations for Alfred Lewis's book *The Boss* (which was originally serialized in *Putnam's Monthly* from August through November 1903) can be found in

his superb *Graft* (plate 21) of that year. The hard-faced woman, presumably the madam of a bordello, is paying off the heavily garbed seated man, who is very temporarily on the premises. Glackens brought the viewer close to the transaction, defining his figures in broad, whiplike strokes of chalk that suggest the urgency of the moment.

Many of Glackens's finest drawings appear to have been destined for illustration but never reproduced. Some of the finest of these are animated outdoor scenes in New York City, in which he concentrated on close-up views of groups of individuals, often contrasted in terms of age, social status, and economic position. Sometime around 1907–10

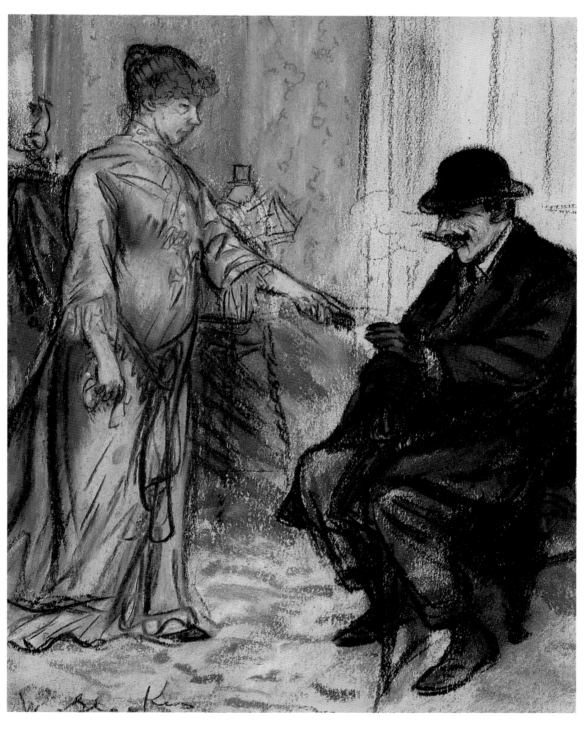

21. GRAFT, 1903
Colored pastel on paper, 10 x 8 in.

2. THE ILLUSTRATOR

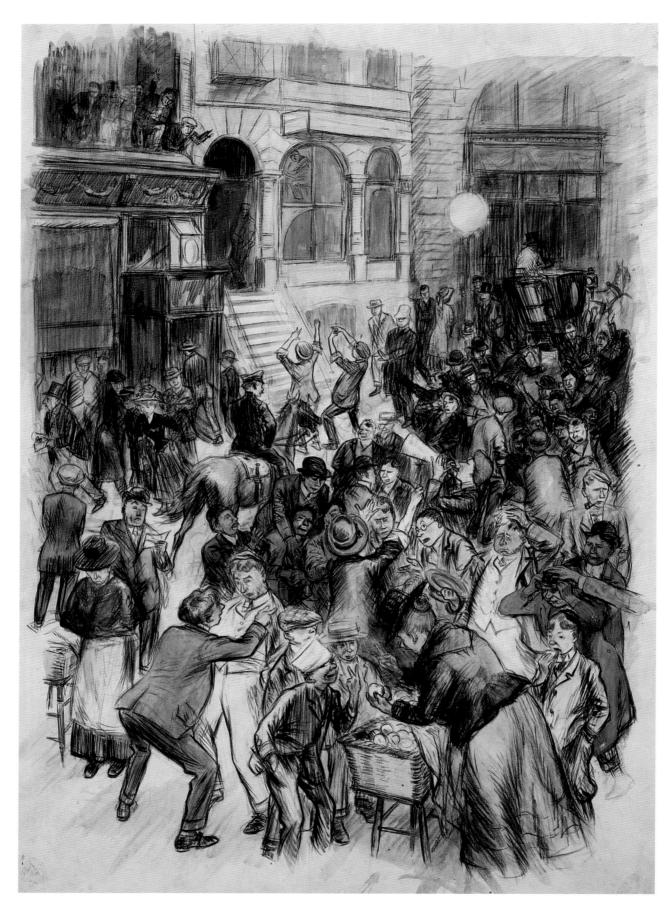

22. Curb Exchange No. 3, 1907–10
Gouache and Conté crayon on paper, 26½ x 18 in.

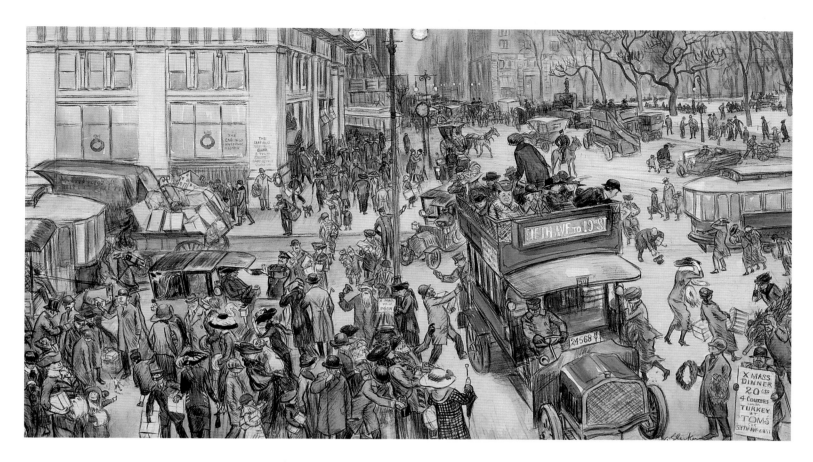

23. CHRISTMAS SHOPPERS, MADISON SQUARE
(also known as FIFTH AVENUE SHOPPERS), 1912
Crayon and watercolor on paper, 17½ x 31 in.

Glackens created a marvelous series of drawings of the Curb Exchange (plate 22), on Broad and Wall Streets in Lower Manhattan, depicting the frenzied activity of brokers without a place on the New York Stock Exchange. These scenes in ink, carbon pencil, and watercolor involve masses of men and a few women hemmed in among the tall buildings, drawn in Glackens's somewhat shorthand style, with figural types gently caricatured. Glackens had earlier provided *The Curb Brokers on Broad Street, in Front of the Stock Exchange* to illustrate H. Allaway's article "The New Wall Street," which appeared in *Munsey's Magazine* in April 1899, but that was a much more sedate affair, not nearly as lively as his wonderful drawings from a decade later. In the Curb Exchange series and in the artist's other multifigured graphics, individuals and small groups of figures were meant to be read as embodying individual incidents within the overall scene, with each contributing to the sense of frenzied activity.[17]

The Curb Exchange was overwhelmingly a male domain, whereas Glackens's *Christmas Shoppers, Madison Square* (plate 23) includes at least an equal number of women and men. Glackens was especially adept at depicting crowds of people, and the variety of figural types, costumes, movements, and positions in this work is astonishing. At the corner of Twenty-third Street and Fifth Avenue, the urban populace mixes with vehicles of all types, with an open-top double-deck Fifth Avenue bus in the foreground and Madison Square at upper right. The prominent building at the left, the Garfield National Bank, had recently replaced the grand old Fifth Avenue Hotel, once the most prestigious of New York hostelries, demolished in 1908. This was a neighborhood for upper-class shoppers, but Madison Square did have its share of undesirables as well, and Glackens included in the center foreground a pickpocket and his accomplice, whose activity has not gone unnoticed. *Christmas Shoppers, Madison*

Square appeared as a large, two-page illustration in *Collier's Weekly* on December 13, 1912, titled *The Day before Christmas on Madison Square*. The theme of Christmas shopping had previously been incorporated in the series of illustrations Glackens prepared for the article "New York's Christmas Atmosphere," written by John J. à Becket, and published in *Harper's Bazar* on December 15, 1900.

It was in a series of full-page centerpieces and frontispieces published in 1910–13 in *Collier's Weekly* that some of Glackens's most celebrated and most complex illustrations appeared. This magazine seems to have particularly appreciated Glackens's

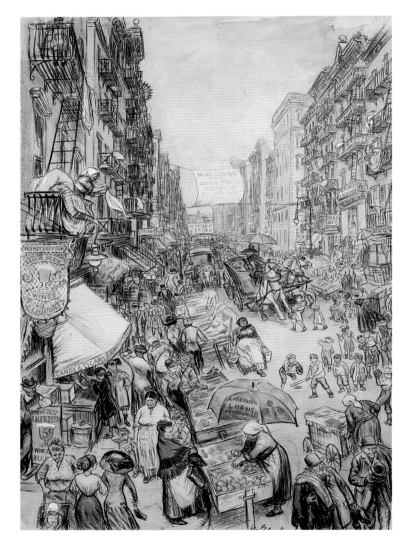

24. FAR FROM THE FRESH AIR FARM: THE CROWDED CITY STREET, WITH ITS DANGERS AND TEMPTATIONS, IS A PITIFUL MAKESHIFT PLAYGROUND FOR CHILDREN, 1911
Crayon heightened with watercolor on paper, 24½ x 16½ in.

mastery of the crowd, and Glackens, in turn, unfettered by the restraint of conformity to literary narrative, is seen at his finest here. His admiring colleague Shinn noted, "None of us could do a crowd quite like Glackens."[18]

The artist's best-known illustration is probably *Far from the Fresh Air Farm,* based on a carbon pencil and watercolor drawing (plate 24) and published in *Collier's* on July 18, 1911. Though the location here is not specified, it is certainly the Lower East Side and probably Tompkins Street.[19] The published illustration was accompanied by a moralizing caption: "The crowded city street, with its dangers and temptations, is a pitiful makeshift playground for children." Actually, the children playing and dancing in the street at the right, with one group in danger from a runaway team of horses, constitute only a small percentage of the remarkable cast of characters, which includes street merchants and shoppers of all kinds, elders with children, and women on fire escapes airing blankets, sheets, and mattresses. Conspicuous among the tenement housing and small shops is N. Slitskey's tavern, featuring the "best lager beer for five cents." Glackens's caricatures in *Far from the Fresh Air Farm,* in his several Curb Exchange pieces, and in *Christmas Shoppers, Madison Square,* though gentle, nevertheless involve a stereotyping that allowed the artist to observe the urban human comedy from a distance.

Glackens remained identified with *Collier's Weekly* over a long period, from 1901 until his last magazine designs appeared there in 1919. They illustrated the dramatic shipwreck story "On the Beach," by Roy Norton, which was the last of four narratives of the sea that Glackens illustrated for *Collier's* between June 8, 1918, and February 22, 1919. His final design was *They Saw Her Slip, Almost Furtively, Stern Foremost, from Sight, and Flotsam Arose to Bob among the Crests* (plate 25). All of these sea-born narratives relied upon Glackens's incisive graphic style, but *They Saw Her Slip* surpasses all the rest in depicting a mass of humanity in tragic circumstances.

During his first years in New York, Glackens appears to have concentrated heavily on illustra-

tion, and few significant paintings are known from this period. It has been suggested that the artist resented the demands made upon him by magazine and book illustration, preventing him from concentrating on the "higher" arts and the greater freedom of expression that uncommissioned painting allowed. This seems unlikely. Even after his marriage in 1904, which considerably enhanced the artist's financial situation, Glackens continued and in some ways even increased his illustrative activities. The truth is probably that he enjoyed both kinds of picture making, relishing their diversity while using them to stimulate each other in terms of style and subject.

Between 1899 and 1906, the period of the artist's most intense involvement with illustration, he provided designs for over 160 articles; eleven of the fourteen books for which he supplied illustrations were also published during that period. He illus-

trated twenty-four articles in the year 1899 alone; in 1903 he illustrated an incredible forty-five articles, and 1903, too, was his most prolific for book illustration—four volumes appeared that year. These figures testify to the speed and sureness of his illustrative strategies and explain the absence of significant paintings from his oeuvre of this time.

Glackens's reputation as one of America's greatest illustrators continued to be advanced even after he had achieved acclaim as a painter. He was the first artist discussed in a 1909 article entitled "Foremost American Illustrators," in which his work was praised "because of the great truth which Mr. Glackens had to tell, and because of the line and form and color which he has used in telling it. Practically this encompasses all there is of good illustrating—truth to tell and sincerity in telling it. There is no question of aesthetics or of ethics in such art, but only of reality."[20]

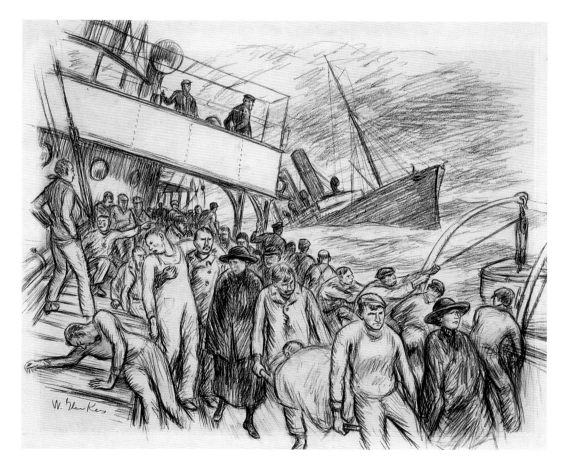

25. THEY SAW HER SLIP, ALMOST FURTIVELY, STERN FOREMOST,
FROM SIGHT, AND FLOTSAM AROSE TO BOB AMONG THE CRESTS, 1919
Charcoal on paper, 13¾ x 17 in.

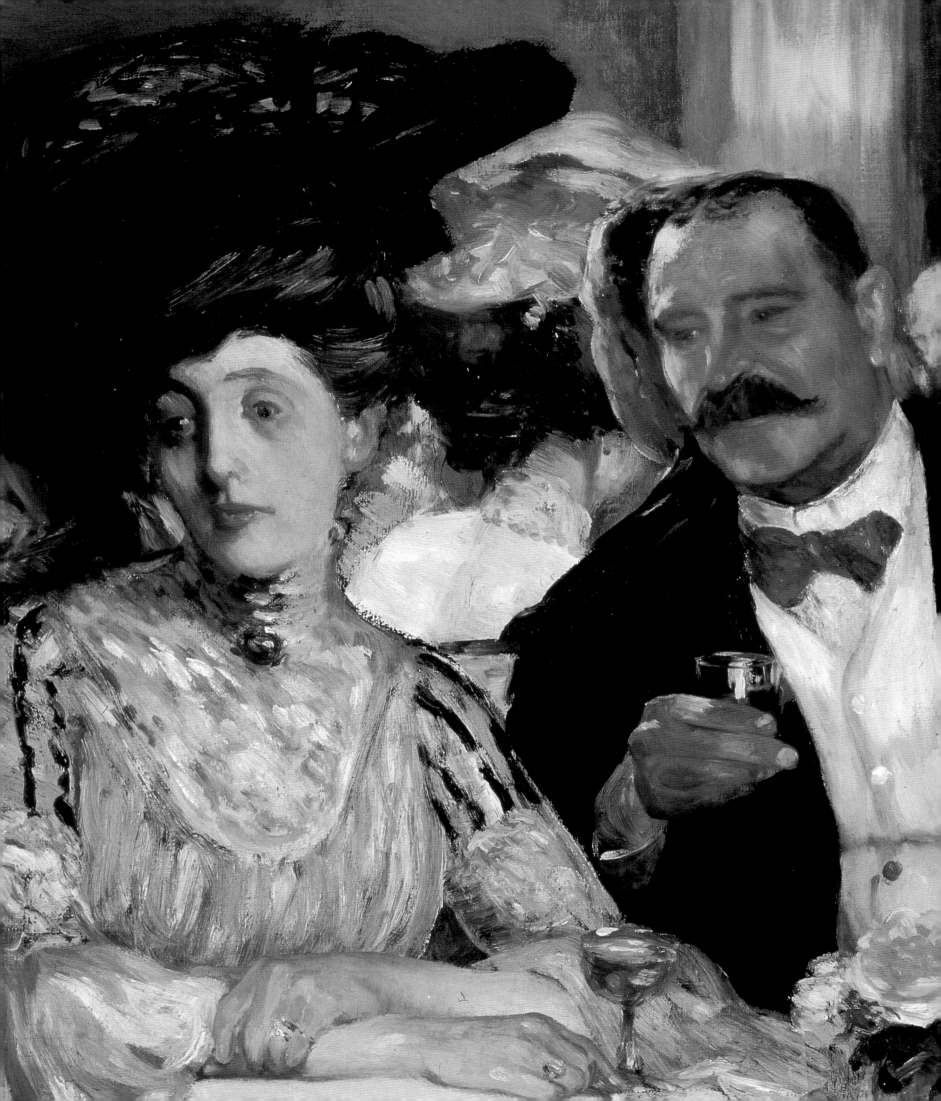

3
NEW YORK SCENES

The earliest of Glackens's major paintings done from his new base in New York is *Outside the Guttenberg Race Track (New Jersey)* (plate 26) of 1897. A large, dark, and dramatic work, it might seem by its subject to have been inspired by the racing pictures of Edouard Manet and Edgar Degas. However, the painting is not actually about racing at all, although horses do figure significantly in it.

Guttenberg is a suburb of New York, across the Hudson River in New Jersey, but the racetrack was in neighboring North Bergen. It was opened in 1882 by the North Hudson Driving Park Association as a half-mile trotting course. The following year it was bought by John C. Carr, a New York pharmacist, who turned it into the Hudson County Jockey Club and ran it as a racetrack. "They are off to the 'Gut,'" became a common slang expression during the following decade. But by the time Glackens painted this scene, antigambling state legislation had stopped organized racing at this track; the last race had been run on September 30, 1893.[1] While still in action the site was a popular meeting place for sporting folk and unsavory types from New York City, and Glackens may have attended an unofficial event there. In any case, unlike the races at Longchamps outside Paris or even at Saratoga Springs in upper New York State, those at the Guttenberg track were relatively ramshackle affairs.

As his title indicates, Glackens concentrated on the activities *outside* the track. The rough wooden wall blocks the view across three-quarters of the picture; a few sketchily painted spectators sit hap-

hazardly atop it. The plebeian nature of the environment is suggested by the establishments in the foreground, which include a makeshift open-air eatery at the left and, in the center, a small carousel wittily mimicking the racetrack beyond (as do the horse and rider in the lower left foreground). The informality of the scene as well as the random and crowded placement of the structures is echoed both in the loose and sketchy paint treatment and in the almost ideographic summation of the figures casually consuming their chowder, watching the merry-go-round, walking alongside the roadway, and playing on the high-flying swings. Movement is a major theme of the painting, with Glackens contrasting the trolley with the horse and buggy and emphasizing the motion of the carousel, the (unseen but implied) race, and the soaring swings.

Outside the Guttenberg Race Track was displayed at the Pennsylvania Academy in January 1901, the first of Glackens's mature New York–area scenes to appear in a major exhibition. It was seen again in November 1905 in the *Tenth Annual International Exhibition* at the Carnegie Institute in Pittsburgh (Glackens's first appearance in that celebrated showplace), where it was overshadowed by his other entry, then called *At Mouquin's* (plate 39). The picture announced Glackens's continued commitment to the theme of urban and suburban pleasure grounds—usually those frequented by the hoi polloi. This choice of subject, as much as his choice of aesthetic strategies, was the legacy of the artist's experience in France. It remained a prominent

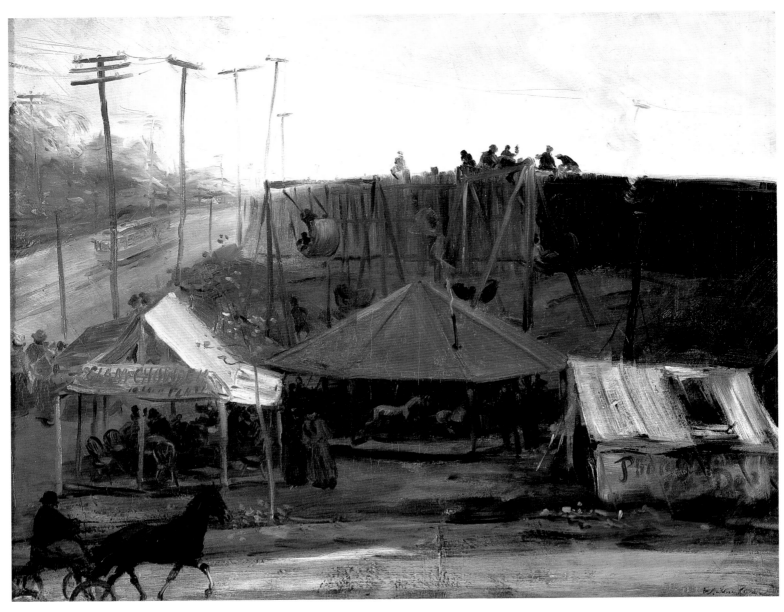

26. Outside the Guttenberg Race Track
(New Jersey), 1897
Oil on canvas, 25½ x 32 in.

27. Brighton Beach Race Track, 1907–8
Oil on canvas, 26 x 32 in.
© 1995 Barnes Foundation, Merion Station,
Pennsylvania

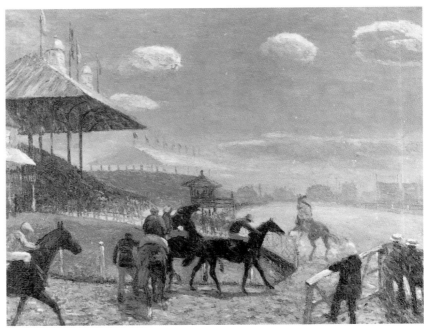

feature of his art, even after Glackens adopted a more colorful, Renoir-derived mode, and it differentiates his work from that of his friend and mentor Robert Henri, whose dramatic cityscapes of the late nineteenth and early twentieth century—painted in Paris, Philadelphia, and New York—rarely depicted the world of entertainment and communal enjoyment. Glackens returned to the racetrack theme over a decade later, in 1907–8, with his *Brighton Beach, Race Track* (plate 27)—a view of crowds in the grandstand, with horses and jockeys on the track.[2] Adjoining the Hotel Brighton at Coney Island, this was one of a number of extremely popular racetracks that operated successfully in Brooklyn until horse racing was banned in the city in 1910.

Another depiction of communal pleasure, *Fruit Stand, Coney Island* (plate 28), probably painted not long after his Guttenberg scene, took the artist to a very different urban outpost—the city's nearby beaches. Glackens avoided here the warm sparkling sunshine that animated the beach scenes of the French Impressionists and that would characterize his own later bathing depictions, and he also avoided the panoramic stretches of sand and water customary in earlier American coastal depictions. He focused his composition not on figures bathing but on the small, solid mass of a fruit stand—deliberately contrasting the green of the stand with the yellows and oranges of the fruit; a pair of small American flags wave jauntily from its roof. This is probably a weekday, for only a few males are present; the other figures are women strolling together on the sands. Only young girls actually venture into the water: three at left are in bathing costumes, including one who may actually have submerged herself, while two smaller girls at the right timidly raise their skirts and test the water.

Glackens was one of the first American Impressionists to paint Coney Island. This area of southern Brooklyn became popular with both the masses and the beau monde—the different classes frequenting separate sections of the sandbar—only after

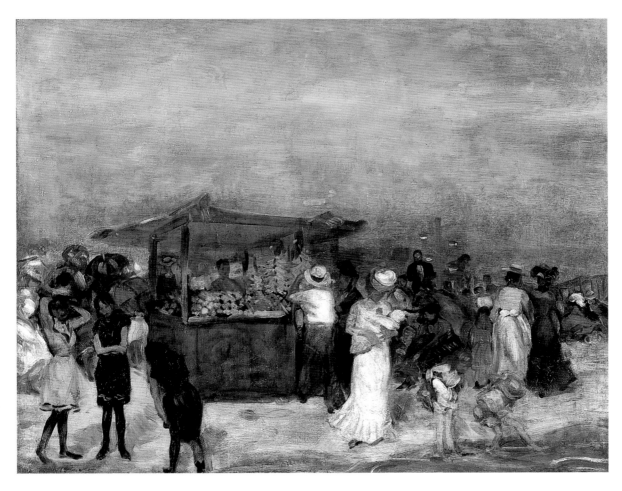

28. FRUIT STAND,
CONEY ISLAND, c. 1898
Oil on canvas,
25½ x 31 in.
John H. Surovek Gallery,
Palm Beach, Florida

29. Robert Henri
BEACH AT FAR ROCKAWAY, 1902
Oil on canvas, 26 x 32 in.
Private collection

30. AFTERNOON AT CONEY ISLAND, 1907
Watercolor, 14½ x 18⅝ in.
The Metropolitan Museum of Art,
New York; Gift of Albert E. Gallatin,
1915. (15.152.1)

the construction of railroads to the beach in the 1870s. During the 1880s and '90s few artists found it pictorially attractive, probably because the area was associated with a certain aura of vice and crime. Not until the second decade of the twentieth century did New York beaches begin to receive significant artistic attention. Glackens's early image can be considered a precursor of Henri's single excursion on a similar theme, his 1902 *Beach at Far Rockaway* (plate 29).

Glackens exhibited a painting called *Coney Island* in April 1903 at the Colonial Club in New York; this may have been *Fruit Stand, Coney Island*.[3] He continued to record Coney Island's popularity in a number of drawings and watercolors, such as *Morning at Coney Island* (Metropolitan Museum of Art) and *Afternoon at Coney Island* (plate 30), both of about 1907. In both, children find space to play or loll on the crowded sands; an immigrant family rests on a beach; and well-dressed younger men and women rest, flirt, and stroll. One dashing roué at left moves swiftly along, with a belle on each arm. All of this is set against the background of bathhouses and the iron pier, where one of the ferries that brought day-visitors from Manhattan is docked. Judging by the number of adult

males present, these watercolor drawings depict weekend or holiday excursionists. In fact, these scenes may be the result of a trip that Glackens made by boat to Coney Island the day before the Fourth of July holiday in 1907.[4] Glackens may also have used the drawings made at this time for one of his illustrations for Elliott Flower's short story "A Stranger in New York," which appeared in *Putnam's Magazine* in March 1909. In that work he concentrated more on women and children actually bathing, set against a background of the amusement park at Coney Island.[5]

Strangely, Glackens's early New York paintings were not exhibited in the city. Whether he attempted to show them and the works were rejected, or whether he avoided the art establishment, his early pictures appeared neither at the National Academy of Design nor at the somewhat more avant-garde Society of American Artists. In an undated letter written from New York to Henri in Philadelphia, probably in 1897, Glackens stated, "The exhibitions over here are atrocious but you can see good things in the loan exhibitions." And in a later letter to Henri, written January 22, 1898, Glackens suggested why his paintings might be rejected by the official annual exhibitions: "Don't bother yourself

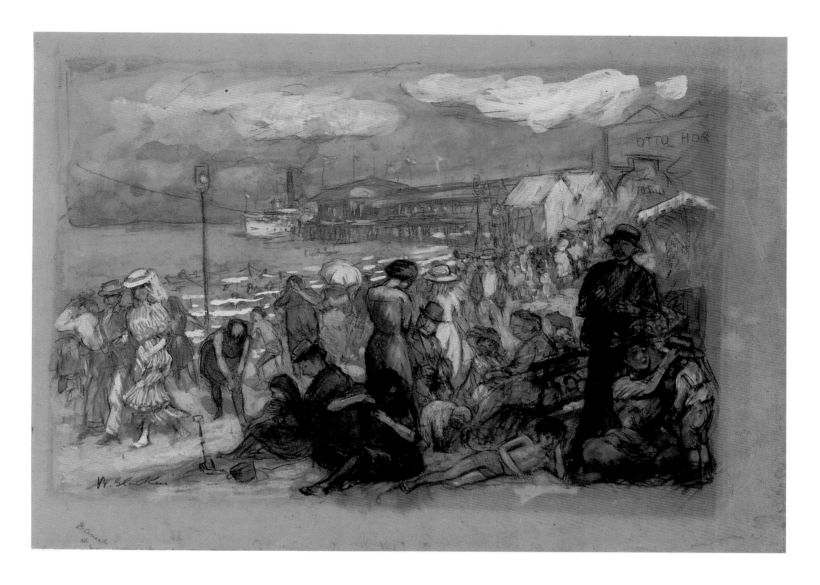

in the least about my *'execution.'* I can understand very readily that they could never go in any exhibition—a mixed exhibition that is. And especially in a place where you were unfortunate enough to have been a so called student. So it was down with the 'Mud' school was it?"[6] Ironically, even as he was writing that letter, five of Glackens's paintings were on view at the Pennsylvania Academy's sixty-seventh annual, but all of them had French subjects.

In addition to his urban genre scenes, and perhaps in purposeful contrast to scenes in which multiple small figures sometimes appeared almost ideographic, Glackens also created single-figure paintings. He would concentrate on specific models, almost always female, whose identities have often been lost but whose individuality and characterization is foremost. Among these is his masterful *Girl in Black Cape* (plate 31). This is an essay in the handling of neutral tones, with the only true color appearing in the figure's face. Youthful and attractive but not conventionally pretty, she has an expression that suggests fatigue and melancholy. Her no doubt slim figure is overwhelmed by the heavy, thickly painted cape, while her black hat seems to press down upon her head, adding to the effect of oppression. There is no "story" here—the background is totally neutral—but the figure herself is both monumental and forceful.[7]

Glackens's antecedents in such modern masters as Edouard Manet and James McNeill Whistler seem clear, while his broad paint handling recalls artists of the Munich School such as Frank Duveneck. It is likely that the artist's ultimate source was the painting of Frans Hals and Diego Velázquez, the same old masters who had inspired Duveneck and his colleagues in the 1870s. Again, it may have

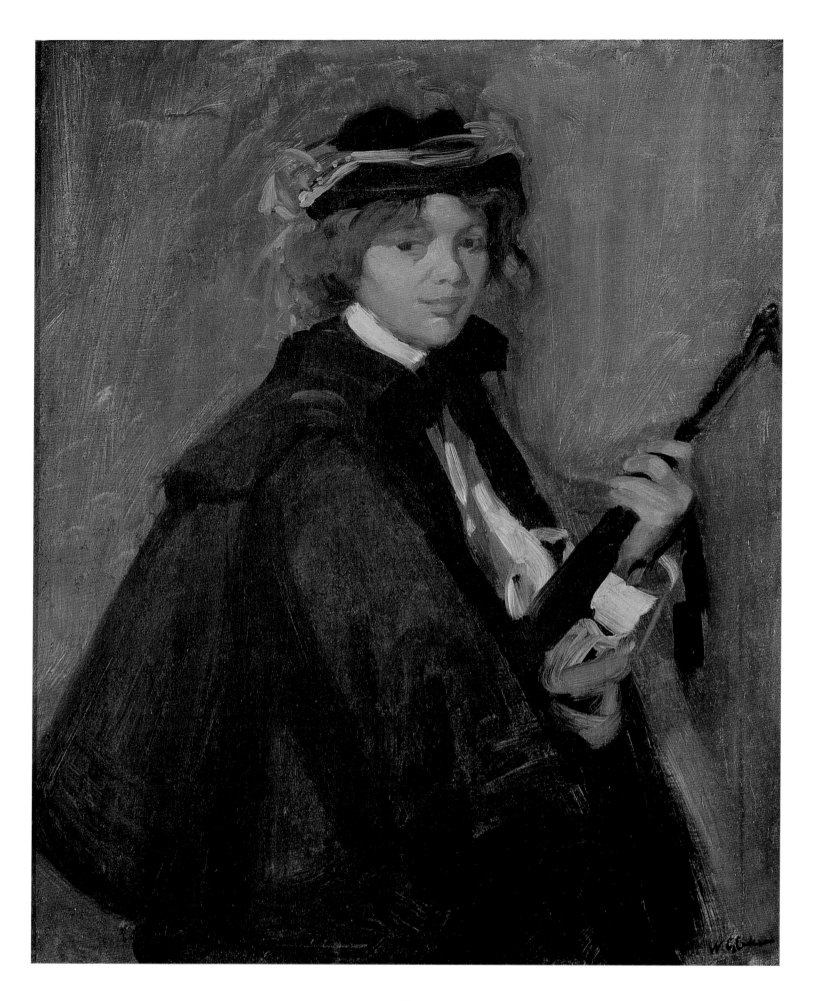

been Henri who provided Glackens with the most immediate source of inspiration, in his Velázquez-inspired works such as *Portrait of Carl Gustave Waldeck* (1896; Saint Louis Art Museum), painted in Paris when he and Glackens were there together. Even closer to *Girl in Black Cape* in subject, style, and spirit is Henri's *Woman in Manteau* (Brooklyn Museum), but this was painted in Paris in June 1898, and Glackens could not have seen it until Henri returned to America in August 1900, when he stayed with Glackens.

In 1899 Glackens moved to a studio at 13 West Thirtieth Street, close to many of the publishers who bought his illustrations.[8] Glackens's studio became a meeting place for his colleagues—those artists who would form a circle around Henri after he returned from Paris the following year.

In 1900 Glackens began exhibiting his paintings in New York, showing *Portrait of a Young Woman* at the Society of American Artists in late March; the work appears to have attracted no critical notice. Glackens did not exhibit with the society the following year. Instead, in April 1901 he participated in a group exhibition at the Allan Gallery (14 West Forty-fifth Street), along with his friends Henri, Sloan, and Alfred Maurer; his fellow illustrator from the *Herald* Ernest Fuhr; and Van Dearing Perrine and Willard Bertram Price. Henri was the prime mover behind this exhibition, being the only relatively well-established painter among the seven. The artists appear to have shown from one to five pictures each, where "Everybody is equally arranged half in light and half in dark."[9] The show was significant for Glackens, for it led to his earliest serious review, written by the newly appointed art critic for the *New York Evening Sun,* Charles FitzGerald. FitzGerald, who would become not only a close friend of the artist but ultimately his brother-in-law, noted that "today [Glackens] is one of the very few illustrators in this country whose work deserves serious considera-

tion. In this field he stands as an artist of pronounced individuality." FitzGerald also found him a painter of "more than ordinary ability," recognizing that he was

> one who has undoubtedly studied Manet, but surely this cannot discount the intrinsic value of such studies as that of the dancer that hangs opposite to the door of the entry, and the admirable scenes at Charenton, in a dance hall, and in a park. It is very well to carp at such things, but in picking out failings and shortcomings here and there we risk overlooking the positive qualities of the work. Now in Mr. Glackens the positive is an interest in the life around him.[10]

FitzGerald continued to give favorable notice to the artist's work. On March 4, 1902, he praised two drawings that Glackens showed at the first annual of the Associated Illustrators, referring to him as "the most remarkable illustrator that has appeared here in the last few years."[11] And three years later, in reviewing the inclusion of "Henri and his group" in the spring 1905 annual at the Society of American Artists, FitzGerald offered an even more extended encomium to Glackens, concluding that he was "one of the vital forces in our art to-day."[12]

It is possible to perceive the small Allan Gallery exhibition of the work of seven painters—Glackens, Henri, and Sloan among them—as the genesis of the exhibition of The Eight in 1908. A year later, in April 1902, Henri was prepared to organize a show of four painters that would have included Glackens, Luks, Arthur B. Davies, and himself, but plans were shelved after Luks departed for Europe. This departure followed a bon voyage party at Mouquin's restaurant, arranged by Henri, Glackens, and FitzGerald, whom Glackens and Henri had met through their friend the Canadian James Wilson Morrice, and who was increasingly becoming a

31. GIRL IN BLACK CAPE, C. 1897
Oil on canvas, 32 x 25½ in.

champion of all the artists of Henri's circle.[13] Glackens had become familiar with Davies's work as early as his 1894 trip to New York with Henri, and Glackens probably met him shortly after he moved to New York, when Henri and Davies also began a long friendship.

Maurice Prendergast joined the Henri circle in 1901, when he came down from Boston to paint scenes in Central Park and the East River Park (the present-day Carl Schurz Park). It was Glackens who introduced Prendergast to Henri on October 29, though they had both become aware of the Boston painter much earlier in Paris, again through their friend Morrice. Ernest Lawson appears to have been the last associate of the future Eight to join the Henri circle. He, too, was introduced to the group by Glackens, and he began his association with Henri, Glackens, Sloan, and Luks when they all exhibited together in *Exhibition of Paintings Mainly by New Men* in late March 1903 at the Colonial Club.

Glackens's three entries in that show introduced the artist's mature work to New York audiences and were much admired by FitzGerald. "Where shall we look for another who has given us what he gives us here? The children at play in the park, the bourgeoisie out for a holiday, the crowds at Coney Island—here, without the embarrassment of a text, is the life revealed to us already in his illustrations; it is the life that all of us have seen, but to which he sends us back again with renewed understanding, with keener insight."[14] That critics were already sensing the cohesion of the Henri circle is affirmed by the writer for *Town Topics* who "regretted that such an exhibition as this has nothing from Arthur Davies and Everett Shinn."[15]

Several of FitzGerald's references to Glackens's paintings in the Allan Gallery exhibition suggest that the artist was continuing to show his French pictures from 1895–96. But the allusion to a picture of a dancer suggests a new attraction for the artist, the world of the theater and indoor entertainment. The Allan Gallery painting might have been *Dancer in Blue* (plate 32), but it was more likely *Ballet Girl in Pink* (c. 1901; unlocated), which was

shown at the Society of American Artists in the spring of 1903 and then at the Louisiana Purchase Exposition in Saint Louis in 1904, where Glackens won a silver medal for it.[16] The bright color and general tonality of *Dancer in Blue* suggest a later date. Its colorful palette and decorative background contrast strongly with the far more austere *Dancer in Pink Dress* (plate 33), a picture of 1902, with its neutral background and single color note in the simple pink shift, strategically closer to the *Girl in Black Cape. Dancer in Pink Dress* suggests a youthful model assuming a dancing pose; *Dancer in Blue* resembles a theatrical performer, but more likely from a variety hall than the ballet or opera—the source of the dancers painted by Degas and Manet. Other theatrical subjects painted by Glackens, presumably now unlocated, are *Miss K. of the Chorus* (possibly an alternative title for *Dancer in Blue*) and *Ballet, Carmen*.

Another, more complex theatrical image of this period is Glackens's *Seated Actress with Mirror* (plate 34), a painting more deeply inspired by the works of Manet and Degas. Here, the *déshabillé* subject is shown in her dressing room, casually chatting with a fully clothed male visitor. Despite the separation of the two figures by a shaft of light from the window, which throws the visitor even more into the shadows of secrecy, the actress's costume and casual pose suggest a sexual intimacy rarely found in American paintings of the time. The mirror, a favorite device of Manet and Degas,

OPPOSITE:
32. DANCER IN BLUE, C. 1905
Oil on canvas, 48 x 30 in.

PAGE 46:
33. DANCER IN PINK DRESS, 1902
Oil on canvas, 40½ x 24 in.

PAGE 47:
34. SEATED ACTRESS WITH MIRROR, C. 1903
Oil on canvas, 48 x 30 in.
Sansom Foundation, New York; Promised gift to the
Museum of Art, Fort Lauderdale

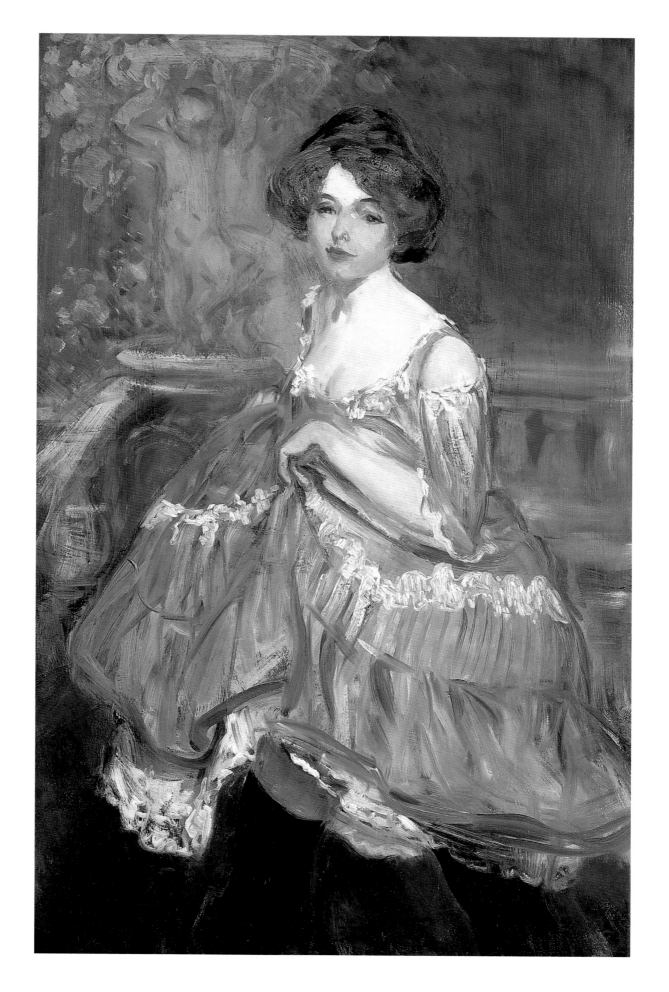

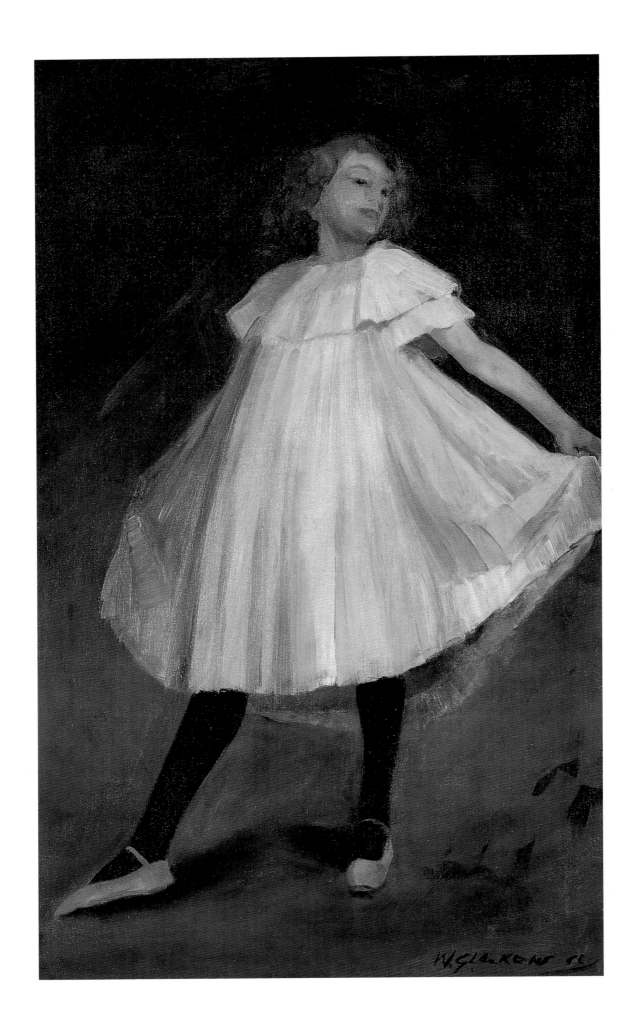

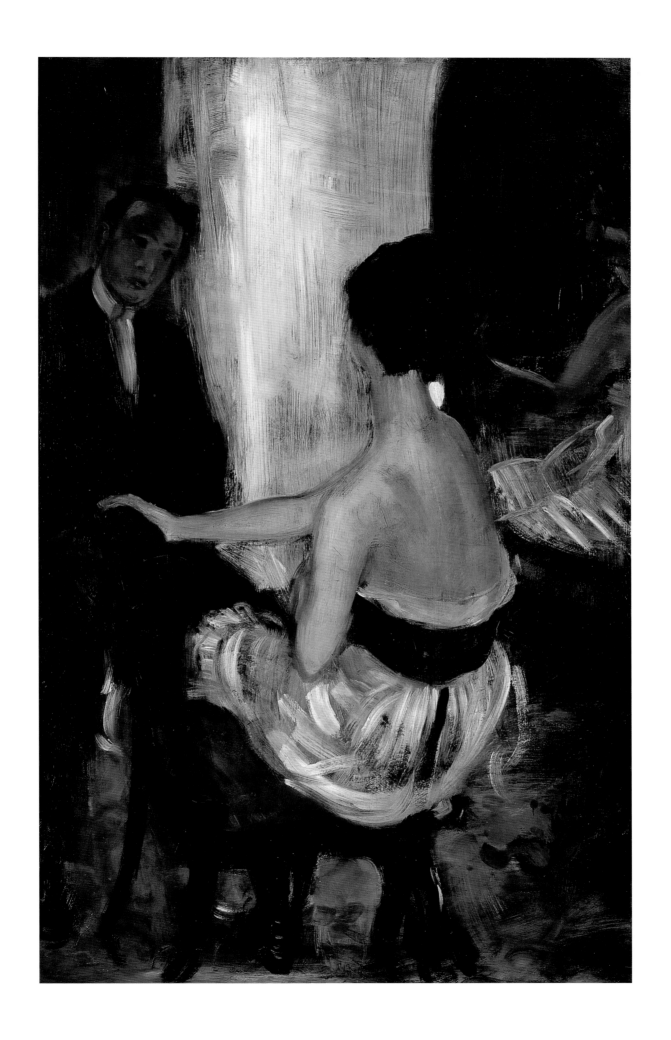

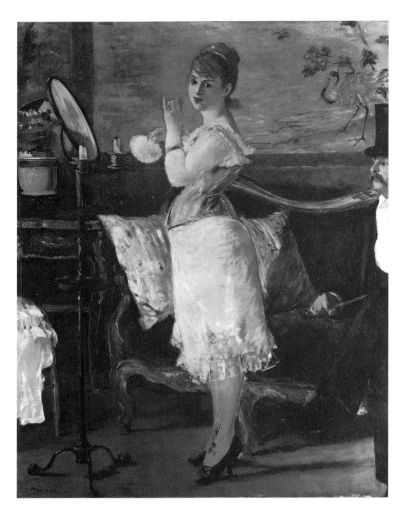

gives her further exposure, in both senses. Indeed, the painting particularly suggests a debt to Manet's *Nana* (plate 35), though the French work is much more provocative, with its unmistakable air of sexual transaction.

Not all of Glackens's figure paintings of this period are concerned with the world of entertainment; witness his small, superb *Ermine Muff* (plate 36), depicting a darkly elegant woman seated on a couch in what is surely the artist's studio. Though the figure is quite formally garbed, with emphasis on the brilliant whites of the scarf and the fur muff, her position is casual and the scene is generally informal—typical qualities of the "dark Impressionism" of this circle of artists.

The more intimate figure paintings of actresses and dancers contrast with Glackens's earliest American entertainment scene, *Hammerstein's Roof Garden* (plate 37) of c. 1901. The painting may have been completed even earlier, for a near-detail of the picture appeared as an illustration in *Harper's Bazar* in the summer of 1900.[17] Glackens keyed the painting to only a few areas of color—the

35. Edouard Manet
NANA, 1877
Oil on canvas, 60⅝ x 45¼ in.
Hamburg, Kunsthalle

36. THE ERMINE MUFF,
c. 1903
Oil on canvas, 14¼ x 17⅜ in.
Raymond and Margaret
Horowitz, New York

37. HAMMERSTEIN'S ROOF
GARDEN, C. 1901
Oil on canvas, 30 x 25 in.
Whitney Museum of American
Art, New York; Purchase 53.46

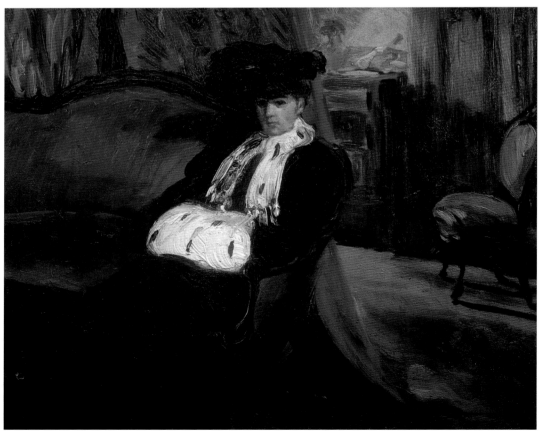

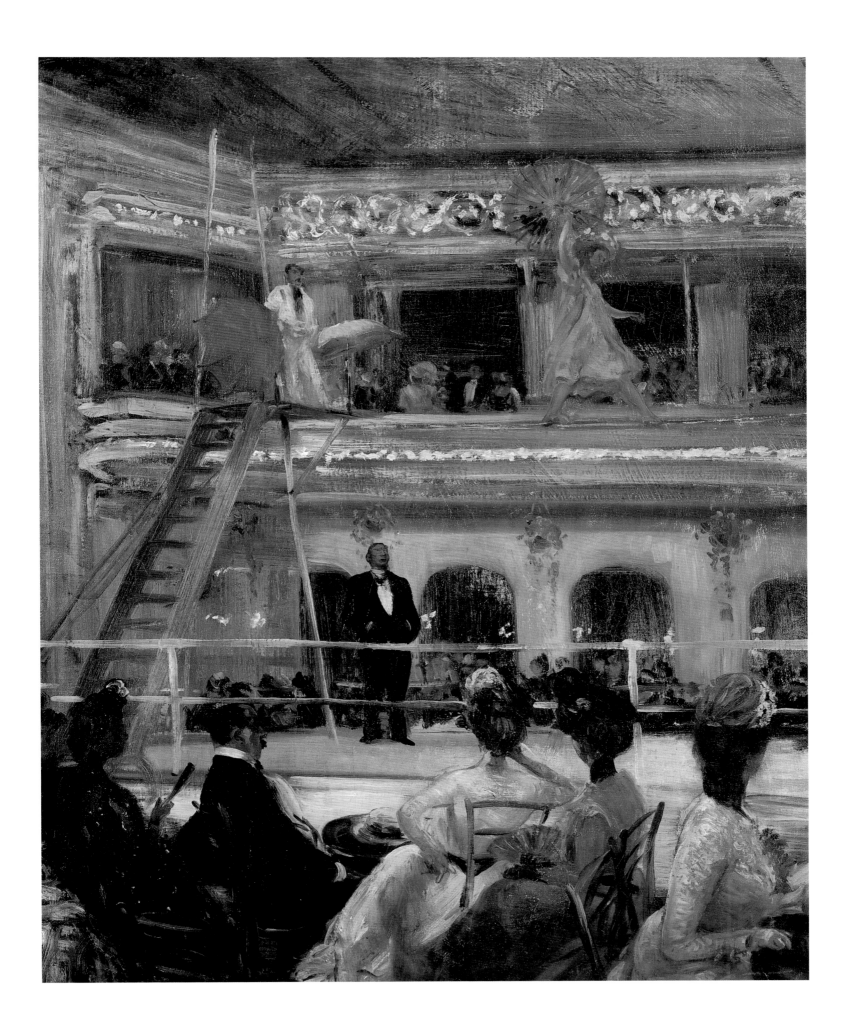

performer's blue costume and the red umbrella on the platform next to her male partner in white; the audience is uniformly garbed in black and white, echoed by the painted architecture. Glackens's authoritative control of anatomy is abundantly evident in the six figures in the foreground. Though all turn toward the stage and the performance, each registers a different reaction, from the stolid, bored male figure, through the casually attentive women to his right, to the woman at the far lower right who turns sharply to direct her attention to the high-wire act. New social mores are suggested by the presence of unaccompanied women, though the three figures in the center probably form a single party.

Glackens's scene takes place in the Paradise Roof Garden, just recently opened by Oscar Hammerstein in 1899 as an adjunct to his Victoria Theater at Forty-second Street and Seventh Avenue, which began operation that year.[18] Hammerstein's was only the latest establishment to cater to the public's fascination with roof-garden entertainment, which had begun in 1883 with Rudolph Aronson's addition of a garden to the top of his 1882 Casino Theater at Broadway and Thirty-ninth Street. Glackens may have chosen to visit this roof garden and then to represent it partly for its novelty value and perhaps also because by 1900 the older roof gardens appear to have lost much of their appeal; it was believed that Hammerstein's would restore popularity to such entertainments.

In the days before air conditioning, roof-garden theaters offered employment to entertainers and diversions to city-bound New Yorkers in the summer months, when other theaters closed due to the heat. And this is a summer scene, signified by the fans held by several of the women in the audience, and by the straw boater inelegantly placed on the small table before the foreground male figure. In choosing to depict a high-wire act, then, Glackens not only contrasts the casual attention of the spectators with a tense and challenging theatrical performance, but he has wittily chosen a high-flying, lofty exploit within the setting of an aerie. Of course, Glackens has chosen to depict tightrope

walking, not the "noble" art of true theater, and his picture recalls the sentiments of Mrs. Schuyler Van Rensselaer: "Cool and breezy places, too, although not in the least poetic, are the roof-gardens that form a summer substitute for theaters; and some day, perhaps, some one will invent for them more forms of entertainment that are neither vulgar nor desperately dull."[19]

Hammerstein's Roof Garden was one of Glackens's first pictures to achieve public recognition in New York. It was displayed, as *The Roof Garden,* at the Society of American Artists in the spring of 1902 and greeted with reserved praise in the *New York Sun* as "right virile stuff, though unnecessarily brusque."[20] FitzGerald began his review of the show with *The Roof Garden,* deploring its installation well above the sight line and commenting, "It is a pity that his paintings are not so well known as they deserve to be, but even this single contribution will help to show his worth."[21]

Such scenes of public entertainment again call to mind the work of Degas and Manet, as well as a number of theatrical subjects painted by Degas's English disciple, Walter Sickert; Nancy Glendinning has suggested that Glackens may well have known Sickert's work in this genre.[22] Glackens's friend and fellow painter-illustrator Everett Shinn had begun to investigate such themes in both pastel and oils as early as 1899.[23] Glackens's own illustrative work dovetailed with his paintings of theatrical entertainments; he prepared designs for such articles as "The Vaudeville Theatre" in October 1899 and "A Vaudeville Turn" in September 1901 (both for *Scribner's Magazine*), and "De Cirque at Ol' Ste. Anne" in March 1902 for *Century.*[24]

Glackens's celebration of even more popular pastimes include *Baseball Game* (also known as *Ball Park;* unlocated), exhibited at the National Arts Club, New York, in 1904. A very different but equally plebeian public entertainment is shown in *Roller Skating Rink* (plate 38). There are some similarities between it and *Hammerstein's Roof Garden,* particularly the row of seated figures observing the activities on the floor beyond. Glackens again created a series of separate vignettes, but in *Roller*

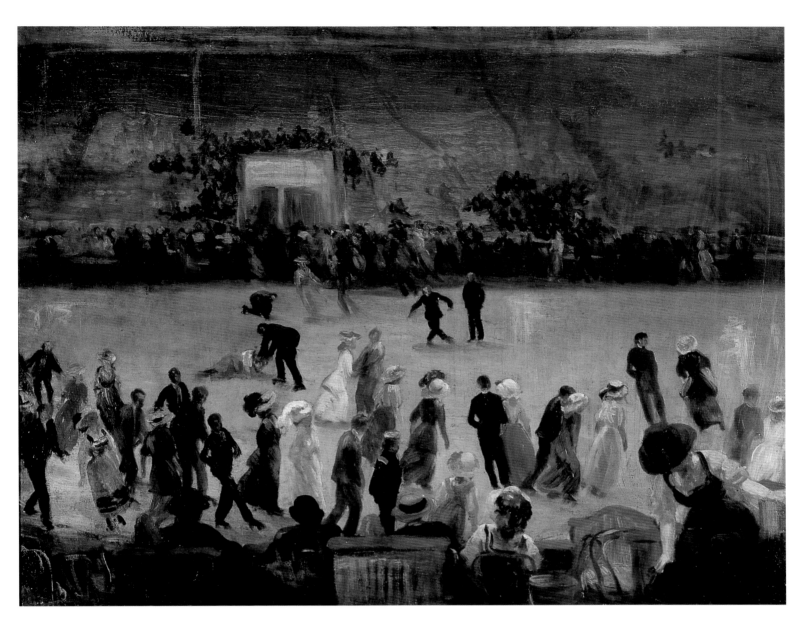

38. ROLLER SKATING RINK, 1906
Oil on canvas, 25 x 31½ in.
Mr. and Mrs. Meyer P. Potamkin, Philadelphia

Skating Rink the forms are less individualized; he distinguished his multitude of figures through pose and costume. A musical accompaniment is suggested by a dancing couple, while one woman is helped up by her escort, and a male figure stands watching another pirouetting. The specific rink in which the action takes place is not known, though one popular spot was the Metropolitan Roller Rink at 1684 Broadway. Glackens's painting corresponds to a contemporary discussion: "The best place to view such tricks is in a rink. There skating becomes an art as well as an amusement, and earth-spurning young women and equally proficient young men swoop and turn and go through intricate and subtle steps to the music of the band. Were it not for the noise the rollers make, there is no doubt that these performers would be more beautiful than skaters on ice."[25] The painting is usually dated to 1905, but Glackens described the excursion with his friends Henri, Lawson, James Moore, and May and James Preston that produced it in a letter to his wife, with an accompanying drawing, on April 23, 1906. The outing had been quite frenetic; in one mishap Moore "practically upset the whole

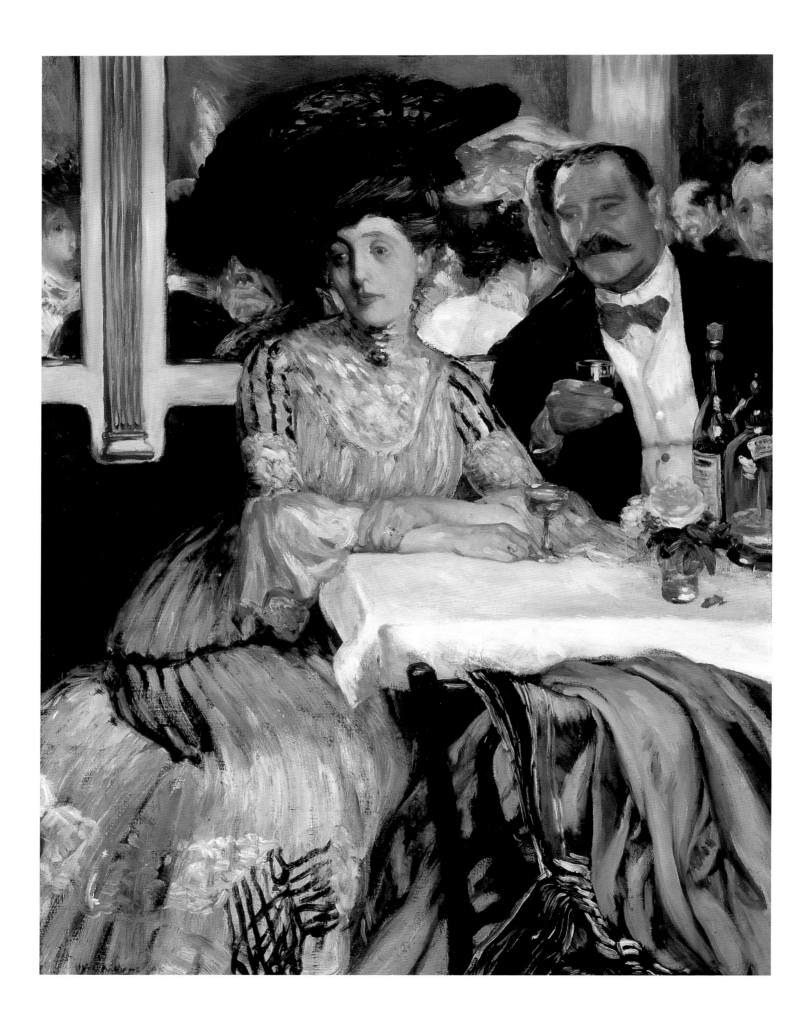

half of the rink," and Glackens himself was the first to fall, leaving him with the realization that "one can certainly get a harder fall on a board floor than on ice."[26]

In 1905 Glackens completed *Chez Mouquin* (plate 39), which remains his most celebrated and most frequently reproduced painting. A monumental indoor urban scene, it is set in a well-known middle-class restaurant that was popular with the theater crowds; Mouquin's was frequented by Glackens and other artists of Henri's circle, as well as by FitzGerald, William J. Gregg, and James Huneker, all empathetic writers from the *New York Sun* and its evening counterpart, the *Evening Sun*. This vigorous slice of contemporary New York life—with its flashy bon vivant accompanied by an attractive female companion—is also a portrait: the male is James Moore, owner of the Café Francis, the other favorite eating establishment of this clique. Mouquin's was at Twenty-eighth Street and Sixth Avenue, and the Café Francis at 53 West Thirty-fifth Street. Glackens, living only a few blocks away on Thirtieth Street, had dined frequently at Mouquin's before his marriage in 1904 and his subsequent move farther downtown.

Mouquin's—founded in 1898 and under the management of both the Swiss-born Henri Mouquin and his son, Louis—was a famed eating and drinking establishment of considerable longevity, an outpost of Paris in New York, featuring French wines and French music played by French musicians.[27] Benjamin DeCasseres, who had first been taken there in 1906 by Glackens's brother, Louis, recalled:

> [What] set it apart from any other French, German or American restaurant in New York were frivolity, a total absence of all formality, *cameraderie* [sic], the subtle

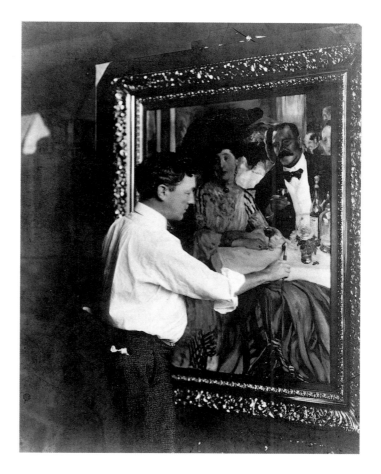

40. William Glackens touching up
CHEZ MOUQUIN, C. 1908

suggestions that came to the nostrils and the eye of wines, wines shimmering and winking at you in every conceivable kind of glass; the wall-mirrors and shiny marble-topped tables in the famous café downstairs, and above all, the feeling that soaked into you on entering that here was a place where business was never discussed.[28]

Unfortunately, Prohibition brought the great institution to an end; Mouquin closed his downtown restaurant on Fulton Street in 1920; the Sixth Avenue establishment was padlocked in 1925.

Mouquin's was a restaurant where the artists would have wonderful meals when they could afford it, but it is noticeable that Moore and his companion are not eating but drinking, with several bottles on the table. The fashionably garbed woman—passive, somewhat bored, and turning away from Moore—has a cocktail, untouched, at

39. CHEZ MOUQUIN, 1905
Oil on canvas, 48¼ x 36¼ in.
The Art Institute of Chicago;
Friends of American Art, 1925.295

her fingertips (there is a cherry in the glass, so it is not wine, the featured drink of Mouquin's): Moore, who lunges toward her, holds a glass of what may be the "hard stuff." The woman— one of the young ladies he referred to as "his daughters"[29]—is all feminine, sinuous curves, while Moore appears as a massive, bulky form.

When *Chez Mouquin* was exhibited in The Eight's traveling show, it was interpreted in quite an ominous fashion by a Cincinnati critic who judged that Glackens "brings out every phase of the gross roué and the young woman who is taking her first step in the field of dissipation, and in the misery shown in her eyes is a mighty lesson."[30] The two figures are silhouetted against the mirrored background of the downstairs section of the restaurant, which is quite crowded, judging by the number of other men and women reflected in the mirror. The male figure mirrored at far right has been identified as Charles FitzGerald, with Glackens's wife, Edith, as his companion. In describing the painting the critic James Huneker identified his colleague as "a young art critic with a Mephistophelean smile" and wondered if he was not envying Moore in the latter's choice of companion.[31] George Luks also portrayed a scene in the downstairs café, *At Mouquin's* (formerly, Mr. and Mrs. Harold L. Renfield collection, New York), one of a series of twelve pictures entitled *About New York (New York Nights)*. In 1904 Everett Shinn had drawn a brilliant pastel, *Mouquin's* (The Newark Museum, Newark, New Jersey), which depicts the exterior of the Fulton Street branch of the restaurant.

Soon after *Chez Mouquin* was painted, Moore lured away the restaurant's chef to his own establishment and advertised the Café Francis as "New York's Most Popular Resort of New Bohemia." Works by some of the artist-patrons were featured on the café's walls, including a now unlocated Spanish bullfight scene by Glackens, painted in 1906.[32] George Luks created a rival canvas to Glackens's, entitled *The Café Francis* (plate 41), depicting Moore, again with one of his "daughters," walking away from a table. In fact, by 1908

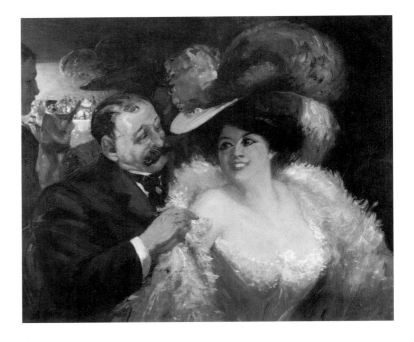

41. George Luks
THE CAFÉ FRANCIS, C. 1906
Oil on canvas, 36 x 42 in.
Butler Institute of American Art, Youngstown, Ohio

Glackens, Luks, and their circle of painters were identified as "the Café Francis school."[33] They also gathered at Moore's four-story brownstone at 450 West Twenty-third Street, where the basement walls were covered, floor to ceiling, in canvas. The artists covered these with paintings—Henri creating a full-length likeness of Moore in the company of friends, and Glackens contributing *The Frog Game*. In a few years Moore, who was also a lawyer and active in real estate, began having financial troubles, and in 1908 both his home and the Café Francis were sold.

In its emphasis on contemporary urban life, as well as its manipulation of interior light, mirror imaging, and cropped figures, *Chez Mouquin* (along with Glackens's other early figural works) has been compared with the paintings of Degas, and especially with the French master's *In a Café* (plate 42). Formally, the two pictures do have a strong similarity, but the sense of despair in Degas's picture is replaced in the Glackens by a buoyant joie de vivre. One frequent writer on Glackens's art, Albert Gallatin, noted in 1910 that "the art of Glackens is closely linked with that of Degas and

Manet; it is, in fact, a lineal descendant." He went on to declare:

But the great difference between Degas and Glackens is that where the former too often seeks for the ugly and repulsive, the painfully sordid, the ultra prosaic, the latter looks only for what gaiety and humor he may discover in the scene. And Glackens is none the less a faithful recorder, an unflinching realist, because his sympathetic pencil is never dipped in gall, as in the case of the brutal brush of the cynic Degas.[34]

Degas and, even more, Manet come to mind in viewing Glackens's portraits. Few in number, these

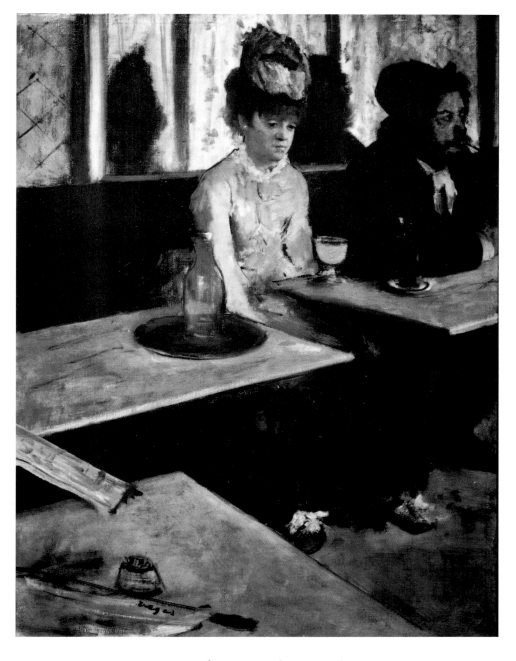

42. Edgar Degas (1834–1917)
IN A CAFÉ, or THE ABSINTHE DRINKER, C. 1875–76
Oil on canvas, 36¼ x 26¾ in.
Musée d'Orsay, Paris

43. PORTRAIT OF CHARLES
FITZGERALD, 1903
Oil on canvas, 75 x 40 in.

44. Robert Henri
PORTRAIT OF WILLIAM GLACKENS,
1904
Oil on canvas, 78 x 38 in.
Sheldon Memorial Art Gallery,
University of Nebraska,
Lincoln, Nebraska.
Thomas D. Woods Memorial
Collection

45. Photograph of Edith Dimock, c. 1902

has dominated the show and his influence is apparent on every side. This is shown in a full length portrait of a young man by W. Glackens."[35] The *New York Sun* praised it as "one of the most interesting portraits of the exhibition,"[36] and by virtue of this and another picture, Glackens was made a member of the society that year.

The year 1904 was a momentous one in Glackens's life, for on February 16 he married the young artist Edith Dimock from West Hartford, Connecticut (plate 45)—the emancipated daughter of Ira Dimock, a wealthy New England textile manufacturer.[37] She had been a student at the New York Art Students League from 1895 to 1899 and then at William Merritt Chase's New York School of Art. Glackens came to know Edith through his good friend the artist James Preston, who had been a newspaper illustrator back in Philadelphia in the 1890s and was a member of the Henri circle there. Glackens may actually have met Edith during his first trip abroad, in 1895–96; Elsie Fuhr, the widow of Glackens's illustrator friend and traveling companion Ernest Fuhr, recalled that Edith said that "her romance with Willie started in Paris while she was there on a short trip with May Preston."[38]

The wedding, with James Moore as best man, took place at the Dimock's grand house on Vanderbilt Hill (now called West Hill), built around 1880 by Cornelius Jeremiah Vanderbilt; a special Pullman car was chartered to bring family and guests from Philadelphia and New York, including Luks, Shinn, and FitzGerald.[39] Such a felicitous marriage certainly eased Glackens's financial concerns; in 1907 John Sloan noted in his diary, "He [Glackens] should be happy, a wife, a baby, money in the family, genius."[40] Glackens and his new bride established themselves temporarily in a studio in the Sherwood Studio Building at Sixth Avenue and Fifty-seventh Street, where Edith had shared a studio with her friend May Wilson (later Preston) and where Henri had been located for several years. By the summer the newlyweds had moved to 3 Washington Square North, where they remained for four years; Glackens took a studio at

were not commissioned works; rather, they depict family and friends. The earliest, and certainly one of the finest, is *Portrait of Charles FitzGerald* (plate 43). The slender young critic projects confident urbanity, with one hand on his hip and the other holding his hat and stick. The indebtedness to Velázquez, or at least to the tradition of Velázquez as reinterpreted first by Manet and Whistler and then by Henri, is especially striking. Henri had, this very year, started to concentrate on full-length portraits, and in 1904 he completed a series of dark, dramatic likenesses of his friends and fellow painters, including Glackens himself (plate 44)—a painting that bears particular comparison with Glackens's image of FitzGerald.

Glackens exhibited the FitzGerald portrait at the Society of American Artists in 1905, where it was one of several pictures indebted to Whistler. The

46. Portrait of
the Artist's Wife, 1904
Oil on canvas, 74⅝ x 39⅝ in.
Wadsworth Atheneum, Hartford,
Connecticut; Gift of Ira Glackens
in memory of his mother, the
former Edith Dimock of Hartford

50 Washington Square South, which he briefly shared with Ernest Lawson.[41]

Glackens painted *Portrait of the Artist's Wife* (plate 46) in the Sherwood studio the year of their marriage, and it is one of his finest works.[42] Edith is portrayed seated, with her pleated skirt flared, next to a ravishingly painted fruit still life. She has a knowing, confident, but quizzical expression on her face. Her body appears full under her weighty garments, in contrast to her small face, and Glackens has not attempted to beautify his new bride, frankly acknowledging her pert nose and small chin. Glackens's image of Edith contrasts interestingly with Henri's more slender and elegant view of her in *Portrait of Edith Dimock Glackens* (plate 47). Henri had begun the picture in 1902 and completed it in May 1904, along with his likeness of her husband, presenting them as wedding gifts.

About this time or shortly after Glackens painted a portrait of his good friend the German-born pianist and teacher Ferdinand Sinzig (plate 48). Sinzig and his wife, Louise, were also members of the Henri circle. Sinzig's portrait is identical in size to FitzGerald's and appears to be almost a mate to it; both are standing full-lengths, and while FitzGerald faces to the right, Sinzig faces left. For variation, Glackens posed Sinzig holding his hat in one hand and his cane in the other, with his cloak over his arm. The Sinzig portrait is somewhat lighter and more colorful, with the musician wearing a blue tie and light-colored trousers, but the indebtedness to Velázquez and to Henri's series of full-length likenesses is equally apparent.

Glackens also painted likenesses of several of his fellow members of The Eight, including George Luks (twice) and Robert Henri (unlocated). Glackens wrote to Edith on January 21, 1905:

My picture of Hen is progressing very favorably from my point of view. Whether Henri approves of it altogether I can't say. He appears to be afraid of not being made big enough, of having a brow not so lofty and broad as he possesses or square enough jaw

47. Robert Henri
PORTRAIT OF EDITH DIMOCK GLACKENS, 1902–4
Oil on canvas, 76¾ x 38⅜ in.
Sheldon Memorial Art Gallery, University of Nebraska,
Lincoln, Nebraska; Gift of Miss Alice Abel,
Mr. and Mrs. Gene H. Tallman, The Abel Foundation,
and Mrs. Olga N. Sheldon

48. PORTRAIT OF FERDINAND SINZIG (also known as PORTRAIT OF A MUSICIAN and PORTRAIT OF A MUSICIAN [FERDINAND SINZIG]), c. 1906
Oil on canvas, 75¼ x 40 in.

49. PORTRAIT OF ERNEST LAWSON, 1910
Oil on canvas, 30 x 25 in.
National Academy of Design, New York

or altogether as impressive and formidable as he wishes. Of course I have to gather this from the slight criticism he gives. I may be wrong. Hen's personal vanity is not all together a joke I fear. I don't think myself it is the best side of him. I would have to do that from memory.[43]

A somewhat later portrait is that of Ernest Lawson (plate 49), created by Glackens as the lat-

ter's diploma portrait for qualification for associate membership in the National Academy of Design, to which Lawson had been elected in 1908. The portrait is usually dated to that year, but actually it was not painted until 1910, as the more colorful palette very plainly suggests, and the picture was not formally presented until January 9, 1911. Lawson provided the Academy with a progress report in a letter of April 13, 1910: "Glackens had only a few touches to do on the portrait but yester-

day he got it in a bad state and he couldn't finish it. So I can't send it up today as I said. I'll send it as soon as it is done. I pose again tomorrow. I never knew [my] mug was so hard to get."[44]

Glackens's paintings had been exhibited in a loan exhibition organized by Henri and held at the National Arts Club on Gramercy Park, beginning on January 19, 1904. This display brought together the work of Davies, Glackens, Henri, Luks, Prendergast, and *(hors de catalogue)* John Sloan—in all, six of the future members of The Eight, lacking only Lawson and Shinn. This was a show that identified clearly for New York's art establishment the new directions that were being taken by these young insurgent painters. The critics gave it a good deal of attention, most of it favorable. The catalog listed seven works by Glackens, but judging by the reviews, more were actually on view. The seven works registered were four full-length figure pieces, primarily from the world of entertainment, as well as *French Fête, Baseball Game,* and *East River Park;* also cited by critics were *East River* and *The Big Rock* (now known as *Boys Sliding;* Delaware Art Museum, Wilmington).

Arthur Hoeber was the principal protester, characterizing the pictures as "lugubrious" and "unhealthy"[45]; not surprisingly, FitzGerald was the group's most enthusiastic champion. Comparing the work to that recently shown at the National Academy, FitzGerald noted, "There is nothing here of the vague compromise that we are accustomed to . . . no fumbling of awkward facts, none of the usual bribes to taste," but rather "frank decision and forthright power."[46] Charles de Kay, too, compared the work favorably to that shown at the Academy and the Society of American Artists, labeling the exhibitors "red-hot American painters," who "represent the vigorous school of picture-making."[47] He and others designated these painters "Impressionists,"[48] and many of the critics, FitzGerald included, associated them specifically with the school of Manet and Degas.

The theme that Glackens undertook most frequently during the early and middle years of the first decade in this century was the outdoor urban scene—views along Manhattan's periphery, the harbor and rivers, and the parks. In this Glackens was hardly unique; Henri had devoted himself primarily to urban New York views for several years after he returned from Paris in 1900, before concentrating on figural work. Henri was followed in this not only by Glackens but by almost all the other future members of The Eight: Luks; Lawson; Shinn, especially in his pastels; Sloan, after he moved to New York in 1904; and Prendergast, during his 1901 sojourn in the city. Henri (for those several years) and Lawson (continually) concentrated on the urban landscape, while the others were more concerned with the activities of the populace within the city environment, often focusing on the lives of the less privileged. Much of the work by Henri, Luks, Shinn, and Sloan was raw and rugged, whereas that by Lawson and Prendergast tended to be more gentle and lighthearted, recapitulating to some extent the earlier approach of the American Impressionists. Glackens's art, in both theme and modes of expression, was somewhere in between. Basically he favored scenes of public play, spectacle, and entertainment, avoiding the more problematic and depressing lower-class themes that sometimes engaged his former Philadelphia colleagues. Indeed, Glackens's somewhat insensitive comments about the lower classes were quoted by Louis Baury in 1911.[49]

Glackens found the slums "good subjects for pictures" in his illustrations but not in his easel paintings, in which he concentrated instead on the spectacle of ordinary urban life. One of the earliest of these paintings is *Park on the River* (plate 50), painted around 1902. Typical of Glackens's approach at this time, the foreground consists of a series of vignettes between two tall, dark trees, centering on two little girls on an open park walk. The costumes suggest summer, as does the parasol over the pram and the rather listless movement of the figures; in contrast is the busy river traffic, which includes a sailing vessel and a ferry, all set against an industrial background. This is almost surely a scene in East River Park, on the East River at Eighty-sixth Street.[50]

50. Park on the River, c. 1902
Oil on canvas, 25⅞ x 32 in.
The Brooklyn Museum, New York; Dick S. Ramsay Fund

In 1901 Maurice Prendergast had produced several watercolors along the East River, including two of this park, and it seems likely that he and Glackens painted there together. While Glackens and his associates often chose outdoor subjects near their homes and studios, they also roamed freely throughout Manhattan. East River Park was quite far from Glackens's base on Thirtieth Street; so was the southern tip of Manhattan, where he painted *The Battery* (plate 51), a subject also depicted at much the same time by a number of the leading American Impressionists. As in *East River Park,* Glackens presented the Battery as a pleasure area and concentrated on the pictorial dialogue between the figures in the foreground: the couples seated on park benches in front of the

51. THE BATTERY, 1902–4
Oil on canvas, 26 x 32 in.
Abby and Alan D. Levy, Los Angeles, California

Aquarium (the former defense bulwark known as Castle Clinton and later Castle Garden), along with a schoolboy trudging on a park path. It is probably late spring or early summer, suggested by the light-colored dresses of the women. These casual vignettes contrast with the active tugs, ferries, and even a sailing ship plying New York harbor. While the city's skyline, with its tall buildings, has been omitted, the dynamism of its economic life has not.

In this same period Glackens turned his attention to the vibrant activity on the East River itself, in his Manet-like *East River from Brooklyn* (plate 52). This was painted in 1902, when Henri was involved in similar subjects, and uses an *alla prima* technique similar to his, with flat, painterly brushstrokes de-

52. East River from Brooklyn, 1902
Oil on canvas, 25⅛ x 30 in.
Santa Barbara Museum of Art, Santa Barbara, California;
Gift of Mrs. Sterling Morton for the Preston Morton Collection

rived from Manet. Compared to the more regulated Hudson River, the East River was considered more picturesque, with polyglot denizens among the markets, ship-stores, and sailors' lodging houses on the waterfront, as well as a greater variety of maritime activity. Artists painted the East River far more often than the Hudson; Glackens himself had illustrated an East River waterfront scene at the foot of Wall Street in 1900.[51] In *East River*

from Brooklyn, Glackens positioned himself across the mouth of the river. In the foreground a group of "river rats"—naked young male swimmers—are entering the river, while in the distance is a variety of vessels—a sailing ship, a side-wheeler, and a tug; the Brooklyn Bridge stretches across the far distance.[52]

The urban realists, Glackens among them, were drawn especially to the tugboats on the rivers and

53. TUGBOAT AND LIGHTER, 1904–5
Oil on canvas, 25 x 30 in.

harbors, the workhorses of the seaways, rather than elegant steamships. He made one the center of focus in *Tugboat and Lighter* (plate 53), where a harbor "dialogue" is in progress between the compact tug, belching white smoke, and the lighter with its slender loading equipment paralleling the black smokestack of the tug. The dark, dramatic tug is contrasted also with the white paddle steamer at the left, more graceful and elegant. This vessel

bears the name *Sloan,* but whether this was the boat's actual name or a witty tribute to Glackens's colleague is not known. If the painting does date to 1904, this might have been in recognition of Sloan's recent move to New York.

In the distance in *Tugboat and Lighter* is the Statue of Liberty. The monument appears again in Glackens's *Breezy Day, Tugboats, New York Harbor* (plate 54). The cast of characters is somewhat simi-

54. Breezy Day, Tugboats, New York Harbor, c. 1910
Oil on canvas, 26 x 31¾ in.
Milwaukee Art Museum; Gift of Mr. and Mrs. Donald B. Abert and Mrs. Barbara Abert Tooman

lar to those in *East River from Brooklyn* and *Tugboat and Lighter*—tugs, a ferry, and a sailing vessel—but now the viewpoint is right on the harbor's waters, with the two tugs in the foreground close up and quite detailed, more like "portraits" of individual small vessels. In both of these tugboat pictures the Statue of Liberty looms as a somewhat frail and ghostly beacon for both the viewer and the ships in the harbor. Glackens's brushwork in *Breezy Day, Tugboats, New York Harbor* is even

looser and more staccato than in the other river scenes, and his palette, though still dark, is more varied and colorful, more traditionally "Impressionist," especially in the pigments laid on side by side in both the sky and the water.

Of all the urban landscape that Glackens painted during the century's first decade, none received more public exposure than his Central Park views. Glackens, Henri, and their circle made something of a specialty of views of Central Park, a site they

also visited for skating and relaxation. Though several Central Park scenes by Ernest Lawson have been dated to 1896, Maurice Prendergast may have been the first of the group to paint the park regularly, with over thirty watercolors created in 1900 and 1901. Henri, who taught at the Veltin School on Seventy-fourth Street near Central Park, painted several oils of the park in 1901–2; Shinn and Luks also painted the park occasionally. Glackens's earliest images of Central Park were not paintings but illustrations published in *Harper's Bazar* in 1900.[53] These illustrations, with scenes of horseback riding and promenading, focus more on upper-class activities than do his oil paintings. Exactly when Glackens began to paint the park is not documented, but it was almost surely not before spring 1904. No Central

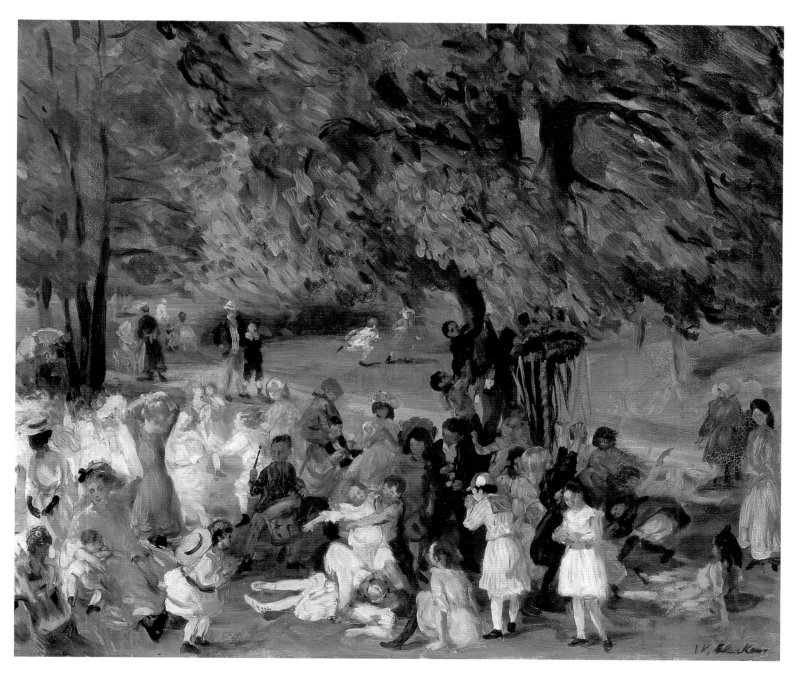

55. MAY DAY IN CENTRAL PARK, C. 1905
Oil on canvas, 25⅛ x 30¼ in.
The Fine Arts Museums of San Francisco; Gift of Charles E. Merrill Trust
with matching funds from the de Young Museum Society, 70.11

3. NEW YORK SCENES

Park paintings by him (or by any of his colleagues) appeared in the catalog of the National Arts Club show in January 1904, but in January 1905 he exhibited *May Day in Central Park* (plate 55) at the *Hundredth Annual Exhibition* of the Pennsylvania Academy. Since the work commemorates the May Day celebration in the park, it must surely have been painted the previous year.

Glackens's scene is an idyllic one, dominated by the fresh greens of springtime. A few of the distant figures on a park path are quite sedate—a nurse wheeling a perambulator and an older man walking with a boy in knee britches—but the foreground group of literally dozens of figures, almost all children, is raucous. A number are running swiftly, perhaps playing tag, and one girl at the right lies awkwardly sprawled on the ground, while another is falling nearby, indecorously revealing her undergarment. One older boy carries another on his shoulders; a boy hoists another up the central tree behind the striped maypole, perhaps after the single piece of red fruit among the green leaves; still another boy beats a drum; and several pairs of figures tussle strenuously. In the aftermath of the May Day procession the maypole itself, leaning against a tree, is all but forgotten. Typical of Glackens, these are all separate vignettes, though here exceptionally well integrated. A similar but somewhat more sedate canvas is *Little May Day Procession* (1905; Manoogian Collection).

Prendergast had already painted at least a half dozen watercolors of the May Day celebration in the Park several years earlier. Henri had earlier painted a series, mostly stark, austere winter scenes. Glackens's two May Day paintings may be indebted in part to Henri's far more staid but still casual *Picnic at Meshoppen, Pennsylvania, 4 July, 1902* (Westmoreland Museum of Art, Greensburg, Pennsylvania). In turn, the Glackens work may have served as inspiration for George Bellows's two 1905 versions of *May Day in Central Park* (Ira and Nancy Koger collection, and Ohio State University Faculty Club, Columbus); for John Sloan's *Picnic Grounds* (1906–7; Whitney Museum of American Art, New York), a scene recorded in Bayonne,

New Jersey; and for Ernest Lawson's somewhat later *A May Party* (alternatively, *May Day Central Park;* unlocated). Ultimately, the spirit of Manet, in terms of both theme and painterly technique, hovers over *May Day in Central Park*. This was noted by Glackens's friend the art writer Walter Pach: "As Edouard Manet saw the life of the Parisian café of his time, or of the French capital, represented in the 'Music of the Tuilleries,' so William J. Glackens has given us documents of American life in his significant series of pictures, the 'May-Day,' 'At Mouquin's,' etc."[54]

Four years later Margaret Anderson projected the same mixed message of French derivation and national character when she wrote: "Such things as his 'May-day in Central Park' are distinctly French. They might have been done by Manet. . . . These resemblances, however, only emphasize the originality of the American landscape."[55] And Shinn must have been reflecting on pictures such as this when he noted of Glackens: "All color is mingled in his mighty draftsmanship. . . . Paint is audible in children's games in square and park."[56]

Central Park, Winter (plate 56) was probably painted in the early winter of 1904–5, for it was shown along with *Park on the River* and *May Day in Central Park* in Portland, Oregon, at the Lewis and Clark Exposition in 1905. The winter season is conveyed by the dark trees, silhouetted against the snow, and the overall bluish tonality. Middle-class families have brought their nicely dressed children to play, some on sleds and others just rolling down the snowy slopes. A fashionably garbed woman with a muff leans on a tree at the right, attentively watching her little daughter with her red sled.[57] Glackens confirms here that in wintertime especially, Central Park was recognized as a preserve for children. "It is the children that glory most in the snow, and find in it temptations fit to make the nurses weary."[58]

Glackens was concerned here with capturing both the rapport between adults and their offspring and the pleasures to be found in such a setting. His compositional choreography in portraying the carefree activities in *Central Park, Winter* allows the viewer's eye to range freely in various directions,

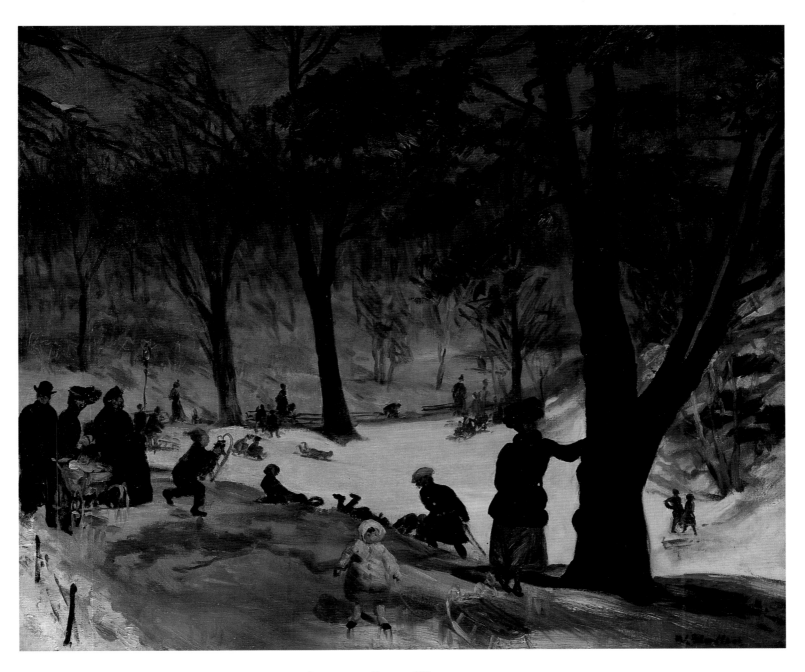

56. Central Park, Winter, c. 1905
Oil on canvas, 25⅛ x 30¼ in.
The Metropolitan Museum of Art, New York;
George A. Hearn Fund, 1921. (21.164)

giving the work a sense of liberation that seems to democratize the park itself, particularly compared to the more measured construct of park views by William Merritt Chase and Childe Hassam. And as one observer noted in 1900, there was an exciting freedom conceded in the winter months, for while visitors were confined to the asphalt paths during most of the year, in order to preserve the lawns,

shrubbery, and trees; "a fall of snow opens the way to any place in the Park."[59]

Even when Glackens painted a more upper-class subject, such as *The Drive—Central Park* (plate 57), members of diverse classes walk on the paths and sit on the benches in casual poses, while fashionable folk drive in carriages and a well-dressed family promenades on the pathway. An elegant victoria at

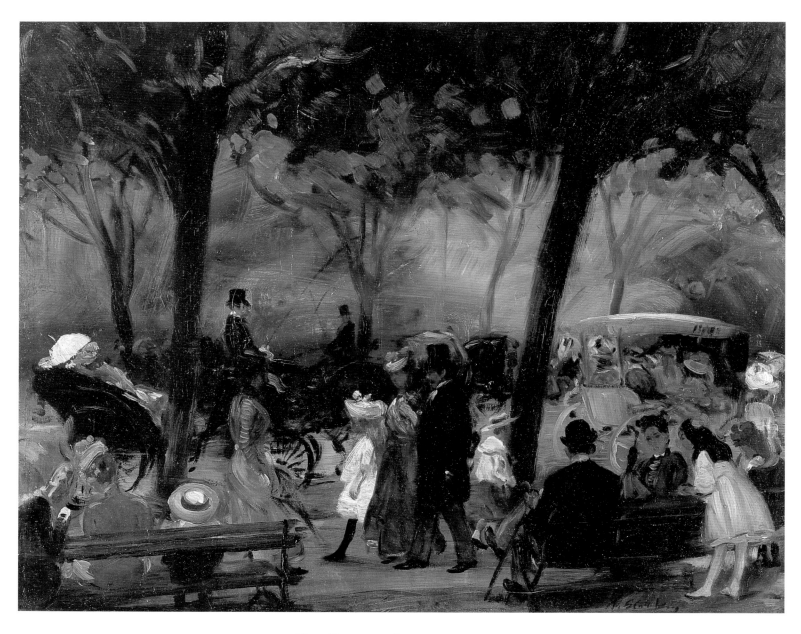

57. The Drive—Central Park, 1905
Oil on canvas, 25¾ x 32 in.
© The Cleveland Museum of Art; Purchase from the J. H. Wade Fund, 39.524

the left contrasts with the vehicle on the right with the awning, probably a park carriage for those who could afford the twenty-five-cent fare. William D. Howells wrote in 1894, "The people in the carriages do not seem any happier for being there, though I have sometimes seen a jolly party of strangers in a public carriage."[60] This scene, anticipated in one of Glackens's 1900 illustrations,[61] probably takes place along the East Drive in the late afternoon. The wealthy, who had earlier followed a carriage route that began at Central Park West but were now skit-

tish about the increasingly polyglot population in the park, were at this point confining their drives to the roadway near Fifth Avenue.[62]

In the mid-1900s Glackens was becoming deeply involved in depicting the urban landscape, but rural landscapes were still rare in his oeuvre. He was a city creature, and whether living in Philadelphia, Paris, or New York he found his subjects close to home. Not surprisingly, his practice of landscape painting coincided with his excursions out of the city, and in these years none took him

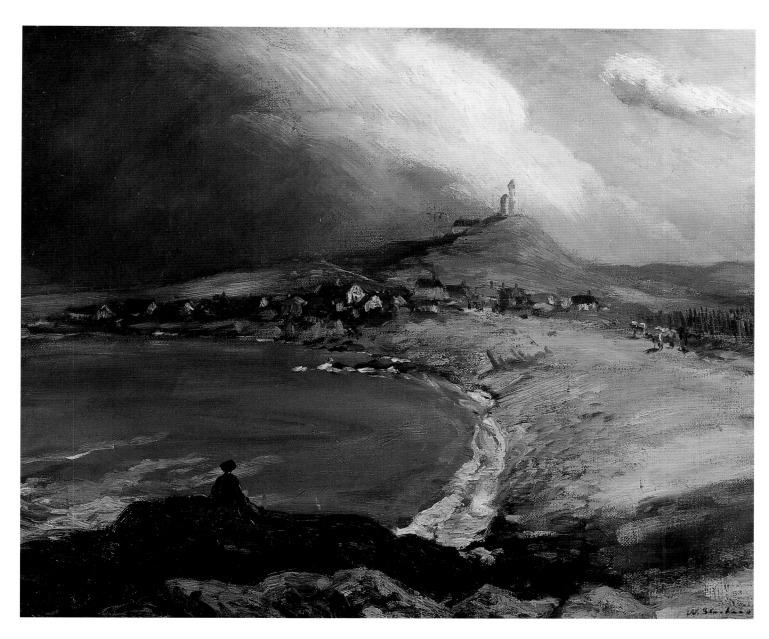

58. Cap Noir—Saint Pierre, 1903
Oil on canvas, 25 x 30 in.
John H. Surovek Gallery, Palm Beach, Florida

farther than his three-week sojourn, in August 1903, on the tiny French island Saint Pierre, off the Canadian coast just south of Newfoundland.

What brought Glackens and his companion, the illustrator Ernest Fuhr, to this remote part of North America is not clear, but the general area was not unknown to artists within his circle, for Prendergast had been born in Newfoundland and Lawson came from Halifax, Nova Scotia—the city via which Glackens reached the island. Glackens returned with a sketchbook of drawings, but only

one painting is known to have resulted, *Cap Noir— Saint Pierre* (plate 58). The houses of a small village appear in the middle distance, almost swallowed up by land, sea, and sky. An isolated figure—Fuhr, perhaps—sits on the dark rocks in the foreground, juxtaposed with a lighthouse rising from the top of a distant hill. The view is bleak, but Glackens has masterfully portrayed the great sweep of barren landscape and the inherent drama of the natural elements—what Glackens himself called "a wilderness of rock."[63]

4
A BRIEF HONEYMOON ABROAD

Glackens married only a few months after he returned from Saint Pierre, but Edith and he postponed their honeymoon for over two years. In the spring of 1906 they finally went off to Europe, their wedding trip financed by Ira Dimock. Glackens was especially eager to see the pictures by Diego Velázquez in the Prado in Madrid—a painter who had already been so influential, directly and indirectly, on his artistic development—so Spain was their first destination. They traveled to Madrid via Gibraltar, Granada, and Seville. The visit to Granada was the basis for *Gypsies Dancing in the Garden of the Alhambra* (formerly, J. Gutman collection), and the one to Seville resulted in Glackens's unlocated bullfight scene.[1] In Madrid the couple spent their days at the Prado and their evenings in the cafés and the Buen Retiro park, which was deserted during the hot June days but filled in the evenings. Glackens recorded the park in one of his most ambitious and exuberant paintings, *In the Buen Retiro* (plate 59). He concentrated especially on infants tended by nursemaids in a variety of costumes and on children dancing and playing games; occasional adults, including military men, are packed into the crowd farther back, surrounded by greenery. Glackens's celebration of the gardens recalls a description that had appeared in an 1893 *Harper's Weekly* concerning this "favorite resort of the people of Madrid, who flock [there] . . . at every time of year for the delight of seeing and

being seen, of exchanging hearty greetings with friends, rejoicing with them in their happiness, and weeping with them in their woes."[2] The picture again brings to mind Manet's *La Musique aux Tuileries* (plate 15), but *In the Buen Retiro* is further removed from that inspiration than had been Glackens's earlier Parisian scenes in the Luxembourg Gardens (plates 13 and 14). The composition is here more strictly symmetrical, the figures building into a strict trapezoid, and the colors are much brighter—lots of whites and reds, with brightly rouged cheeks on many of the female figures.

These same distinctions hold true for the paintings that Glackens created in Paris, where he and Edith journeyed after leaving Madrid late in June, and where they remained for three weeks. They lived on the rue Falguière, behind the Gare Montparnasse, with May and James Preston; Alfred Maurer, a friend and colleague since the Allan Gallery show in 1901, had a studio at the same address. This was Glackens's favorite city, and he was overjoyed to return to its pleasures. After looking up such old friends as James Morrice and Maurer, he turned to portraying some of the same subjects he had painted a decade earlier. Boulevard nights and Parisian cafés again appear, in paintings such as *Café de la Paix* (plate 60). Here the four figures seem more distinctly and individually rendered than those massed together in his earlier Paris

DETAIL OF PLATE 59

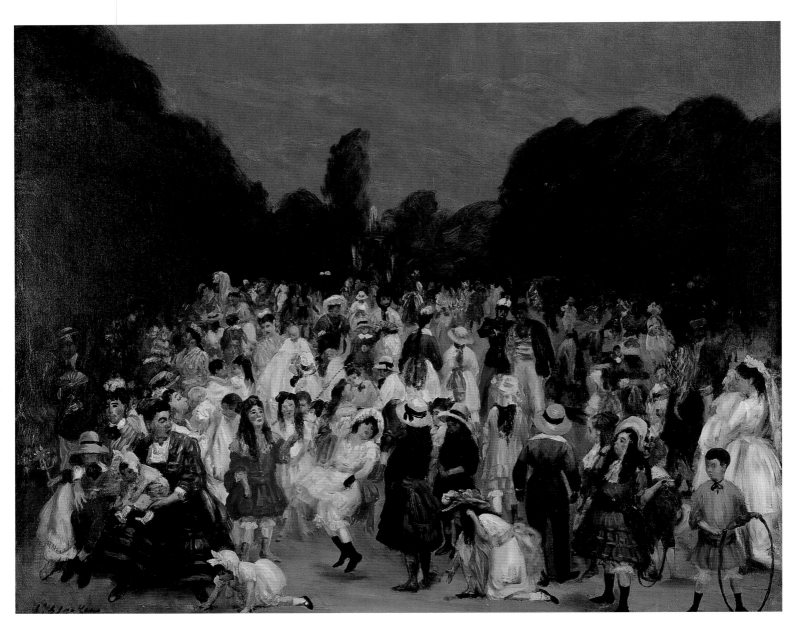

59. In the Buen Retiro, 1906
Oil on canvas, 25½ x 32 in.
Private collection

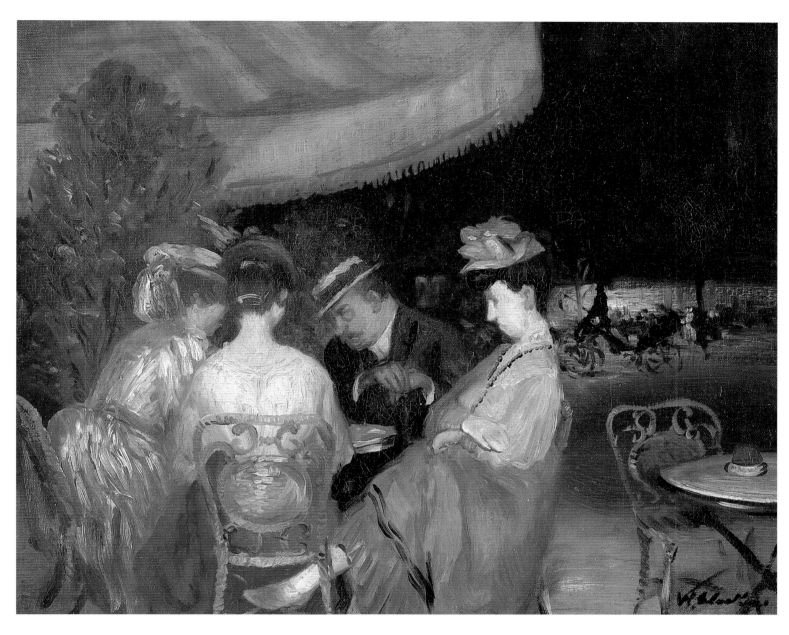

60. CAFÉ DE LA PAIX
(also known as PARIS CAFÉ), c. 1906
Oil on canvas, 15 x 18¼ in.

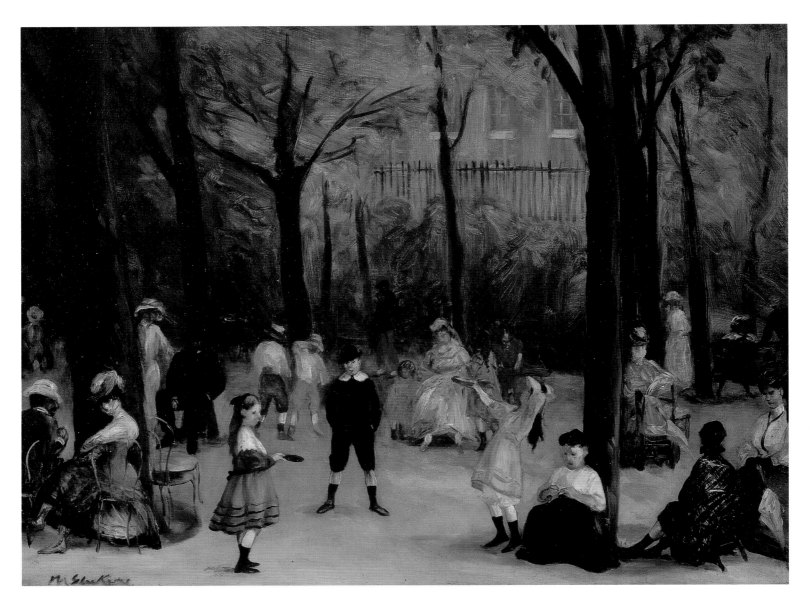

61. In the Luxembourg Gardens, 1906
Oil on canvas, 23¾ x 32 in.
Corcoran Gallery of Art, Washington, D.C.;
Museum Purchase, William A. Clark Fund

scenes, and the color is brighter and more varied, even in a night scene, with short, choppy brush-strokes. The suggestion of caricature—the some-what flushed man directing his attention to the tabletop, the grim-faced woman sprawled ungra-ciously in her chair at the right—indicate the art-ist's awareness of the strategies of illustration.

Glackens returned to the Luxembourg Gardens, the favorite painting ground of his previous Parisian visit, and produced at least three views there; to some extent, each of these also suggests an indebt-edness to Manet's *La Musique aux Tuileries.* The best-known of these is *In the Luxembourg Gardens* (plate 61), which, though not as crowded as *In the Buen Retiro,* is characterized by a similar symmetry, with the figures arranged as separate vignettes. The composition centers on a well-dressed boy in a dark hat, jacket, and knee-britches, who appears to be refereeing a game of battledore played by the little girls on either side of him. A man and a woman sit in the park's characteristic wire chairs by the tree at the left, engaged in conversation and possibly flirtation. Other figures are ranged among the trees along a second and third plane.

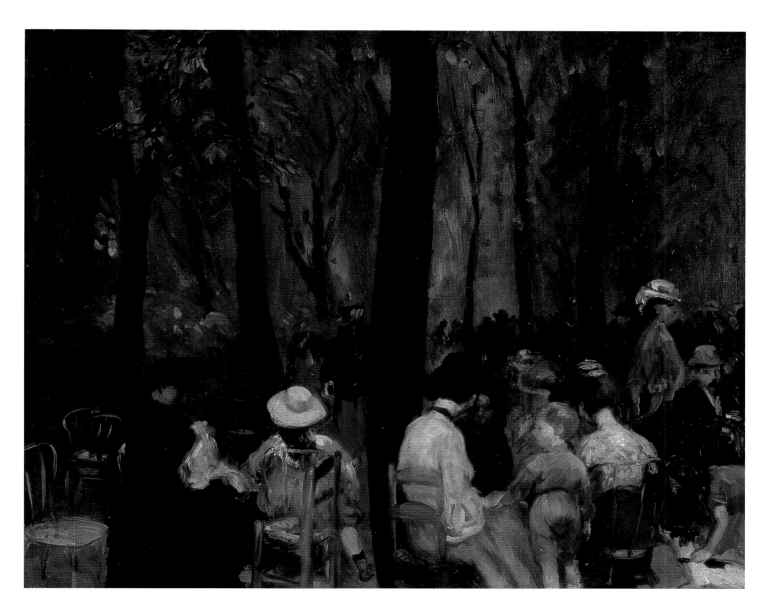

62. UNDER THE TREES, LUXEMBOURG GARDENS, 1906
Oil on canvas, 19¾ x 24¼ in.
Munson-Williams-Proctor Institute, Museum of Art,
Utica, New York

Under the Trees, Luxembourg Gardens (plate 62) is more casual, though the composition is rather rigidly divided in half by the strong vertical element of the central tree, and many of the figures are turned away so that the viewer sees only their backs or shadowy profiles. It is a dark painting, enlivened by bright touches of color in the clothing. A seated older woman in a black dress appears to be sewing while guarding the young girl in white and pink next to her, as a soldier in a splendid red-and-black uniform approaches. At the right of the tree, a group of seated women and standing children converse in the foreground, a girl in red plays with her black-and-white dog, and other adults are standing and seated behind, with shadowy figures farther back among the trees. There is an air of informality and relaxation in all of Glackens's Luxembourg Gardens scenes, but they lack the dynamics of his previous Central Park views and embody a decorum that may not only be characteristic of the gardens but may also bespeak his greater maturity (he was now thirty-six years old) and his more settled married state, compared to his youthful Parisian visit a decade earlier.[3]

63. STUDY FOR "FLYING KITES,
MONTMARTRE," 1906
Oil on panel, 6 x 8 in.

64. FLYING KITES,
MONTMARTRE, 1906
Oil on canvas, 26 x 34¼ in.
Museum of Fine Arts, Boston;
The Hayden Collection

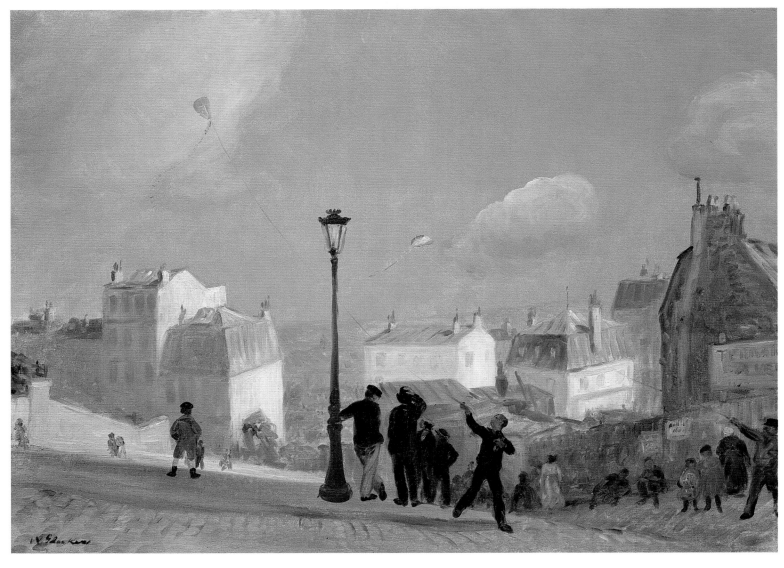

The Luxembourg Garden pictures are almost certainly weekday paintings, for the working-class male is conspicuously absent. These are genteel scenes, populated by the middle and upper-middle classes—the same sector of society to which Glackens himself increasingly belonged, thanks to his fortunate marriage. More in the spirit of what would become known as the Ashcan School is Glackens's study for *Flying Kites, Montmartre* (plate 63) and his finished canvas (plate 64). Here, a group of shadowy children and young and older men, standing in a working-class district on the Montmartre hillside, are flying kites over the city. Lacking the more studied, measured approach of Glackens's Luxembourg Gardens pictures, the work has great breadth and spontaneity, with the figures more carefully drawn and more elegantly posed in the finished work than in the study. An old man with a cane, shambling into the scene from the lower left of the study, was eliminated in the final composition. Since the children are not in school and the older male figures are not at work, this is probably a Sunday scene and, in fact, this work may be identical with Glackens's

Montmartre, Sunday Afternoon, which figured in the traveling exhibition of The Eight in 1908–9. *Flying Kites, Montmartre* calls to mind a number of Manet's scenes of Paris painted half a century earlier.[4]

During their three weeks in France, Glackens and his wife did not spend their entire time in Paris. They may have joined Maurer at one of his favorite painting grounds, Chezy-sur-Marne, where Glackens also painted;[5] one day all three took a trip along the Marne and stopped to swim at Château-Thierry, a town sixty miles east of the capital. Glackens recorded this event in *Château-Thierry* (plate 65). The town, seen across the river in the distance, offered a holiday retreat on the river, and many visitors are in summer apparel and bathing costumes. William and Edith, also attired in bathing costumes, cross the road, while Maurer, wearing red swimming trunks, is about to plunge into the river.

After stopping off in London, Glackens returned to New York at the end of the summer. He must have spent the rest of the year working up his European pictures as well as returning to the lucrative

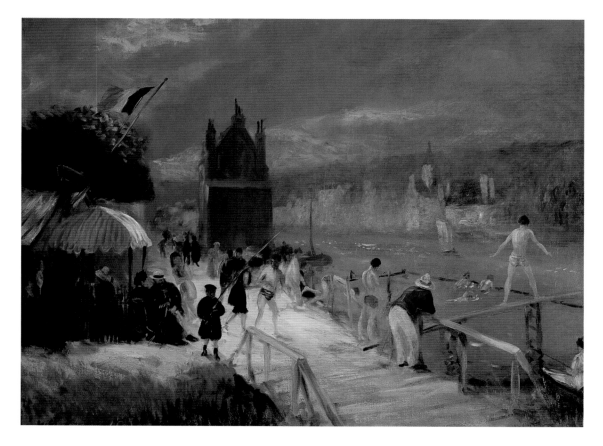

65. Château-Thierry,
1906
Oil on canvas, 24 x 32 in.
The Henry E. Huntington
Library and Art Gallery,
San Marino, California;
The Virginia Steel Scott
Collection

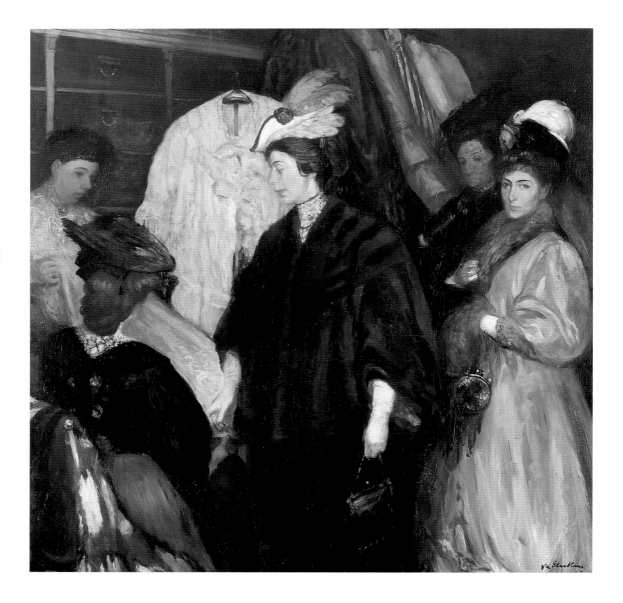

66. The Shoppers, 1908
Oil on canvas, 60 x 60 in.
The Chrysler Museum,
Norfolk, Virginia; Gift of
Walter P. Chrysler, Jr.

field of illustration. And some of the following year, 1907, must have been devoted to preparing the Glackens household at 3 Washington Square North for their first child, a boy who was born on July 4 and named Ira after his maternal grandfather. That summer Edith left her husband in New York and took the newborn to her parents' house in West Hartford.

Edith is the central figure in one of the largest pictures of Glackens's career, *The Shoppers* (plate 66). He had painted the picture in the winter of 1906–7 and then first exhibited it in the eleventh annual Carnegie International in Pittsburgh in April 1907. Having agreed to lend it next to the 103d annual of the Pennsylvania Academy, he had it returned to his New York studio for alterations; these changes

plus his subsequent commitment to the show of The Eight at the Macbeth Gallery, which opened at the same time, prevented *The Shoppers* from appearing in the Philadelphia show.[6] On January 17, a few weeks before that show opened on February 3, 1908, he wrote Edith a letter, with an accompanying drawing (plate 67), admitting that the heads of the figures at the left and right remained painted out and that he despaired of having the work ready for the opening; however, by January 31 the work had been "rescued."[7]

The theme of urban shopping was not new to Glackens; he had illustrated the subject a number of times, perhaps most notably in *Broadway below Twenty-third Street, Christmas Eve,* in December 1900,[8] and it would appear again in his *Christmas*

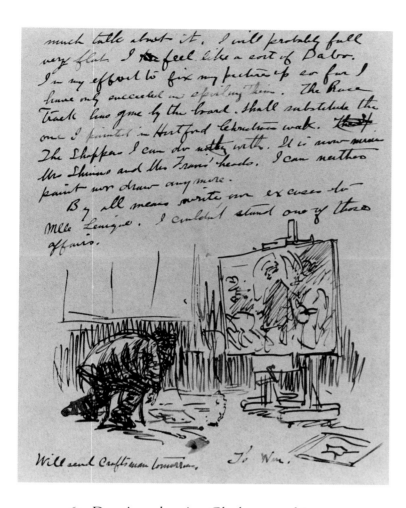

67. Drawing, showing Glackens working on
THE SHOPPERS, in letter from William Glackens to
Edith Glackens, January 17, 1908. Glackens Archives,
Susan Conway Gallery, Washington, D. C.

Shoppers, Madison Square (plate 23), along with its
subsequent illustration, *The Day before Christmas on
Madison Square* in *Collier's Weekly* on December 13,
1912. In the 1907 oil painting Glackens zeroed in on
a monumental group of four shoppers and a sales-
woman inside a New York department store; by
taking this approach he was using a strategy favored
by Degas in works such as *At the Milliner's* (1882;
Metropolitan Museum of Art, New York). Though
Glackens's aim was to record a typical middle-class
urban experience, the three central figures are all
portraits of identifiable subjects. Edith Glackens is
in the center, wearing a massive dark coat, light
gloves, and a feathered hat, and carrying a beaded
purse. At the right is her friend the illustrator Flo-
rence Scovel Shinn, wife of Glackens's colleague

Everett Shinn, and seen from the back at the left is
Lillian Gelston Travis, a schoolmate of Edith's from
the Art Students League, and a noted beauty. Nei-
ther the veiled woman behind Mrs. Shinn nor the
salesperson has been identified.[9]

Neither Glackens nor Edith would have enjoyed
the description of these figures recorded the follow-
ing year by Joseph Edgar Chamberlin: "The ugly
woman in the foreground is the essence of the dis-
agreeable shopper," whereas "the pretty lady to
the right . . . is all that is appealing and poetic."[10]
Chamberlin did not interpret the scene as a shop-
ping excursion among friends, for he found that
"the accident of commerce brings together these
diverse women." Shopping in a department store
thus could be an opportunity for a chance meeting
among women. Edith Glackens examines some dry
goods rather skeptically, while her companions at
the right exhibit a somewhat frosty grandeur. In
contrast, the saleswoman, respectably garbed in a
white shirtwaist with a gold pin at the neck, is cut
off at the canvas edge, and appears hesitant and
deferential—in costume and expression her class
status is defined as markedly different from that
of her customers.

This painting elucidates an aspect of modern
life—the development of the department store
and its dependence on an all-female clientele. By
suggesting that the scene takes place in a lingerie
department—a lacy negligee trimmed with white-
and-blue ribbons hangs just beyond the fabric
Mrs. Glackens is examining—Glackens defined
the setting as a specifically feminine space, and
one devoted to conspicuous consumption.[11] James
Huneker found the work "contemporary with a
vengeance. It breathes of to-day, of to-morrow,
and of Macy's every morning."[12] The specific
emporium here is not actually identified, though
Cynthia Roznoy perceptively speculates that it
may be the new Wanamaker Department Store
between Broadway and Fourth Avenue, and Eighth
and Ninth Streets, which had been built the year
before, in 1906; it was only a few blocks from the
Glackens residence on Washington Square.[13]

5
FROM THE EIGHT TO RENOIR

Just before traveling to Europe, Glackens had become an associate of the National Academy of Design, when the Society of American Artists merged with the older institution in April 1906 and all its members were automatically made National Academy associates. This merger meant one less venue in the city where artists could exhibit, a situation that would have been especially serious for Glackens, who had not yet established an enduring connection with a commercial gallery, unlike his colleagues. Henri, Prendergast, and Davies were already in the "stable" of William Macbeth's gallery, where they had one-artist shows, while Lawson, Luks, and Sloan at least left works on consignment with Macbeth, and Shinn was selling his pictures through the Boussod-Valadon Company.[1]

All of the paintings that Glackens submitted to the Academy's 1906 winter exhibition were rejected, as were those by Luks and Shinn, and some of Sloan's. And when Glackens again submitted his works to the National Academy in 1907 for their prestigious spring exhibition, all but one of his entries—*The Sixth Bull* (unlocated; possibly identical with *The Bull Fight*), a Spanish subject—were again refused, as was Luks's single submission and one of Sloan's two pictures—despite Henri's service on the jury that year. Even two of Henri's three submissions were given only qualified approval, to be hung if space could be found for them. (Despite the unquestioned dominance of New York as the center of the American art world, the Academy's quarters at the Fine Arts Society on West Fifty-seventh Street were far too inadequate to house the great number of superior works submitted to its winter and spring exhibitions, thus accounting for the more favorable reception of pictures by the artists of Henri's circle at the major annual exhibitions in cities *outside* New York.)

Henri withdrew pictures he had submitted, and that March he and Sloan met with Glackens at his home on Washington Square to discuss the possibility of holding their own independent exhibition. Ever since these three, together with Luks, Davies, and Prendergast, had shown together at the National Arts Club in 1904, the critics had recognized a new development in the New York art world. As early as 1905, in reviewing the annual of the Society of American Artists, Charles FitzGerald had noted, "Mr. Henri and his group is one of the significant phrases that crop out in the current criticism of the Society's exhibition."[2] And in February 1906 Henri, Glackens, Sloan, Luks, Shinn, and Lawson had shown together, along with a few other painters, at Sigmund Pisinger's newly opened and short-lived Modern Art Gallery at 11 East Thirty-third Street.[3]

On April 4, 1907, another meeting at Henri's studio included Luks, Davies, and Lawson, and in May they were joined by Shinn, while word reached them from Boston of Prendergast's enthusiasm. Davies approached William Macbeth, the

first dealer to devote his gallery to the exhibition of contemporary American artists, and one who had been showing the work of a number of these painters, and he agreed to house a show of their pictures the following February in his gallery at 450 Fifth Avenue. Thus was born "The Eight," though the name was never meant to be a formal one (perhaps deriving from that of the Impressionist group the Ten American Painters, or "The Ten," a name affixed by critics a decade earlier). Macbeth himself took pains, somewhat ingenuously, to note that "these artists are not either formally or informally a banded together 'eight,' as so frequently dubbed. Their exhibition was in no sense 'a protest' against anything under the sun, nor intended for 'a new departure' from any tradition or in any direction."[4]

And the critics did take notice of this revolt by insurgent artists, from the moment plans for the show were announced. Not surprisingly, the first notice of these plans and the first identification of the group as The Eight appeared in the newspaper that had been most consistently favorable toward the artists, the *New York Evening Sun*.[5] Such publicity was consciously promoted by Henri, both to attract the public to their show as well as to test the potential of the small, independent exhibition, as opposed to the traditional spectacles at the Academy.[6] Henri's agenda was both a large and a narrow one. He aimed to promote a new kind of exhibition, jury-free and chosen by the artists themselves, but also one that would promote the painters in his circle, those whom he had mentored in Philadelphia, and those, such as George Bellows, whom he had taught at the New York School of Art. And in 1908, with the help of the press, he promoted the exhibition of The Eight as a revolt against the Academy and as a nationalist revolution of newness and originality against traditional, European-influenced art.

At the Macbeth Gallery each artist was assigned about twenty-five running feet in two galleries, with their pictures grouped separately, itself an innovation from traditional Academy hanging (though a strategy that had been employed by The Ten, at least in their early exhibitions). The artists differed in their number of entries; Prendergast showed the most,

seventeen paintings, the majority of which were recent pictures painted in France at Saint-Malo. Shinn showed eight works, primarily theater scenes; Lawson, four landscapes; Sloan, seven New York scenes; Luks, six works, including his *Pigs*, which attracted the most virulent negative reviews; Henri, nine oils, including seven figure pieces; and Davies, six works. Glackens showed seven pictures. The catalog listed six: *At Mouquin's* (plate 39); *Buen Retiro, Madrid* (misspelled *Bues Retiro*) (plate 59); two Central Park pictures—*Coasting, Central Park* (1905; formerly, Knoedler Galleries, New York) and *May Day, Central Park* (plate 55);[7] and two of his most recent pictures, *The Shoppers* (plate 66) and *Brighton Beach, Race Track* (plate 27). At the last minute he added a seventh, *New England Landscape,* which was noted by one of the critics.[8]

This seventh canvas was almost surely *View of West Hartford* (plate 68), painted from the Dimock house on Vanderbilt Hill off Farmington Avenue, where Glackens had spent the previous Christmas week with Edith. This is a quintessential suburban winter landscape, radiant with color and sunlight, the season established by the skaters on the ice in what was known as the "damp spot" in Whiting's

68. View of West Hartford, 1907
Oil on canvas, 26⅝ x 32 in.
Wadsworth Atheneum, Hartford, Connecticut; The Ella Gallup Sumner and Mary Catlin Sumner Collection Fund

Pasture. Beyond the field is the town center of West Hartford, with the spires of the old Baptist and Congregational churches, and in the distance, Talcott Mountain, once known as Gin Still Hill.[9] Glackens captured the essence of the rolling hills of the Connecticut terrain, with rural pleasures combined with a bow to both the traditional and the modern—the steeples of the two churches rise up among the houses in the distance, while the electrified Farmington Avenue trolley and the telephone poles in the lower right acknowledge technological progress and suggest proximity to a city.

A curious anomaly appears in the catalog of the show, in which each artist was allowed one illustration; Glackens's illustration was *The Battery* (plate 51), which was not in the exhibition. This may have been a work he was planning to include, if he couldn't finish repainting *The Shoppers. The Battery* was even reproduced in a review of the exhibition that appeared the day before the show began and that referred specifically to this painting, suggesting that the picture had actually been on a wall of the Macbeth Gallery just prior to the opening.[10]

Sales from the exhibition were respectable, totaling some four thousand dollars, and Glackens wrote Edith that Macbeth was sure that he could have sold twenty-five thousand dollars' worth of pictures had the national economy been healthier.[11] None of Glackens's pictures sold, however; this was especially regrettable, Sloan believed, because "it would give him better standing with his wife's commercial, new rich family."[12] It is now generally recognized that, despite a few hostile reactions,[13] the show's reception was quite favorable. James B. Townsend concluded his review with the exclamation, "All hail 'The Eight,'" and he heralded the possibility of a revival of the modernist spirit that had been embodied in the founding of the Society of American Artists in 1877.[14] But many of the critics also recognized, more fully than ever before, that these artists were truly the disciples of the French Impressionists, following "in the footsteps of the men who were the rage in artistic Paris twenty years ago. . . . Manet, Degas, and Monet."[15] The public flocked to the show, with

people lined up at the door before the gallery opened at 9 A.M. One writer noted, "Never at an art exhibition in this city has there been such an attendance as gathered to view the pictures shown by 'the eight' at the Macbeth Gallery."[16]

Most of the critics were favorably impressed with Glackens's paintings, though Arthur Hoeber found *The Shoppers* dreary and depressing, and *Coasting, Central Park* "a joke."[17] Joseph Chamberlin greatly admired both *Shopping* and *Chez Mouquin,* but in a wryly perceptive analysis stated that he believed he had "discovered why Mr. Glackens draws houses out of plumb, and trolley cars and other mechanical inventions the parts of which do not hang together. He desires to represent the fluidity of a world in motion, to get as far as possible away from the instantaneous photograph."[18] James Huneker, an admirer of The Eight, found one basic defect in the exhibition as a whole: "Materialism rules, the aspect and not the soul of things." He saw that materialism in Glackens's *Shoppers* especially, admiring the artist's depiction of "furs, hats, faces, fabrics" and his solution of technical problems, but wondering if the subject itself was worth while.[19]

Although the exhibition of The Eight had not originally been conceived as a touring exhibition, once the show opened, the Pennsylvania Academy invited it to its galleries, and Sloan became the "curator" of the traveling show. When the show went on tour, there were certain changes along the way. At the Pennsylvania Academy in March, Glackens continued to show seven works, the catalog now acknowledging the presence of *New England Landscape,* while a painting entitled *Luxembourg Garden* was substituted for *Brighton Beach, Race Track.* The tour continued to Chicago, where the show opened in September at the Art Institute; to the Toledo (Ohio) Museum of Art in October; the Detroit Museum of Art (now the Institute of Arts) in December; the John Herron Art Institute in Indianapolis, in January 1909; the Cincinnati Art Museum in February; the Carnegie Institute, Pittsburgh, in March; and the Bridgeport (Connecticut) Public Library in April. The show concluded at the Newark (New Jersey) Museum Association in May.

In Chicago, *Montmartre, Sunday Afternoon* (possibly *Flying Kites, Montmartre,* plate 63) was substituted for *Luxembourg Garden,* but the latter reappeared in Newark. Glackens's paintings, among all those shown, elicited the most favorable reaction in the various cities on the tour, and though no sales resulted from the tour, having the show displayed in public institutions, as opposed to its initial venue in a commercial gallery, enhanced the stature of the artists. An annotated copy of the Detroit catalog provides an idea of the prices Glackens was asking for his paintings: $650 for each of the scenic works; $2,000 for *Chez Mouquin;* and for *The Shoppers,* $3,000.[20] The discrepancies probably reflect not only the superior values placed on figural works as opposed to landscapes but also the relative acclaim already achieved by *Chez Mouquin* and the contemporaneity of *The Shoppers.*

The tour proved that these artists were not only sufficiently well known but also popular enough to be invited to some of the nation's most significant public institutions. Glackens was even asked to participate in selecting the National Academy's winter exhibition in 1909, but as only one of twenty-seven jurors he had little effect on the outcome; for instance, only one of John Sloan's four entries, *Chinese Restaurant* (Memorial Art Gallery of the University of Rochester, New York) was accepted.[21] A follow-up show of The Eight was discussed in December 1908, but Macbeth's galleries were booked for the winter by then and the matter was dropped.[22] Nevertheless, their potential legacy survived in the growth of independent exhibitions, along with a commensurate decline in the prestige of the annual shows at the National Academy.

In 1910 Henri, Sloan, Davies, and the younger painter Walt Kuhn helped organize a show of about six hundred works in direct opposition to the traditional juried display of the Academy. This was the *Exhibition of Independent Artists,* which opened at the beginning of April, with no prizes offered and with each participant free to submit whatever works they wished. The show brought together well-known and little-known painters, sculptors, and printmakers, from the full spectrum of contemporary art and with unfettered freedom of artistic expression, which had long been Henri's goal.[23] The critics were enthusiastic, and some recognized the show as an attempt to break down the exclusivity of the Academy. Others assumed that the core group of The Eight had engineered the exhibition; one (generally negative) reviewer of the show even spoke of the "Luks-Glackens octette," although Luks was actually absent from the exhibition, having a one-artist show of his own at the same time.[24] Attendance was good, though few works were sold.

Glackens participated in the *Exhibition of Independent Artists* with four oils and a group of drawings, and he was one of six of his colleagues among The Eight on the selection committee, but he was otherwise not intimately connected with its organization. The following year, 1911, what was probably his most significant exhibition that year was both the smallest and the briefest—a show of twenty-four pictures that lasted for three days, April 13–15, at the Union League Club in New York. Though this again was said to have been supervised by Henri, Glackens was very much involved, soliciting works by Sloan and Davies, for instance, and even recommending the inclusion of specific ones.[25] The show brought all of The Eight together again, along with paintings by Edith Dimock (Glackens's wife), and examples by George Bellows, Rockwell Kent, Walt Kuhn, James and May Preston, and Max Weber. Glackens's two contributions were *Interior with Portraits* (perhaps *Family Group,* plate 69), and *Woman with Black Hat* (Kraushaar Galleries, New York; also known as *Semi-Nude with Hat*).[26] Even as late as 1911, however, the work of these painters was generally unacceptable to the conservative members of the general public, including the membership of the club. The critics related this small exhibition to the independent-artists show of the previous year and called the painters involved the "Insurgents."[27] The show has also been viewed as the first division in the ranks of the radical realists, who would ultimately separate into two groups: those rallying around Henri and those supporting Rockwell Kent.[28]

69. FAMILY GROUP, 1910–11
Oil on canvas, 72 x 84 in.
National Gallery of Art, Washington, D.C.; Gift of Mr. and Mrs. Ira Glackens 1971

Three years after the *Exhibition of Independent Artists,* Glackens was much more involved with the *International Exhibition of Modern Art*—the famous Armory Show—mounted by the Association of American Painters and Sculptors, which opened in New York in February 1913 and which introduced modern European art to America as it had never been seen before. Glackens was one of the charter members of the association, which first met on December 19, 1911, at the Madison Art Gallery at 305 Madison Avenue. Arthur B. Davies was made president of the association, and he, in turn, appointed Glackens chairman of the Committee on Domestic Exhibits. But even though the American section of the Armory Show outnumbered the foreign works, it was the modernist collection that garnered critical attention. And Glackens himself, who entered three paintings in the show—*Family Group, Sailboats and Sunlight* (unlocated), and *The Bathing Hour*

(Barnes Foundation, Merion Station, Pennsylvania)—shared that preference.[29]

In one of Glackens's few published essays, written at this time, he stated:

Everything worth while in our art is due to the influence of French art. We have not yet arrived at a national art. The old idea that American art, that a national art, is to become a fact by the reproduction of local subjects, though a few still cling to it, has long since been put into the discard. . . . Our own art is arid and bloodless. It is like nothing so much as dry bones. It shows that we are afraid to be impulsive, afraid to forget restraint, afraid above everything to appear ridiculous. . . . I am afraid that the American section of this exhibition will seem very tame beside the foreign section. But there is promise of a renaissance in American art.[30]

When the Armory Show went on tour to Chicago, many of the American paintings were omitted, and Glackens was represented only by *The Bathing Hour;* even this was eliminated at the final stop in Boston, where no American works appeared. Subsequently, the show's original organizers divided into two camps: realists and a more radical, though not avant-garde, group. Glackens (along with Davies, Prendergast, and Lawson), had seceded to the latter camp, at odds with Henri, Luks, Sloan, and such realist colleagues as George Bellows and Jerome Myers. Although Glackens was not only sympathetic with Henri Matisse's art but appears to have been influenced by the abundant examples of it in the Armory Show, he soon came to have strong reservations about Cubism—examples of which were also prevalent in the show. His reservations were due, at least in part, to Cubism's preoccupation with theory and its alienation from either public concerns or public appeal. In 1917 he wrote:

What I object to in this Cubist business is that the work is no different from what it was at the start. I cannot see progress in the Cubist paintings here or in France. I sometimes feel that I would like to get these Modernists, some of them, up against a real psychologist, a man who knows the ins and outs of the human spirit, and who has probed deep into the great mysteries. I do not feel that most of these new young painters have done so. If they had, all the wonder of what they found would flow back through their art to the public.[31]

Glackens nevertheless became associated for a while with the more modernist tendencies that began to permeate American painting in the post–Armory Show years, perhaps because of his affiliation with the progressive clique that split from the original group of organizers. In 1913 his work was selected by Arthur B. Davies for inclusion in a traveling exhibition meant to establish the impact of the Armory Show on American artists.[32] This display was first shown at the Museum of Art of the Carnegie Institute, Pittsburgh, in December 1913, and appeared in a larger version at the Cincinnati Art Museum in March 1914; a still bigger but quite different selection of pictures, still by many of the same artists, including Glackens, appeared at the Memorial Art Gallery in Rochester, New York, in February 1915. The artists were variously described as Cubist-Futurist or, in Rochester, as "representative of the modern movement in American art.[33] Work by Glackens (and Davies and Prendergast) was shown in the company of such American modernists as Charles Demuth, James Doherty, Walt Kuhn, Man Ray, Morton Schamberg, Charles Sheeler, and Henry Fitch Taylor—a far cry from both the company of The Eight and the aesthetics implicit in their show.[34]

Glackens was to become involved with several more newly created organizations during the 1910s. The first was the Society of Independent Artists, formed in 1916, in part as an outgrowth of the 1910 *Exhibition of Independent Artists.* The society was also prompted into existence by a group of European modernists who had come to America during World War I and encouraged the creation of an

organization modeled on the French Société des Artistes Indépendants. The first exhibition this time was a huge show of over two thousand works of art, shown at Grand Central Palace on Lexington Avenue, beginning on April 10, 1917. Again, the primary purpose was to inaugurate shows without juries and without prizes, where an artist could display his work for a small fee. Glackens was elected the first president of the society, a position he occupied for only one term; he was succeeded in 1918 by Sloan, who remained the president thereafter. Unlike its progenitor show of 1910, however, the society continued to hold annual exhibitions through 1944. Glackens naturally showed in the initial venture and participated in almost every show for the society's first thirteen years; in 1939 there was a small memorial section of his work.[35]

In 1919 Glackens joined in the formation of another organization, the American Painters, Sculptors and Gravers, which the following year was renamed the New Society of Artists, and he served on its council. This group attempted to resuscitate the liberalism of the old Society of American Artists, in opposition to the stodginess of the National Academy, but it never achieved the identity with modernity that it sought. Glackens exhibited with this group from the beginning, first at Wildenstein and Co. and then, from 1923, at the Anderson Galleries, and it was there that he showed a number of the most distinctive works of the early 1920s in his career.[36]

Henri, in contrast, did not exhibit with the Society of Independent Artists in 1917, and in fact he published an article that June, in the new magazine *Touchstone,* criticizing the hanging of works in alphabetical order and recommending instead the creation of smaller groups by artists in harmony with one another. Henri came out against the "Big Exhibition" altogether, preferring a series of small shows throughout the year, featuring work by cohesive groups of artists.[37] In a rebuttal article in the same magazine, Glackens broke with his former mentor and derided the group-hanging concept, which he believed would make it impossible to hang a show quickly; he also suspected that "the groups might

be selected or select themselves through friendships rather than art ideals."[38] Glackens insisted

> there is an important element of psychology in the big exhibition. It has what we Americans call the "punch." The public in this country takes more interest in a big show and so the big show carries its own advertising. Such an exhibition once a year is looked forward to; it attracts attention and takes its place as an event. The public as a whole, will not look in to any small venture, but anything stupendous brings out the curiosity-seeker; the students are all eager for it.

But he agreed that students must educate themselves by attending smaller exhibitions and one-artist shows.

Glackens's beliefs had changed over the course of the decade since the exhibition of The Eight, and so had his life and his art. With the birth of his son, Ira, on July 4, 1907, and of his daughter, Lenna, on December 6, 1913, the family had assumed a prime place in his personal concerns and in his art. And at the same time, his artistic strategies had moved away from the dark Impressionism of Manet and Degas (and, by extension, the dramatic realism of Henri) toward a more orthodox Impressionism of light and color—related specifically to the painting of Auguste Renoir.

This, the most crucial transition in the course of Glackens's career, has been frequently discussed, and attempts have been made to pinpoint the change to a specific moment. In fact, however, it was not only a gradual shift that occurred in the later 1900s but also one modulated by the nature of the subjects he depicted. Thus, as early as *Château-Thierry* (plate 65), in 1906, Glackens had already adopted not only a higher color key than in the pictures he was almost simultaneously painting in Paris, but he also positioned himself farther back from the activity, reducing the figures to somewhat more stereotypical forms in more generalized poses, as opposed to the more individualized figuration of most of his other pictures. In 1907, for example,

his interior scene of *Shoppers* is still a dark picture, influenced by Manet and Degas, but the bright colorism of such outdoor paintings as *View of West Hartford* (plate 68), *Brighton Beach Race Track* (plate 27), and *Breezy Day, Tugboats, New York Harbor* (plate 54) allies his work with the Impressionism of Monet, along with that of other French and American landscapists of the movement.

The affiliation with Renoir surfaced in even slightly earlier works. James Huneker, writing about *Chez Mouquin,* noted that "Renoir is slightly evoked."[39] A combination of experiences may have influenced the changes in Glackens's art, which seem to have begun during or shortly after his second trip to Paris, when he may have seen paintings by Renoir and other French artists that could liberate him from the dark drama of Manet and Degas. Indeed, to some degree he may even have come under the influence of more avant-garde painters, such as the Fauves. His close friend and companion in France, Alfred Maurer, was just at that time turning away from figural work not dissimilar from that by Glackens and Henri to the blazing colorism of Henri Matisse. Glackens never met Gertrude Stein in Paris in 1906, and thus would not have seen her collection of avant-garde painting, but by 1908 he would have had the opportunity of seeing Matisse's work in New York, at Alfred Stieglitz's gallery 291. He did visit the Stein collection in Paris in 1912, and Violette de Mazia has suggested that, by around 1913 especially, sometimes "bold and strikingly bizarre color relationships" in Glackens's painting reflect the influence of Matisse, who was well represented in New York that year at the Armory Show.[40]

Unlike Maurer, Glackens was no Fauve, yet his *Cape Cod Pier* (plate 70)—with its vivid orchestration of yellows, oranges, and vermilions in the buildings and dunes, contrasted with the intense green patches of grass, the blue-purple walkway, and the two walking women in stark white—comes as close to Fauvism as Glackens would ever get. The more distant figures, down on the beach, resemble those that would appear in Glackens's later beach pictures painted on Long Island.

For the summer of 1908 Edith rented a house in Dennis, Massachusetts, on Cape Cod, where the family had their first seaside holiday. Maurice Prendergast visited during the course of the season, and the family did not return to New York until the end of September.[41] *Cape Cod Pier,* along with the earlier *Château-Thierry* and *Beach at Dieppe* (Barnes Foundation, Merion Station, Pennsylvania), presages Glackens's fascination with beach and swimming subjects, which allowed a full exploration of casual outdoor enjoyment among sunshine and bright color. Glackens also exhibited *Beach Scene, Cape Cod* (unlocated) at the National Academy's winter exhibition that year, which was sold from the show.[42]

It was at the *Exhibition of Independent Artists* in April 1910 that Glackens's conversion to mainstream Impressionism was clearly identified. Arthur Hoeber was struck by his new colorism and concluded, "If Mr. Glackens thus sees his nature, he must enjoy life far more than the ordinarily equipped human, for there is a riot of tone to his vision."[43] Hoeber was reacting particularly to Glackens's earlier *Brighton Beach, Race Track,* with "its vivid reds and greens," but the painting that announced the artist's affiliation with Renoir more than any other was his 1910 *Nude with Apple* (plate 71), identified as *Girl with Apple* at the show—perhaps second only to *Chez Mouquin* as the signature piece of Glackens's career, and one with which he would be forever identified.[44] James B. Townsend described *Girl with Apple* as "decidedly suggestive of Renoir," while Huneker found that "Glackens's big nude is surprisingly brilliant, though reminiscent of Renoir, particularly in the color scheme."[45]

This was Glackens's earliest and finest exploration of the nude, a theme that would subsequently occupy much of his attention. A studio model partially reclines in a corner of a couch, with her clothes piled alongside, emphasizing her nakedness all the more.[46] The model's slightly weary but forthright expression and even the ribbon tied around her neck, call to mind Manet's *Olympia* (1863; Musée d'Orsay, Paris).[47] The young woman

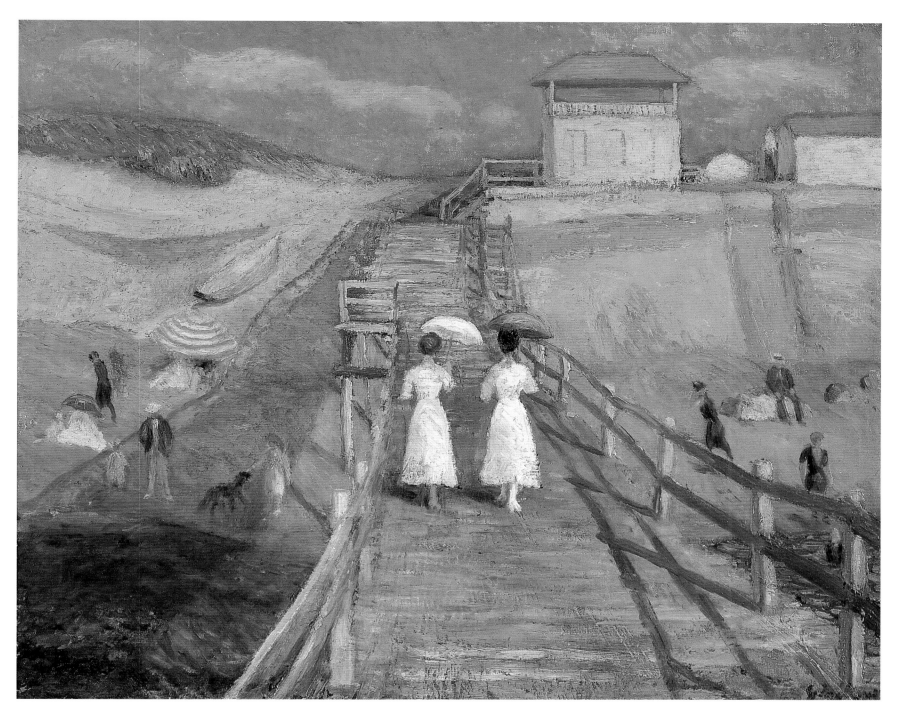

70. CAPE COD PIER, 1908
Oil on canvas, 26 x 32 in.

71. NUDE WITH APPLE, 1910
Oil on canvas, 40 x 57 in.
The Brooklyn Museum, New York; Dick S. Ramsay Fund, 56.70

is presented frankly as a modern Eve, who has taken one bright red apple out of the fruit bowl at her elbow. In the upper left hangs a painting with a woman walking on a beach, perhaps one of Glackens's Cape Cod pictures of 1908. Glackens's colleague Henri wrote of *Nude with Apple* when it was in the *Exhibition of Independent Artists:* "He shows a wonderful painting of a nude that has many of the qualities that you notice in the Neo-Impressionist movement. But Glackens seems to me to have attained a greater beauty and a more fundamental truth. There is something rare, something new in the thing that he has to say."[48]

Few of Glackens's other nudes combine, as here, the frankness of Manet, the firm draftsmanship of

Degas, and the sensuality of Renoir. At the same time, *Nude with Apple* not only denotes Glackens's increasing involvement with the figure in the interior—*The Shoppers,* after all, is also an interior subject—but also his concentration on his own private environment—the studio and the home. In the autumn of 1908, a little over a year after the birth of their son, the Glackenses had moved around the corner from Washington Square to 23 Fifth Avenue, at the corner of Ninth Street, and then in 1911 back to the square, at number 29.

While they were still living on Fifth Avenue Glackens began his 1911 *Family Group,* depicting Edith and the young Ira along with Edith's sister, Irene, and Edith's longtime friend Grace Dwight

72. Twenty-three Fifth Avenue,
Interior, c. 1910
Oil on canvas, 19½ x 24 in.

Morgan, daughter of a former mayor of Hartford, General Henry C. Dwight. Glackens clearly distinguished the visitors, wearing hats and elegant clothes, from the family, with Edith wearing a simple at-home dress. The siblings' closeness is carefully emphasized by Edith's position next to Irene, with one arm encircling the back of her sister's chair. Grace Morgan, just back from Paris, is stylish to the hilt, wearing a newly acquired feathered hat and red dress. The picture bespeaks a prosperous life, with decoratively upholstered chairs, oriental rugs, and fringed curtains in front of the balcony overlooking Fifth Avenue. The range of color is dazzling, especially the iridescent blue-pink-purple of Irene Dimock's dress. This chromatic freedom

again recalls Renoir and perhaps Pierre Bonnard as well. Glackens painted a figureless version, *Twenty-three Fifth Avenue, Interior* (plate 72)—presumably as a preliminary study for *Family Group,* though a wonderfully colorful painting in its own right. Glackens completed *Family Group* early in 1913, in time for its exhibition at the Armory Show that year, where it was the most significant of his three entries.[49] *Family Group* was praised at the time as "one of the most radiant, courageous, color paintings America has produced, and in addition, it has grace, humanity and the quality that artists call painting."[50] It was at this time, too, that Sloan identified the change in Glackens's artistic strategies, noting, perhaps specifically concerning *Family*

Group, that Glackens was "in the obviously color class just now."[51]

Another, more intimate family painting created at the same time was *The Artist's Wife and Son* (plate 73), which shares with *Family Group* the combination of strong draftsmanship and variegated color. Here the two figures are hemmed in by the heavily upholstered furniture, increasing the sense of their bonding. The devoted Edith encircles the passive figure of the young Ira, who is doubly protected both by his caring parent and by his nearly impenetrable environment. Glackens gave special emphasis to the picturesque quality of what he called Edith's "Zebra Dress,"[52] and his fondness for similarly decorative striped costumes is evident in a number of other important pictures of this period, including *Pony Ballet* (1912; Barnes Foundation, Merion Station, Pennsylvania) and *Girl in Black and White* (1914; Whitney Museum of American Art, New York).[53] The paintings of about 1908–11 have occasionally been identified as Glackens's "transitional period," between his dark, Manet-inspired early work and his more complete dependence on Renoir from about 1912 on.[54] In future years Glackens himself was the first to acknowledge his dependence on Renoir. When his admirer and frequent critic, Forbes Watson, spoke to Glackens about allegations of his imitation of Renoir, Glackens replied, "Can you think of a better man to follow than Renoir?"[55]

Renoir's paintings were initially seen in America at the *Foreign Exhibition* held in Boston in 1883, where three of his works were shown, and where he garnered the most favorable critical reaction of any of the French Impressionists. But three years later, when the French dealer Paul Durand-Ruel sent over an enormous show of French Impressionist works, including thirty-eight Renoirs, to be exhibited at the American Art Association in New York, it was Monet who reaped the accolades, and Renoir was grouped with Degas and Manet among the figure painters whose works were generally rejected for their poor drawing and vulgarity of color as well as for expressing the brutality, the pessimism, even the depravity of modern life.

In subsequent years Renoir received only limited critical attention and nowhere near the patronage enjoyed by Monet. Nevertheless, by the end of the century, works by Renoir were owned by a number of the major collectors specializing in French Impressionist art. Renoir's pictures were also to be seen occasionally in commercial galleries, such as the New York branches of Durand-Ruel and Boussod-Valadon and the Delmonico Gallery, which included Renoir in an Impressionist show in January 1894. From 1900 on, Renoir's painting became a more familiar commodity in New York's art world, starting with a show of work by Renoir and Monet in April of that year at Durand-Ruel's New York gallery, and followed up eight years later with Renoir's first one-artist show, held there in November with forty-one works.[56]

Renoir, therefore, was an increasingly known quantity in America by the mid- and later 1900s, when Glackens was moving into his orbit, and the appearance of his one-artist display in 1908 could only have intensified Glackens's awareness of his art. In addition, Glackens almost surely would have seen Renoir's paintings much earlier, beginning with his first visit to Paris; Durand-Ruel presented a show of forty-two Renoir canvases in 1896, during the time Glackens and Henri were staying in Paris. And Glackens's enthusiasm for Renoir may well have been further aroused by the Metropolitan Museum's acquisition in 1907 of Renoir's great portrait *Mme Charpentier and Her Daughters.* His interest would have been further strengthened by the responses of several of his writer friends. In 1910 the critic James Huneker characterized Renoir as "a painter of joyful surfaces" and "an incorrigible optimist. He is also a poet. The poet of air, sunshine and beautiful women."[57] Walter Pach, with whom Glackens would be associated in the organization of the Armory Show, was also an admirer of Renoir's and published an interview with him in 1912.[58] In a reversal of the critical opprobrium heaped on Renoir's paintings in 1886, Guy Pène du Bois wrote in 1914, "Of the impressionists, the most admired man in modern circles today is Renoir."[59] Interestingly, Glackens may have been

73. THE ARTIST'S WIFE AND SON, 1911
Oil on canvas, 36 x 48 in.
On extended loan to the Snite Museum of Art, University of Notre Dame, Notre Dame, Indiana

one of the first American painters to emulate Renoir, but he was not the only one. During these years, Frederick Frieseke, in the artists' colony in Giverny, France, was consciously emulating that French Impressionist, even while residing in the same village as Claude Monet.[60]

Glackens's conversion to the aesthetic strategies of Renoir has often been linked to his association with Albert Barnes, who had been a schoolmate of his at Philadelphia's Central High School and who was to become one of the most notable collectors of modern art in the United States. It is true that Glackens and Barnes formed a close relationship, beginning about 1910 or 1911, when Barnes looked up his former classmate and asked Glackens to visit him in Merion Station, Pennsylvania, to review the pictures he had collected. Glackens concluded that Barnes had formed an innocuous, undistinguished assemblage and that he had bought "safe" paintings from New York dealers at exorbitant prices. John Sloan quoted Glackens as telling Barnes: "I know what you have. A couple of Millets, red heads by Henner, a Diaz, and fuzzy Corots. They are just stinging you as they do everybody who has money to spend."[61]

By February 1912, when Glackens was on his way to Paris to spend twenty thousand dollars to expand Barnes's holdings, he was playing an important role in building up the collection of what is now the Barnes Foundation. With the aid of Alfred Maurer, he visited leading Parisian dealers and met collectors of European modernism, including Leo Stein. He wrote to Edith on February 13, "I am to meet Alfy at one o'clock and he is going to introduce me to a Mr. Stein, a man who collects Renoirs, Matisse, etc."[62] Glackens's first acquisition for Barnes was a small Renoir portrait; in addition to acquiring works by Alfred Sisley and Bonnard, he was also scouting out paintings by Paul Cézanne for Barnes and acquired *Toward Mount Ste. Victoire* for Fr 13,200 ($2,640) from the Galerie Bernheim-Jeune on February 28, 1912, though he had previously not seen Cézanne's work firsthand.[63] Barnes was putting his faith in Glackens, and the painter was introducing him to work by the European

Impressionists and Post-Impressionists, as well as by those Americans with whom he was associated, such as Alfred Maurer and his colleagues among The Eight. Barnes also acquired over sixty works by Glackens himself, including *Brighton Beach, Race Track*, about which Barnes wrote in one of his most important publications.[64]

Unfortunately, Barnes never produced the monograph about Glackens that he planned—one of two small books about which he wrote to Edith Dimock Glackens (the other was to be about Prendergast). In his letter he stated: "I know what is in my head about those painters and if I can put it on paper I think perhaps intelligent people will sit up and take notice of what they have overlooked. The books will be illustrated—very much so—and they will be published by the Barnes Foundation."[65] Barnes did publish an article on Glackens in April 1924, on the occasion of his receiving the Temple Gold Medal from the Pennsylvania Academy for his painting *Nude* (formerly, Dr. J. Edward Taylor collection, sold Sotheby's, New York, May 24, 1989). Barnes equated Glackens's draftsmanship to that of Francisco de Goya, Honoré Daumier, and Degas, and his painterly ability to that of Manet.[66]

Glackens's impact on the Barnes collection should not be overestimated. After all, he served as a purchasing agent for only three weeks, arriving in Paris on February 12 and departing on March 2, 1912. What kind of compensation Glackens received from Barnes for this initial foray into the Parisian picture market is not known. From 1912 on, Barnes's own tastes developed so rapidly that he never again allowed Glackens, or anyone else, to purchase art for him, although as late as 1926 he invited Glackens to accompany him to Basel, Switzerland, to look at some pictures for possible acquisition.[67] In addition, Barnes also made a point of replacing eight of Glackens's initial purchases with better examples.[68] On the other hand, it is certain that Glackens's veneration for Renoir is at least partially responsible for Barnes's acquisition of several hundred of Renoir's canvases; 175 remain in the Barnes Foundation. On the publication of Barnes's book *The Art of Renoir,* the author sent Glackens a

copy, inscribed with this testimonial: "To Butts, who started my interest in Renoir. Albert C. Barnes."[69] Barnes and Glackens both had minds of their own, and Barnes's championing as well as collecting of a great number of canvases by Cézanne and Matisse, for instance, seems to have left only a limited impression upon Glackens's own painting. Likewise, Glackens could not keep Barnes from acquiring examples by American artists whom he, himself, did not admire, such as Marsden Hartley.

Despite disagreements, Glackens and Barnes remained close friends until the artist's death in 1938, and Barnes never wavered in his admiration for the artist; in 1913 he wrote to Leo Stein that he considered Glackens "the strongest man in America."[70] And he acknowledged in 1915: "The most valuable single educational factor to me has been my frequent association with a lifelong friend who combines greatness as an artist with a big man's mind."[71] Glackens drew a crayon portrait of Barnes (private collection), perhaps when they visited Long Island together in the summer of 1912. He also painted two pictures of Mrs. Barnes in a garden (unlocated; formerly, Brooklyn Museum).[72]

A great deal of ink has been spilled—too much ink, in fact—concerning the shift in Glackens's art away from Manet and toward Renoir. Barnes himself discussed this in his article, distinguishing between influence and imitation:

> For color the skillful, joyous use of brilliant, strong moving color, the only man of this generation who can be said to be [Glackens's] equal was Renoir. His psychology is so near that of Renoir, he saw the world in so nearly the same terms, that he has been much influenced by Renoir, especially in the use of color. But Renoir never had the ability of Glackens to express by drawing some of the things in life which move us most deeply. Renoir seems to us now to be a greater artist than Glackens; but those of us who have lived with the work of both men long enough to know the characteristics of each, never would mistake one for the other or

admit that Glackens is either an imitator of Renoir or less of an individual artist because he has expressed himself in color which we associate with Renoir's work.[73]

By 1913 Glackens was being regularly associated with Renoir, although at first only in a positive sense. One writer noted, "If one is at all reminded of Renoir . . . the thought of slavish imitation never arises, but rather the thought of artistic affinity."[74] A number of Glackens's strong supporters—Albert Gallatin, Guy Pène du Bois, and especially Forbes Watson—endorsed his change of direction. Gallatin, for instance, wrote two articles on Glackens, one in 1910 and the other in 1916. In the first he acknowledged the influences of Manet and Degas; in the second he recognized that "in many of his recent portraits and figure compositions the influence that Renoir has exerted on his technique and on his palette is quite apparent."[75] Watson, who wrote more often on Glackens than anyone else, believed that "Glackens' gifts did not flower fully until he came into contact with the art of Renoir. He delighted in the art of Renoir to such an extent that the uninitiated, the unthinking, and the prejudiced have called him an imitator of Renoir."[76] Harry Salpeter later noted, "On a superficial acquaintance he has been called America's Renoir and there is no doubt that had Renoir never painted, Glackens might have painted differently, if no less luminously."[77]

Catherine Beach Ely noted as early as 1921, "The vigor with which Glackens' admirers defend him against any imputation of imitation seems to show their sensitiveness at this point."[78] And indeed, other critics judged Glackens's shift to Renoir-influenced color, brushwork, and even physical types as detrimental. No writer was more dismayed at this shift than Henry McBride, who noted in his review of the artist's memorial exhibition at the Whitney Museum in New York in 1938: "The succession of the pictures shows that he threw his pots of black paint out the window and became a violent impressionist almost overnight, trailing along abjectly in pursuit of the secrets of

Renoir. . . . Glackens's disaster lay in the fact that he could not see form in color."[79]

Glackens's later defenders, some of them issuing from the Barnes Foundation, have been at pains to distinguish between the work of the two artists. While acknowledging the Renoir connection, Richard J. Wattenmaker (a former student at the Barnes Foundation) has emphasized that Glackens, far more than Renoir, "revelled in the episodic drama of everyday occurrences . . . in a direct, immediately illustrative way."[80] The most systematic study of the relationship was published by Violette de Mazia, the Barnes Foundation's director of education, in 1971. She stated: "It is questionable whether any two painters ever had a greater measure of temperamental affinity, and, *up to a point,* ever saw eye to eye more compatibly than did Glackens and Renoir." De Mazia acknowledged that "the pervasive colorfulness of Glackens' paintings, their rich, luxuriant brightness, the sparkling luminosity, the singing vibrancy combined with voluptuous, flower-like freshness and delicacy in the hues and tones, and a fluidity and gentleness in the drawing are qualities very much like those that identify Renoir's color effects, and, at first blush, they make Glackens' color design seem almost a replica of Renoir's." But she went on to analyze their differences, pointing out Glackens's less structural use of color and his limited blending of different hues. She attributed the differences between their work both to Glackens's original involvement with illustration, which required a sense of narrative, and to the impact made on him by his exposure to Manet and Matisse.[81] In a different vein, Vincent de Gregorio went so far as to state: "While light is a dominant factor in determining the intensity of color, Glackens' canvases are rich in hue and his forms have retained a certain crispness and firmness of contours not encountered in Renoir's works. Thus, it is only the color range itself that is somewhat similar in the works of these men."[82]

Glackens was quite open about his new chromatic investigations à la Renoir, and he enjoyed the critics identification of him as a significant colorist. He also repudiated his earlier dark manner on a number of occasions. Salpeter, who identified Glackens as "America's Sun Worshiper," stated that "Mr. Glackens himself looks with a sour eye upon his own early muddy paintings."[83] It has not been previously noted but it may be significant that Glackens's involvement in illustration declined sharply after 1910, the period when his aesthetic was changing. He may have withdrawn from illustration simply because he had tired of it or because his improved financial status meant that he had no need to continue that line of work. But it may also be more than coincidental that his graphic strategies were obviously more aligned with the tonal manner of his earlier pictures than with his later work, in which color was dominant. And so illustration may no longer have offered Glackens sufficient creative satisfaction when color and light were his primary concerns.

At the same time that Glackens was increasingly working with a full chromatic range and excising the blacks, browns, and grays from his palette, he was enjoying the role of a fairly well-to-do, settled family man—living comfortably in an attractive middle-class neighborhood, delighting in his children, and enjoying summer holidays with his family by the seashore. (Tennis in the city and fishing in the countryside were Glackens's favorite sports.) Life was comfortable, though not luxurious. Ira Glackens noted that the Dimocks did not support their daughter and her artist-husband to any great extent, though on visits Edith's father would occasionally press a hundred-dollar bill in her hand.[84] Perhaps it is not farfetched to suggest that the explosion of light and color in Glackens's painting reflected his contentment with his life—a mode of living less rousing perhaps than his early bachelorhood days spent working for newspapers or his later years of close involvement with Henri and the various exhibitions of "The Black Gang."

But with better times came some personal losses. James Moore died during World War I, and so did Ferdinand Sinzig. Glackens remained very friendly with Henri, of course, as well as with other members of The Eight, but the two artists went their more or less separate ways, particularly after

74. Maurice Prendergast
IRA GLACKENS AT FIVE, C. 1912
Oil on canvas, 20 x 16 in.

75. Maurice Prendergast
NANHANT (also known as LANDSCAPE WITH
A CARRIAGE), C. 1912–13
Watercolor and pencil on paper, 14¾ x 21½ in.

the Armory Show. Yet, they continued to socialize; Henri and his second wife, the former Marjorie Organ, spent many evenings with the Glackenses, along with their colleagues Lawson, Sloan (who remained a good friend of Glackens's for life), and Shinn.[85] In 1925, in one of his last publications, Henri gave the lead illustration to a Glackens family painting, *Lenna with Rabbits* (c. 1920; subsequently destroyed in a railroad fire after its exhibition at the Cleveland Museum of Art in the early summer of 1928).[86]

Maurice Prendergast had painted a very sympathetic portrait of Glackens's son, *Ira Glackens at Five* (plate 74), about 1912, and the following year Edith bought a Prendergast *Study* (now, *Nanhant,* or *Landscape with a Carriage,* plate 75) at the Armory Show. Glackens drew even closer to Prendergast and his brother, Charles, when the two moved from Boston to New York in 1914, settling on the top floor at 50 Washington Square South, over Glackens's studio there in an old, high-ceiling

house; the brothers remained there until Maurice's death in 1924, when Charles moved to nearby Irving Place. Glackens and his wife also developed a special rapport with Everett Shinn, whose studio was also close by, at 112 Waverly Place. During 1911–12 Shinn wrote a series of plays, performed by the Waverly Place Players, which numbered William and Edith Glackens among the performers. Indeed, William Glackens remained Shinn's one lifelong friend and the only colleague whose art Shinn really admired.[87]

Throughout their married lives the Glackenses entertained their friends royally. Ira Glackens explained: "Mother liked to entertain and constantly had people in the house to small pot-luck dinners and planned banquets. Father was always genial with his guests and kept very busy mixing drinks. He saw to it that the correct wines were served, and sometimes suggested people he would like to have to dinner, but had nothing else to do with it. The guests ranged through the arts and professions."[88]

6

IN THE PARK AND
AT THE BEACH

Apart from his book and magazine illustrations, Glackens was known primarily as a painter in oils. He appears to have produced independent etchings only sporadically—the finest of these appear to have been Parisian scenes—and he may not have been entirely comfortable with watercolor as an independent medium rather than a component in his illustrative drawing work. He began to contribute to the annual exhibitions of the American Water Color Society only in 1909, showing four works that year, three of which were *Scribner's* illustrations; the fourth was a watercolor version (unlocated) of *May Day in Central Park* (plate 55). The following year, 1910, he showed more scenic watercolors of Washington Square and summer bathing at Wickford, Rhode Island, but after exhibiting two watercolors in the 1911 annual, he ceased to participate. Glackens may have entered the shows to encourage his wife's participation, for, as Edith Dimock, she also exhibited in 1910 and 1911.

Like Degas and other of the French Impressionists, as well as several of his close colleagues among The Eight, Glackens was attracted to the pastel medium. He utilized pastels in many of his early illustrative works, and with his new colorism of around 1910 pastel took on a fresh role in his oeuvre, used both for independent city and beach scenes and for preliminary studies; he continued to prepare pastel studies for works as late as his 1935 oil *The Soda Fountain* (plate 131). Glackens's

increased involvement with pastel coincided with his participation in the first two shows of a new exhibiting society, the Pastellists, who began showing at the new Folsom Gallery in New York in January 1911; the group held four shows, through 1914. The shows were generally popular with both the critics and the public, though one dissenting reviewer found Glackens's five pastels in the first show "brutal."[1] Glackens's pastels may have constituted an exception to the restrained colorism of almost all the other work; his *Summer House* was cited as "a mosaic of brilliant color, and his *Washington Square* was called "a bit garish."[2]

Some of Glackens's pastels in the Pastellists exhibitions relate to his oil paintings of the Washington Square neighborhood painted during the same period. I have no documentation for Glackens's earliest exploration of Washington Square as a source of pictorial themes in his easel work, but he was active there by May 1, 1906, when he wrote to Edith, "I have been trying to paint one, a Washington Square with the fountain."[3] Many of his newly colorful scenes of New York painted in the early 1910s are set in the square, as was one of his major illustrations, *A Spring Morning in Washington Square, New York,* which appeared on the cover of *Collier's Weekly* on April 16, 1910.

The oils comprise a number of genre scenes, including *Descending from the Bus* (plate 76), *The Green Car* (plate 77), and *March Day, Washington*

76. Descending from the Bus, c. 1910
Oil on canvas, 25 x 30 in.
Collection IBM Corporation, Armonk, New York

Square (private collection), all painted about 1910–12. The figures he chose to represent are not there to enjoy the square but are usually hurrying about their business, traveling on foot, by automobile, by electric tram, or by double-deck bus. Glackens was also concerned with documenting the square in all seasons of the year and under different weather conditions. In *Descending from the Bus* one is very aware of the cold because of the snow and

the well-bundled figures; the women wear hats and muffs. In *March Day, Washington Square* the men and women are still heavily clothed, but they move in a more relaxed fashion, carrying furled umbrellas against the rain. In all of these pictures, the figures are painted almost peremptorily, with fairly thick, ragged strokes, and the palette is Renoiresque.

Both *Descending from the Bus* and *March Day, Washington Square* are taken from the south side

77. THE GREEN CAR, 1910
Oil on canvas, 24 x 32 in.
The Metropolitan Museum of Art, New York;
Arthur Hoppock Hearn Fund, 1937. (37.73)

of the square, with the Washington Arch looming up across the park. This was most convenient for Glackens, of course, since his studio was on Washington Square South. This was also the less fashionable side of the square, the northern boundary of an ethnic Italian neighborhood. In *The Green Car* a hatless woman in a shawl appears with her child in contrast to the more elegantly garbed woman hailing the streetcar. Another mother

carries her child in Glackens's colorful *Mother and Baby, Washington Square* (plate 78), which is probably a springtime work, since the grassy plots are richly green. That the square itself is respectable and well kept up is attested by the street sweeper dressed in white in the middle ground, a figure already familiar in many of Childe Hassam's New York pictures, including some painter in the vicinity of the Square; Glackens also featured this

78. Mother and Baby, Washington Square, 1914
Oil on canvas, 14¼ x 17½ in.

subject in a now unlocated picture, *Street Cleaner, Washington Square.* Glackens quite prominently recorded Giovanni Turini's statue of Giuseppe Garibaldi in the upper right—a gift, in 1888, from Italian Americans to the city of New York.

Glackens also recorded various Italian American celebrations held in the square, especially the Columbus Day parades, as in *Parade, Washington Square* (plate 79) and *Italo-American Celebration, Washington Square* (plate 80). The latter is a sedate crowd of men and women, kept in order by a few policemen, who observe a procession

of top-hatted officials passing under the Washington Arch and into the square, carrying a combination of American and Italian flags. The arch itself, of course, based upon Roman triumphal arches, equally refers to an Italian heritage. *Parade, Washington Square* is a more loosely organized affair, with adults and children milling around the park, carrying Italian flags. Glackens's paintings reflect the tendency in both art and literature to replace images of the older, aristocratic Washington Square North with its ethnic counterpart to the south.

79. PARADE, WASHINGTON
SQUARE, 1912
Oil on canvas, 26 x 31 in.
Whitney Museum of
American Art, New York;
Gift of Gertrude Vanderbilt
Whitney

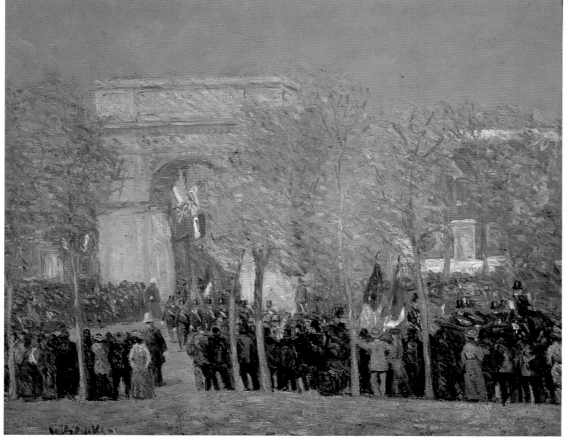

80. ITALO-AMERICAN
CELEBRATION,
WASHINGTON SQUARE,
C. 1912
Oil on canvas, 26 x 32 in.
Museum of Fine Arts, Boston;
Emily L. Ainsley Fund

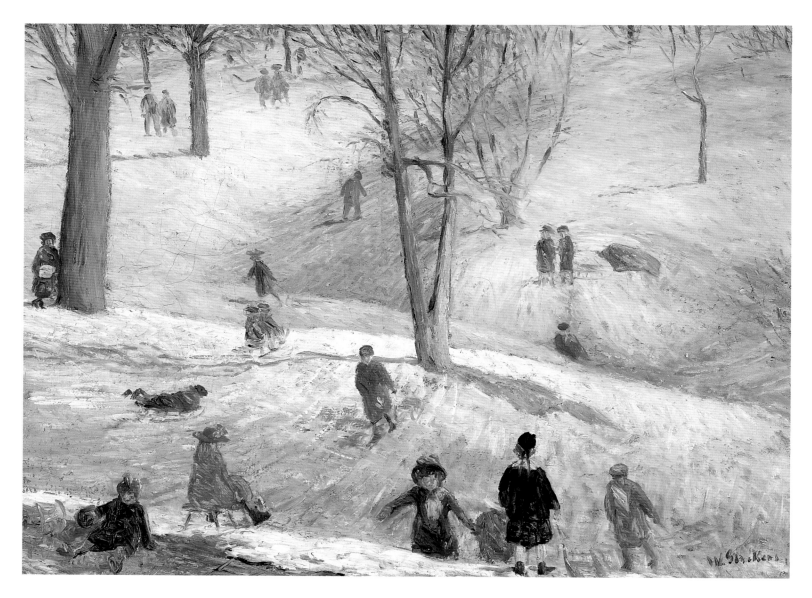

81. SLEDDING, CENTRAL PARK, 1912
Oil on canvas, 23 x 31½ in.

Glackens's Washington Square paintings were first seen publicly in March 1909 at the annual exhibition of the National Academy of Design, where he showed a canvas entitled *Washington Square.* In his one-artist show at the Madison Art Gallery in March 1912, "The green car at Washington Square" appeared "and other notes from that park, with a crowded and brilliant Italian parade, full of people and banners, beyond and around the Memorial Arch."[4] This exhibition appears to have been Glackens's first one-artist show, and the critics were generally very receptive to the work.

Washington Square was Glackens's own neighborhood, but it was a small plot of land; for more expansive subjects he returned to Central Park, producing a series of winter scenes in 1912. One of the finest is *Sledding, Central Park* (plate 81). The scene recalls his earlier *Central Park, Winter* (see plate 56), but the ensuing years have not only abolished the adult guardians of these children enjoying their winter sledding but also the dark neutral tones that dominate the earlier picture. This is a truly Impressionist scene, with the bright colors of the children's winter clothing played off against the white snow

filled with blue and violet shadows. Painted from on high, the view follows the course of the sleds and suggests a limitless play field for the young folk; right of center, and about to join the fun, is five-year-old Ira Glackens, dressed in a distinctive Scottish costume.

While children rode sleds, adults enjoyed winter skating, a Central Park activity that Glackens painted a number of times, including such colorful canvases as his *Skaters, Central Park* (plate 83). Recalling the indoor activities of his earlier *Roller Skating Rink* (plate 38), Glackens presented vignettes of couples, of individuals performing, and of a gentleman helping a fallen female companion, against a backdrop of the tall apartment buildings on Central Park West. Glackens indulged in his new, Impressionist colorism in his skating pictures, and their ideographic figures and inclusion of multiple incidents also recall rather specifically Renoir's *Skating in the Bois de Boulogne* (1868; private collection). Glackens returned to a number of his other earlier themes during the 1910s, including roller skating. In *Children Roller Skating* (plate 82) the skaters are outdoors in Washington Square, presumably in early springtime or autumn, since the figures are warmly dressed.

At least once, Glackens also returned to the

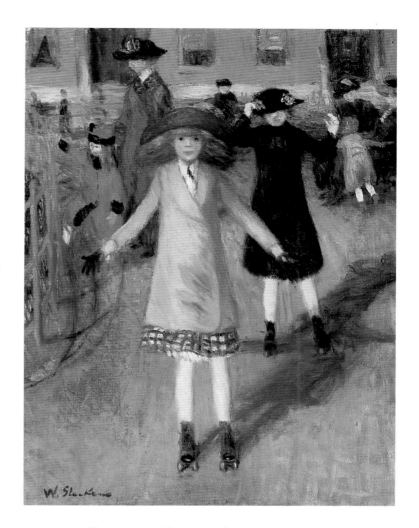

82. CHILDREN ROLLER SKATING, C. 1918–21
Oil on canvas, 24 x 18 in.
The Brooklyn Museum, New York;
Bequest of Laura L. Barnes

82. SKATERS,
CENTRAL PARK, N.D.
Oil on canvas, 16½ x 29¼ in.
Mount Holyoke College
Art Museum,
South Hadley, Massachusetts;
Museum purchase,
Nancy Everett Dwight Fund

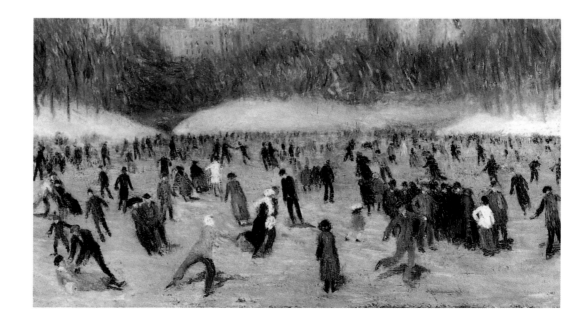

world of theatrical entertainment. In a work that is probably a study for *Music Hall Turn* (plate 84; sometimes titled *A Vaudeville Turn*) he utilized his broad chromatic spectrum to capture the garish pageant of a theatrical chorus backing a scantily clad lead performer with a voluptuous figure. Though generally dated to c. 1918, this may be the painting (or a preliminary version) so admired by the critic for the *New York Sun* who wrote in December 1910: "Glackens has in his studio, South Washington Square, a large canvas, a study of some girls, possibly vaudeville 'artistes,' on which he daily practices his colored scale, trills and arpeggios. He redresses one of the ladies in gorgeous array each day and you watch, with curiosity growing apace, the kaleidoscopic hues that come and go on this canvas."[5] This painting calls to mind not so much Glackens's earlier paintings of public enter-

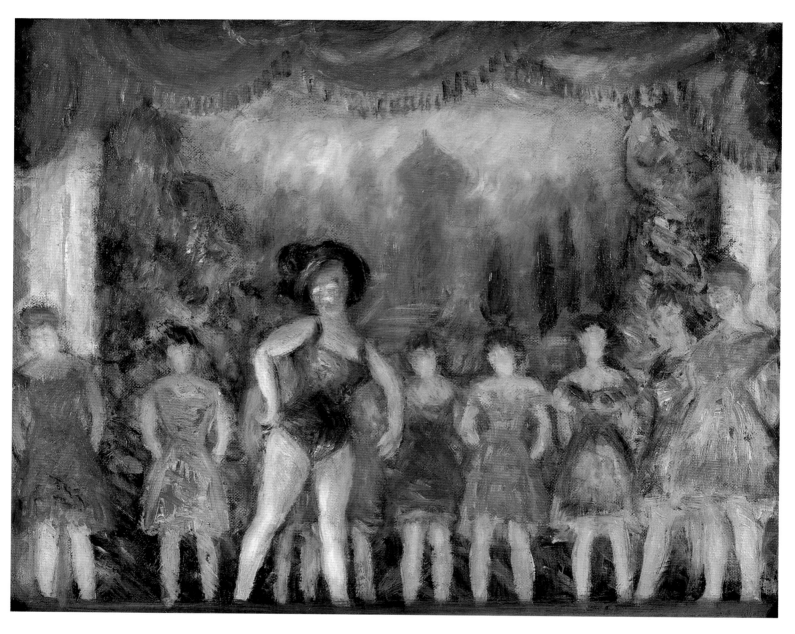

84. Study for "Music Hall Turn"
(also known as A Vaudeville Turn), c. 1918
Oil on canvas, 13 x 16 in.

tainment as his *Scribner's* illustrations of the early 1900s, one set of which illustrated an article titled "A Vaudeville Turn"; both the chorus line and the footlight illumination hark back to his single illustration, *A Musical Comedy,* for John Corbin's 1905 article "The Lights and Stars of Broadway."[6]

Washington Square and Central Park may have been among Glackens's favorite outdoor painting grounds during most of the year, but in the summers he concentrated on the beaches he visited during annual holiday excursions with his family. In fact, such subjects became his largest body of outdoor work—not only the pictures he most frequently exhibited but also his most popular, judging by their presence today in many of America's leading art institutions. They also enjoyed the most critical attention in their own time and were addressed again in the most serious scholarly study that Glackens has received in recent years.[7] They reflect the coloristic strategies of Renoir but reject the classicizing treatment of many of the French master's bathing pictures in favor of an emphasis on middle-class holiday enjoyment.

Holiday bathing was a subject that had attracted Glackens at least as far back as his 1906 honeymoon trip with Edith, when he produced *Château-Thierry* (plate 65) and *Dieppe Harbor* (Barnes Foundation, Merion Station, Pennsylvania). And the related subject of beach scenes had appeared even earlier, in such works as *Fruit Stand, Coney Island* (plate 28) of c. 1898, a locale he visited again in 1907. Glackens's series of brightly colored American beach scenes can be said to begin with those he painted at Cape Cod in the summer of 1908, such as *Cape Cod Pier* (plate 70). The next summer the Glackenses were neighbors of the Shinns when they took their holiday at Wickford, Rhode Island, near Narragansett Bay. Their activities—playing tennis, bathing, and clamming on Cold Spring Beach—were recorded by Glackens in brightly colored oils, along with harbor scenes; at least eight Wickford paintings are recorded. In February 1910 he showed a beach scene in an exhibition of landscapes held at the National Arts

Club, presumably drawn from his Wickford summer. Arthur Hoeber described it as "showing a seashore with bathers and a group of summer visitors. It is fearfully and wonderfully made with splashes of white to indicate boats, with masses of pigments the meaning of which leaves the spectator in great doubt"; Hoeber described them as demonstrating "a brand-new manner."[8]

Glackens was beginning to seek identification with his summer beach and bathing pictures; the lower part of one of these figures prominently in the upper-left corner of his monumental *Nude with Apple* (plate 71); since this work must have been completed by April 1910, in time for its exhibition with the Independent Artists, this presumably was a Cape Cod or Wickford painting of 1908 or 1909.[9]

In the summer of 1910 the Glackenses went farther afield and vacationed around Chester, Nova Scotia, a town southwest of Halifax on Mahone Bay. The artist's *Mahone Bay* (plate 85) is one of the finest coastal pictures of his career, with a fascinating configuration of land and sea, and a variety of sailing vessels on the water. Vacationers use the bathhouses and promenade on the pier, some with parasols, while others loll on the grassy knoll overlooking the water. There is a sense of the reality of the scene and, in fact, the largest boat is identifiable as the *Blackbird.*[10] The artist's reasons for visiting this area, which he had visited seven years earlier, are unknown.

Glackens's technique in the Cape Cod, Wickford, and Mahone Bay pictures is transitional between his earlier, darker manner and his full reliance on the strategies adopted from Renoir. These paintings display a full coloristic range, but the individual hues are quite intense and the paint is laid on densely; Glackens had not yet adopted the feathery brushwork that was to mark his subsequent holiday pictures. His Nova Scotia paintings, such as *Mahone Bay, Chester, Nova Scotia* (Berman Collection), and *Beach at Nova Scotia* (Canajoharie Library and Art Gallery, Canajoharie, New York) excited the critics:

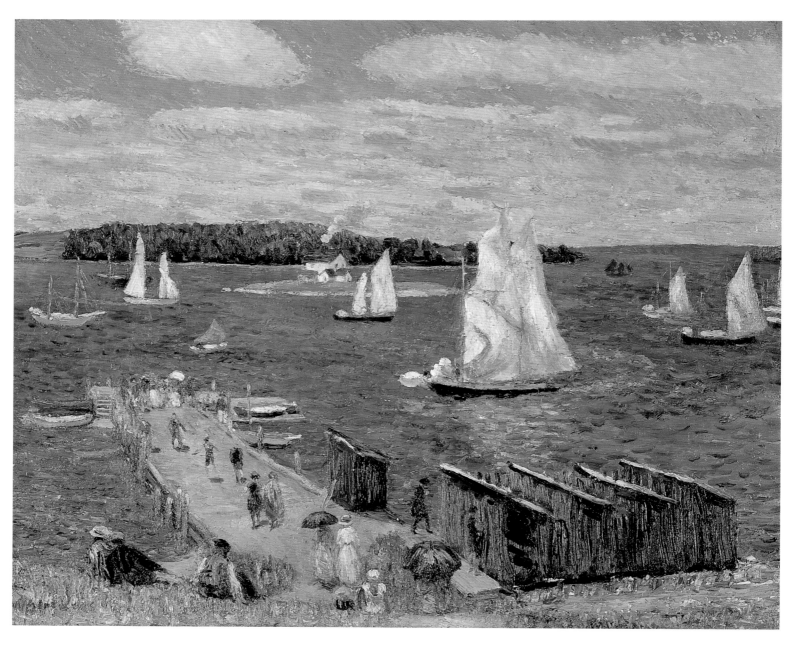

85. MAHONE BAY, 1911
Oil on canvas, 26¼ x 31¾ in.
Sheldon Memorial Art Gallery, University of Nebraska,
Lincoln, Nebraska. F. M. Hall Collection

Apart from their technical accomplishment, they begin to show, however dimly, the goal to which this ambitious and gifted young man is steering. Beaches of inland seas, the waters of which are vivid blue; skies of hard blue as Italy's, white cloud boulders that roll lazily across the field of vision, and shine on their edges with re-flected light; grass so green that you ask yourself if Nova Scotia raises the crop from Celtic seed; nothing tempered as would a less sincere artist, but set forth unmodu-lated and in audacious opposition; these waters, skies, beaches, bath houses of uncompromising lines, these drifting or moored boats with humanity strolling,

sitting, bathing are nevertheless so real, or rather evoke the illusion of reality, that you experience in their presence what Henry James calls "the emotion of recognition."[11]

The following summer, 1911, Glackens and his family finally settled on a favorite vacation area, where they would return through 1916, first renting the Petty cottage on Bellport Avenue in Bellport, Long Island, and then, for the next five seasons, the Carman cottage.[12] Bellport was a middle-class resort in the center of the island, on Great South Bay; a ferry took vacationers across to Fire Island and ocean swimming. The area was becoming something of an artists' and writers' colony at this time; Glackens's close friends May and Jimmy Preston had remodeled a house there, and a number of the artist's colleagues—Shinn, Lawson, and Prendergast among them—also visited. It was during his 1912 summer visit that Prendergast painted his oil portrait of the young Ira Glackens (see plate 74).[13] Lillian Travis, who had modeled for *The Shoppers* (see plate 66), was also a visitor, and Albert Barnes came over, too, and in turn invited them to nearby Blue Point (another summer resort, to the east), where Mrs. Barnes's mother had a cottage and where Glackens also painted.[14]

Glackens painted many scenes on the beaches of Bellport. *At the Beach, Bellport* (plate 86), though undated, seems to be one of the earliest of his Long Island beach paintings, with its strong areas of flat color, rather carefully modeled figures, and especially its reliance on a sharply defined geometric structure of architectural forms, created by the repeated shapes of the bathhouses and the boardwalks. This is also one of the quieter of his Bellport pictures, with only two women bathers about to go down to the ocean, and no sign of water or beach activity. Some of these first Bellport pictures were included in Glackens's one-man exhibition at the Madison Art Gallery in March 1912, where one critic identified him as a realist through his ability to combine with "emphatic conviction

the dazzle of sunlight . . . with that fidelity to little uncompromising uglinesses of the regime of the summer boarder."[15]

It was during the evolution of his Bellport pictures that the basic transformation of Glackens's artistic strategies became most apparent, as evident in the critical reaction to some of the beach scenes he painted during his second summer, in 1912. When these appeared in his one-artist show at the Folsom Gallery in March 1913, one critic wrote regretfully that "after enjoying the refreshing tone of so much vibrant color, it is not difficult to pick out parts of these pictures in which the drawing is far from being a high achievement of draughtsmanship." He also noted "several bathing pictures, in which figures are treated as spots of color rather than as forms."[16] Yet if Glackens's renowned draftsmanship was diminished in these paintings, the glorious colors and the immersion in rich sunlight could more than compensate, as in such scenes as *Beach Side* (plate 87). Color and light dominate this idyllic scene, centered on a large group of children who observe several of their comrades swimming, accompanied by an adult.[17]

Naturally, the majority of these summer pictures were bathing and beach subjects, but Glackens also painted other genre subjects, such as *The Swing* (1913; Walker Art Museum, Minneapolis), and a few pure landscapes, such as his colorful *Pine Trees, Great South Bay* (c. 1912; private collection). By 1916, when he painted *Beach Umbrellas at Blue Point* (plate 88), Glackens relied for compositional unity on recurrent rhythms: the arcs of the orange and yellow umbrellas; the repeated green vertical shutters on the hotel; and the clumped masses of foliage at the right. With soft and feathery brushwork, he integrated figures, sand, umbrellas, and background into a single coloristic mass, the composition dominated by the grand hotel looming up in the left background.

There were at least five, and possibly six, Bellport beach pictures in Glackens's 1913 show at the Folsom Gallery.[18] Most critics greeted the show favorably, and it was reported that five of

86. At the Beach, Bellport
(also known as The Boardwalk), c. 1910
Oil on canvas, 18 x 24 in.
Private collection

the pictures sold—one to "the finest private collection in America, where it has the unique distinction of being the only American canvas," possibly a reference to Albert Barnes.[19] The same critic attributed Glackens's success to changes in the public's attitudes toward art, with less fear of color; he or she postulated that these changes had been spurred by the modern European art that had just appeared at the Armory Show and by the richer colors being used by many American painters, especially the former members of The Eight.

At the end of 1913 Glackens moved from the Folsom Gallery to the new Daniel Gallery, which opened at 2 West Forty-seventh Street in December as a commercial outlet for modern art; his work appeared in the gallery's first show.[20] It was almost four years later, in January 1917, following his last summer in Bellport, that Glackens had his

87. BEACH SIDE, 1913
Oil on canvas, 26¼ x 32¼ in.
The Nelson-Atkins Museum of Art, Kansas City, Missouri;
Bequest of Frances M. Logan, 47-109

first and only one-artist show at the gallery. One reviewer perhaps best summed up the character of his beach and park pictures: "His world is a restless reflection of himself—a world crowded with a multitude of accidents and incidents all worth recording; all crying out to be recorded and all unseen by most of us, for most of us have grown a hard shell around our curiosity."[21]

Glackens's fascination with bathing subjects did not cease, despite the epidemic of infantile paralysis in 1916 that led the Glackens family to abandon their Bellport cottage and move to a vacant house in nearby Brookhaven for the rest of the summer, depriving the artist of easy access to beach scenes. The family did not return to Bellport again, and much of 1917 was spent in West Hartford, after both of Edith's parents died that May. In the summer of 1918 they vacationed in

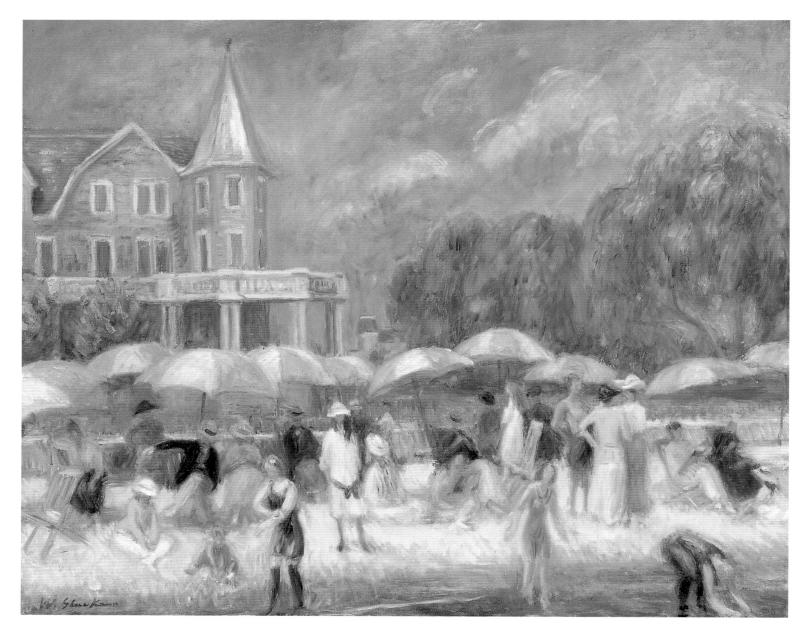

88. Beach Umbrellas at Blue Point, 1916
Oil on canvas, 26 x 32 in.
National Museum of American Art, Smithsonian Institution, Washington, D.C.;
Gift of Mr. and Mrs. Ira Glackens

Pequot, near New London, Connecticut, staying in a house that had been in the Dimock family, and in 1919 they joined the long-established art colony in Gloucester, Massachusetts, where a number of Glackens's colleagues, such as John Sloan, had previously summered. Glackens produced fine beach pictures in both locations; *The Bandstand* (plate 89), a paean to total summer relaxation painted in New London, is typical of these. Its

warm harmonious hues testify to the joyousness that continued in Glackens's summer work.[22]

Ironically, Glackens arrived for his one season in Gloucester the same summer that Sloan had abandoned the colony after having summered there for five years. Typical of the nine pictures that Glackens is known to have painted there is *Pavilion at Gloucester* (The White House, Washington, D.C.).[23] That same summer, Glackens's

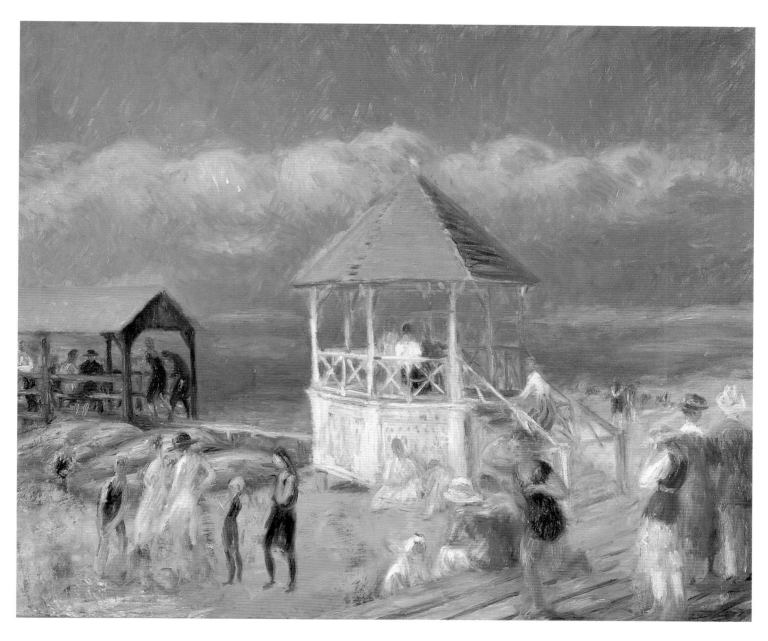

89. THE BANDSTAND, 1919
Oil on canvas, 25 x 30 in.

brother, Louis, visited, and the Glackenses also spent a good deal of time with Charles Demuth. Glackens had not completely deserted the urban beaches near New York. Several paintings, undated but probably created around 1916, depict the Silver Spring swimming pool at North Beach, located on Flushing Bay in Queens (now the site of LaGuardia Airport). In *North Beach Swimming Pool* and *Outdoor Swimming Pool: North Beach* (both, Spanierman Gallery, New York) urban New Yorkers cavort in the pool, while spectators stand around watching the activities.[24]

7
THE LATE WORK

Despite the wealth of paintings that Glackens produced in the parks of New York City, and especially the abundance of beach scenes resulting from his summer work during the 1910s, from about 1912–13 on, he became increasing identified as a figure specialist rather than a scenic artist. Reviewers of his March 1912 show of about a dozen paintings at the Madison Art Gallery noted that "he had gone out of doors to paint, and has painted with all his faculties alert to the appeal of nature."[1] But a year later it was his *Nude with Apple* (plate 71) that received the most extensive commentary, even though there were scenes at the beach and in Washington Square in his exhibition at the Folsom Gallery. As one writer commented, "Figure paintings, to return to the most important phase of Mr. Glackens's work, dominate the Folsom exhibit."[2]

Increasingly, Glackens concentrated on the individual figure painted in an interior setting. Based either on members of his family or on professional models, these were not meant as portraits; in fact, Glackens stated quite specifically, "I have never considered portraiture as one of my best points."[3] After his initial spurt of painting full-length likenesses at the beginning of the century, he produced only a few more portraits. One was the splendid seated painting of an old friend from the Pennsylvania Academy days, the portraitist Alice Mumford (sold Christie's, New York, 1991). The best known of these is his portrait of the illustrious actor, *Walter Hampden as Hamlet* (plate 90), for which a number of preparatory studies exist (plate 91). Hampden's brother, Paul Dougherty, a leading

painter of seascapes in the early twentieth century, was a friend of Glackens's and may have introduced him to his brother. Brooklyn-born Walter Hampden Dougherty had trained in London, and after returning to New York in 1905 he became one of America's most illustrious Shakespearean performers, appearing in *Hamlet* at the Plymouth Theatre, New York, on November 22, 1918, just before Glackens painted his portrait. Glackens appears to have been captivated by Hampden's Hamlet at the time of his American debut in the part and wrote to Mary Fanton Roberts on February 12, 1919, "I am going tomorrow afternoon to see Hamlet."[4]

By choosing Hampden as a subject, Glackens was reverting to Manet as his principal influence; the French painter's two most renowned theatrical portraits were *The Tragic Actor: Philibert Rouvière as Hamlet* (1865; National Gallery of Art, Washington, D.C.) and that of the opera singer, Jean-Baptiste Faure as Hamlet (1877; Museum Folkwang, Essen, Germany). Glackens would almost surely have known these works, for both had been included in Durand-Ruel's 1895 one-artist show of Manet's work in New York. Glackens's paint handling is to some degree derived from Renoir's, but it is thinner than that of either of these French Impressionists, suggesting the manner of Whistler instead. This source was noted by Mary Fanton Roberts, who appears to have instigated the work from Glackens, though she never took possession of it.[5] Roberts applauded the *Portrait of Walter Hampden as Hamlet* for achieving the supreme goal of the

RIGHT:
90. PORTRAIT OF WALTER HAMPDEN
AS HAMLET, 1919
Oil on canvas, 75½ x 40 in.
National Portrait Gallery, Smithsonian
Institution, Washington, D.C.; Gift of
Mr. and Mrs. Ira Glackens

BELOW:
91. STUDY FOR "WALTER HAMPDEN
AS HAMLET," 1916
Oil on canvas, 26 x 13½ in.

92. THE CONSERVATORY
(also known as LENNA AND HER MOTHER IN THE CONSERVATORY), C. 1917
Oil on canvas, 18 x 24 in.

theatrical portrait—capturing both the personality of the actor and the character portrayed by him.[6]

Other than the likeness of Alice Mumford and this singular foray into formal, if theatrical portraiture, the great majority of Glackens's many figure paintings of the 1910s, '20s, and '30s were not of publicly recognizable figures. The models with whom the artist felt the closest kinship were undoubtedly his own family: Edith, Ira, and Lenna. Following up on his monumental paintings of 1911, *Family Group* and *The Artist's Wife and Son*, Glackens depicted Edith and Lenna in *The Conservatory* (plate 92), painted in West Hartford in the

summer of 1917, when the family was staying in the Dimock house. The soft, feathery brushwork and variegated colors recall Renoir's Bordighera landscapes, but the emphasis on the domestic, with the casual summer furniture and Edith's evident affection for her daughter, is very much Glackens's own.

A quieter domestic moment back in New York is lovingly recorded in *The Artist's Wife Knitting* (plate 93). The scene seems to be situated in the Glackenses' newly purchased house at 10 West Ninth Street. In 1919 they had left their Washington Square apartment and taken an old five-story house that dated from around 1830. After a few

93. The Artist's Wife Knitting, c. 1920
Oil on canvas, 24 x 30 in.

years Glackens had a studio built on the top floor there, and his withdrawal from his Washington Square studio may have been one factor in his abandonment of subjects set in the square. On the wall behind Edith's head in *The Artist's Wife Knitting* may be one of the handsome pilasters reaching up to the eighteen-foot ceilings of which the family was so proud; one of Glackens's floral still lifes graces the wall at left.[7] This was to be the Glackens abode for the remainder of William's life.

The young Ira appears in one or two paintings alone, as well as in several family groupings, but it was Lenna whose development Glackens chronicled in paintings of great charm and tremendous richness. These often feature near-explosions of color, which serve as a pictorial metaphor of his affection (see plate 94). *Lenna at One Year* (plate 95) is a quick study of the little girl with her vivid red hair played off against the color in her cheeks and just a few details of costume. *Lenna Painting* (plate 96), made about four years later, shows her painting a landscape with an intensity belying her youth and

94. William Glackens and
Lenna Glackens, c. 1914

95. LENNA AT ONE YEAR,
1914
Oil on canvas, 15 x 12 in.

96. LENNA PAINTING,
C. 1918
Oil on canvas, 12½ x 15½ in.

RIGHT:
97. THE ARTIST'S
DAUGHTER IN
CHINESE COSTUME,
1918
Oil on canvas,
48 x 30 in.

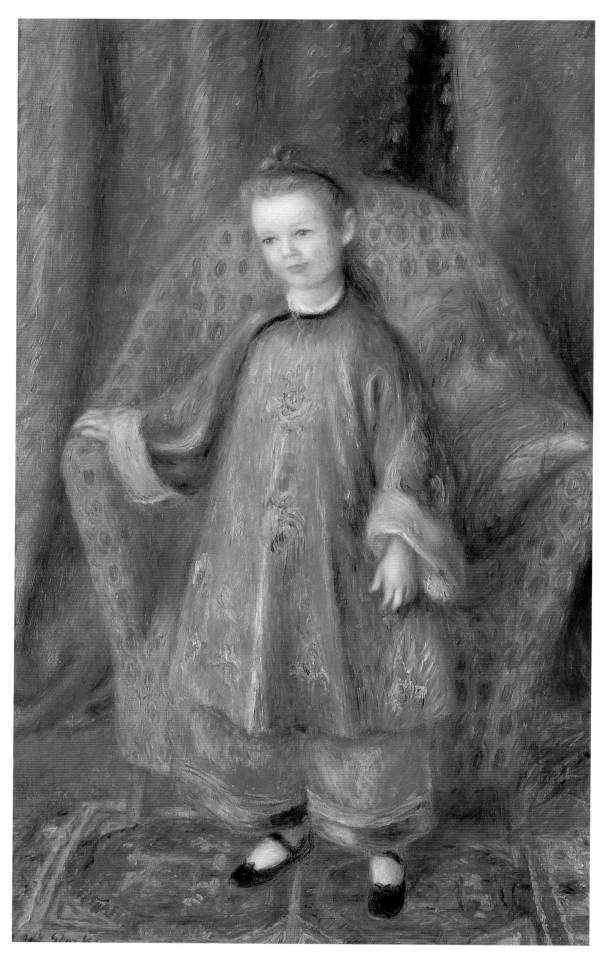

BELOW:
98. Lenna Glackens
in a Chinese costume,
1918

thus following in the artistic footsteps of her parents—as she was, in fact, to do in maturity.

Around 1920 Glackens painted more formal and more ingenious paintings of Lenna. Perhaps the most beautiful is *The Artist's Daughter in Chinese Costume* (plate 97), in which Lenna's touchingly hesitant pose, one hand resting on the arm of the upholstered chair for support, conveys the impression of childhood.[8] This time Glackens has carefully delineated her distinctive countenance, particularly the small features and broad forehead that made her so identifiable. The blue of her Chinese robe contrasts with the rich reds surrounding her. Glackens also carved the frame for this picture—one of a number of frames that he created, almost surely inspired by his close friendship with the Prendergast brothers.[9]

This painting became one of the most widely viewed of Glackens's works during his later career, shown in 1921 at the annual of the Pennsylvania Academy and at the Carnegie International in Pittsburgh. This was his first submission to that renowned venue since *Nude with Apple* was rejected in 1911, but from 1921 on, his paintings appeared in almost every Carnegie International held until 1938, the year of his death.[10]

In 1923 Glackens created *The Dream Ride* (plate 99), a large, imaginative "dream" picture of Lenna mounted on Spit Fire, her hobbyhorse, against a fanciful landscape background with a carriage and a red house with a violet roof. The painting is derived from one of Lenna's crayon drawings based on her toys (Museum of Art, Fort Lauderdale) and on stories that father and

99. The Dream Ride, 1923
Oil on canvas,
48 x 54 in.
Collection of
Mrs. Patricia Arden,
New York

daughter made up.[11] The hobbyhorse had belonged to her aunt, Irene Dimock, and Lenna had played with it whenever the family visited the Dimock house in West Hartford. After the house was torn down, Spit Fire was moved to New York, with new ears attached, made from leather gloves.[12] The decorative and somewhat flattened, surreal effect, unique in Glackens's oeuvre, may owe something to the Post-Impressionist work of Maurice Prendergast and perhaps also to the panels depicting exotic figures and animals painted by Maurice's brother, Charles.[13] Far more naturalistic is *Lenna with Rabbit Hound* (plate 100), a charming picture of Lenna astride her dog.

Glackens was preceded by several generations of American painters whose interpretations of the figure were based on family members, yet their approaches were somewhat different. Late-nineteenth-century painters such as Abbott Thayer and George de Forest Brush had embodied in such images traditional values of purity, with religious overtones. And their somewhat younger contemporaries, such as Edmund Tarbell and Frank Benson (only slightly older than Glackens), had portrayed their children out of doors, as emblems of health and vitality. Glackens's family images seem more purely domestic, more personal, and less conceptual.

Aside from his familial images, principally of Lenna, Glackens's many figure paintings during these decades were strictly studio images of mostly professional models. Most include only a single figure—some are half-length, others full-length. The models, some of whom appear in several canvases, are occasionally identified by their first names— *Miss Olga D.* (plate 101) of 1910, one of the earliest of these images, was probably modeled by Olga Dalzell.[14] Sometimes the titles are individualized by elements of costume, such as *Girl* (or *Woman*) *with Yellow Stockings* (1909; private collection), one of the earliest of these; *Little Girl in Green* (Denver

Art Museum); and *Woman in Red Blouse* (Barnes Foundation, Merion Station, Pennsylvania).

Many of these and similar pictures are presently unlocated, known only from early exhibition catalogs or from more recent auction records. And of course, titles have frequently been altered from exhibition to exhibition and from owner to owner. *Woman with Fox Furs* (formerly, Nelle Mullen collection, Merion Station, Pennsylvania), for instance, shown at one of Glackens's one-artist shows at the Daniel Gallery, may well be the same as *Woman with Fox Neckpiece* (formerly, Kennedy Galleries, New York). Glackens's *Café Lafayette (Portrait of Kay Laurel)* (plate 102), is unusual in that it not only fully identifies the model, but shows her in a social context.[15] She is having a drink in a favorite artists' rendezvous of the day, located in the Lafayette Hotel at University Place and Ninth Street, just around the corner from the Glackens home on Washington Square. Though the interpretation is Renoiresque, the artist harks back to the tradition of Manet as well as to his own *Chez Mouquin* (plate 39) in enlarging the visual field through a mirrored background, revealing other tables and other patrons.

Some of Glackens's models were quite pretty; others were not, and beauty seems not to have been a requisite for posing for him. His son recalled, "Father was always prone to hire models who needed a job, and that is why so many of his canvases were of exceedingly plain females, though paintable."[16] Glackens's concentration on the model was part of a larger phenomenon during this

PAGE 126:
101. MISS OLGA D., 1910
Oil on canvas, 32 x 26 in.
Hunter Museum of Art, Chattanooga, Tennessee;
Gift of the Benwood Foundation

PAGE 127:
102. CAFÉ LAFAYETTE
(PORTRAIT OF KAY LAUREL), 1914
Oil on canvas, 31¾ x 26 in.
Collection of Barney Ebsworth, St. Louis, Missouri

OPPOSITE:
100. LENNA WITH RABBIT HOUND, C. 1922
Oil on canvas, 26 x 32 in.

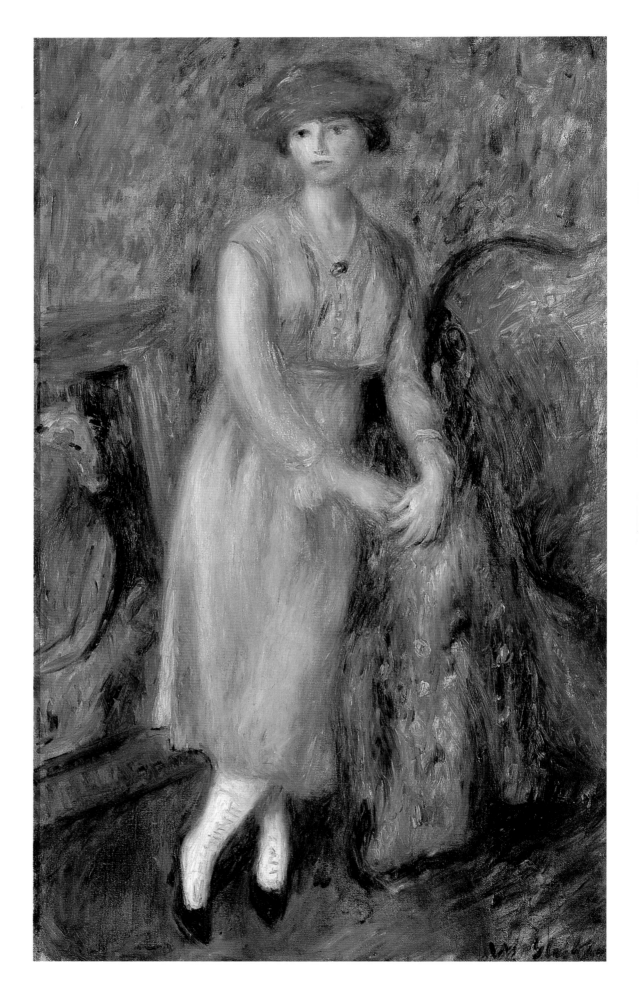

103. Standing Girl
in White Spats, 1915
Oil on canvas,
29½ x 17½ in.

period of American art. Milton Brown has characterized the artists who specialized in this genre as a "middle of the road group of painters who were satisfied with simply painting pictures. Most of these men were influenced to some extent by modern ideas, experimented for a time, but progressively dropped extremism as they matured." Brown labeled these artists "studio painters," whose concentration on the studio picture he saw as "one reflection of the artist's increasing isolation from normal social relationship. . . . If the ultimate value of a picture is not in what it says, but in how it is said, then a bowl of fruit is the artistic equal of the crucifixion and apples take the place of madonnas." Brown recognized that Renoir and Degas had great influence on the American studio artists, but he also acknowledged a peculiar modernity in such imagery, in the early twentieth century and under the influence particularly of Matisse:

> it was customary to present the model simply and boldly, without subterfuge, as a model posed arbitrarily, and not as a woman caught in an act of intimate preparation and adornment. Studies from the model, which traditionally were the exercises of art students, now became a recognized subject of painting. Dependence upon the model as a source of inspiration came more and more pronounced while, at the same time, the figure was stripped of all human significance in itself and its environment.[17]

In such a painting as *Standing Girl in White Spats* (plate 103), the studio location is underscored by the presence of the framed painting *Julia's Sister* leaning on the wall at left.

This is not to say that there are not some messages offered in Glackens's paintings of models. Whether the models were poor or not, they do not appear to have come into the studio from poverty row; they are usually quite well dressed, suggesting their ownership of paintable costumes. The painting technique and at times the facial interpretations suggest Renoir, but the multiple patterns and the

more acidic palette often recall Bonnard. And at times there is a sensuality that brings Matisse to mind. Matisse, Renoir, Manet, and even Eugène Delacroix offer antecedents for Glackens's more exotic images with ethnic or national identification, including *The Pink Silk Trousers* (c. 1916–18; Museum of Art, Fort Lauderdale); *Peruvian Girl* (1924; Kraushaar Galleries, New York); *Negress in Oriental Costume* (private collection); *Andalusian Woman* (1920; David Kimball Art Collection of the Centenary College Library, Shreveport, Louisiana); *Spanish Lady on a Sofa* (Iola S. Haverstick collection); *Russian Lady* (c. 1910; Museum of Art, Florida International University, North Miami); *Russian Girl Seated* (Barnes Foundation, Merion Station, Pennsylvania); and *Armenian Girl* (1916; Barnes Foundation).

There is great naturalness in Glackens's portrayal of the female body, and it is perhaps in his many paintings of the nude that he came closest to Renoir. His models in works such as *Nude in a Green Chair* (plate 104) and *Back of Nude* (plate 105) appear to be unaware of the artist, although they display themselves openly, even brazenly, for the delectation of the viewer. Glackens's liquid brushwork caresses the flesh, playing off the bright skin tones against deep greens and reds. Glackens's nudes were admired in their own time, and one of them, *Nude* (formerly, Dr. J. Edward Taylor collection, sold Sotheby's, New York, May 24, 1989), perhaps the most Renoiresque of all, won the Temple Gold Medal at the Pennsylvania Academy annual of 1924, the Academy's most prestigious prize.

Glackens's most curious group of pictures, painted in the winter of 1914–15, involve South Asian deities, such as *Buddha and the Maidens* (plate 106). The artist was not particularly concerned with religious

PAGE 130:
104. NUDE IN GREEN CHAIR, AFTER 1924
Oil on canvas (unfinished), 30 x 25 in.

PAGE 131:
105. BACK OF NUDE, C. 1930S
Oil on canvas, 30 x 25 in.

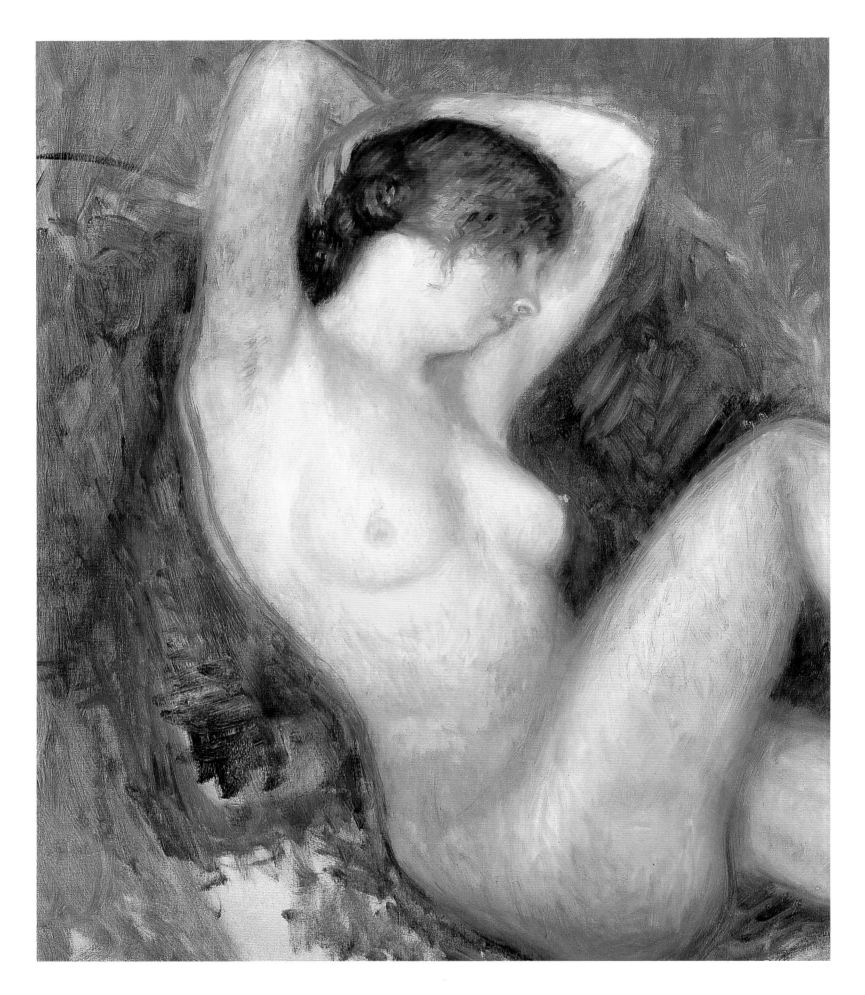

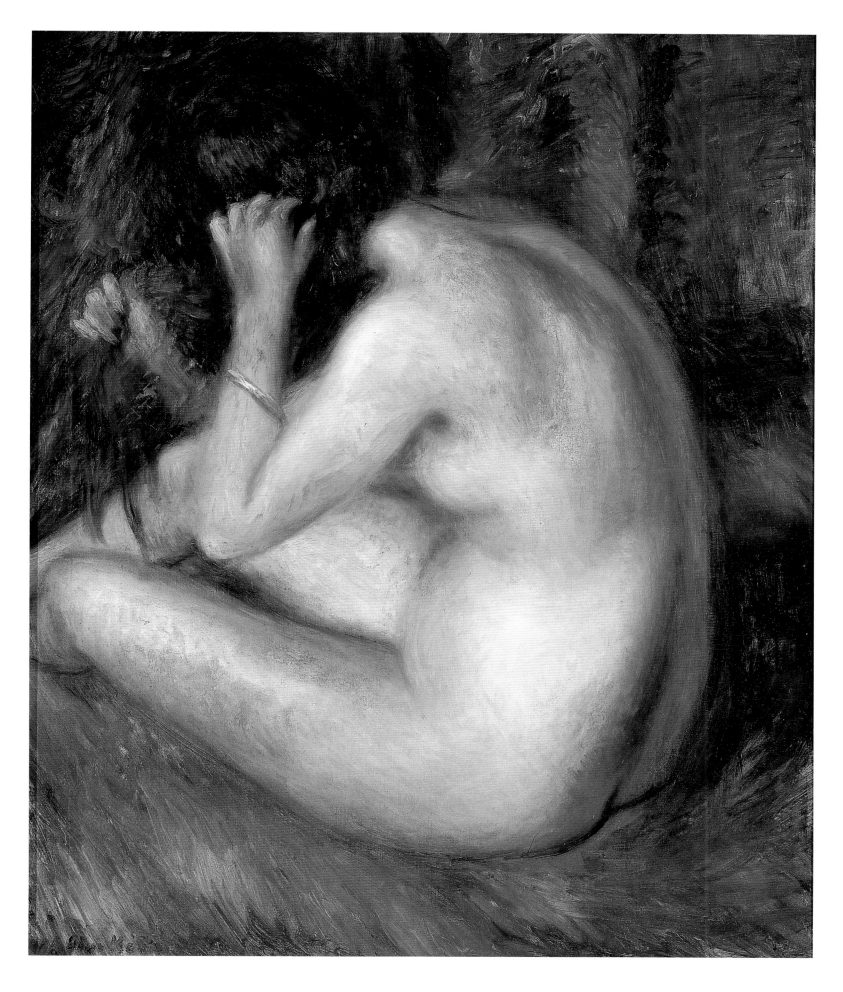

106. BUDDHA
AND THE MAIDENS
(A DECORATION),
C. 1916
Oil on canvas,
48 x 30 in.

beliefs of any sort, so his motivation was not spiritual or theological. Ira Glackens suggested that this was an experimental series, done as a decoration for a lampshade for Edith, inspired by his reading books on Hindu mythology.[18] The subject here, of course, is Buddhist, not Hindu, although several other paintings in the series are entitled *Hindu Legend, Krishna and the Gobis,* and *East Indian Legend* (all unlocated), as well as the work *Krishna* (Barnes Foundation, Merion Station, Pennsylvania).[19] These pictures, along with several others by Glackens, were exhibited in 1915 at the Montross Gallery in New York in a group show of modern American art, some of which was specifically designed for decoration.[20] The gallery's next show, which opened on April 18, was called *Special Exhibition of Modern Art Applied to Decoration by Leading American Artists.* Montross wrote in the catalog foreword that such modern work was experimental, eschewing storytelling and replacing it with decorative self-expression. Ironically, this description was more apt for Glackens's several decorative pictures in the earlier exhibition than of his pictures in the second Montross show. Glackens had previously exhibited several pictures in an exhibition at the Montross Gallery in February 1914, and continued a relationship there at least through 1923.

It may be Glackens's small group of pictures on Indian subjects to which Walter Pach referred when he wrote, "For a time he was interested in an imaginative rendering of themes taken from his reading, but he soon returned to the things of sight."[21] On the one hand, Glackens's utilization of subject matter from the Indian subcontinent suggests the inspiration, evident in the Armory Show, of modernist investigations of non-Western sources. On the other, it reflects similar interests that had recently developed in the art of his close colleagues Maurice and Charles Prendergast; both Prendergasts exhibited works in the 1915 Montross Gallery shows.[22] Charles Prendergast's association with Glackens's foray into such exotica can be documented, for Glackens carved in wood an East Indian subject for which the third panel was completed from Glackens's design by Charles Prendergast, who

also carved the frame for this elaborate work (all are in the Museum of Art, Fort Lauderdale).

Equally unusual, though in a very different way, was the giant poster-mural, *Russia* (plate 107), that Glackens created in the autumn of 1918, in connection with the Fourth Liberty Loan Drive supporting American participation in World War I. He created it as a public demonstration in the "Liberty Studio"—an outdoor display set up in front of the New York Public Library on Fifth Avenue. There, on twenty-two successive days, the public could watch an American artist paint a canvas within an eight-by-sixteen-foot frame, honoring a different one of the Allied nations. Glackens's painting was

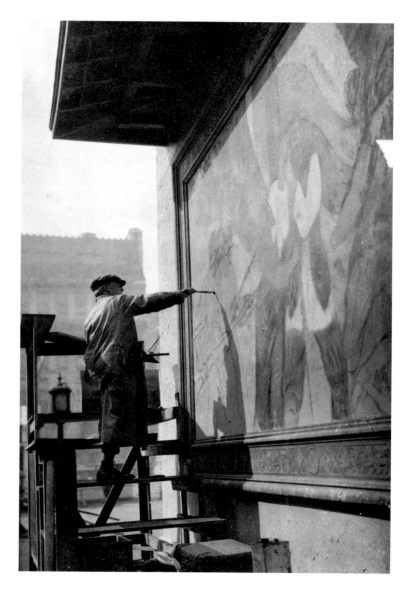

107. William Glackens painting a mural, Russia, in front of the New York Public Library during a war drive, c. 1918

108. HOME IN NEW HAMPSHIRE, C. 1919
Oil on canvas, 22 x 32 in.

presumably painted on October 16, and his friend the critic Frederick James Gregg judged it the best of the lot.[23] Gregg emphasized the patriotic motivation of the artists, noting:

> Mr. Glackens and the other artists who have worked from day to day in trying circumstances of time and place, to make the Fourth Liberty Loan a success, deserve all the credit that has been given to them. They have taught New York a lesson. They have shown that they are not apart from the life of the community and the nation. They brought into the great drive, into the great effort to raise money, an intellectual and imaginative quality of the greatest importance.

The paintings were to have been reproduced as color postcards and used for propaganda abroad, but the armistice on November 11 put an end to the idea; Glackens's painting presumably did not survive.

In 1920 the Glackenses abandoned the coast for their summer vacation and, instead, settled into a house on a lake near Conway, New Hampshire. One of the region's main attractions for Glackens was the opportunity to indulge in his passion for fishing in Walker Pond (later enlarged into a reservoir and renamed Conway Lake), using a fishing rod that Robert Henri had given him. Occasional visitors such as Albert and Laura Barnes came by, while Lillian Travis, Edith's old school chum, owned a farm in South Tamworth (twenty-five

miles away), and Alice Mumford was persuaded to take a house close by.[24]

Like Gloucester, Conway had been the center of an art colony for several generations, but these had been artists devoted to depicting the White Mountains, a school long gone by the time Glackens and his family arrived, and he was the only professional of significant fame during his five summers there, 1920–24.[25] Although Glackens did paint a few pictures of New Hampshire scenery, including Mount Washington and the Saco River, mountains and wilderness scenery held little appeal for him. Rejecting for the most part the rugged scenery that had attracted countless earlier painters, he concentrated instead on painting his own local environment, primarily when summer was turning to autumn and variegated colors were beginning to tint the landscape. His subjects included the house they rented, the garden they tended, the local apple trees, the boathouse on the lake, and the pond where they swam and bathed. Typical of Glackens's domestic works in an Impressionist manner—the most significant Impressionist paintings of this famed region—is *Home in New Hamp-*

shire (plate 108), probably painted during one of the family's first summers in Conway. It depicts Lenna playing with the family dog, next to Glackens himself standing beneath a tree whose leaves are turning autumnal; Edith emerges from the brightly colored house, at left, while another figure—perhaps Ira—stands at the well at the right. This is a picture of comfort and contentment. *Ira and Lenna's Egyptian Burial Ground* (plate 109), painted during a later summer in New Hampshire, records the brightly colored images of Egyptian deities that Glackens painted on one of the many boulders on their property.

Back in New York, after so many years of painting and illustrating the urban scene, Glackens appears to have pretty much abandoned that subject from the mid-1910s on, turning primarily to studio figure painting. A rare exception is *Carl Schurz Park, New York* (plate 110; formerly known as *Gracie Square*), in which Glackens's conversion to the full colorism of Impressionism is especially impressive. This is the same subject he had painted twenty years earlier in *Park on the River* (plate 50)—East River Park had been renamed in 1910 for the

109. Ira and Lenna's Egyptian Burial Ground, 1923
Oil on canvas, 13 x 16 in.

110. CARL SCHURZ PARK, NEW YORK, C. 1922
Oil on canvas, 18 x 24 1/16 in.
The White House Collection, Washington, D.C.;
Gift of Mr. and Mrs. Ira Glackens

great reformer, statesman, and journalist Carl Schurz. Though more surely middle-class than before, Glackens's cast of characters is strikingly similar to those in the earlier work. Again there is a pair of young girls along with two older women and a single man on a path, as well as a family group—in *Park on the River* a mother with a perambulator, and in *Carl Schurz Park* a woman holding a young boy.

In the later picture the figures are more active, and each is identified by a different color glowing in the bright sunlight, while the background is enlivened by the rich greens of the park foliage and the deep blue of the East River, looking north to its confluence with the Harlem River at Hell Gate. Likewise, the smokestacks, probably of the Edison Power Plant at Hallett's Point in Astoria, again are visible at the far right, and commercial vessels—a ferry and a tug—ply the river. In the far distance, a visible if somewhat ghostly symbol of progress in transportation and engineering, is Gustav Linden-thal's Hell Gate, or New York Connecting Railroad

Bridge, just completed in April 1917, and the strongest steel arch bridge in the world.[26]

For a while Glackens continued to have pictures at both the Daniel and Montross Galleries, and in February 1917, right after his one-artist show at the Daniel Gallery, he began to exhibit at the Bourgeois Galleries in New York, participating in their second annual *Exhibition of Modern Art*. Here he was in unusual company; only Maurice Prendergast among the former Eight was included, along with John Covert, John Marin, Morton Schamberg, Joseph Stella, and such European modernist expatriates as Albert Gleizes and Francis Picabia. In January 1918 two of Glackens's paintings and nine pastels and drawings were shown at the gallery in *Modern Paintings, Drawings, Etc., for the Benefit of the American War Relief*, and in March he had three paintings in the third annual *Exhibition of Modern Art*. But in the fourth annual, held in May 1919, he was no longer represented.

During the 1910s Glackens seems to have been repeatedly invited to join a number of the galleries that aimed to go beyond mainstream American art and promote the avant-garde, but in each case after a few years his work was seen to be more traditional and more "comfortable" than the image those galleries—Daniel, Montross, Bourgeois—wanted to project. In the early 1920s his only one-artist show was a small exhibition at the Whitney Studio Club in 1922.[27] Finally, in 1925, Glackens joined the C. W. Kraushaar Art Galleries, then at 680 Fifth Avenue in New York—an affiliation that would remain intact for the rest of his life and that continues to this day. An old, distinguished enterprise, the Kraushaar Galleries had been established in 1885. During his lifetime Glackens enjoyed four one-artist shows there: seventeen works in April 1925; twenty-three works in March 1928; sixteen works in April 1931 (fourteen listed in the catalog, and two added *hors de catalogue*); and twenty-seven works in February 1935. In each of these he exhibited some of his latest productions and also showed a variety of different subjects, but the last exhibition was something of a retrospective and included earlier scenes painted in the Luxembourg Gardens

and Washington Square, as well as Bellport and Blue Point beach pictures and his famous *Nude with Apple* (plate 71). In addition, the Kraushaar Galleries included Glackens's work in numerous group shows and were instrumental in entering his pictures in major exhibitions throughout the United States plus making sales to public institutions, beginning with the acquisition of *Chez Mouquin* by the Art Institute of Chicago in the autumn of 1925.[28]

With a respected commercial gallery handling his art, Glackens and his family were ready in 1925 to go abroad; basically they lived in France for the next six years, although they also visited southern Europe and made a number of trips back to the United States. They first stayed in Paris and met up with their good friends Leon Kroll and his French wife, Viette, but they soon moved on to the Hôtel Beau Rivage in Samois-sur-Seine, outside Paris, where the Krolls had a home; the Glackenses rented a house there, the Maison Dabonourt. Charles Prendergast, devastated by the death of his brother, Maurice, in 1924, came for a long visit. Glackens alternated between painting and fishing on the Seine and taking long bicycle rides in the nearby Forest of Fontainebleau.

111. The Glackens family in front of Villa les Pivoines, 1926. Standing in the back row: Leon Kroll (left) and William Glackens. Seated, from left to right: Lenna Glackens, Ivette Kroll, Edith Glackens, and two unidentified companions.

112. THE PROMENADE, 1926–27
Oil on canvas, 32 x 25¾ in.
Detroit Institute of Arts; City of Detroit Purchase

These European years were peripatetic ones for the Glackens family. In the winter of 1925–26 they settled into a house named Les Pivoines (the peonies) in Vence in the south of France (plate 111), while the Krolls were established in Saint-Jean-Cap-Ferrat, east of Nice; it was Viette Kroll who hired a donkey for Lenna, and Glackens painted Lenna riding on it in *The Promenade* (plate 112). In Vence the family joined a small group of American artists headed by Ethel Mars and Maude Squire, companions from the Midwest who were longtime residents in the town.[29] On May 1, 1926, Glackens and his family went to Italy for the first time, visiting Naples, Pompeii, Sorrento, Rome, Orvieto, Perugia, Siena, Assisi, Florence, and Venice. From Italy they returned to the north of France, settling in a rented house at l'Isle-Adam on the Oise River, an hour north of Paris. Glackens had a separate studio in the town overlooking the river's bathing beach and a little island.

In the winter of 1926–27 they moved into a rented house in Paris at 51, rue de Varenne, near the Musée du Luxembourg, where Leo Stein dined with them, and then, the next summer, they returned to l'Isle-Adam, though in a different house. In the autumn they made a trip to England to visit Edward and Irene FitzGerald; later that autumn they returned for a while to New York and even spent a few weeks in Florida. In March 1928 Glackens was back in Paris, having left New York too early to attend the opening of his one-artist show that month at the Kraushaar Galleries; Edith and Lenna joined him after Lenna's school let out. Meanwhile, Glackens was enjoying Parisian nightlife on his own, regularly visiting some of the clubs and cafés favored by artists. Among his artist friends were the Frederick Friesekes and the Maurice Sternes. It was during this period that the Glackenses acquired a French poodle they named Imp, which figures in paintings by both Glackens and his daughter. In the summer the family returned to l'Isle-Adam, and in the winter they were again back in New York.

In the spring of 1929 the family returned to France, living in Paris that summer at 110, rue du Bac, next door to a studio that Whistler had occupied; Glackens painted in the small garden there. In August they went to Hendaye, on the Spanish frontier; finding it unpaintable, the family settled at Saint-Jean-de-Luz, making excursions into Spain to San Sebastián and Pamplona, and to Pau and Lourdes in France. For a short while in the autumn they were back on the rue du Bac, but by November they were once again at Les Pivoines in Vence, where they remained through the winter. In May 1930 Glackens traveled back to Paris via Arles, Nîmes, Orange, Avignon, Aix-en-Provence, and Beaune, but they did not stay long, because the family spent the summer at the Villa des Cytharis in La Ciotat, between Marseille and Toulon. In early September, Edith and the children returned to New York, where William joined them in October. In the spring of 1931 they were once more in

Paris and then spent August and September in the south of France, this time at the Villa des Orangers on the hill of Le Suquet, in the old quarter of Cannes, on the Mediterranean, finally returning to New York in the fall of 1931.[30]

This detailed and complicated itinerary of Glackens's six years abroad is presented here because the artist was extremely active during this period, painting landscape and figural subjects that are often identified by location and that can often be dated according to his residency. I have not located any pictures painted during the spring trip to Italy in May 1926, perhaps because the family was constantly on the move, and the brief foray into Spain in the late summer of 1929 appears to have yielded only a few Spanish paintings. Similarly, the French capital appears to have provided only occasional urban subjects during Glackens's intermittent residencies there. Relatively few of his French pictures have such vague titles as *Along the Marne* (plate 114). Glackens had painted on the Marne, of course, on his wedding trip in 1906, but

113. William Glackens
at age 61, 1931

114. ALONG THE MARNE,
AFTER 1925
Oil on board, 12½ x 15½ in.

the rich colorism and free brushwork identify this as a painting from the late 1920s, though its exact location is unrecorded. That summer of 1925 Glackens painted a number of pictures of the Seine at Samois, as well as the surrounding hillside. His pictures painted in Vence beginning late that year, such as *Town of Vence* (plate 115), as well as those done in 1928 and 1929, often concentrate on colorful panoramic landscapes of the Midi, the hilly countryside interspersed with buildings; others center on Les Pivoines, featuring its flowering gardens, Mediterranean architecture, and tropical scenery.

The summer paintings of l'Isle-Adam concentrate more on the suburban landscape and on urban Parisians enjoying their holidays; these are among the closest of all of Glackens's works to those painted by Monet and Renoir half a century earlier. Some of the pictures done on the beaches at Saint-Jean-de-Luz in the summer of 1929, such as *Beach, St.-Jean-de-Luz* (plate 116), recall Glackens's Long Island bathing scenes of a decade and a half earlier. These French bathing pictures were exhibited in Glackens's one-artist shows at the Kraushaar Galleries in 1928 and 1931, and they were well re-

115. TOWN OF VENCE, C. 1925–26(?)
Oil on board, 12½ x 16 in.

116. BEACH, ST.-JEAN-DE-LUZ, 1929
Oil on canvas, 32 x 23¾ in.
Terra Foundation for the Arts,
Daniel J. Terra Collection, 1988.8; Courtesy of
Terra Museum of American Art, Chicago

117. BOWLERS, LA CIOTAT, 1930
Oil on canvas, 25 x 30 in.

ceived back in the United States; *Beach, St.-Jean-de-Luz,* for instance, won the Jennie Sesnan Medal for the finest landscape in the annual exhibition held at the Pennsylvania Academy in January 1936.

Certain stylistic shifts are evident in some of the paintings Glackens created during his last several summers in the south of France. *Bowlers, La Ciotat* (plate 117) is a much starker picture than those of

118. Fête du Suquet, 1932
Oil on canvas, 25¾ x 32 in.
Whitney Museum of American Art, New York; Purchase

1925–29, the slender bowlers presented as analogues to the gently serpentine trees among which they play. The interplay of the firm forms of trees and the open spaces, along with the solids and voids of the background architecture, suggest a distant relationship to the work of Cézanne, evident also in other paintings by Glackens of this period.

Far more animated is Glackens's *Fête du Suquet* (plate 118), painted from a window of the rented Villa des Orangers, outside Cannes in 1931, during the family's last summer in France. The motif of an urban celebration, with people dancing in the street, harks back to the artist's earliest accomplishments in Paris, but *Fête du Suquet* is infused not only with Impressionist light, but also with both the colorism and the structural concerns of Cézanne. It may be that Glackens's long familiarity with Cézanne's art received increased impetus

when he traveled through Cézanne's own countryside around Aix in the spring of 1930, but whatever the explanation, many, though not all, of Glackens's late French paintings evince a new structural rigor and a more muted, though still colorful palette.

Critics became aware of the changes that had occurred in Glackens's paintings when his southern French landscapes were shown in his one-artist exhibition at the Kraushaar Galleries in April 1931. It was noted that he had been "painting through France, especially in the South. . . . Yet, in his newer work, done near the Alps, one realizes a greater space, handled with a simpler technique."[31] Another writer stated: "I should unhesitatingly put down these new Glackens landscapes as the best work that he has ever shown. . . . He takes Southern France with its terraced hillsides, accents of olives, villa walls, bright rooftops and the distant glimpse of the sea, and records them, giving a free and fresh account of these oft-painted slopes that is indeed epoch-making for this artist."[32]

Probably the most unusual picture Glackens painted during this period is *Bal Martinique* (plate 119), which had been preceded by a similar, but by no means identical, highly finished study (plate 120). This is a very colorful scene in a jazz nightclub, with a combo playing in the rear and a highly animated group of men and women dancing intensely, while spectators look on from above. In the study these latter are seated in elevated boxes at the right, but in the finished work the audience peers down over a balcony. Some of the dancers wear heavy make-up and costume—in the study, many of the men wear bright red fezes—and at least one interracial couple appears in the left foreground.

Despite its distinctiveness and its celebrity—*Bal Martinique* was exhibited in Glackens's one-artist show at the Kraushaar Galleries in 1931 and won the first J. Henry Scheidt Memorial Prize in 1938 at the Pennsylvania Academy annual—the painting has garnered only stylistic, not thematic, attention. Vincent de Gregorio, in his 1955 dissertation, states that the picture was painted in France

in the summer of 1928;[33] the Kraushaar Galleries has exhibited the picture a number of times, sometimes with the date of 1928, sometimes as 1929. *Bal Martinique* may well document an event that Glackens attended in Paris in the early spring of either 1928 or 1929, when he was in the French capital alone. In early April 1928, for instance, he wrote home to Edith a number of times from Paris, suggesting that he was a habitué of the famous Café Dôme and had also visited La Coupole, a new café nearby.[34]

I have not, so far, found specific reference to a café named "Bal Martinique," but this could be Glackens's reference to the celebrated Bal Nègre on the rue Blomet, which had opened during the 1920s as a social center for members of Paris's Caribbean community. Operated by French colonial blacks, many of whom came from Martinique, by the late 1920s the club came to be enjoyed by a mixed racial audience as one of the trendiest of the exotic nightclubs in Paris.[35] Glackens's title may have derived from the popularity of the beguine, the national dance of Martinique, often played by the Bal Nègre's orchestra.[36] Alternatively, the Bal Martinique may have been a specific event that took place in a Parisian café, similar to the Bal Ubu, which occurred in February 1929 at the Bal Nègre.[37] Thus, *Bal Martinique* not only records the mature Glackens's return to the palaces of entertainment that had figured importantly in his early career but also may document his fascination with the singular aspects of jazz-age Paris in the late 1920s.

Glackens's health had begun to deteriorate the winter before they left for France in 1925; he developed pneumonia after a dinner party at George Bellows's house. Gifford Beal described Glackens as "a high liver" and attributed his waning health in later years to his love of good wines and rich foods.[38] Edith swore by the European doctors they consulted for Glackens's headaches, bronchitis, and other ailments during their years abroad. A number of times during the late 1920s he returned to Paris from New York earlier than he wanted in order to undergo medical treatment from the Parisian doctors his wife favored.[39] After the family had gone back to

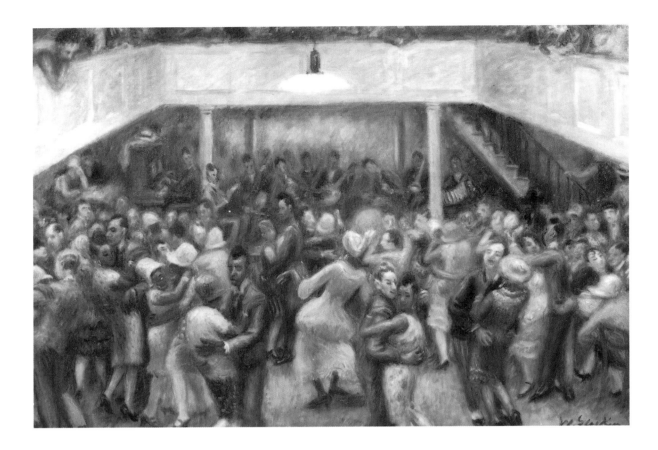

119. BAL
MARTINIQUE,
1928–29
Oil on canvas,
22 x 32 in.
Private collection

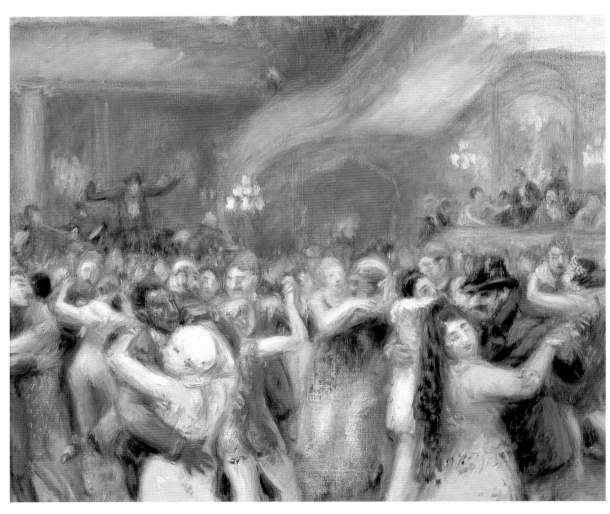

120. STUDY FOR
"BAL MARTINIQUE,"
1926
Oil on canvas,
19½ x 24 in.

New York in the autumn of 1931—Edith and the children in September and Glackens the following month—Glackens's traveling became slowly curtailed, though it never ceased. His production of paintings, particularly figure and outdoor work, declined precipitously. In the winter of 1932 he and Edith visited Ernest Lawson in Coral Gables, Florida (plate 121), and in the summer of 1934 they visited Vermont, then went on to Baie Saint Paul in Canada, northeast of Quebec City. Here Glackens produced a series of small landscapes, quiet and colorful idyllic scenes, such as *Baie St. Paul, Quebec, No. 2* (plate 122). In 1936 he and Edith went to England, visiting the FitzGeralds at their home in Sidmouth and traveling to other English localities, before crossing to France and returning home to New York in midsummer. Due to the intense heat they immediately returned to Cape Ann in Massachusetts, where they had vacationed back in 1919,

121. Ernest Lawson and William Glackens at Coral Gables, Florida

122. Baie St. Paul, Quebec (No. 2), 1934 Oil on canvas, 12½ x 15½ in.

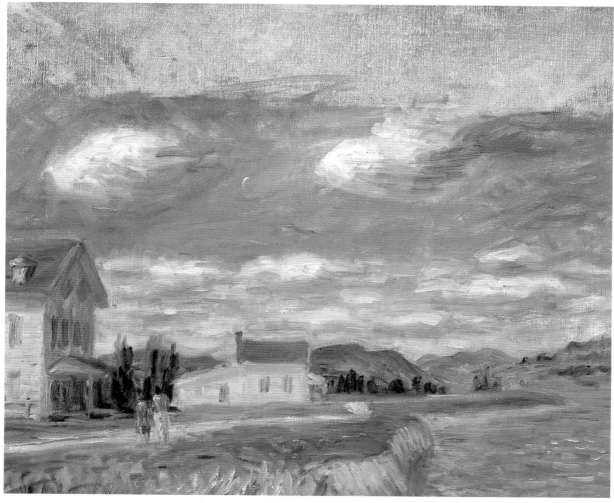

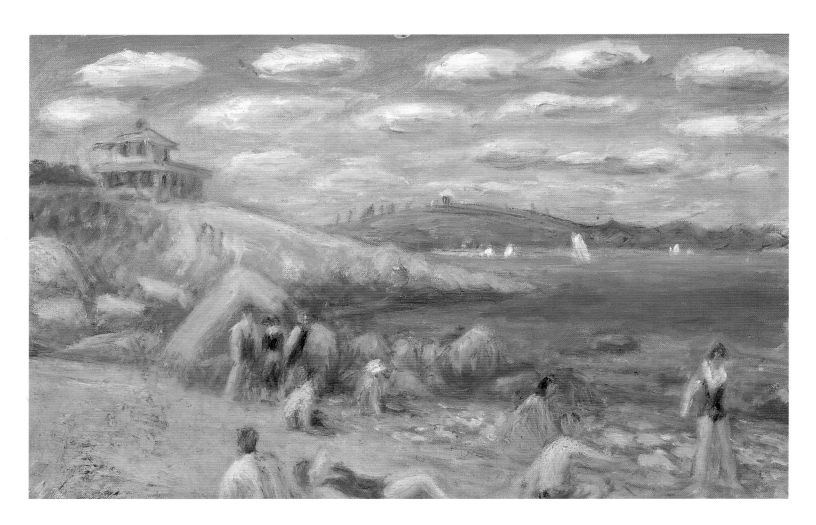

123. ROCKPORT, MASSACHUSETTS, No. 5, 1936
Oil on board, 11¼ x 19½ in.

renting a house in Rockport, which was still a lively artists' colony. Among Glackens's last outdoor subjects are pictures such as *Rockport, Massachusetts (No. 5)* (plate 123), in which he returned to the colorful beach scenes he had specialized in two decades earlier; other of his canvases record the harbor, houses, and headlands of the local landscape. Glackens also produced one or two outdoor paintings during his final summer, spent at Stratford, Connecticut.[40]

The one theme that Glackens continued to essay in his later years of ill health, not only fairly abundantly but also with no diminishing facility or inspiration, was the still life (see plate 124). Still lifes had figured early in Glackens's oeuvre as an occasional accessory to the figure, most notably in his 1904 *Portrait of the Artist's Wife* (plate 46), in

which a silver bowl of fruit on a low table accompanies Edith. Ira Glackens wrote that this work was rejected for exhibition at the Society of American Artists, presumably in either 1905 or 1906, because the fruit had taken the picture out of the realm of portraiture, though this seems extremely improbable.[41] Such a combination of figure and still life in this Manet-inspired picture suggests inspiration from works such as Manet's *Woman with a Parrot,* which has hung at the Metropolitan Museum of Art in New York since 1889.

Once Glackens had moved into the orbit of Renoir and adopted an increasingly colorful palette, fruit and flower still lifes became an attractive and decorative adjunct to his figure paintings, as in *Nude with Apple* (plate 71). Still lifes are especially prominent in his family paintings, both those in

which the whole family was included—such as the vases of flowers in *Family Group* (plate 69) and *The Artist's Wife and Son* (plate 73)—and in many of his paintings of his daughter, such as *Lenna Resting* (plate 125), in which the burst of energy in the red and yellow tulips in the foreground overshadows the dormant figure on the couch behind. In *Breakfast Porch* (plate 126), one of the paintings that Glackens painted in 1925 at Samois-sur-Seine, the symmetrical grouping of Edith and both children at the table centers on a brilliant still life of zinnias and other flowers. These not only repeat the colors of the figures's costumes but also add a joyousness to an otherwise strangely solemn and somewhat hermetic assembly.[42]

Exactly when Glackens began to treat the still life as an independent motif is not clear, though he eventually was to create more such pictures than any other theme. The earliest record I have come across so far of such a picture by Glackens was a *Still Life* exhibited in a group show at the Daniel

124. William Glackens painting an unidentified flower piece, 1935

125. LENNA RESTING, C. 1920
Oil on canvas, 26 x 32 in.
Collection C. Richard Hilker, Fort Lauderdale, Florida

126. Breakfast Porch, 1925
Oil on canvas, 30 x 25 in.

Gallery in the autumn of 1916. By December of that year, in a three-artist show with Prendergast and William E. Schumacher at the St. Botolph Club in Boston, half of Glackens's eight entries were floral still lifes. Since Glackens had shown no still lifes in the several exhibitions in which he participated at the Montross Gallery in early 1915, it seems safe to assume that he began to investigate this motif in 1915–16. From then on it became a standard feature of his repertory, and his still lifes appeared in numerous exhibitions, particularly those held in the 1920s and '30s.

Glackens's turn to still life followed his increasing preoccupation with the studio figure-piece, in which floral still lifes often appear with the models. This occurred along with both his abandonment of illustration and his partial turn away from outdoor painting (other than his summer work). And, of course, fruit and flower pictures are also studio pictures—arrangements created by the artist rather than observed in the greater world outside. Glackens was the only one of his early circle of colleagues to involve himself with still-life painting to any great extent; still lifes are not part of the repertory of Davies, Henri, Lawson, Luks, Shinn, or Sloan. Among The Eight only Maurice Prendergast produced a small but significant body of still lifes; these seem to have been exercises in form and color derived especially from Cézanne and are usually dated to a brief period in the artist's career, c. 1910–13.[43] Among the painters with whom Glackens later fraternized, Frederick Frieseke undertook still-life painting that bears some similarity to Glackens's work, though it was never a dominant motif in Frieseke's repertoire.

Glackens's still lifes are generally very simple constructions of ordinary fruit—apples, grapes, and the like—and simple garden or field flowers, as well as more expensive bouquets or exotic blooms. The raw materials were purchased in the market or came from the gardens that William and Edith tended whenever they were installed in country homes. They are displayed in attractive but never terribly elaborate ceramic ware or occasionally in a basket or a glass vase. Sometimes a patterned

127. FLOWERS ON A GARDEN CHAIR, 1925
Oil on canvas, 20 x 15 in.

hanging or curtain serves as a background, and the arrangements are usually set on a piece of furniture covered by a cloth, though less often they may be placed outdoors, as in *Flowers on a Garden Chair* (plate 127). The flowers and fruits were generally arranged not by the artist himself but by Edith, for decoration in their home. Such casualness coincides with the recollections of Mrs. George Bellows that Glackens believed that flowers placed in a vase essentially arranged themselves.[44]

Since Glackens exhibited his still lifes under generic titles and never dated them, it is almost impossible to determine when and where they were painted. It may be that the more solidly constructed pictures are the earlier examples and the more loosely painted pictures, such as *Fruit*

ABOVE:
128. FRUIT AND A WHITE ROSE, C. 1930S
Oil on board, 13 x 16 in.

OPPOSITE:
129. FLOWERS IN A QUIMPER PITCHER, C. 1930
Oil on canvas, 24 x 18 in.

and a White Rose (plate 128), are later. Glackens reveled in the different shapes, sizes, and bright colors of the blooms, and his mastery of this form continued until the end of his life. *Flowers in a Quimper Pitcher* (plate 129) offers wonderful assurance that the master had not lost his touch, with the floral pattern on the lovely French pitcher (a favorite container for his still-life arrangements), an echo of the live flowers bursting above. *White Rose and Other Flowers* (plate 130) records blooms

picked from the flower beds surrounding a house outside Stratford, Connecticut, where the Glackenses spent their final summer together. This was Glackens's last completed canvas.[45]

The still lifes were usually priced a good deal less than Glackens's other pictures when they appeared in exhibitions, and the public appears to have enjoyed them. So did the critics and his fellow artists. Guy Pène du Bois claimed that Glackens made "some of the most vibrant flower pieces

130. White Rose and Other Flowers, 1937
Oil on canvas, 15 x 20 in.

known to our painting."[46] Margaret Bruening, reviewing a show of Glackens's flower paintings at the Kraushaar Galleries in January 1937, wrote:

There is something disarming in the simplicity of the arrangements, just little handfuls of flowers casually placed in vases. But the casualness is, of course, camouflage, for there is the utmost subtlety in the patterns of color, in the relations of form and contour. . . . And what joy in pure painting these flower pieces afford! What lusciousness of pigment, what purity of color and astounding candor of statement. Flowers are, after all, satisfying sitters, requiring no flattery or emphasis of personal traits; submitting to arbitrary arrangements, surrendering their fragile beauty to the exigencies of decorative design and triumphing over it and with it.[47]

Even in these last years Glackens did not entirely forsake the figure. *Nude with Pink Chair* (private collection) was painted around 1934, and that same year he began his last monumental picture, *The Soda Fountain* (plate 131), completed in 1935. Here he returned to the public arena, showing two young, probably working-class women sitting at the counter of a soda fountain—one being served, the other preparing to leave. Ira Glackens served as model for the counter attendant, which he described as a "good portrait." He wrote that his father had "set up a sketchy soda-fountain in his studio, mostly to get color-relations. The two models who posed for the girls, however, I never saw; but their dresses were left on the chairs, again for comparative color values, while the work was in progress."[48]

The picture returned Glackens to the arena of public life, which he had essayed decades earlier when he painted *The Shoppers* (plate 66); now there appears much less social disparity between counterman and customers. The world of the working-class woman was very much part of the artistic scene in these Depression years, featured in paintings by artists such as William Gropper, Philip

Evergood, and Moses and Raphael Soyer. Yet just as Glackens had, in his early easel paintings, parted from his colleagues among The Eight in refusing to depict the seamier sides of urban life, so at the end of his career did he avoid the sense of despair that permeated so much Depression art. Rather, he opted for a straightforward presentation of modern life, which was associated in these years with some of the painters of the Fourteenth Street School in New York, a group that had emerged in the late 1920s. The spirit of *The Soda Fountain* is more akin to the work of Reginald Marsh, Isabel Bishop, and especially Kenneth Hayes Miller, whose many paintings of New York shoppers recall Glackens's earlier treatment of that theme. What motivated Glackens so late in his career to return to a subject featuring monumental figures in a contemporary, everyday setting—to create, that is, an up-to-date *Chez Mouquin*—is not clear; perhaps it was the challenge to prove himself against newer figures on the contemporary art scene.

About 1935 Glackens's health worsened considerably, and he developed a heart condition and high blood pressure. Yet he and Edith continued to travel—to England then to Rockport in 1936, and they spent the summer of 1937 in Stratford. In the late spring of 1938 they were spending the weekend in Westport, Connecticut, with Charles Prendergast and his wife, Eugénie, and it was there, on May 22, that Glackens suffered a cerebral hemorrhage and died. He was buried in Cedar Hill Cemetery in Hartford, in the Dimock family plot.

The Whitney Museum quickly organized a memorial exhibition, which opened in December 1938, with 132 paintings and drawings on view for a month; on February 1, 1939, the same show opened at the Carnegie Institute in Pittsburgh.[49] At the same time, Edith Glackens began a series of annual exhibitions of her late husband's work at their house on Ninth Street—the first one held in February 1939 and the last in November 1947.[50] By 1943 the catalogs accompanying these annual shows stated that the works were not for sale, "as they form the nucleus of a permanent Glackens Gallery."[51]

131. The Soda Fountain, 1935
Oil on canvas, 48 x 36 in.
Pennsylvania Academy of the Fine Arts, Philadelphia;
Joseph E. Temple and Henry D. Gilpin Funds

The various exhibitions held after the artist's death were generally well received, although some critics took a dim view of Glackens's later paintings in their dependence on Renoir. Particularly censorious was Jerome Mellquist, who in 1942 championed a nationalist strain that he felt Glackens had betrayed. "His attachment . . . to Renoir, unfortunately, coincided with, if indeed it did not reflect, a slackened response to American life. Interiors, family portraits, scenes at St. Jean de Luz—are they not the product of the international scene rather than of a specific locale. . . . He became instead one of the complaisant against whom he earlier had protested."[52]

Today we can see beyond the narrow demands for an art that satisfied nativist ambitions in a time of world conflict and recognize Glackens's many achievements. His incisive draftsmanship made him one of the greatest of American illustrators. In his early years he chronicled, both dramatically and wittily, many aspects of contemporary life. When the abbreviated memorial exhibition was in Cleveland, Grace V. Kelley perceptively acknowledged the merits of his later work: "For those who enjoy good painting, intrinsic color, a singing wonder in the artistic vision, Glackens will always give pleasure. . . . My own summing up might be that Glackens with no axe to grind and motivated only by the visual thrill, has passed on his visual experiences to those capable of receiving them as visual experiences, and in so doing has fulfilled the function of the authentic artist."[53]

The Kraushaar Galleries has continued to represent Glackens and hold exhibitions of his work, and in January 1967 the University Art Gallery at Rutgers University in New Brunswick, New Jersey, held a small Glackens show. This exhibition complemented what has remained the largest show to date, *William Glackens in Retrospect,* which opened at the City Art Museum of Saint Louis in November 1966 and went on to the National Collection of Fine Arts in Washington, D.C., in February 1967 and to the Whitney Museum of American Art in New York that April. Other, smaller shows, some devoted just to his drawings and graphic work, have taken place since (see the bibliography), but with the establishment of the Glackens Collection and the Glackens Archives at the Museum of Art in Fort Lauderdale, the understanding and appreciation of this artist has entered a new and exciting phase.

NOTES

1.
EARLY LIFE AND TRAVELS

1. Louis, about whom little has been written, early demonstrated his artistic talent and was an illustrator for years on the New York magazine *Puck*. See Delaware Art Museum, *City Life Illustrated, 1890–1940* (Wilmington, 1980), pp. 45–47. After his style of illustration went out of fashion, Louis returned to live in the family home in Philadelphia along with his unmarried sister, Ada. (Ira Glackens, *Ira on Ira: A Memoir* [New York: Writers and Readers Publishing, 1992], pp. 45–47; hereafter cited as *Ira on Ira.*) In 1924 Louis provided the illustrations for the book *Monsieur and Madame* (New York and London: Harper and Brothers), written by Edwin Dimock, William Glackens's brother-in-law.

2. Ira Glackens, *William Glackens and the Ashcan Group* (New York: Crown, 1957), rpt. as *William Glackens and The Eight: The Artists Who Freed American Art* (New York: Writers and Readers Publishing, 1990), p. 5; hereafter cited as *Glackens and the Ashcan Group.* This is the primary published source on Glackens to date, and I have drawn upon it liberally for biographical information, though my concentration is on the artist's paintings and graphic work.

3. Everett Shinn, "William Glackens as an Illustrator," *American Artist* 9 (November 1945): 222–23. Glackens, in Walter Pach, *Queer Thing, Painting* (New York and London: Harper and Brothers, 1938), p. 322. An important source of information on Glackens's high-school years is Earl B. Milliette, "Art Annals of the Central High School of Philadelphia," *Barnwell Bulletin* (Philadelphia) 20 (May 1943): 5–40; Glackens is discussed on pp. 29–31.

4. Harry Salpeter, "America's Sun Worshiper," *Esquire* 7 (May 1937): 190.

5. *Florida Swamp,* identified as Glackens's "second earliest canvas," was listed in *The Fourth Annual Memorial Exhibition of the Paintings of William Glackens* (New York, 1942).

6. Bennard B. Perlman, "Drawing on Deadline," *Art and Antiques* (October 1988): 115–16.

7. *Glackens and the Ashcan Group,* p. 5. In the fall of 1893 Glackens briefly joined the staff of the *Philadelphia Public Ledger,* where his drawings appeared between October 10 and November 7, before he returned to the *Press.* (See Bennard Perlman, *The Golden Age of American Illustration: F. R. Gruger and His Circle* [Westport, Conn.: North Light Publishers, 1978], pp. 27–28; and Vincent John de Gregorio, "The Life and Art of William J. Glackens" [Ph.D. diss., Ohio State University, 1955], p. 41; hereafter cited as de Gregorio. For the most vivid discussion of artistic life at the

Press, see Everett Shinn, "Life on the Press," *Philadelphia Museum Bulletin* 41 (November 1945): 9–12.

8. Perlman, "Drawing on Deadline," p. 115.

9. Shinn, "William Glackens as an Illustrator," p. 22.

10. Anshutz, himself a pupil of Thomas Eakins, was then the most renowned teacher at the Academy. On his death, in June 1912, John Sloan referred to him as "the teacher of all of us—Henri, Glackens, Shinn and all the rest." (Quoted in Bruce St. John, ed., *John Sloan's New York Scene from the Diaries, Notes and Correspondence, 1906–1913* [New York: Harper and Row, 1965], entry for June 17, 1912, p. 621; hereafter cited as *Sloan's New York Scene.*) Sloan included Glackens among the audience in his etching *Anshutz on Anatomy,* recording a talk that Anshutz gave in Robert Henri's class at the New York School of Art in 1905. (See Peter Morse, *John Sloan's Prints* [New Haven, Conn., and London: Yale University Press, 1979], pp. 179–80.)

 At one point there was some confusion concerning a younger painter also named William J. Glackens, who studied at the Pennsylvania Academy during the years 1901–2 and again in 1921–23; this was a cousin of Glackens. Vincent John de Gregorio clarified the distinction after interviewing Mrs. Laura Krauss of Philadelphia, sister of the younger Glackens, in 1954. (Letter from de Gregorio to Mabel Eiseley, registrar of the Academy, September 26, 1954, courtesy of Cheryl Leibold, archivist, Pennsylvania Academy of the Fine Arts, Philadelphia.)

11. For the Charcoal Club, see Bennard B. Perlman, *The Immortal Eight* (New York: Exposition Press, 1962), pp. 57–59, and Perlman, *Golden Age,* pp. 20–21.

12. Lloyd Goodrich, *John Sloan, 1871–1951* (New York: Whitney Museum of American Art, 1952), p. 7. In 1908 Sloan recorded in his diary: "I have done very little outdoor work since eighteen years ago when Glackens, [Joseph] Laub, [Willard E.] Worden and I used to go out on Sundays in the neighborhood of Philadelphia." (*Sloan's New York Scene,* entry for June 14, 1908, p. 226.)

13. Glackens was inspired during this period by Henri's magnetic personality and his antagonism toward traditional academic means, along with his espousal of Manet, Frans Hals, and Diego Velázquez. However, Glackens's paintings of this period, such as *Philadelphia Landscape* (plate 5), share an artistic approach not with Henri's contemporaneous explorations of the light and color of Impressionism, but with the urban scenes that Henri was soon to produce, after his return to France.

 Glackens, in Regina Armstrong, "Representative Young Illustrators," *Art Interchange* 43 (March 1899): 109. See also Regina Armstrong, "The New Leaders in American

Illustration, IV: The Typists: McCarter, Yohn, Glackens, Shinn and Luks," *Bookman* 11 (May 1900): 247.

14. See Sloan's comments in Dartmouth College, *John Sloan, Paintings and Prints* (Hanover, N.H., 1946), no. 29, unpaginated. Glackens's etching of the same subject is in the Museum of Art, Fort Lauderdale.

 Printmaking never held any great attraction for Glackens; Ira Glackens had plates of fifteen etchings by his father, plus an impression of one etching for which there was no plate; these did not include some of the etchings that Glackens had prepared for Paul de Kock's novels. (Ira Glackens Papers, Archives of American Art, Smithsonian Institution, Washington, D.C.) In "Artists of the Press," *Philadelphia Museum Bulletin* 41 (November 1945): 15, it was stated that Glackens produced only nine prints—seven etchings or drypoints and two lithographs—impressions of all of which were donated to the Philadelphia Museum of Art by Albert Gallatin. These are presumably in addition to the dozen etchings that Glackens prepared for the eight novels by Paul de Kock that he illustrated between 1902 and 1904. The Library of Congress has fourteen Glackens etchings, ten of which are de Kock illustrations. The Museum of Art, Fort Lauderdale, owns thirteen etchings and drypoints by Glackens, in addition to some of the de Kock etchings.

15. See William Innes Homer, *Robert Henri and His Circle* (Ithaca, N.Y., and London: Cornell University Press, 1969), for Glackens's association with Henri.

16. "An Attractive Display," *Philadelphia Public Ledger,* December 17, 1894, p. 2. The Whistler to which the critic referred is probably *Nocturne, Valparaiso* (now *Nocturne in Blue and Gold: Valparaiso Bay,* Freer Gallery of Art, Washington, D.C.), lent to the 1893 annual by Sir John C. Day; the other three Whistlers shown then were all figure pieces and would have offered a less suitable comparison.

17. Entry form for the *Sixty-Fourth Annual Exhibition* of the Pennsylvania Academy of the Fine Arts, on file at the Art Museum, Princeton University. It is just possible that *Portrait* might be *Girl with White Shawl Collar* (c. 1894; Museum of Art, Fort Lauderdale).

 For the *Fake Exhibition* see Bennard B. Perlman, *Robert Henri: His Life and Art* (New York: Dover, 1991), p. 29.

18. The picture is dated, but the last digit is almost illegible.

19. Homer, *Henri and His Circle,* pp. 85–87.

20. Morrice may have accompanied Glackens and Henri on their summer trip to the Low Countries, and his pictures of this period are often quite similar to Glackens's. (See Nicole Cloutier, *James Wilson Morrice, 1865–1924* [Montreal: Montreal Museum of Fine Arts, 1985], p. 21.)

21. For a description of the Bal Bullier from about this time, see George Day, trans., *Pleasure Guide to Paris* (London: Nilsson and Co., 1903), pp. 110–13. For Glackens's description of the Bal Bullier on a later visit, see his letter to his wife written February 21, 1912, after he went there with the American painter Alfred Maurer. (*Glackens and the Ashcan Group,* p. 159.) Henri painted the *Facade Bal Bullier—Night* (formerly, Macbeth Gallery), presumably at the same time; it was exhibited at the Pennsylvania Academy in October 1897.

22. Armstrong, "New Leaders in American Illustration," p. 251. Glackens could well have seen *Ballet Espagnol* when it was exhibited in the Manet exhibition at the Durand-Ruel Gallery, New York, in 1895.

23. The title of plate 11, perhaps assigned to the picture later, is complicated by a torn label on the back, the legible part of which reads "Terasse [*sic*]." While in Paris, Glackens did paint a now unlocated picture entitled *Terrace de la Café d'Harcourt,* which he exhibited at the Pennsylvania Academy in 1898; this might possibly be *Café Scene* (1895; Archer M. Huntington Art Gallery, University of Texas at Austin), though it has also been suggested that that scene depicts the Closerie des Lilas, a café where Glackens and Henri met regularly. (See Carolyn Appleton and Jan Huebner, "Nineteenth-Century American Art at the University of Texas at Austin," *Antiques* 126 [November 1984]: 1242). In March 1961 the Davis Galleries in New York exhibited a French scene by Glackens entitled *The Terrace* (sold Sotheby's, New York, May 28, 1987), but this does not appear to relate to a café. Glackens wrote in September 1895, "The Paris cafés are a never ending source of inspiration to me." (See Kraushaar Galleries, *William Glackens: The Formative Years* [New York, 1991], unpaginated.) The current title, *Circus Parade,* appears relevant to the painting but not to a Parisian café scene, so the Terasse on the label remains puzzling.

24. See the excellent discussion of this picture by Rebecca Butterfield in *American Paintings and Sculpture to 1945 in the Carnegie Museum of Art* (New York: Hudson Hills Press, 1992), pp. 200–202. Butterfield suggests Glackens's indebtedness here to the 1857 woodblock print *The Bamboo Wharf at Kyobashi* by Utagawa Hiroshige, from the series *One Hundred Views of Edo.*

25. A number of other paintings by Manet included in Durand-Ruel's New York exhibition may also have prompted the formal directions that Glackens's art assumed in Paris, especially in *Race at Longchamps* and *Bullfight.*

26. Charles de Kay, "Mr. Chase and Central Park," *Harper's Weekly* 35 (May 2, 1891): 325, 327–28.

27. *Quatorze Juillet* seems to be identical with *The Fête Night,* which was exhibited in October 1898 at the Pennsylvania Academy; on the stretcher of *Quatorze Juillet* is a Pennsylvania Academy label with *The Fête Night* written on it.

28. Paul Shakeshaft, "William Glackens: On the Quai," *Cresset* (Valparaiso, Indiana) 50 (January 1987): 18–19.

29. This is an illustration for May Brown's short story "A Broad Prairie Mating," *Collier's Weekly,* August 31, 1912, p. 19.

30. The most thorough description of the completed project is "The Academy's Lecture Room," *Philadelphia Public Ledger,* April 16, 1897.

31. Sloan's murals were *Dramatic Music* (Pennsylvania Academy of the Fine Arts) and *Terpsichore* (destroyed).

32. "Instructions for Pennsylvania Academy of the Fine Arts Mural Decoration by Henry Thouron," John Sloan Trust, Delaware Art Museum, Wilmington.

33. Pennsylvania Academy of Fine Arts, *Description of Mural Decorations in the Lecture-Room of the Pennsylvania Academy of the Fine Arts* by Students Recent and Present of the Academy Schools, printed description from the Archives of the Pennsylvania Academy of the Fine Arts, courtesy of Cheryl Leibold, archivist. There was also a plan to commission high-relief sculptures for the walls of the lower end of the lecture

room, in order to celebrate that other aspect of art taught at the Academy, but no documentation indicates that this was ever done.

34. Armstrong, "New Leaders in American Illustration," p. 247.

2.
THE ILLUSTRATOR

1. See the essay by Nancy E. Allyn, in Allyn and Elizabeth H. Hawkes, *William Glackens: Illustrator in New York, 1897–1919* (Wilmington: Delaware Art Museum, 1985).

2. About this time Glackens created a pair of sanguine drawings of his two artist-reporter colleagues, *George Luks* and *Everett Shinn* (both, Amherst College Collection, Amherst, Massachusetts).

3. Edgar John Bullard III, "John Sloan and the Philadelphia Realists as Illustrators, 1890–1920" (M.A. thesis, University of California, Los Angeles, 1968), p. 49.

4. Bennard B. Perlman, *The Golden Age of American Illustration: F. R. Gruger and His Circle* (Westport, Conn.: North Light Publishers, 1978), p. 36.

5. *Glackens and the Ashcan Group*, p. 23.

6. Glackens's pass to Santiago, courtesy of the Glackens Archives, Susan Conway Gallery, Washington, D.C. George Luks had preceded Glackens in Cuba by several years, having been sent by the *Philadelphia Evening Bulletin* in December 1895 to cover the revolt against Spain that had erupted the previous February.

7. Glackens's byline for the article was "Illustrated with drawings by W. J. Glackens, special artist for *McClure's Magazine* with the Army of Invasion"; *McClure's Magazine* 11 (October 1898): 499.

8. The Spanish-American War drawings are discussed in Alan Fern, "Drawings by William Glackens," *Library of Congress Quarterly Journal of Current Acquisitions* 20 (December 1962): 12–18. See also the brief but trenchant essay by Janet A. Flint in National Collection of Fine Arts, *Drawings by William Glackens, 1870–1938* (Washington, D.C.: Smithsonian Institution Press, 1972), unpaginated.

9. Forbes Watson, "William Glackens," *Arts* 3 (April 1923): 252.

10. A complete account of all Glackens's magazine and book illustrations was compiled by Nancy E. Allyn and Elizabeth H. Hawkes for Delaware Art Museum, *William Glackens: A Catalogue of His Book and Magazine Illustrations* (Wilmington, 1987), in which almost all of the works are reproduced.

11. See Regina Armstrong, "Representative Young Illustrators," *Art Interchange* 43 (March 1899): 106–9; Armstrong, "The New Leaders in American Illustration, IV: "The Typists: McCarter, Yohn, Glackens, Shinn and Luks," *Bookman* 11 (May 1900): 244–51; John R. Neil, "Another Philadelphian Wins Fame in Art," *North American Book Supplement*, November 1, 1901, unpaginated; Grace Alexander Fowler, "Among the Illustrators," *Harper's Bazar* 39 (June 1905): 534; Mary H. Bothwell Horgan, "Our Leading Illustrators," *Independent* 59 (December 14, 1905): 1397–98.

12. Everett Shinn, "William Glackens as an Illustrator," *American Artist* 9 (November 1945): 22.

13. Beal to Roland Kraushaar, in his reminiscences of The Eight, typescript, n.d., Kraushaar Galleries, New York.

14. My thanks to Elizabeth H. Hawkes for information on Glackens's de Kock illustrations. Some of these had appeared previously among his magazine articles, such as those published by Jesse Lynch Williams in her *New York Sketches* (New York: Charles Scribner's Sons, 1902); James L. Lord's *The Brazen Calf* (New York: Dodd, Mead and Company, 1903); Isaac Kahn Friedman's *The Autobiography of a Beggar* (Boston: Small, Maynard and Company, 1903); Alfred Henry Lewis's *The Boss, and How He Came to Rule New York* (New York: A. S. Barnes and Company, 1903); William Allen White's *In Our Town* (New York: McClure, Phillips and Company, 1906); and Will Irwin's *Confessions of a Con Man* (New York: B. W. Huebsch, 1909).

15. H. R. Durand, "A Sucker," *Cosmopolitan* 39 (May 1905): 83–94, with five illustrations by Glackens; the Altschul drawing appeared in the Durant article on p. 89. This is discussed in Marianne Doezema, *George Bellows and Urban America* (New Haven, Conn., and London: Yale University Press, 1992), pp. 80–82.

16. Shinn, "Glackens as an Illustrator," passim.

17. Bullard, "Sloan and the Philadelphia Realists," p. 118. See also the discussion by Rebecca Zurier, "Picturing the City: New York in the Press and the Art of the Ashcan School, 1890–1917" (Ph.D. diss., Yale University, 1988), pp. 249–53.

18. Shinn, "Glackens as an Illustrator," p. 23.

19. Identified in a note in the curatorial files at the Wadsworth Atheneum, Hartford, Connecticut. (See Zurier, "Picturing the City," p. 253.)

20. [Mary Fanton Roberts?], "Foremost American Illustrators: Vital Significance of Their Work," *Craftsman* 17 (December 1909): 267.

3.
NEW YORK SCENES

1. I am grateful to Alejandro Anreus, curator of the Jersey City Museum, for investigating this enterprise for me. See Charles H. Winfield, *History of the County of Hudson, New Jersey,* 2d ed. (Jersey City: New Jersey State Chamber of Commerce, 1900), pp. 79–80.

2. Violette de Mazia stated that this work was painted around 1913, over a 1907 version, according to Glackens himself. (De Mazia, "The Case of Glackens vs. Renoir," *Journal of the Art Department* [Barnes Foundation] 2 [autumn 1971: 11].) However, critics wrote about the picture's "vivid reds and greens" as early as 1910. See Arthur Hoeber, "Art and Artists," *New York Globe and Commercial Advertiser,* April 5, 1910, p. 10.

3. See the review of the Colonial Club show in The Expert, "The Oldest Thing in Art," *Town Topics* 49 (April 2, 1903): 19.

4. *Glackens and the Ashcan Group*, p. 78.

5. *I Spent Most of My Time at Coney Waiting for Somebody to Come Out of the Ocean so There's Be Room for Me to Get In,* in Elliott Flower, "A Stranger in New York," *Putnam's Magazine* 5 (March 1909): 686.

6. The two letters are quoted in *Glackens and the Ashcan Group,* pp. 19–20.

7. A somewhat similar painting by Glackens, though with the model's face more masklike and less expressive, is *Girl with*

White Shawl Collar (c. 1894; Museum of Art, Fort Lauderdale), which appears to be earlier than *Girl in Black Cape.*

8. Glackens's friend from his Paris sojourn of 1895–96, the Canadian James Morrice, noted Glackens's Thirtieth Street address in a sketchbook when he visited New York in 1903. (See Nicole Cloutier, *James Wilson Morrice, 1865–1924* [Montreal: Montreal Museum of Fine Arts, 1985], p. 111; the sketchbook is in the Montreal Museum of Fine Arts.)

9. Henri to Sloan, April 6, 1901, John Sloan Archives, Helen Farr Sloan Library, Delaware Art Museum, Wilmington.

10. [Charles FitzGerald], "Art Notes," *New York Evening Sun,* April 11, 1901, p. 4.

11. [Charles FitzGerald], "At the American Art Galleries and Elsewhere," *New York Evening Sun,* March 4, 1902, p. 4.

12. [Charles FitzGerald], "Certain Painters at the Society," *New York Evening Sun,* April 1, 1905, p. 4.

13. Bennard B. Perlman, *Robert Henri: His Life and Art* (New York: Dover, 1991), p. 51.

14. [Charles FitzGerald], "The Society of American Artists," *New York Evening Sun,* April 3, 1903, p. 6.

15. "The Expert, Oldest Thing in Art," p. 19.

16. Ira Glackens illustrated this picture and discussed it on pp. 49–50 of *Glackens and the Ashcan School.* Glackens appears to have again been following Henri's lead, or working together with him, for in 1901 Henri painted a *Ballet Dancer* (formerly, Adolph Lewisohn collection) that is quite similar to Glackens's dancer images.

17. *A Summer-Night Relaxation,* in Ada Sterling, "New York's Charm in Summer," *Harper's Bazar* 33 (August 18, 1900): 265. See also the excellent discussion of this painting by David Park Curry in Metropolitan Museum of Art, *American Impressionism and Realism: The Painting of Modern Life, 1885–1915* (New York, 1994), pp. 203–13.

18. Some reports date the opening of the roof garden to 1900, but that July, Leander Richardson specifically noted its opening the year before, in Richardson, "The Passing of the Roof Garden," *Metropolitan Magazine* 12 (July 1900): 81. For more information on roof gardens, see Robert H. Montgomery, "The Roof Gardens of New York," *Indoors and Out* 2 (August 1906): 214–19; Stephen Burge Johnson, *The Roof Gardens of Broadway Theatres, 1883–1942* (Ann Arbor, Mich.: UMI Research Press, 1985).

 I do not know the source for the identification of the painting as specifically *Hammerstein's* Roof Garden; nor when this identification was first made; in the picture's earlier exhibitions it was identified simply as *The Roof Garden;* it appeared as *Hammerstein's Roof Garden* at the *William Glackens Memorial Exhibition,* held at the Whitney Museum of American Art in New York in December of 1938. This title reflects the actual identification of the building itself; not long after the roof garden was installed, the building was covered with large signs reading Hammerstein's Roof Garden on both Seventh Avenue and Forty-second Street; the theater sign for the "Victoria" was much smaller. (See Nicholas van Hoogstraten, *Lost Broadway Theatres* [New York: Princeton Architectural Press, 1991], pp. 36–43.)

19. Mrs. Schuyler Van Rensselaer, "Midsummer in New York," *Century Magazine* 62 (August 1901): 490. It is quite possible that the performers in Glackens's picture were circus entertainers contracted from Barnum and Bailey to perform dur-

ing the summer off-season. (See Johnson, *Roof Gardens of Broadway Theatres,* p. 88.)

20. "Society of American Artists Exhibition: Third Notice," *New York Sun,* April 14, 1902, p. 6.

21. [Charles FitzGerald], "The Society and the Ten Deserters," *New York Evening Sun,* April 3, 1902, p. 4.

22. Nancy I. Glendinning, "William James Glackens: American Illustrator and Artist" (M.A. thesis, Bryn Mawr College, 1965–66, pp. 41–43; hereafter cited as Glendinning.) Glendinning notes that Sickert's paintings were probably not available to Glackens but that the English artist provided illustrations of London music-hall scenes for *The Yellow Book* in 1894–95, with which Glackens seems to have been familiar.

23. See Linda S. Ferber, "Stagestruck: The Theater Subjects of Everett Shinn," in *American Art around 1900: Lectures in Memory of Daniel Fraad,* Studies in the History of Art, no. 37 (Washington, D.C.: National Gallery of Art, 1990), pp. 51–67. Ferber discusses the close similarities between Shinn's *Balcony* (private collection) of c. 1900 and Glackens's design for *The Balcony* (Arthur G. Altschul collection, New York), an illustration reproduced in William Le Queux, "The Hermit of Rue Madame," *Ainslee's Magazine* 3 (April 1899): 268, when Shinn was the magazine's art editor.

24. Edwin Milton Royle, "The Vaudeville Theatre," *Scribner's Magazine* 26 (October 1899): 485–95; Cyrus Townsend Brady, "A Vaudeville Turn," *Scribner's Magazine* 30 (September 1901): 351–55; Wallace Bruce Amsbary, "De Cirque at Ol' Ste. Anne," *Century Illustrated Magazine* 63 (March 1902): 708–10. A few years later Glackens provided a single theatrical illustration as the frontispiece for John Corbin, "The Lights and Stars of Broadway," *Scribner's Magazine* 37 (February 1905): 129.

25. Wallace Hilary Evans, "Skating on Wheels," *Collier's Outdoor America* 44 (November 13, 1909): 22.

26. William to Edith Glackens, April 23, 1906, courtesy of the Glackens Archives, Susan Conway Gallery, Washington, D.C.

27. Amy Lyman Phillips et al., "Famous American Restaurants and Some of the Delicacies for Which They Are Noted," *Good Housekeeping* 48 (January 1909): 23.

28. Benjamin DeCasseres, "Mouquin's," *American Mercury* 25 (March 1932): 364. DeCasseres noted that he went to the Café Francis to sober up, but to Mouquin's "to play battledore and shuttlecock with Art, Literature, Philosophy, the Cosmos and all points south and west," p. 365.

29. *Glackens and the Ashcan Group,* p. 54.

30. Behrens, "Art Notes," *Cincinnati Commercial Tribune,* February 7, 1909, p. 9.

31. [James Huneker], "Eight Painters: Second Article," *New York Sun,* February 10, 1908, p. 6.

32. When the Café Francis went out of business and its contents were auctioned, Edith Glackens purchased *The Bull Fight* for six dollars. (*Sloan's New York Scene,* entry for April 27, 1908, p. 216.) *The Bull Fight* may be identical with *The Sixth Bull,* also unlocated.

33. Joseph Edgar Chamberlin, "Two Significant Exhibitions," *New York Evening Mail,* February 4, 1908, p. 6.

34. A. E. Gallatin, "The Art of William J. Glackens: A Note," *International Studio* 40 (May 1910): lxviii; *Chez Mouquin* appears on the following page. It is unlikely that Glackens

would have been familiar with Degas's *In a Café,* at least not in the original.

35. "Pictures by American Artists Admired on 'Varnishing Day,'" *New York World,* March 24, 1905, p. 7. The portrait was also referred to as a "souvenir of Whistler" in "Society of American Artists," *New York Evening Post,* March 27 1905, p. 4.

36. "American Paintings Shown," *New York Sun,* March 26, 1905, p. 3. Glackens identified the picture at the society only as *Portrait of a Young Man,* and Albert Gallatin used the same anonymous title when he reproduced it in "Art of William J. Glackens," p. lxviii. The subject was identified by one writer as "a well-known young art critic." (See "American Art at Society's Show," *New York World,* April 16, 1905, p. 4.)

37. See the reminiscence of Ira Dimock by his grandson and namesake, Ira Glackens, *Ira on Ira,* pp. 14–20.

38. Elsie Fuhr to Ira Glackens, January 10, 1955, courtesy of the Glackens Archives, Susan Conway Gallery, Washington, D.C. Elsie Fuhr suggests, alternatively, that Glackens might have returned to Paris on a short trip in 1900 when he showed a work at the Salon and could have met Edith and May Wilson then. Such a trip is otherwise unrecorded and denied by Ira Glackens in *Glackens and the Ashcan Group,* p. 69.

39. For a full discussion of the Dimock mansion, see Edward C. Lavelle, "Fabulous Mansion," *West Hartford News,* June 3, 1954, sec. E, pp. 1–23.

40. *Sloan's New York Scene,* entry for July 20, 1907, p. 143.

41. De Gregorio, pp. 111–16.

42. Some of my information here is taken from the entries on Glackens's paintings prepared by Elizabeth Russeel McClintock for the forthcoming catalog of the American paintings collection in the Wadsworth Atheneum, Hartford, Connecticut, to be published by Yale University Press in 1995. My thanks to Amy Ellis and Elizabeth Kornhauser for their assistance.

43. William to Edith Glackens, January 21, 1905, courtesy of the Glackens Archives, Susan Conway Gallery, Washington, D.C.; the Henri portrait may never have been completed.

44. Lawson to National Academy, April 13, 1910, Archives of the National Academy of Design, New York; my gratitude to Abigail Booth Gerdts, former curator of the Academy, for providing me with this information.

45. [Arthur Hoeber], "A Most Lugubrious Show at the National Arts Club, *New York Commercial Advertiser,* January 21, 1904, p. 7.

46. [Charles FitzGerald], "A Significant Group of Paintings," *New York Evening Sun,* January 23, 1904, p. 4.

47. [Charles de Kay], "Six Impressionists: Startling Works by Red-Hot American Painters," *New York Times,* January 20, 1904, p. 9.

48. See *Black Mirror* 2 (1904): 25–30. See also "Six Painters in a Club Show," *New York Mail and Express,* January 25, 1904, p. 5. For a perceptive study of the National Arts Club show, see Elizabeth Milroy, "Modernist Ritual and the Politics of Display," in Milwaukee Art Museum, *Painters of a New Century: The Eight and American Art* (Milwaukee, 1991), pp. 36–37.

49. Louis Baury, "The Message of Proletaire," *Bookman* 11 (December 1911): 410.

50. Park on the River (plate 50) is likely the picture specifically identified as *East River Park,* one of two New York urban views that Glackens exhibited at the National Arts Club in January 1904. It was the first picture he ever showed at the National Academy of Design, New York, appearing in the eightieth annual, which opened on December 31, 1904. It was singled out by a critic as one of "the most delightful works in the exhibition"; he found that the painting, "with its snappy air and dexterous drawing of lounging figures and speeding river craft, displays pretty nearly at his best an ardent follower of Manet." ("The National Academy," *New York Evening Post,* January 7, 1905, p. 8.)

51. *The Sights and Smells of the Water-Front Are Here Too,* in Jesse Lynch Williams, "The Cross Streets of New York," *Scribner's Magazine* 28 (November 1900): 579.

52. This may be the painting referred to as *East River* and shown in January 1904 at the National Arts Club. The work is not listed in the catalog of this show but is mentioned as being on view at the club in [de Kay], "Six Impressionists," p. 9.

53. *Waiting for the Swan Boats in Central Park,* in Sterling, "New York's Charm in Summer," p. 266; John J. à Becket, "Autumn Days in Central Park," *Harper's Bazar,* December 17, 1900, pp. 1814–19.

54. Walter Pach, "Manet and Modern American Art," *Craftsman* 17 (February 1910): 483.

55. Margaret Steele Anderson, *The Study of Modern Painting* (New York: Century Co., 1914), p. 225.

56. Everett Shinn, "Recollections of The Eight," in Brooklyn Museum, *The Eight* (Brooklyn, 1943), p. 19.

57. Unaccountably, H. Barbara Weinberg has detected images of the impoverished in this scene, but all the figures appear well dressed and comfortably insulated against the cold. (See Metropolitan Museum of Art, *American Impressionism and Realism,* p. 156.)

58. Raymond S. Spears, "Central Park in Winter," *Munsey's Magazine* 22 (February 1900): 634.

59. Ibid.

60. W[illiam] D. Howells, "Letters of an Altrurian Traveller," *Cosmopolitan* 16 (January 1894): 272.

61. *Bowling Along in a Comfortable Victoria,* in à Becket, "Autumn Days in Central Park," p. 1818.

62. Roy Rosenzweig and Elizabeth Blackmar, *The Park and the People: A History of Central Park* (Ithaca, N.Y., and London: Cornell University Press, 1992), p. 335.

63. William to Edith Glackens, August 23, 1903, courtesy of the Glackens Archives, Susan Conway Gallery, Washington, D.C.

4.

A BRIEF HONEYMOON ABROAD

1. *Gypsies Dancing in the Garden of the Alhambra,* as reworked by Glackens in 1915, is reproduced in Mary Fanton Roberts, "W. J. Glackens: His Significance to the Art of His Day," *Touchstone* 7 (January 1920): 194.

2. Emilio Castelar, "Madrid," *Harper's Weekly* 37 (March 11, 1893): 238.

3. See C[harles] C. Cunningham, "Recently Acquired American Landscapes," *Bulletin of the Museum of Fine Arts* (Boston) 36 (June 1938): 39–40.

4. In Glackens's third *Luxembourg Gardens* (1906; Wichita Art Museum, Wichita, Kansas), the figures, more carefully

depicted and individualized, are in the foreground and in front of, rather than among, the trees. The painting has the brightest, lightest, and most colorful palette of the three and most looks forward to Glackens's future strategies. In 1906 Glackens also prepared an etching with color of *The Luxembourg Gardens* (Philadelphia Museum of Art and Museum of Art, Fort Lauderdale).

5. See Glackens's *Chezy-sur-Marne* (sold Sotheby's, New York, April 21, 1977).

6. Glackens to John D. Trask, managing director of the Academy, June 10, 1907, Archives of the Pennsylvania Academy of the Fine Arts, Philadelphia.

7. William to Edith Glackens, January 31, 1908, courtesy of the Glackens Archives, Susan Conway Gallery, Washington, D.C.

8. *Broadway below Twenty-third Street, Christmas Eve,* in John J. à Becket, "New York's Christmas Atmosphere," *Harper's Bazar* 33 (December 15, 1900): 2077.

9. Glackens may have utilized Waki Kaji, a Japanese American professional model, for the figure of the salesperson. Ms. Kaji recounted to John Sloan in the summer of 1909 that "she had posed a little over two years ago for Henri and Glackens." (*John Sloan's New York Scene,* entry for August 19, 1909, p. 329.)

10. Joseph Edgar Chamberlin, "Two Significant Exhibitions," *New York Evening Mail,* February 4, 1908, p. 6.

11. See the unpublished paper by Cynthia Roznoy, "Social Discourse in William Glackens' *The Shoppers*" (City University Graduate School, fall 1990), for a complete analysis of this work.

12. [James Huneker], "Eight Painters: Second Article," *New York Sun,* February 10, 1908, p. 6.

13. Roznoy, "Social Discourse," pp. 10–11.

5.
FROM THE EIGHT TO RENOIR

1. See the excellent essay by Gwendolyn Owens, "Art and Commerce: William Macbeth, The Eight and the Popularization of American Art," in Milwaukee Art Museum, *Painters of a New Century: The Eight and American Art* (Milwaukee, 1991), especially pp. 69–73.

2. [Charles FitzGerald], "Certain Painters at the Society," *New York Evening Sun,* April 1, 1905, p. 4.

3. C[harles. F[itz]G[erald], "Art Exhibitions of the Week," *New York Evening Sun,* February 25, 1905, p. 4.

4. [William Macbeth], *Macbeth Notes,* no. 35 (March 1908): 545–46.

5. [Frederick James Gregg?], "The Eight," *New York Evening Sun,* May 15, 1907, p. 6.

6. Glackens, Henri, Luks, Shinn, Lawson, and Sloan, in fact, participated in another small exhibition at the National Arts Club in January 1908, just a month before their show with Macbeth, where Glackens exhibited a scene of Montmartre (perhaps his *Flying Kites, Montmartre,* plate 63), as well as his portraits of FitzGerald (plate 43) and his wife (the latter under the title *Lady with Fruit*).

7. This was listed in the catalog as *Grey Day, Central Park,* an unknown, unlocated work. But, in a letter to Edith, who was staying with her family in West Hartford, Glackens listed the entries he planned to show, one of which was not *Grey Day, Central Park,* but *May Day in Central Park* (plate 55). (*Glackens and the Ashcan Group,* p. 86.) The work appeared as *May Day, Central Park* in the subsequent tour of the Macbeth exhibition.

8. Arthur Hoeber, "Art and Artists," *Globe and Commercial Advertiser,* February 5, 1908, p. 9.

9. One reviewer noted a trolley car in one of Glackens's entries (as it is in *View of West Hartford*), a motif not present in any of the other pictures. (Joseph Edgar Chamberlin, "Two Significant Exhibitions," *New York Evening Mail,* February 4, 1908, p. 6.) For the identification of Talcott Mountain, I am indebted to the entry on this picture prepared by Elizabeth Ruseell McClintock for the forthcoming catalog of the American paintings collection in the Wadsworth Atheneum, Hartford, Connecticut, to be published by Yale University Press in 1995. My thanks to Amy Ellis and Elizabeth Kornhauser for their assistance.

10. "New York's Art War and the Eight Rebels," *New York World,* February 2, 1908, magazine sec., p. 1.

11. De Gregorio, p. 335.

12. *Sloan's New York Scene,* entry for February 17, 1908, p. 198.

13. See especially The Gilder ("Palette and Brush: The Architectural League and the Eight Discontents," *Town Topics* 59 [February 6, 1908]: 15), who concluded, "The whole thing creates a distinct feeling of nausea."

14. James B. Townsend, "'The Eight' Arrive," *American Art News* 6 (February 8, 1908): 6.

15. W. B. M'C[ormick], "Art Notes of the Week," *New York Press,* February 9, 1908, p. 6.

16. "'The Eight' Exhibit New Art Realism," *New York American,* February 4, 1908, p. 10.

17. Hoeber, "Art and Artists," p. 9.

18. Chamberlin, "Two Significant Exhibitions," p. 6.

19. [James Huneker], "Eight Painters: Second Article," *New York Sun,* February 10, 1908, p. 6.

20. Detroit Museum of Art, *Paintings by Eight American Artists Resident in New York and Boston* (Detroit, 1908). My thanks to Dr. Judith Zilczer for the wealth of material she shared with me concerning the tour of The Eight. For an excellent discussion of it, see her article "The Eight on Tour, 1908–1909," *American Art Journal* 16 (summer 1984): 20–48.

21. *Sloan's New York Scene,* entries for November 22 and December 7, 1909, pp. 353, 358.

22. Owens, "Art and Commerce," in *Painters of a New Century,* p. 77. The Macbeth Gallery did recall that historic show thirty years later in the exhibition *"The Eight" Thirty Years After,* held in January 1938, just a few months before Glackens's death.

23. Henri explained the nature and purpose of the show in Robert Henri, "The New York Exhibition of Independent Artists," *Craftsman* 18 (May 1910): 160–72.

24. The Gilder, "Palette and Brush: The Self-Styled Independent Artists," *Town Topics* 63 (April 7, 1910): 16.

25. For Glackens's contributions, see *Sloan's New York Scene,* entries for April 5, 7, and 15, 1911, pp. 524–26.

26. *Semi-Nude with Hat,* dated to c. 1909, is illustrated in Kraushaar Galleries, *William Glackens: The Formative Years* (New York, 1991), no. 12.

27. For the club members' responses, see "Rap Independents' Art Works," *New York Press,* April 14, 1911, p. 4. For the critics,

see "Insurgent Art Show at the Union League," *New York Herald,* April 14, 1911, p. 11; "Art Notes," *New York Evening Post,* April 15, 1911, p. 9.

28. Rowland Elzea, *John Sloan's Oil Paintings: A Catalogue Raisonné,* 2 vols. (Newark: University of Delaware Press, 1991), vol. 1, p. 109.

29. Edith Glackens, under her maiden name, Edith Dimock, entered eight watercolors in the Armory Show, six of which sold to George E. Marcus; Edith herself acquired a drawing by Walt Kuhn and a watercolor by Maurice Prendergast, both in the Glackens Collection, Museum of Art, Fort Lauderdale. (Milton W. Brown, *The Story of the Armory Show,* rev. ed. [New York: Abbeville Press, 1988], pp. 130, 262.)

30. W[illia]m J. Glackens, "The American Section: The National Art," *Arts and Decoration* 3 (March 1913): 159–62.

31. "The Biggest Art Exhibition in America and, Incidentally, War, Discussed by W. J. Glackens," *Touchstone* 1 (June 1917): 166.

32. Aaron Sheon, "1913: Forgotten Cubist Exhibitions in America," *Arts Magazine* 57 (March 1983): 104–5.

33. Memorial Art Gallery, *An Exhibition of Paintings by W. Elmer Schofield and an Exhibition of Paintings Representative of the Modern Movement in American Art* (Rochester, N.Y., 1915).

34. The precise origin, history, and interrelationships of these exhibitions have not yet been precisely determined; this show may well have traveled to other cities in the Midwest as well. My thanks to Dr. Rina Youngner of the Carnegie Museum of Art, Pittsburgh, for her assistance in the ongoing research.

35. See Clark S. Marlor, *The Society of Independent Artists: The Exhibition Record, 1917–1944* (Park Ridge, N.J.: Noyes Press, 1984); and Francis Naumann, "The Big Show: The First Exhibition of the Society of Independent Artists," parts 1 and 2, *Artforum* 17 (February 1979): 34–39; (April 1979): 49–53.

36. Glackens showed *Portrait of Walter Hampden as Hamlet* (plate 90) in the second annual, in November 1920 (shown only as *Portrait* in the catalog listing but identified as Hampden in the illustration); *Child in Chinese Dress* (*The Artist's Daughter in Chinese Costume,* plate 97) at the third annual, in November 1921; and *Child on a Hobby Horse* (*The Dream Ride*) (plate 99) in the fifth annual, in January 1924. He even prepared a rare lithograph as a dinner invitation for the opening of the 1924 exhibition. (Invitation sent to John Sloan, in the collection of the National Museum of American History, Smithsonian Institution, Washington, D.C. I am grateful to Helena E. Wright, curator of the Division of Graphic Arts, for this information. Another copy is in the collection of the Museum of Art, Fort Lauderdale.)

37. Robert Henri, "The 'Big Exhibition,' the Artist and the Public," *Touchstone* 1 (June 1917): 174–77, 216.

38. "Biggest Art Exhibition in America," pp. 210, 165.

39. [Huneker], "Eight Painters: Second Article," p. 6.

40. Violette de Mazia, "The Case of Glackens vs. Renoir," *Journal of the Art Department* (Barnes Foundation) 2 (autumn 1971): 10–11.

41. *Sloan's New York Scenes,* entry for September 30, 1908, p. 251. Glackens may have sojourned and painted at Gloucester that season, perhaps visiting Prendergast, who had planned to spend most of the summer at nearby Annisquam. Included in one of the nine annual shows that Edith presented at their home on West Ninth Street after William's death was a painting of 1908, *Rocks and a Lighthouse, Gloucester* (Fine Arts

Museums of San Francisco). (See *The Fourth Annual Memorial Exhibition of the Paintings of William Glackens* [New York, 1942].)

42. *Sloan's New York Scene,* entry for January 3, 1910, pp. 277–78. Sloan (referring to the picture as *Bathing, Cape Cod*) described the news of the sale as "splendid," also noting, "This is of great importance to Glack and can't fail to encourage him and count with his wife's connections with whom money is a great talker."

43. Arthur Hoeber, "Art and Artists," *New York Globe and Commercial Advertiser,* April 5, 1910, p. 10.

44. John Gordon, "Nude with Apple," *Brooklyn Museum Bulletin* 19 (winter 1958): 6–9.

45. James B. Townsend, "The Independent Artists," *American Art News* 8 (April 9, 1910): 2. [James Huneker], "Around the Galleries," *New York Sun,* April 7, 1910, p. 6.

46. Ira Glackens described his father's studio at 50 Washington Square South as having "some old furniture, tables, chairs, the sofa that appears in 'Nude with Apple,' some piles of draperies, a woman's large, old-fashioned hat covered with artificial flowers (often painted), and a green-backed hand mirror for the model." (*Glackens and the Ashcan Group,* p. 116.)

47. Glendinning, pp. 50–51, particularly makes the comparison with the Manet.

48. Henri, "New York Exhibition," p. 166.

49. De Gregorio, p. 381, from an interview with Ira Glackens.

50. [Mary Fanton Roberts?], "Notes of General Interest: Art in New York This Season," *Craftsman* 24 (April 1913): 136.

51. On April 15, 1911, Sloan had visited the 1911 Union League Club show with the collector John Quinn and went on from there to Walt Kuhn's exhibition at the Madison Art Gallery, subsequently likening Kuhn's new emphasis on color to Glackens's. (*Sloan's New York Scene,* entry for April 15, 1911, p. 526.)

52. Ira Glackens recalled this reference in the talk he gave at the City Art Museum of Saint Louis during the 1969 Glackens retrospective there; original manuscript and typed transcript, Glackens Archives, Museum of Art, Fort Lauderdale.

53. Glendinning, pp. 57–58, notes the affinity of these canvases and traces Glackens's preference for striped costumes to the influence of Renoir's *La Loge* (1874; Courtauld Institute, London).

54. See, for instance, de Gregorio, pp. 164–91.

55. Glackens, in de Gregorio, p. 270, based on an interview with Watson, November 8, 1954.

56. Glackens's exposure to Renoir would have been continued by Durand-Ruel's one-artist shows of his work in the 1910s: twenty-one examples in February 1912; thirty in February 1914; and thirty-five in April 1919. Glendinning, pp. 52–55, analyzes the American familiarity with Renoir's art.

57. James Huneker, *Promenades of an Impressionist* (New York: Charles Scribner's Sons, 1910), pp. 248–49. Huneker has a whole section on Renoir in this publication, pp. 242–50.

58. Walter Pach, "Interview with Renoir," *Scribner's Magazine* 51 (May 1912): 616–18; Pach would later refer to Renoir as the greatest of the Impressionists. See Walter Pach, *The Masters of Modern Art* (New York: B. W. Huebsch, 1924), p. 37.

59. Guy Pène du Bois, "A Modern American Collection. The Paintings of Contemporary Artists," *Arts and Decoration* 4

(June 1914): 325. Early recognition of Glackens's role in the formation of the Barnes collection is published here.

60. See my *Monet's Giverny: An Impressionist Colony.* New York, Abbeville, 1993, p. 176. Frieseke discussed his admiration for Renoir with Clara MacChesney in "Frieseke Tells Some of the Secrets of His Art," *New York Times,* June 7, 1914, sec. 6, p. 7.

61. Glackens, in John Sloan, *Gist of Art* (New York: American Artists Group, 1944), p. 25.

62. Glackens, in *Glackens and the Ashcan Group,* p. 157. Maurer knew Leo Stein well; however, it is possible that Glackens was being taken to the apartment of Michael and Sarah Stein, who owned works by Matisse, among others.

63. John Rewald, *Cézanne and America* (Princeton, N.J.: Princeton University Press, 1989), p. 161. The comment "Mr. Glackens has never seen Cézanne's work . . . ," appeared in "Seen in the World of Art," *New York Sun,* December 18, 1910, p. 4.

64. Albert C. Barnes, *The Art in Painting* (New York: Harcourt, Brace and Company, 1925), p. 534. Forty-five works by Glackens remain in the Barnes Foundation collection.

65. Barnes, in *Glackens and the Ashcan Group,* pp. 257–58.

66. Albert C. Barnes, "L'Art de William Glackens," *Les Arts à Paris* 10 (November 1924): 2–3 (the article was dated April 14, 1924). Barnes noted that a comparison between Renoir and Glackens would be available when the Barnes Foundation opened, for he had at the time more than a hundred paintings by Renoir and fifty by Glackens. Typically, this article on Glackens was illustrated not with one of the artist's pictures but with a photograph of Dr. Barnes and his dogs in his private park in Merion Station, Pennsylvania.

67. William Schack, *Art and Argyrol* (New York and London: Thomas Yoseloff, 1960), p. 191.

68. Ibid., p. 281.

69. Bennard B. Perlman, *The Immortal Eight* (New York: Exposition Press, 1962), p. 211.

70. Barnes to Stein, March 30, 1913, Yale Collection of American Literature, Beinecke Rare Book and Manuscript Library, Yale University, New Haven, Connecticut.

71. Barnes, in Howard Greenfeld, *The Devil and Dr. Barnes* (New York: Viking, 1987), p. 39.

72. Laura Barnes bequeathed nine paintings by Glackens to the Brooklyn Museum in 1967; two remain in the collection.

73. Barnes, "L'Art de William Glackens," p. 3. A year later, in *The Art in Painting,* Barnes recapitulated his perception of Glackens's relationship to Renoir. (Barnes, *Art in Painting,* pp. 362–63.)

74. "Art Notes: William Glackens," *New York Evening Post,* March 8, 1913, sec. I, p. 9.

75. A. E. Gallatin, "William Glackens," *American Magazine of Art* 7 (May 1916): 261; this essay was reprinted, with additional illustrations, in Gallatin's *Certain Contemporaries* (New York and London: John Lane, 1916), pp. 3–10.

76. Forbes Watson, "William Glackens," *Arts* 3 (April 1923): 252–53.

77. Harry Salpeter, "America's Sun Worshiper," *Esquire* 7 (May 1937): 87. Salpeter may have been referring specifically to C. J. Bulliet, the Chicago art writer and one of Glackens's harshest critics, who had written in 1934: "Glackens is known as the American Renoir, and the designation, unfortunately, is too exact. Glackens must stand or fall by that comparison,

and I am afraid that the fall will be inevitable. . . . On Renoir's instrument, he improvises melodies of his own. They are Renoirish without the sublimity of Renoir—Renoir without the soul." (C. J. Bulliet, in Art Institute of Chicago, *1934 Art Masterpieces in a Century of Progress Exhibition* [Chicago, 1934], p. 21.)

78. Catherine Beach Ely, "The Modern Tendency in Lawson, Lever and Glackens," *Art in America* 10 (December 1921): 137.

79. Henry McBride, "Glackens's Memorial Exhibition," *New York Sun,* December 17, 1938, p. 8.

80. Richard J. Wattenmaker, "The Art of William Glackens," *University Art Gallery Bulletin* (Rutgers University, New Brunswick, N.J.), 1, no. 1 (1967): 8–9.

81. De Mazia, "Glackens vs. Renoir," p. 3, and especially pp. 6–12, 19–23.

82. De Gregorio, p. 216.

83. Salpeter, "America's Sun Worshiper," p. 87.

84. Ira Glackens's typed annotations to Richard J. Wattenmaker, "The Art of William Glackens" (Ph.D. diss., New York University, 1972). Courtesy of the Glackens Archives, Susan Conway Gallery, Washington, D.C.

85. William Innes Homer, *Robert Henri and His Circle* (Ithaca, N.Y., and London: Cornell University Press, 1969), p. 197.

86. Robert Henri, "What about Art in America?" *Arts and Decoration* 24 (November 1925): 35.

87. Edith DeShazo, *Everett Shinn, 1876–1953: A Figure in His Time* (New York: Clarkson N. Potter, 1974), pp. 155, 176.

88. *Ira on Ira,* p. 5.

6.
IN THE PARK AND AT THE BEACH

1. André Tridon, *New York Call,* in *Sloan's New York Scene,* entry for January 24, 1911, p. 501.

2. The paucity of color is mentioned in "Pastellists at Folsom's," *American Art News* 9 (June 14, 1911): 6. Glackens's high colorism was mentioned in "First Exhibition of 'The Pastellists' Suggests the Revival of a Charming Form of Eighteenth Century Art," *New York Times,* January 15, 1911, sec. 5, p. 5; and Henry Tyrrell, "Up and Down Picture Lane," *New York Evening World,* January 14, 1911, p. 6.

3. William to Edith Glackens, May 1, 1906, courtesy of the Glackens Archive, Susan Conway Gallery, Washington, D.C.

4. "Art Notes," *New York Evening Post,* March 11, 1912, p. 7.

5. [James Huneker?], "Seen in the World of Art," *New York Sun,* December 18, 1910, p. 4.

6. Cyrus Townsend Brady, "A Vaudeville Turn," *Scribner's Magazine* 30 (September 1901): 351–55. John Corbin, "The Lights and Stars of Broadway," *Scribner's Magazine* 37 (February 1905): 129.

7. Richard J. Wattenmaker, "William Glackens's Beach Scenes at Bellport," *Smithsonian Studies in American Art* 2 (spring 1988): 75–94.

8. Arthur Hoeber, "Art and Artists," *New York Globe and Commercial Advertiser,* February 7, 1910, p. 8.

9. I am grateful to Dr. Linda Ferber, chief curator at the Brooklyn Museum, for confirming the nature of the painting within the picture. John Gordon, in "Nude with Apple,"

Brooklyn Museum Bulletin 19 (winter 1958): 6–9, suggests that this picture may be a Maurice Prendergast seascape.

10. According to Edwin Pugsley of New Haven, Connecticut, as noted in Sheldon Memorial Art Gallery, *The American Painting Collection of the Sheldon Memorial Art Gallery* (Lincoln: University of Nebraska, 1988), p. 68.

11. [Huneker?], "Seen in the World of Art," p. 4.

12. *Glackens and the Ashcan Group,* pp. 170–71. Wattenmaker, "Glackens's Beach Scenes at Bellport," p. 91 n. 1.

13. *Glackens and the Ashcan Group,* p. 120.

14. Ronald G. Pisano, *Long Island Landscape Painting, 1820–1920* (Boston: Little, Brown and Company, 1985), p. 154.

15. "Art Notes," *New York Evening Post,* March 11, 1912, p. 7.

16. "Art Notes," *New York Evening Post,* March 8, 1913, sec. 1, p. 9.

17. The Glackens Collection at the Museum of Art, Fort Lauderdale, includes a sketchbook dated Bellport, 1912, with many sketches directly related to this picture.

18. The Folsom Gallery was located at 396 Fifth Avenue; Glackens's exhibition there consisted of eighteen works and ran from March 1–17. No catalog survives, but from the reviews one can reconstruct almost the entire exhibition: *Pony Ballet;* three works titled *Nude; Nude with Apple* (plate 71, then titled *Woman with an Apple*); *Sleeping Girl; Skating, Central Park; After Rain, Washington Square; Street Cleaners, Washington Square; Race Track; Girl with the Yellow Hat; Head of a Girl; Summer Hotel; Summer on the Coast; Bellport Bay; Bay Bathers;* and *Children on the Beach.* Except where previously noted, none of these works is presently located, but they may now be known by alternative titles. I am tremendously grateful to my good friend and colleague Margi Conrads, at the Nelson-Atkins Museum of Art, Kansas City, for sharing with me her research on Glackens's beach scenes and his show at the Folsom Gallery.

19. [Mary Fanton Roberts?], "Notes of General Interest: Art in New York This Season," *Craftsman* 24 (April 1913): 135–36.

20. See the definitive study by Julie Mellby, "A Record of Charles Daniel and the Daniel Gallery" (M.A. thesis, Hunter College of the City University of New York, 1993). The review of the first show, *Modern American Art,* which opened on December 16, 1914, identified Glackens as a painter "to whom the wonderful fullness of Renoir's color has come in recent years as a revelation." ("New Modern Gallery," *Arts and Decoration* 4 [February 1914]: 159.) In all, Glackens was included in sixteen group exhibitions at the Daniel Gallery through November 1923, including two four-artist shows with Henri, Lawson, and Prendergast in January 1920 and again in January 1921. I am tremendously grateful to Julie Mellby for sharing her information on Glackens at the Daniel Gallery and the history of the gallery generally. My thanks also to Heather B. Nevin of the Zabriskie Gallery, New York.

21. "Notes of the Studios and Galleries," *Arts and Decoration* 7 (February 1917): 200.

22. The pavilion and pier in *The Bandstand* (plate 89) appear in a postcard of New London in the collection of the Museum of Art, Fort Lauderdale. Glackens was obviously attracted to this particular subject, since these structures also appear in his well-known *Beach Scene, New London,* acquired by the great collector Ferdinand Howald from the Daniel Gallery; this work is now part of the Howald Collection at the Columbus Museum of Art, Columbus, Ohio.

23. Nine Gloucester paintings by Glackens are known, according to a list in the Ira Glackens Papers, Archives of American Art, Smithsonian Institution, Washington, D.C.

24. I am grateful to Lisa Peters of the Spanierman Gallery, New York, for sharing her research on these pictures.

7.
THE LATE WORK

1. "Art Exhibitions," *New-York Daily Tribune,* March 20, 1912, p. 7.

2. [James Huneker?], "Glackens Seen in His Recent Art Work," *New York Sun,* March 5, 1913, p. 9.

3. Glackens to Mary Fanton Roberts, February 12, 1919, Archives of the National Portrait Gallery, Smithsonian Institution, Washington, D.C.

4. Glackens to Mary Fanton Roberts, February 12, 1919, photocopy in the Archives of the National Portrait Gallery, Smithsonian Institution, Washington, D.C. Glackens may, of course, have meant that he was going to visit Hampden personally rather than witness his theatrical performance; the two had become friends. Hampden is perhaps best identified for contemporary audiences in his role as the aged actor who presents Eve Harrington with the Sarah Siddons Award in the 1950 motion picture *All about Eve.*

 Roberts, a leading art writer of her time, was a close friend of the Glackens family and for some years lived with them as a nonpaying guest. She also compiled, edited, and wrote the introduction for the book by Lenna Glackens, *I Want to Be a Columnist* (New York: Exposition Press, 1947).

5. Glackens wrote a rather obliquely worded letter to Roberts on April 22, 1919: "My mysterious patroness takes the completion of the portrait for granted. . . . I will let you know just as soon as I varnish it, and will be only too pleased to show it to you. . . . What am I to do with the portrait after it is quite completed? Where shall I send it?" (Photocopy in the archives of the National Portrait Gallery, Washington, D.C.) Whether Roberts was, in fact the "patroness," or whether there was another party involved is not clear, but the picture remained in Glackens's possession. I am tremendously grateful to Ellen Miles, curator at the National Portrait Gallery, for providing me with archival material on this painting.

6. Mary Fanton Roberts, "Glackens' Walter Hampden," *Arts* 1 (December 4, 1920): 16.

 Roberts likened *Walter Hampden as Hamlet* to Whistler's 1884 portrait of the great violinist Pablo de Sarasate (*Arrangement in Black;* Museum of Art, Carnegie Institute, Pittsburgh). Actually, she could have fixed on an even closer theatrical source: Whistler's *Arrangement in Black, No. III: Portrait of Sir Henry Irving as Philip II of Spain* (1876–85; Metropolitan Museum of Art, New York).

 The critic Henry McBride, no fan of the painter's later work, derided Glackens's likeness of Hampden, suggesting that "the best friends of both could only wish them better luck next time. His Hamlet was a wobbly creature and certainly not the person to say 'Boo' to a ghost." (McBride, "Modern Art," *Dial* 70 [January 1921]: 112–13.)

7. *Glackens and the Ashcan Group,* p. 195.

8. This painting has been variously dated 1918, 1919, and 1920; I'm inclined to the last, since Lenna appears to be about seven.

9. Charles Prendergast had become one of Boston's leading frame makers about 1897 and continued to create frames during his entire career; Maurice joined him in a frame making partnership that lasted for at least twenty years. (See Nancy Mowll Mathews, *The Art of Charles Prendergast from the Collections of the Williams College Museum of Art and Mrs. Charles Prendergast* [Williamstown, Mass.: Williams College Museum of Art, 1993], pp. 10–11.)

10. My thanks to Dr. Rina Youngner for the information about Glackens's representation in the Carnegie Internationals.

11. De Gregorio, p. 417.

12. Ira Glackens, in ACA Galleries, *Nineteenth and Twentieth Century Masterpieces in New York Private Collections* (New York: ACA Galleries, 1978), p. 40.

13. As discussed with Nancy Mowll Mathews, who has written extensively on Charles and Maurice Prendergast. Though unique in its imaginative character, *The Dream Ride* (plate 99) can be seen as a precursor of Glackens's *The Promenade* (plate 112) of 1927, depicting a young girl on a very real donkey.

14. Olga Dalzell lived in New York at both 318 West 140th Street and 145 Audubon Avenue, according to the "Models" notebook, Glackens Archives, Museum of Art, Fort Lauderdale. Many of Glackens's models lived in the upper reaches of Manhattan.

 "Julia" appears to have been his most frequent model, appearing in *Julia* (Mr. and Mrs. Bob London collection); *Julia with Apple* (c. 1915; Mr. and Mrs. Francis Keally); *Julia with Books* (c. 1914; Mr. and Mrs. David B. Pall collection); and *Julia's Sister* (Daniel J. Terra collection). She was probably Julia Osterberg, who was twelve years old and lived at 615 West 146th Street, according to the Models notebook.

15. Kay Laurel lived at 435 Fort Washington Avenue in New York, according to the "Models" notebook, Glackens Archives.

16. Ira Glackens, letter of November 27, 1975, to the Hunter Museum of Art in Chattanooga, Tennessee, in response to an inquiry concerning the identity of the model in *Miss Olga D.* (plate 101). (William T. Henning, Jr., *A Catalogue of the American Collection* [Chattanooga, Tenn.: Hunter Museum of Art, 1985. p. 114.)

17. Milton W. Brown, *American Painting from the Armory Show to the Depression* (Princeton, N.J.: Princeton University Press, 1955), p. 154.

18. Ira Glackens to Vincent John de Gregorio, February 24, 1955; in de Gregorio, p. 256.

19. Several of these titles may be interchangeable and refer to the same picture. Both an oil and a pastel version of *East Indian Legend* were shown in the fifth annual Glackens memorial exhibition in New York in November 1943.

20. *Exhibition of Paintings, Drawings, and Sculpture,* Montross Gallery, New York, March 23–April 25, 1915. This show is discussed by Judith Zilczer, "'The World's New Art Center': Modern Art Exhibitions in New York City, 1913–1918," *Archives of American Art Journal* 14, no. 3 (1974): 5. I am very grateful to Dr. Nancy Mowll Mathews for supplying me with photocopies of the Montross exhibition catalogs.

21. Walter Pach, "William J. Glackens," *Shadowland* 7 (October 1922): 76.

22. See especially Maurice Prendergast's watercolors, *Sea Maidens* (private collection), *Indian Dancers* (Mrs. Charles Prendergast collection), and *Oriental Figure (Fantasy)* (Fundacion Robert Brady A.C.), and Charles Prendergast's gessoed panels, *Tree and Dancers* (Mimi and Sanford Feld collection) and *The Riders* (Williams College Museum of Art, Williamstown, Massachusetts). I am grateful to Dr. Nancy Mowll Mathews for discussing the relationship of Glackens and the Prendergasts, especially in regard to these exotic themes.

23. Each of twenty-two days of the Liberty Loan campaign, between September 29 and October 19, was dedicated to one of the twenty-two Allied nations; Russia's day was October 16. ("Each Day of Campaign to Be Dedication to One Allied Nation," *New York Tribune,* September 28, 1918, p. 4.)

 Frederick James Gregg, "William Glackens' Work Foremost in That Done for Liberty Loan," *New York Herald,* October 20, 1918, sec. 3, p. 7. Glackens's mural has presumably not survived, but an original sketch for it was reproduced in Gregg's article.

24. For the New Hampshire summers, see *Glackens and the Ashcan Group,* pp. 192–95.

25. The extensive literature on artists in the White Mountains usually concludes about 1900. For the most substantial exception, see Hood Museum of Art, Dartmouth College, *"A Sweet Foretaste of Heaven": Artists in the White Mountains 1830–1930* (Hanover, N.H., 1988), in which Glackens is included.

26. See the discussion of this picture by William Kloss in Kloss, *Art in the White House: A Nation's Pride* (Washington, D.C.: White House Historical Association, 1992), pp. 246–47. For the Hell Gate Bridge, see Sharon Reier, *The Bridges of New York* (New York: Quadrant Press, 1977), pp. 58–65.

27. Avis Berman, *Rebels on Eighth Street: Juliana Force and the Whitney Museum* (New York: Atheneum, 1990), p. 179.

28. Glackens had had one earlier museum sale: his *Central Park, Winter* was acquired by the Metropolitan Museum of Art in New York in 1921. Following the acquisition of *Chez Mouquin* (plate 39) by Chicago, the Detroit Institute of Arts acquired *Promenade* (plate 112) in 1930. From 1933 museum acquisitions were made yearly: the Whitney Museum of American Art purchased his *Fête du Suquet* (plate 118) in 1933; the Denver Art Museum, his *Little Girl in Green* in 1934; the Albright Art Gallery in Buffalo, his *Jetties, Bellport,* in 1935; Phillips Academy's Addison Gallery of American Art in Andover, Massachusetts, his *Saint-Jean* in 1936; and in 1937 the Corcoran Gallery of Art in Washington, D.C., acquired *Luxembourg Gardens* and the Metropolitan Museum purchased a second example by Glackens, *The Green Car* (plate 77). In the year of his death, 1938, the University of Nebraska in Lincoln purchased *Mahone Bay* (plate 85) and the Museum of Fine Arts, Boston, acquired *Flying Kites, Montmartre* (plate 63).

29. *Ira on Ira,* pp. 70–71. Mars and Squire were the subject of a short story by Gertrude Stein, "Miss Furr and Miss Skeene."

30. Ira Glackens deals fully with the family's French travels and residences in *Glackens and the Ashcan Group,* pp. 198–250.

31. Mary Fanton Roberts, "Speaking of Art: W. J. Glackens Annual Show," *Arts and Decoration* 34 (March 1931): 45. Roberts summed up her estimation of Glackens here as "essentially a great colorist and an artist with a witty appreciation of life."

32. "William Glackens: Kraushaar Galleries," *Artnews* 29 (April 18, 1931): 10.

33. De Gregorio, p. 475.

34. *Glackens and the Ashcan Group*, pp. 219–21.

35. See Jody Blake, "Le Tumulte Noir: Modernist Art and Popular Entertainment in Jazz-Age Paris, 1900–1930" (Ph.D. diss., University of Delaware, 1992), pp. 338–39. For descriptions of the nightclub at just the time Glackens's picture was painted, see: Georgette Camille, "Le Bal Nègre à Paris," *Variétés* 1 (June 15, 1928): 78–80; André Reuze, "Le Bal Doudou de la rue Blomet," *Excelsior*, July 28, 1928, p. 4; "Le Bal Nègre: Rue Blomet sous le ciel des tropiques," *La Presse*, March 12, 1928, pp. 1–3—all cited in Blake, p. 381. I am tremendously grateful to Cynthia Roznoy for providing me with an in-depth study of mixed-race cabarets, particularly in terms of their *in*frequency in contemporaneous nightclub scenes in New York's Harlem.

36. In this context, the now lost painting *Martinique Dancer,* by Archibald Motley, the African American artist from Chicago who was also in Paris in 1929, painting cabaret, nightclub, and café scenes, may have significance beyond a reference to racial origins and culture. (See Jontyle Theresa Robinson, "The Life of Archibald J. Motley, Jr.," in Chicago Historical Society, *The Art of Archibald J. Motley, Jr.* [Chicago, 1991], p. 18.)

37. See Billy Klüver and Julie Martin, *KiKi's Paris* (New York: Harry N. Abrams, 1989), passim. A photograph on page 200, of the audience at the Bal Ubu, bears some similarity especially to Glackens's study for *Bal Martinique,* particularly in regard to both maquillage and costume. I am deeply grateful to Alan Moore and Dr. Marc Miller for their assistance in identifying this image.

38. Gifford Beal to Roland Kraushaar, in his reminiscences of The Eight, typescript, n.d. Kraushaar Galleries, New York.

39. *Glackens and the Ashcan Group*, p. 219.

40. *House at Stratford* (unlocated) of 1937 is in the catalog of the *Fifth Annual Memorial Exhibition of the Paintings, Sketches, and Drawings of William Glackens,* New York, 1943.

41. *Glackens and the Ashcan Group*, p. 77.

42. Glackens created a very different version of this picture, also entitled *The Breakfast Porch* (formerly, John H. Surovek Gallery, Palm Beach, Florida), with Lenna alone at a table on which stands a large basket of flowers. This has sometimes been suggested as a final version of the subject, but actually Lenna appears to me to be a trifle younger than in the variation reproduced (plate 126). The picture of Lenna alone was reproduced in Harry Salpeter, "America's Sun Worshiper," *Esquire* 7 (May 1937): 87.

43. Carol Clark, Nancy Mowll Mathews, and Gwendolyn Owens, *Maurice Brazil Prendergast, Charles Prendergast: A Catalogue Raisonné* (Williamstown, Mass.: William College Museum of Art; Munich: Prestel-Verlag, 1990), pp. 271–77. None of Prendergast's still lifes are dated nor were any exhibited during his lifetime, so that the dating of 1910–13 is speculative, based both on style and on the fact that floral arrangements also appear in a few of Prendergast's even rarer (and undated) portraits, which have been assigned to the same period; these, too, however, do not have firm dates. The one exception here is Prendergast's *Apple and Pear on the Grass* (Museum of Art, Fort Lauderdale), painted on a visit to the Glackenses at Bellport, Long Island, in the summer of 1912 and then given to them. I am grateful to Dr. Nancy Mowll Mathews for discussions concerning this problem. In the past a number of the Prendergast still lifes appear to have been arbitrarily assigned to the year 1915. However, it is possible that Prendergast and Glackens began to investigate the still-life theme jointly that year, after Maurice had moved to New York and into Glackens's studio building on Washington Square in 1914. Glackens remained absorbed with the motif; Prendergast did not.

44. De Gregorio, p. 231.

45. *Glackens and the Ashcan Group,* p. 258.

46. Guy Pène du Bois, *Artists Say the Silliest Things* (New York: American Artists Group; Duell, Sloan and Pearce, 1940), pp. 83–84. The title of du Bois's book was a quote from Glackens.

47. Margaret Bruening, "Glackens and Schnakenberg," *American Magazine of Art* 30 (February 1937): 117. This was not a single-artist exhibition for Glackens, but one room of the Kraushaar Galleries was given over solely to his flower paintings.

48. Ira Glackens to Joseph T. Fraser, Jr., March 18, 1955, Archives of the Pennsylvania Academy of the Fine Arts.

49. Whitney Museum of American Art, *William Glackens Memorial Exhibition* (New York, 1938); and Department of Fine Arts, Carnegie Institute, *William J. Glackens Memorial Exhibition* (Pittsburgh, 1939). A show of forty works was selected from the *Memorial Exhibition,* with most of the pictures lent by Edith Glackens; that show was circulated by the American Federation of Arts to Chicago in May, Los Angeles in July, San Francisco in September, Saint Louis in October, Louisville in November, Cleveland in December, Washington, D.C. (at the Corcoran Gallery of Art), in January 1940, and Norfolk, Virginia, in March.

Glackens's first solo exhibitions in public institutions had taken place in 1936: there was a show in February at the Addison Gallery of American Art, Phillips Academy, Andover, Massachusetts, and one in April at the Columbus (Ohio) Gallery of Fine Arts. Both shows were provided by the Kraushaar Galleries, the incentive for the second being the inclusion of three works by Glackens in the Ferdinand Howald Collection in the Columbus Gallery of Fine Arts.

50. The final exhibition was catalogued as the *Tenth Memorial Exhibition of Paintings by William Glackens;* however, the shows ran sequentially for nine years, the seventh annual occurring in November 1945 and the Ninth Annual in November 1946. I strongly suspect that there was a miscount and that, in fact, no *Eighth Annual Memorial Exhibition* occurred. I am greatly indebted to Judy Throm of the Archives of American Art, Smithsonian Institution, Washington, D.C., for providing me with the copies of these catalogs.

51. *The Fourth Annual Memorial Exhibition of the Paintings of William Glackens* (New York, 1942).

52. Jerome Mellquist, *The Emergence of an American Art* (New York: Charles Scribner's Sons, 1942), pp. 129–30.

53. Grace V. Kelley, "Glackens Memorial Showing of Paintings, Illustrations Featured at Art Museum," *Cleveland Plain-Dealer,* December 10, 1939, sec. B, p. 18; in de Gregorio, p. 305.

BIBLIOGRAPHY

Books, Periodicals, Newspapers, Theses, and Dissertations *(Arranged alphabetically)*

Allyn, Nancy E., and Elizabeth H. Hawkes. *William Glackens: Illustrator in New York, 1897–1919.* Wilmington: Delaware Art Museum, 1985.

Anderson, Margaret Steele. *The Study of Modern Painting.* New York: Century Co., 1914.

Armstrong, Regina. "Representative Young Illustrators." *Art Interchange* 43 (March 1899): 106–9.

———. "The New Leaders in American Illustration, IV: The Typists: McCarter, Yohn, Glackens, Shinn and Luks." *Bookman* 11 (May 1900): 244–51.

"Art Exhibitions." *New-York Daily Tribune,* March 20, 1912, p. 7.

"Artists at Work on 'Avenue of the Allies'." *American Art News* 17 (November 22, 1918): 5.

"Artists of the Press." *Philadelphia Museum Bulletin* 41 (November 1945), including essays by Everett Shinn and John Sloan.

"Art Notes." *New York Evening Post,* March 11, 1912, p. 7.

"Art Notes: William Glackens." *New York Evening Post,* March 8, 1913, sec. I, p. 9.

B[arker]., V[irgil]. "The Month in the Galleries: William Glackens." *Arts* 13 (May 1928): 317.

Barnes, Albert C. "L'Art de William Glackens." *Les Arts à Paris* 10 (November 1924): 2–3.

———. *The Art in Painting.* New York: Harcourt, Brace and Company, 1925.

Baury, Louis. "The Message of Proletaire." *Bookman* 11 (December 1911): 399–413.

Berman, Avis. *Rebels on Eighth Street: Juliana Force and the Whitney Museum.* New York: Atheneum, 1990.

"The Biggest Art Exhibition in America and, Incidentally, War, Discussed by W. J. Glackens." *Touchstone* 1 (June 1917): 166.

Blake, Jody. "Le Tumulte Noir: Modernist Art and Popular Entertainment in Jazz-Age Paris, 1900–1930." Ph.D. diss., University of Delaware, 1992.

Brooks, Van Wyck. "Eight's Battle for U.S. Art." *Artnews* 53 (November 1954): 41–43, 69–7.

Brown, Milton W. "The Ash Can School." *American Quarterly* 1 (summer 1949): 127–34.

———. *American Painting from the Armory Show to the Depression.* Princeton, N.J.: Princeton University Press, 1955.

———. *The Story of the Armory Show.* Rev. ed. New York: Abbeville Press, 1988.

Bruening, Margaret. "Glackens and Schnakenberg." *American Magazine of Art* 30 (February 1937): 117.

———. Comprehensive View of William Glackens." *Art Digest* 23 (January 1, 1949): 12.

Bullard, Edgar John, III. "John Sloan and the Philadelphia Real-ists as Illustrators, 1890–1920." M.A. thesis, University of California, Los Angeles, 1968.

Chamberlin, Joseph Edgar. "Two Significant Exhibitions." *New York Evening Mail,* February 4, 1908, p. 6.

Cortissoz, Royal. "The Paintings of William Glackens." *New York Herald,* December 18, 1939, sec. 6, p. 8.

Cournos, John. "Three Painters of the New York School." *International Studio* 56 (October 1915): 239–46.

Cunningham, C[harles]. C. "Recently Acquired American Landscapes." *Bulletin of the Museum of Fine Arts* (Boston) 36 (June 1938): 39–40.

———. "In Memoriam: William J. Glackens and Edith Dimock Glackens," *Wadsworth Atheneum Bulletin* 66 (June–September 1956): 1.

Davidson, Martha. "The Gay Glackens: In Memoriam." *Artnews* 37 (December 17, 1938): 9.

DeCasseres, Benjamin. "Mouquin's." *American Mercury* 25 (March 1932): 363–71.

de Gregorio, Vincent John. "The Life and Art of William J. Glackens." Ph.D. diss., Ohio State University, 1955.

[de Kay, Charles]. "Six Impressionists: Startling Works by Red-Hot American Painters." *New York Times,* January 20, 1904, p. 9.

de Mazia, Violette. "The Case of Glackens vs. Renoir," *Journal of the Art Department* (Barnes Foundation) 2 (autumn 1971): 3–30.

DeShazo, Edith. *Everett Shinn, 1876–1953: A Figure in His Time.* New York: Clarkson N. Potter, 1974.

Dinnerstein, Harvey, and Burt Silverman. "New Look at Protest: The Eight since 1908." *Artnews* 56 (February 1958): 36–39.

du Bois, Guy Pène. "Pastellists Hold Their First Exhibition: Grace and Charm Mark Delightful Show." *New York American,* January 16, 1911.

———. "W. J. Glackens Exhibition." *Arts and Decoration* 3 (April 1913): 210–11.

———. "A Modern American Collection: The Paintings of Contemporary Artists." *Arts and Decoration* 4 (June 1914): 304–6, 325–26.

———. "William Glackens, Norman Man, The Best Eyes in American Art." *Arts and Decoration* 4 (September 1914): 404–6.

———. *William J. Glackens.* American Artists Series. New York: Whitney Museum of American Art, 1931.

———. *Artists Say the Silliest Things.* New York: American Artists Group; Duell, Sloan and Pearce, 1940.

[du Bois, Guy Pène]. "Who's Who in American Art." *Arts and Decoration* 7 (October 1916): 85.

———. "Notes of the Studios and Galleries." *Arts and Decoration* 7 (February 1917): 199–200.

"Eighteen Canvases by Glackens on View." *New York American,* March 10, 1913, p. 8.

"'The Eight' Exhibit New Art Realism." *New York American,* February 4, 1908, p. 10.

Ely, Catherine Beach. "The Modern Tendency in Lawson, Lever and Glackens." *Art in America* 10 (December 1921): 132–43.

Elzea, Rowland. *John Sloan's Oil Paintings: A Catalogue Raisonné.* Vol 1. Newark: University of Delaware Press, 1991.

Ferber, Linda S. "Stagestruck: The Theater Subjects of Everett Shinn." *American Art around 1900: Lectures in Memory of Daniel Fraad.* Studies in the History of Art no. 37. Washington, D.C.: National Gallery of Art, 1990.

Fern, Alan. "Drawings by William Glackens." *Library of Congress Quarterly Journal of Current Acquisitions* 20 (December 1962): 12–18.

"First Exhibition of 'The Pastellists' Suggests the Revival of a Charming Form of Eighteenth Century Art." *New York Times,* January 15, 1991, sec. 5, p. 5.

[FitzGerald, Charles]. "Art Notes." *New York Evening Sun,* April 11, 1901, p. 4.

———. "At the American Art Galleries and Elsewhere." *New York Evening Sun,* March 4, 1902, p. 4.

———. "A Significant Group of Paintings." *New York Evening Sun,* January 23, 1904, p. 4.

———. "Certain Painters at the Society." *New York Evening Sun,* April 1, 1905, p. 4.

Fowler, Grace Alexander. "Among the Illustrators." *Harper's Bazar* 39 (June 1905): 528–34.

Francis, Henry S. "An Oil by William Glackens." *Bulletin of the Cleveland Museum of Art* 27 (March 1940): 35.

Gallatin, Albert E. *Modern Art at Venice and Other Notes.* New York: J. M. Bowles, 1910.

———. "The Art of William J. Glackens: A Note." *International Studio* 40 (May 1910): pp. lxviii–lxxi.

———. *Certain Contemporaries.* New York and London: John Lane, 1916.

———. "William Glackens." *American Magazine of Art* 7 (May 1916): 261–62.

———. *Art and the Great War.* New York: E. P. Dutton and Company, 1919.

Gerdts, William H. *Impressionist New York.* New York: Abbeville Press, 1994.

Geske, Norman A., and Karen O. Janovy, comps. and eds. *The American Painting Collection of the Sheldon Memorial Art Gallery.* Lincoln: University of Nebraska, 1988.

Gilder, The. "Palette and Brush: The Architectural League and the Eight Discontents." *Town Topics* 59 (February 6, 1908): 15.

———. "Palette and Brush: The Self-Styled Independent Artists." *Town Topics* 63 (April 7, 1910): 16.

Glackens, Ira. *William Glackens and the Ashcan Group.* New York: Crown, 1957. Rpt. as *William Glackens and The Eight: The Artists Who Freed American Art.* New York: Writers and Readers Publishing, 1992.

———. *Ira on Ira: A Memoir.* New York: Writers and Readers Publishing, 1992.

Glackens, W[illia]m. J. "The American Section: The National Art." *Arts and Decoration* 3 (March 1913): 159–62.

"Glackens at Folsom's." *American Art News* 11 (March 8, 1913): 7.

Glendinning, Nancy I. "William James Glackens: American Illustrator and Artist." M.A. thesis, Bryn Mawr College, 1965–66.

Goldin, Amy. "The Eight's Laissez-Faire Revolution." *Art in America* 61 (July–August 1973): 42–49.

Gordon, John. "Nude with Apple." *Brooklyn Museum Bulletin* 19 (winter 1958): 6–9.

Greenfeld, Howard. *The Devil and Dr. Barnes.* New York: Viking, 1987.

Gregg, Frederick James. "William Glackens' Work Foremost in That Done for Liberty Loan." *New York Herald,* October 20, 1918, sec. 3, p. 7.

[Gregg, Frederick James?]. "The Eight." *New York Evening Sun,* May 15, 1907, p. 6.

Hale, Nancy, and Fredson Bowers, eds. *Leon Kroll: A Spoken Memoir.* Charlottesville: University Press of Virginia, 1983.

"Happy Youngsters Celebrate May Day." *New York World,* May 3, 1903, p. 6.

Hawkes, Elizabeth H. *William Glackens: A Catalogue of His Book and Magazine Illustrations.* Wilmington: Delaware Art Museum, 1987.

Henning, William T., Jr. *A Catalogue of the American Collection.* Chattanooga, Tenn.: Hunter Museum of Art, 1985.

Henri, Robert. "The New York Exhibition of Independent Artists." *Craftsman* 18 (May 1910): 160–72.

———. "The 'Big Exhibition', the Artist and the Public." *Touchstone* 1 (June 1917): 174–77, 216.

———. "What about Art in America?" *Arts and Decoration* 24 (November 1925): 35.

Hirschfeld, Charles. "'Ash Can' versus 'Modern' Art in America." *Western Humanities Review* 10 (autumn 1956): 353–73.

Hoeber, Arthur. "Art and Artists." *New York Globe and Commercial Advertiser,* February 5, 1908, p. 9.

———. "Art and Artists." *New York Globe and Commercial Advertiser,* February 7, 1910, p. 8.

———. "Art and Artists." *New York Globe and Commercial Advertiser,* April 5, 1910, p. 10.

Homer, William Innes. *Robert Henri and His Circle.* Ithaca, N.Y., and London: Cornell University Press, 1969.

———. "The Exhibition of 'The Eight': Its History and Significance." *American Art Journal* 1 (spring 1969): 53–64.

Horgan, Mary H. Bothwell. "Our Leading Illustrators." *Independent* (December 14, 1905): 1397–98.

Hudson, Andrew. "The 'Ashcan' Didn't Distract Glackens." *Washington Post,* February 2, 1967, p. G9.

Huneker, James. *Promenades of an Impressionist.* New York: Charles Scribner's Sons, 1910.

[Huneker, James]. "Eight Painters: Second Article." *New York Sun,* February 10, 1908, p. 6.

———. "Around the Galleries." *New York Sun,* April 7, 1910, p. 6.

[Huneker, James?]. "Seen in the World of Art." *New York Sun,* December 18, 1910, p. 4.

———. "Glackens Seen in His Recent Art Work." *New York Sun,* March 5, 1913, p. 9.

Hunter, Sam. "The Eight, Insurgent Realists." *Art in America* 44 (fall 1956): 20–22, 56–58.

"Insurgency in Art." *Literary Digest,* April 23, 1910, pp. 814–16.

Jewell, Edward Alden. "Art of Glackens Put on Exhibition." *New York Times,* December 14, 1938, p. 29.

———. "Glackens Memorial at the Whitney." *New York Times,* December 18, 1938, p. 11.

Johnson, Stephen Burge. *The Roof Gardens of Broadway Theatres, 1883–1942.* Ann Arbor, Mich: UMI Research Press, 1985.

Katz, Leslie. "The World of the Eight." *Arts Yearbook* 1 (1957): 55–76.

Kelley, Grace V. "Glackens Memorial Showing of Paintings, Illustrations Featured at Art Museum." *Cleveland Plain-Dealer,* December 10, 1939, sec. B., p. 18.

Kloss, William. *Art in the White House: A Nation's Pride.* Washington, D.C.: White House Historical Association, 1992.

Klüver, Billy, and Julie Martin. *KiKi's Paris.* New York: Harry N. Abrams, 1989.

Lansing, David. "Mimic Royalties of May Day." *Outing* 51 (May 4, 1895): 144, 150.

Lavelle, Edward C. "Fabulous Mansion." *West Hartford News,* June 3, 1954, sec. E, pp. 1–23.

Loughery, John. "*The New York Sun* and Modern Art in America: Charles FitzGerald, Frederick James Gregg, James Gibbons Huneker, Henry McBride." *Arts* 59 (December 1984): 77–82.

[Macbeth, William]. *Macbeth Notes,* no. 35 (March 1908): 545–46.

McBride, Henry. "Modern Art." *Dial* 70 (January 1921): 111–14.

———. "Glackens's Memorial Exhibition." *New York Sun,* December 17, 1938, p. 8.

McCausland, Elizabeth. "Glackens Memorial at Whitney Museum." *Springfield* (Massachusetts) *Sunday Union and Republican,* December 25, 1938, p. 6E.

———. "Glackens Drawings." *Parnassus* 11 (November 1939): 20.

———. "The Daniel Gallery and Modern American Art." *American Magazine of Art* 44 (November 1951): 280–85.

M'C[ormick]., W. B. "Art Notes of the Week." *New York Press,* February 9, 1908, p. 6.

Marlor, Clark S. *The Society of Independent Artists: The Exhibition Record, 1917–1944.* Park Ridge, N.J.: Noyes Press, 1984.

Mather, Frank Jewett, Jr. "Some American Realists." *Arts and Decoration* 7 (November 1916): 13–16.

"May-Day in New York's Central Park." *Collier's Weekly* 39 (May 4, 1907): 8.

"May Queens Ruled Tiny Subjects in City Parks." *New York World,* May 8, 1904, p. 2.

Mead, Katherine Harper, ed. *The Preston Morton Collection of American Art.* Santa Barbara, Calif.: Santa Barbara Museum of Art, 1981.

Mellby, Julie. "A Record of Charles Daniel and the Daniel Gallery." M.A. thesis, Hunter College of the City University of New York, 1993.

Mellquist, Jerome. *The Emergence of an American Art.* New York: Charles Scribner's Sons, 1942.

Milliette, Earl B. "Art Annals of the Central High School of Philadelphia." *Barnwell Bulletin* 20 (May 1943): 5–29.

Montgomery, Robert H. "The Roof Gardens of New York." *Indoors and Out* 2 (August 1906): 214–19.

Myers, Jerome. *Artist in Manhattan.* New York: American Artists Group, 1940.

Naumann, Francis. "The Big Show: The First Exhibition of the Society of Independent Artists." Parts 1 and 2. *Artforum* 17 (February 1979): 34–39; (April 1979): 49–53.

Neil, John R. "Another Philadelphian Wins Fame in Art." *North American Book Supplement,* November 1, 1901, unpaginated.

"New Modern Gallery." *Arts and Decoration* 4 (February 1914): 159.

"New York's Art War and the Eight Rebels." *New York World,* February 2, 1908, magazine sec., p. 1.

Pach, Walter. "Manet and Modern American Art." *Craftsman* 17 (February 1910): 483–92.

———. "William J. Glackens." *Shadowland* 7 (October 1922): 10–11, 76.

———. *Queer Thing, Painting.* New York and London: Harper and Brothers, 1938.

———. "The Eight Then and Now." *Artnews* 42 (January 1, 1944): 25, 31.

"Pastellists at Folsom's." *American Art News* 9 (June 14, 1911): 6.

Pennsylvania Academy of the Fine Arts. *Description of Mural Decorations in the Lecture-Room of the Pennsylvania Academy of the Fine Arts by Students Recent and Present of the Academy Schools.* Philadelphia, n.d.

Perlman, Bennard B. *The Immortal Eight.* New York: Exposition Press, 1962.

———. "Armory Show: The Years Before." *Art in America* 51 (February 1963): 38–43.

———. *The Golden Age of American Illustration: F. R. Gruger and His Circle.* Westport, Conn.: North Light Publishers, 1978.

———. "Rebels with a Cause—The Eight." *Artnews* 81 (December 1982): 62–67.

———. "Drawing on Deadline." *Art and Antiques* (October 1988): 115–20.

———. *Robert Henri: His Life and Art.* New York: Dover, 1991.

Pisano, Ronald G. *Long Island Landscape Painting, 1820–1920.* Boston: Little, Brown and Company, 1985.

Rewald, John. *Cézanne and America.* Princeton, N.J.: Princeton University Press, 1989.

Richardson, E[dgar]. P. "The Promenade." *Bulletin of the Detroit Institute of Arts* 12 (October 1930): 8.

Richardson, Leander. "The Passing of the Roof Garden." *Metropolitan Magazine* 12 (July 1900): 81–86.

Roberts, Mary Fanton. "A Distinguished Group." *Touchstone* 6 (January 1920): 200–208.

———. William J. Glackens: His Significance to the Art of His Day." *Touchstone* 7 (January 1920): 191–99.

———. "Glackens' Walter Hampden." *Arts* 1 (December 4, 1920): 16–17.

———. "Speaking of Art: W. J. Glackens Annual Show." *Arts and Decoration* 34 (March 1931): 44–45.

[Roberts, Mary Fanton?]. "Notes of General Interest: Art in New York This Season." *Craftsman* 24 (April 1913): 135–36.

———. "Foremost American Illustrators: Vital Significance of Their Work." *Craftsman* 17 (December 1909): 266–67.

Roberts, Mary Fanton [pseud. Giles Edgerton]. "The Younger American Painters: Are They Creating a National Art?" *Craftsman* 13 (February 1908): 512–32.

"The Roof Garden: Its Function and Its Shortcomings." *Harper's Weekly* 46 (July 26, 1902): 974.

Roznoy, Cynthia. "Social Discourse in William Glackens' *The Shoppers.*" City University Graduate School, fall 1990.

St. John, Bruce, ed. *John Sloan's New York Scene from the Diaries, Notes and Correspondence, 1906–1913.* New York: Harper and Row, 1965.

Salpeter, Harry. "America's Sun Worshiper." *Esquire* 7 (May 1937): 87–88, 190–92.

Schack, William. *Art and Argyrol.* New York and London: Thomas Yoseloff, 1960.

Schnakenberg, H[enry]. E. "Exhibitions. William Glackens." *Arts* 17 (April 1931): 579–80.

Seckler, Dorothy Gees. "Fiftieth Anniversary for the Eight." *Art in America* 45 (winter 1957–58): 61–64.

Shakeshaft, Paul. "William Glackens: On the Quai." *Cresset* (Valparaiso, Indiana) 50 (January 1987): 16–23.

Sheon, Aaron. "1913: Forgotten Cubist Exhibitions in America." *Arts* 57 (March 1983): 104–5.

Shinn, Everett. "William Glackens as an Illustrator." *American Artist* 9 (November 1945): 22–27, 37.

"Six Impressionists." *New York Times,* January 20, 1904, p. 9.

Sloan, John. *Gist of Art.* New York: American Artists Group, 1939.

Strazdes, Diana. *American Paintings and Sculpture to 1945 in the Carnegie Museum of Art.* New York: Hudson Hills Press, 1992.

"Thirty Years of Glackens Revealed at Show." *Art Digest* 9 (March 1, 1935): 8.

Townsend, James B. "'The Eight' Arrive." *American Art News* 6 (February 8, 1908): 6.

Tyrrell, Henry. "Up and Down Picture Lane." *New York Evening World,* January 14, 1911, p. 6.

Washburn, Gordon B. "New American Paintings Acquired." *Carnegie Magazine* 30 (June 1956): 193–97.

Watson, Forbes. "William Glackens." *Arts and Decoration* 14 (December 1920): 103, 152.

———. *William Glackens.* New York: Duffield and Company, 1923.

———. "The Barnes Foundation." Parts 1 and 2. *Arts* 3 (January 1923): 9–22; (February 1923): 140–49.

———. "William Glackens." *Arts* 3 (April 1923): 246–61.

———. "The Innocent Bystander." *American Magazine of Art* 27 (March 1935): 166–68.

———. "A Note on William Glackens." *American Magazine of Art* 30 (November 1937): 659, 700.

———. "Glackens." *American Magazine of Art* 32 (January 1939): 4–11.

Wattenmaker, Richard J. "The Art of William Glackens." Ph.D. diss., New York University, 1972.

———. "William Glackens's Beach Scenes at Bellport." *Smithsonian Studies in American Art* 2 (spring 1988): 75–94.

"Whitney Holds Memorial for Glackens, Carefree and Independent." *Art Digest* 13 (December 15, 1938): 5, 29.

"William Glackens." *Arts* 13 (May 1928): 317.

"William Glackens: Kraushaar Galleries." *Artnews* 29 (April 18, 1931): 10.

"The William J. Glackens Exhibition." *Arts and Decoration* 3 (April 1913): 210–11.

"W. J. Glackens, Noted Painter, Dies on Visit." *New York Herald Tribune,* May 23, 1938, p. 10.

Young, Mahonri Sharp. *The Eight.* New York: Watson-Guptill Publications, 1973.

Zilczer, Judith. "'The World's New Art Center': Modern Art Exhibitions in New York City, 1913–1918." *Archives of American Art Journal* 14, no. 3 (1974): 2–7.

———. "The Aesthetic Struggle in America, 1913–1918: Abstract Art and Theory in the Stieglitz Circle." Ph.D. diss., University of Delaware, 1975.

———. "The Eight on Tour, 1908–1909." *American Art Journal* 16 (summer 1984): 20–48.

Zurier, Rebecca. "Picturing the City: New York in the Press and the Art of the Ashcan School, 1890–1917." Ph.D. diss., Yale University, 1988.

EXHIBITION CATALOGS *(Arranged chronologically)*

1904, National Arts Club, New York. *Loan Exhibition of Pictures by Robert Henri, George Luks, W. Glackens, Arthur B. Davies, and Maurice Prendergast.*

1908, Macbeth Galleries, New York. *Exhibition of Paintings by Arthur B. Davies, William J. Glackens, Robert Henri, Ernest Lawson, George Luks, Maurice B. Prendergast, Everett Shinn, John Sloan.*

1908, Detroit Museum of Art. *Paintings by Eight American Artists Resident in New York and Boston.*

1911, Folsom Galleries, New York. *Initial Exhibition of the Pastellists.*

1911, Folsom Galleries, New York. *Second Annual Exhibition of the Pastellists.*

1913, Art Society of Pittsburgh, Carnegie Institute, Pittsburgh. *List of Paintings.*

1914, Cincinnati Art Museum. *Special Exhibition: Modern Departures in Painting; "Cubism," Futurism," Etc.*

1915, Memorial Art Gallery, University of Rochester, Rochester, New York. *An Exhibition of Paintings by W. Elmer Schofield and an Exhibition of Paintings Representative of the Modern Movement in American Art.*

1915, Montross Gallery, New York. *Exhibition of Paintings, Drawings, and Sculpture.*

1915, Montross Gallery, New York. *Special Exhibition of Modern Art Applied to Decoration by Leading American Artists.*

1916, St. Botolph Club, Boston. *Paintings by William Glackens, Maurice B. Prendergast, William E. Schumacher.*

1917, Daniel Gallery, New York. *Catalogue of an Exhibition of Recent Paintings by William Glackens.*

1921, Daniel Gallery, New York. *Glackens, Henri, Lawson, Prendergast.*

1925, Kraushaar Galleries, New York. *Catalogue of an Exhibition of Paintings by William J. Glackens.*

1928, Kraushaar Galleries, New York. *Exhibition of Paintings by William Glackens.*

1931, Kraushaar Galleries, New York. *Paintings by William J. Glackens.*

1934, Art Institute of Chicago. *1934 Art Masterpieces in a Century of Progress Exhibition.*

1935, Kraushaar Galleries, New York. *Exhibition of Paintings by William J. Glackens.*

1936, Addison Gallery of American Art, Phillips Academy, Andover, Mass. *Paintings by William J. Glackens.*

1937, Whitney Museum of American Art, New York. *New York Realists, 1900–1914.*

1938, Whitney Museum of American Art, New York. *William Glackens Memorial Exhibition.*

1938, Macbeth Galleries, New York. *"The Eight," Thirty Years After.*

1939, American Federation of Arts, San Francisco. *William Glackens Memorial Exhibition.*

1939, Department of Fine Arts, Carnegie Institute, Pittsburgh. *William J. Glackens Memorial Exhibition.*

1939, [Edith Dimock Glackens residence], New York. *Loan Exhibition of Paintings by William Glackens.*

1940, [Edith Dimock Glackens residence], New York. *Second Annual Loan Exhibition of the Paintings of William Glackens.*

1941, [Edith Dimock Glackens residence], New York. *Third Exhibition.*

1942, [Edith Dimock Glackens residence], New York. *The Fourth Annual Memorial Exhibition of the Paintings of William Glackens.*

1943, Brooklyn Museum, *The Eight.*

1943, [Edith Dimock Glackens residence], New York. *Fifth Annual Memorial Exhibition of the Paintings, Sketches, and Drawings of William Glackens.*

1944, [Edith Dimock Glackens residence], New York. *Sixth Annual Memorial Exhibition of the Paintings and Drawings of William Glackens.*

1945, [Edith Dimock Glackens residence], New York. *The New York Scene. Seventh Annual Memorial Exhibition of the Paintings and Drawings of William Glackens.*

1946, [Edith Dimock Glackens residence], New York. *Ninth Annual Memorial Exhibition of the Paintings of William Glackens.*

1946, Century Association, New York. *Robert Henri and Five of His Pupils.*

1947, [Edith Dimock Glackens residence], New York. *Tenth Memorial Exhibition of Paintings by William Glackens; Also a Group of Drawings and Paintings by Lenna Glackens.*

1949, Kraushaar Galleries, New York. *Paintings and Drawings by William Glackens.*

1955, Pennsylvania Academy of the Fine Arts, Philadelphia. *The One Hundred and Fiftieth Anniversary Exhibition.*

1957, Kraushaar Galleries, New York. *William Glackens and His Friends.*

1960, Delaware Art Center, Wilmington. *The Fiftieth Anniversary of the Exhibition of Independent Artists in 1910.*

1960, The Carpenter Art Galleries, Dartmouth College, Hanover, New Hampshire. *William Glackens Retrospective Exhibition.*

1966, City Art Museum of Saint Louis. *William Glackens in Retrospect.*

1967, Kraushaar Galleries, New York. *William Glackens.*

1967, University Art Gallery, Rutgers University, New Brunswick, New Jersey. "The Art of William Glackens." *University Art Gallery Bulletin* 1, no. 1.

1969, Fort Wayne Museum of Art, Fort Wayne, Indiana. *The Art of William Glackens.*

1971, National Portrait Gallery, Smithsonian Institution, Washington, D.C. *Portraits of the American Stage, 1771–1971.*

1972, National Collection of Fine Arts, Smithsonian Institution, Washington, D.C. *Drawings by William Glackens, 1870–1938.*

1973, Metropolitan Museum of Art, New York. *American Impressionist and Realist Paintings and Drawings from the Collection of Mr. and Mrs. Raymond Horowitz.*

1976, Philadelphia Museum of Art. *Philadelphia: Three Centuries of American Art.*

1976, Utah Museum of Fine Art, Salt Lake City. *Graphic Styles of the American Eight.*

1977, Kraushaar Galleries, New York. *Drawings by William Glackens.*

1978, ACA Galleries, New York. *Nineteenth and Twentieth Century Masterpieces in New York Private Collections.*

1979, Sordoni Art Gallery, Wilkes College, Wilkes-Barre, Penn. *The Eight.*

1979, Tacoma Art Museum, Tacoma, Washington. *The American Eight.*

1980, Delaware Art Museum, Wilmington. *City Life Illustrated, 1890–1940.*

1980, Whitney Museum of American Art, New York. *The Figurative Tradition and the Whitney Museum of American Art.*

1982, Kraushaar Galleries, New York. *Exhibition of Drawings by William Glackens.*

1985, Delaware Art Museum, Wilmington. *William Glackens: Illustrator in New York, 1897–1919.*

1985, Kraushaar Galleries, New York. *William Glackens (1870–1938).*

1988, Hood Museum of Art, Dartmouth College, Hanover, New Hampshire, *"A Sweet Foretaste of Heaven": Artists in the White Mountains, 1830–1930.*

1989, Kraushaar Galleries, New York. *Drawings by William Glackens.*

1991, Kraushaar Galleries, New York. *William Glackens: The Formative Years.*

1991, Milwaukee Art Museum. *Painters of a New Century: The Eight and American Art.*

1992, Museum of Art, Fort Lauderdale. *W. Glackens: Selections from the Glackens Collection.*

1993, Museum of Art, Fort Lauderdale. *The Magic of Line: Graphics from the Glackens Collection.*

1993, Zabriskie Gallery, New York. *Charles Daniel and the Daniel Gallery, 1913–1932.*

1994, Museum of Art, Fort Lauderdale. *A Century Ago: Artists Capture the Spanish-American War.*

1994, Museum of Art, Fort Lauderdale. *William Glackens: Portrait and Figure Painter.*

1994, Metropolitan Museum of Art, New York. *American Impressionism and Realism: The Painting of Modern Life: 1885–1915.*

THE GLACKENS
COLLECTION

◆

JORGE H. SANTIS

INTRODUCTION

It took half a century for Edith Dimock Glackens's wishes to become reality.[1] In November 1990 her son, Ira Glackens, bequeathed his art collection to the Museum of Art, Fort Lauderdale, in order to perpetuate the legacy of his father, the eminent draftsman and painter William Glackens. Edith Dimock, an artist in her own right,[2] had devoted herself to keeping William's memory alive. Her perseverance, coupled with her son's generosity, have made possible the creation of a new research center at the Museum of Art, Fort Lauderdale, dedicated to the study of William Glackens and his colleagues, the American artists known as The Eight.

The museum's acquisition of the Glackens Collection, as it is now known, was not without competition. Several museums and galleries in Washington, D.C. (where Ira and his late wife, Nancy,[3] kept a townhouse), had expressed considerable interest in housing the collection. Meanwhile, C. Richard Hilker, a close friend of the Glackenses and business adviser to Ira, convinced him that the Fort Lauderdale museum would be the ideal repository for his artistic treasures.[4] In January 1991, after long weeks of negotiations and detailed inventories, the art collection arrived at its new home.

Publicly unveiling the gift had to be postponed for almost a year. Many of the paintings and works on paper needed conservation, and a handful went through more extensive restoration. Expert conservators were hired,[5] and the results of their labors are astounding: once the grime and the yellowish glazes were removed, the images came alive again.

Another factor delaying the exhibition of the Glackens Collection was the lack of suitable frames, for Edith and Ira had not been able to frame many of the works in the collection. The selection and manufacture of the museum's frames was a laborious affair, made twice as difficult by a limited budget. But this phase was finally completed, permitting, at last, the initial viewing of the Glackens gift.

The first exhibition of selected oils from the Glackens Collection went on view in February 1992 and was warmly received by art critics and the general public alike. That inaugural exhibition has been followed by shows that have focused either on overlooked phases of Glackens's career or on interesting comparisons and contrasts between his work and that of his colleagues.

The aesthetic and historical significance of the Glackens Collection is immeasurable. Comprehensive and varied, it is not only a testimony to William Glackens's talents but also a mirror of his milieu. Ranging from some of his earliest works to his last completed canvases,[6] it also includes numerous oil sketches, prints, and drawings related to major works in public and private collections all over the United States.

The Glackens Collection encompasses over four hundred works of art plus an impressive archive of photographs, documents, and news clippings dealing with the artist and his peers.[7] It provides not only a panoramic view of William Glackens's development from artist-reporter to Impressionist painter but also a sampling of artworks by colleagues and by family members: his wife, Edith Dimock

132. Edith Dimock
THE OLD SNUFF TAKER, 1912
Watercolor on paper, 7 x 7 in.

133. Louis Glackens
UNTITLED, N.D.
Pen and ink on paper, 12½ x 8 in.

(plate 132); his older brother, Louis Glackens (plate 133); and his beloved daughter, Lenna. Most of the family's creations are works on paper—sketches and watercolors that offer a welcome glimpse of Glackens's harmonious household.

William Glackens was admired and respected by his fellow artists. His keen eye, which made him highly valued as a curator and as an adviser, also helped him in developing his own collection.[8] Among the painters whose work he acquired are Guy Pène du Bois, Marjorie Organ Henri, Robert Henri, Ernest Lawson, George Benjamin Luks, Maurice and Charles Prendergast, Everett Shinn, Florence Scovel Shinn, and John Sloan. Some of their pieces may have been gifts, others may

have entered the collection through trades or gallery purchases.[9]

By closely examining the works by Glackens in the museum's collection, we learn about his taste and technique. The canvases and drawings illustrate the different stages in his career, from the "dark period" (plate 134), with its somber palette and loose brushwork sharply influenced by Diego Velázquez and Frans Hals, to the "light period" (plate 135), when Glackens's infatuation with the work of Auguste Renoir became evident.[10]

One of the most fascinating components of the collection is a series of scenes drawn by Glackens in 1898 while he was in Cuba covering the Spanish-American War for *McClure's Magazine*. These bold

134. GIRL WITH WHITE SHAWL COLLAR, C. 1894
Oil on canvas, 32 x 25½ in.

135. LAKE BATHERS, No. 2, C. 1920
Oil on canvas, 12 x 15½ in.

drawings, full of energy, demonstrate the artist's inquisitiveness and sense of adventure. One of these sketches is exceptionally engrossing because it illustrates Glackens's modus operandi. In his sketch for *Scene of Embarkation at Port of Tampa* (plate 136), he produced what can be described as the background scenery for the finished gouache now owned by the Library of Congress (plate 137). The soldiers, the intended protagonists of the scene, are noticeably missing from the sketch; they must have been incorporated from a separate, possibly later sketch or perhaps from memory. (Glackens reputedly had a photographic memory that elicited much praise from his awed colleagues.[11]) These sketches provide an indication of Glackens's ingenious pragmatism. He was a resourceful man who, when rushed by imminent danger or a frenzied schedule, could improvise.

The early artistic ties between Glackens and his mentor, Robert Henri, are particularly apparent in two canvases done during their 1895–96 sojourn in Europe (see plates 16 and 138).[12] Both have as their subject the celebration of Bastille Day in Paris, and they are so alike in spirit and in execution that at first glance their authorship could be confused. The Glackens composition is horizontal, with a vantage point higher than eye level, which gives it a more inviting and dynamic effect. His

136. Sketch for "Scene of Embarkation at Port of Tampa," 1898
Graphite on paper, 7¼ x 9⅞ in.

137. Scene of Embarkation at Port of Tampa, 1898
Pen and ink, wash, chinese white, pencil, 11⅞ x 18⅛ in.
(illustration for *McClure's Magazine;* not published)
The Library of Congress, Prints and Photographs Division, Washington, D.C.

138. Robert Henri
NIGHT, FOURTEENTH OF JULY,
c. 1896
Oil on canvas, 32 x 25¼ in.
Sheldon Memorial Art Gallery,
University of Nebraska,
Lincoln, Nebraska.
Nebraska Art Association,
Nelle Cochrane Woods Memorial

picture also suggests a greater sense of mirth and spontaneity,[13] and its figures are depicted in the same realist fashion with a limited palette of earth tones, but display a greater warmth toward each other than do their counterparts in Henri's painting. By contrast, Henri's crowd has a wooden appearance, lacking in gusto and movement.

One of the most thought-provoking canvases in the collection is *Children Roller Skating* (plate 139). Done a couple of years after the groundbreaking Armory Show, it vividly exemplifies Glackens's taste for experimentation, more closely resembling works by Kees van Dongen, Raoul Dufy, Ludwig Kirchner, and Henri Matisse than those by Henri.[14] The figures are elongated and manneristic, the landscape

lacks solidity, and any trace of realism is forsaken in favor of almost ethereal elegance. This decorative approach was an aberration but not an accident, having been carefully planned. In the collection are two works on paper that trace the roots of *Children Roller Skating*. One is a minute graphite sketch (plate 140), in which the basic layout originated. It includes the tiered landscape, the simplified tree, and the presence of figures throughout the design. A watercolor (plate 141) further explores the subject. Experimenting in that more flexible medium, Glackens attempted to work out the color and spatial relationships.

These related pieces illuminate Glackens's sometimes laborious and fastidious way of achieving his

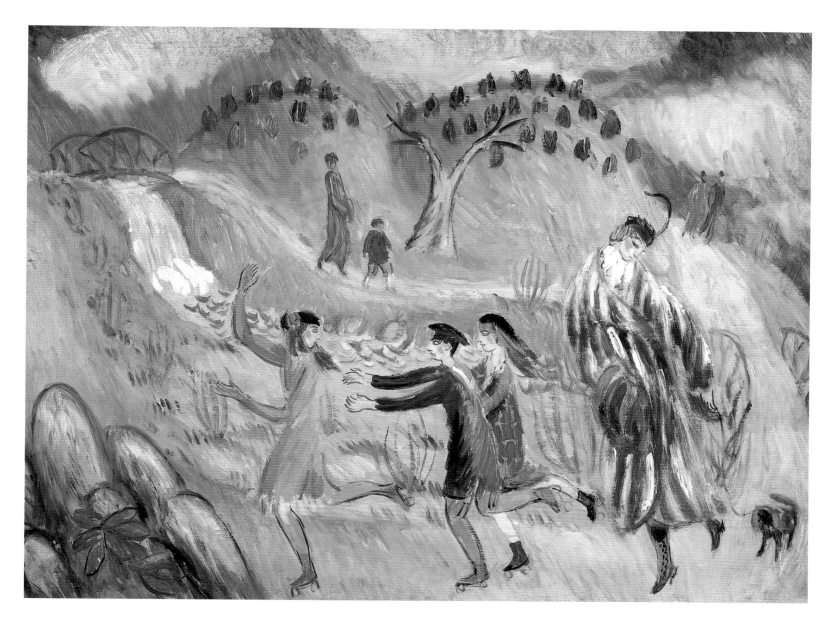

139. Children Roller
Skating, after 1913
Oil on canvas, 18 x 24 in.

140. Sketch for
"Children Roller
Skating," after 1913
Conté crayon on paper,
6 x 9¼ in.

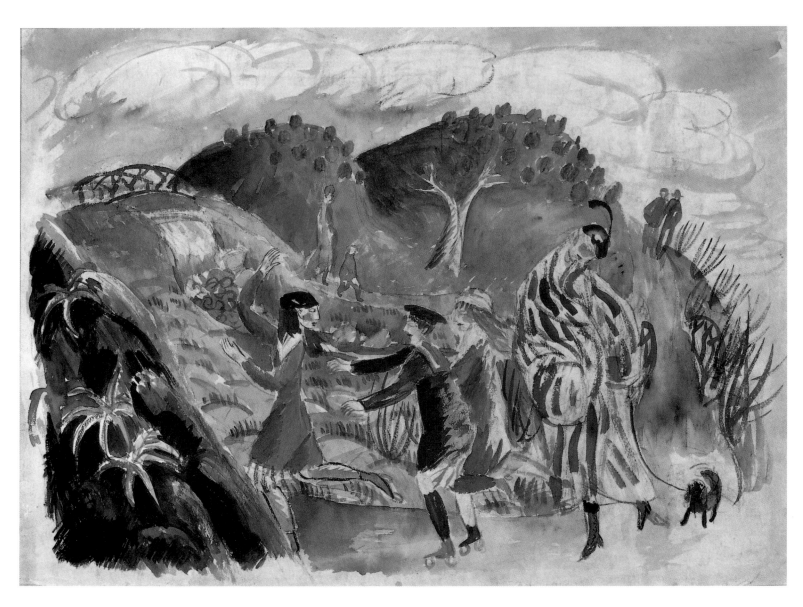

141. STUDY FOR "CHILDREN ROLLER SKATING
(A DECORATION)," AFTER 1913
Watercolor on paper, 15¾ x 21½ in.

aim. His methodical approach seems incongruous
with the generally perceived image of him as an
Impressionist painter, but his finished oils, however
evocative of motion and casualness, were often the
culmination of endless rehearsals.[15] His innate
artistic gift was enhanced by his perseverance and
his high standards.

The encyclopedic scope of the Glackens Collec-
tion is further demonstrated by the presence of such
pieces as *Nymphet Chasing Girl, No. 3*, c. 1917, and
Hindu Figure, 1916 (plates 142 and 143). These two
canvases have little in common with Glackens's
trademarks, showing no hint of romance, gentility,

or domestic bliss. Instead, they are infused with
an air of mystery, exoticism, and even danger. The
Nymphet oil is especially puzzling, revealing an un-
expectedly dark and threatening side of Glackens.
In a sylvan setting an Amazon-like nude pursues an
adolescent. Obviously distraught, the girl clutches
her doll while running in fear. The source and the
meaning of the image remains unclear, though proto-
types of humans and mythological figures cavorting
in nature might be found in images by Pierre Puvis
de Chavannes and Arthur B. Davies. Perhaps an even
closer source is Edouard Manet's *Luncheon on the
Grass* (1863; Musée d'Orsay, Paris). Following the

142. NYMPHET CHASING
GIRL, No. 3,
C. 1917
Oil on canvas, 20 x 24 in.

143. HINDU FIGURE,
C. 1916
Oil on canvas, 23¼ x 17¼ in.

144. UNTITLED (from NYMPHET SERIES), C. 1917
Watercolor and graphite on paper,
17½ x 12¾ in.

lead of the French master, Glackens portrayed fully
dressed and nude subjects together in an outdoor
setting, but unlike his predecessor, he supplanted
lyricism with urgency and peace with turmoil.

Matisse's impact on Glackens is again obvious in
a watercolor (plate 144) from the Nymphet series.
Glackens's nude looks as if she has just stepped out
of the Frenchman's *Joy of Life* (1905; Barnes Founda-
tion, Merion Station, Pennsylvania). The sinuous
quality of the limbs and the preponderance of ara-
besque lines in both works is startlingly similar.

Hindu Figure, like *Nymphet Chasing Girl, No. 3,*
is the product of aesthetic soul-searching and stylis-
tic revamping. In both cases Glackens tried to push

the potential of his original ideas to their limits.
Though little known, these works are not unique,
being variations on two themes that preoccupied the
artist during his later years.[16] Whereas Glackens's
fascination with the nymphet theme might trigger
countless psychological interpretations, his Far
Eastern compositions should not. They were con-
ceived purely as decorative schemes, with little or
no regard for their religious content.[17] Both *Hindu
Figure* and *Nymphet Chasing Girl, No. 3* exhibit the
bright palette and highly expressive brushwork of
Glackens's mature style.

Two other works in the museum's collection
illustrate an aspect of Glackens that is mostly

unseen in other collections. As is well known, even though Henri and his disciples had early training in sketching from antique casts, they rejected this method as they developed their skills and their own philosophies about art. To them, artists should directly draw from nature and experience everything firsthand.

The Museum of Art's *Venus of Cnidus* (plate 145) is one of the few known examples of Glackens's having borrowed inspiration from ancient sources.[18] What sets this pastel apart even from the few other such subjects is its timing within Glackens's artistic development. All his other antique-related images are student works produced for his teacher Henry Thouron. The *Venus of Cnidus,* however, was conceived by Glackens as an experienced artist full of self-confidence. A date of 1925 can be posited for the *Venus* because it is drawn on the reverse side of a page with two incomplete crayon sketches of Ira's torso and arms for an early version of *The Breakfast Porch* (see plate 126).[19] It is startling to see that almost thirty years after having abandoned the practice of borrowing from antiquity, Glackens would pay tribute in this way to the glorious nude

145. VENUS OF CNIDUS, C. 1925
Pastel on brown paper, 11½ x 8½ in.

146. Roman copy of THE APHRODITE OF CNIDUS
(original attributed to Praxiteles), C. 350 B.C.
Marble, h. 48 in.
Musée du Louvre, Paris

sculpture (plate 146) now in the Louvre. Was Glackens simply spellbound by its beauty and hence inspired to bring the sculpture to life again with his luminous strokes of pastel? Or was he, perhaps subconsciously, trying to rebel against a longstanding limitation on his way of working?

The esoteric drawing *A Wild Man* (plate 147) is a grotesque image that has little in common with either Glackens's joyful landscapes or his gentle portraits. The clenched teeth and startled eyes of this gorilla-like creature bespeak terror. The mystery surrounding this sketch is increased by the fact that it was not only titled and initialed by the artist but also carefully dated. Attaching these three specific bits of data to such an unpretentious drawing

was not Glackens's normal practice; in fact, only the gouaches that he produced during the Spanish-American War are labeled so thoroughly. Why was the artist being so precise about the genesis of this simple yet odd image? Did it have a special meaning to him that has been lost?

Dr. Rebecca Zurier, in her book *Art for the Masses* (1988), illustrates and discusses a cartoon by John Sloan that was published in the leftist magazine the *Masses* in February 1914 (plate 148). The drawing, entitled *Orango-Tango,* shows a burly ape dancing with a fashionably dressed woman. This piece preceded the Glackens by at least three months and may have been an indirect source for it. Furthermore, Dr. Zurier cites the numerous

147. A WILD MAN, 1914
Graphite on paper, 8½ x 5 in.

148. John Sloan
ORANGO-TANGO, C. 1914
Published in *Masses,* February 1914, p. 4. Beinecke Rare Book and Manuscript Library, Yale University, New Haven, Connecticut

149. A LARGE DISTRACTED-LOOKING WOMAN
SPRANG FORWARD, C. 1911
Pen and black ink and graphite tracing on paper,
11 x 7¼ in.

150. A LARGE DISTRACTED-LOOKING WOMAN
SPRANG FORWARD, C. 1911
Charcoal on paper, 11 x 8 in.

costume parties that were being held at that time to raise funds for the magazine.[20] If those were his sources, Glackens's desire to assimilate but not to copy again becomes clear. His figure is not a jolly creature acting human but a beast scared by something only it can see. It is an interesting comparison between Glackens and Sloan that the version created by the more romantic and refined painter of the two is the more disturbing one.

The Glackens Collection is noteworthy for containing countless examples of related images in several media, which makes it highly informative. For example, there are two drawings with identical compositions, both entitled *A Large Distracted-*

Looking Woman Sprang Forward—one in pen and ink (plate 149), the other in charcoal (plate 150). The pen-and-ink sketch—which is drier, stiffer, and more remote—appears rather stagy and austere. The charcoal version is softer, livelier, and warmer, with a more painterly effect. The chiaroscuro technique evident in the latter makes the figures appear more voluminous and endowed with a more pronounced and natural sense of motion.

These two graphics help make clear why William Glackens is hailed as one of the best draftsmen that America has produced. He understood the innate properties of each medium and employed them with aplomb and sensitivity. He knew how to be

151. Ernest Lawson
WINDBLOWN TREE, N.D.
Oil on board, 9 x 9 in.

direct with the pen and lyrical with the crayon. His talent was acute, his range immense.

Following his mother's death, Ira started generously donating canvases to various major museums; he and his wife also continued patiently cataloging William Glackens's extensive inventory.[21] That painstaking record, started by Edith, has provided an invaluable resource that has kept forgeries from muddling the market and hurting William's reputation.

The Glackens Archives—which includes a copy of this inventory, and which came to the Museum of Art, Fort Lauderdale, at the same time as the Glackens Collection—includes hundreds of photos related to Glackens's life and work. Snapshots of friends and relatives abound, as do individual photographs documenting the Glackens inventory. In addition, there are dozens of postcards, drafts of lectures on Glackens and The Eight, and crucial documents such as diplomas, diaries, and the artist's will. One jewel of the archives is a tiny notebook that Glackens carried to Europe in 1912, during his trip as purchasing agent and art adviser to his friend, Albert C. Barnes. In it Glackens listed the names of the artists whose work he saw, the titles of their canvases, the names of the art dealers he visited, and the prices he was quoted.

One of the most revealing components of the Glackens Collection is the group of twenty-five sketchbooks that cover all stages of the artist's development, providing a synopsis of his whereabouts and his thought processes. The sketchbooks are as varied in content and execution as one would expect, given the artist's versatile nature. Included in them are drawings in pencil, Conté crayon, and pen and ink, as well as a handful of experimental pastels. Glackens considered his sketchbooks his most precious possessions[22]—they were his source for poses, facial expressions, and environmental details that could be used in his oil paintings. The vital importance of these notebooks cannot be overly emphasized. They relate not only to numerous pieces in the Glackens Collection but also to the artist's works in public and private collections all over the United States. They are a key source for

resolving questions regarding authenticity and priceless tools for other scholarship and research.

The numerous works by other artists in the Glackens Collection not only offer insights into Glackens's milieu but also provide a better understanding of his taste. One of the most captivating paintings in the collection is Ernest Lawson's *Windblown Tree* (plate 151). Though small in dimensions, it has a monumental quality conveyed both by Lawson's close-up approach to the scene and by his invigorating use of impasto. This dazzling panel is also historically important because it pays tribute to Albert Pinkham Ryder, one of the most influential American artists at the turn of the century.[23] Its composition bears a striking resemblance to Ryder's *Siegfried and the Rhine Maidens* (plate 152). Lawson's work seems to quote passages of Ryder's canvas almost verbatim: the gnarled trunk and branches on the primary tree in each painting are almost identical. Although Lawson omits the equestrian Siegfried

152. Albert Pinkham Ryder
Siegfried and the Rhine Maidens, 1888/91
Oil on canvas, 19⅞ x 20½ in.
National Gallery of Art, Washington, D.C.;
Andrew W. Mellon Collection

153. WICKFORD LOW TIDE, C. 1908
Oil on canvas, 25 x 30 in.

and the mermaids, the rest of the setting is remarkably similar.

Maurice Prendergast was for many years one of William Glackens's dearest friends. They vacationed together often and for a while shared studios in the same building.[24] Around 1909 both Prendergast and Ernest Lawson influenced Glackens, a trend in his painting that preceded his later assimilation of the Impressionist style of Auguste Renoir. Glackens's beach scenes from that period, such as *Wickford Low Tide* (plate 153), are undoubtedly

Prendergast-like. The pigment along the bottom third of the painting was applied with a palette knife, creating a thick, irregular surface. A similarly Post-Impressionist effect is evident in Prendergast's *Landscape with Carriage* (also known as *Study*) (plate 154). Both works have a mosaic-like appearance—created in the oil by means of impasto and in the watercolor by allowing sections of the white paper to peek through; in both instances the result is a shimmering effect that makes the images more visually buoyant.

Wickford Low Tide is also interesting for its compositional simplicity and unfinished state. The landscape is set up as a series of consecutive horizontal planes with minimal regard to atmospheric perspective. The blue-violet bands of color farthest away from us have an abstract quality that suggests a link to such Abstract Expressionist painters as Mark Rothko, with whom Glackens shared a sensitivity to the poetic properties of color. The unfinished upper quadrant in this painting is one of the most painterly passages in any Glackens oil. The blue sky is depicted by a crisscross pattern of brushwork that reveals areas of bare canvas underneath. This spareness contrasts sharply with the impasto used below. This painting more than any

other in the collection gives a sense of the artist's presence: exploring, testing, and ultimately abandoning an idea.

The inclusion of work by Guy Pène du Bois in the Glackens holdings is not surprising; for decades he was not only a close family friend but also a devoted admirer of Glackens's talent and a critic who repeatedly praised him in print.[25] The museum boasts a fine example of du Bois's acerbic style in *Pets,* 1927 (plate 155). The male in the picture, a high-ranking officer, looks at the portly female disapprovingly, perhaps in response to her taking more than her share of the available space. Meanwhile the dog peacefully waits, unaware of the rising antagonism. A canvas like *Pets* would have

154. Maurice Prendergast
LANDSCAPE WITH CARRIAGE (also known as STUDY), C. 1912–13
Watercolor and graphite on paper, 14¾ x 21¾ in.

155. Guy Pène du Bois
PETS, 1927
Oil on canvas, 21½ x 18½ in.

been very appealing to all the members of the Glackens household. Edith was well known for her cleverness, while William had an appreciation of humor and pranks that is most apparent in his graphic work. Furthermore, the inclusion of the four-legged friend likely proved irresistible to the Glackenses, since all of them were animal lovers.

Like most artists, William Glackens was immersed in his own work. His greatest satisfaction came from painting, and he dedicated most of his energy to it. Collecting was more of a sideline of his profession than a passionate or systematic pursuit. To this day, Helen Farr Sloan regrets that the Glackenses never acquired a John Sloan canvas for their collection, particularly since Glackens had the greatest affection and admiration for his fellow "Ashcanner."[26]

William, Edith, and Ira were not ambitious collectors. The artists represented in their holdings were mainly close friends and associates. The themes and the mediums of their work are generally subdued, featuring family portraits, restful landscapes, or graphics that were part of group projects.[27] The collection reflects the family's outlook on life and the world. To them every experience counted. They loved art, life, and one another. The Glackens Collection is not only a valuable compendium of Glackens's own art, but also a multifaceted reflection of lives dedicated to the pursuit of beauty and truth.

NOTES

1. In the brief article "Annual Tribute Paid William Glackens" (*Art Digest* [November 15, 1942]: 11), Edith Glackens voiced her determination not to sell any of her late husband's paintings, so that they all could eventually go to a museum dedicated to him. Helen Farr Sloan (widow of John Sloan and an artist and historian), among others, has questioned the wisdom of this decision, believing that Edith's refusal to sell any paintings from the estate had a damaging effect on the then promising market for Glackens's work. (Helen Farr Sloan, interview with author, 1992.)

 For ten years following her husband's death in 1938, Edith held an annual exhibition of his work at her Greenwich Village home. Each show was presented for a month (November–December) and featured works from all facets of his career.

2. Edith briefly studied with William Merritt Chase and attended the New York School of Art around 1901. (Ira Glackens, *William Glackens and the Ashcan Group* [New York: Crown, 1957], rpt. as *William Glackens and The Eight: The Artists Who Freed American Art* [New York: Writers and Readers Publishing, 1990], pp. 35–36.) A proficient watercolorist, she exhibited at the American Water Color Society, 1904; the Armory Show, 1913; and the Whitney Studio Club, 1927. (Ibid., pp. 57, 182, and 233.)

3. Anne Henshaw Middlebrook was Ira's wife for over fifty years. She was from an affluent family whose forebears included the original occupants of Gracie Mansion in Manhattan. Like her husband, Anne was a fancier of good art, food, and spirits. And, like Ira and his relatives, she was a lover of liberal causes. Abhorring racial and gender discrimination, she also was an environmentalist and a great supporter of animal rights. She died at age seventy-nine, five months before Ira.

4. Mr. Hilker initially convinced Ira to donate William Glackens's *Cape Cod Pier,* 1908, to the museum, and that canvas soon became one of the most popular pieces in the collection. To Ira's great delight, it was widely reproduced and promoted by the museum. In 1990, three years after that initial donation and again following Mr. Hilker's advice, Ira bequeathed his personal collection to the museum. Mr. Hilker is presently not only a member of the museum's board of trustees but also president of the Sansom Foundation.

 In addition to his personal collection, Ira had been responsible for the pieces constituting the Sansom Foundation. The Sansom Foundation, whose name was derived from the street in Philadelphia where William was born, is a nonprofit entity established in 1956. The aim of the foundation has been to support the arts and to bring relief to unwanted pets. Income to run the Sansom Foundation is obtained through the sale of artworks from the Glackens estate.

5. Readying the Glackens Collection for display as well as pre-serving it for future generations has been a major undertaking; after more than three years of work there is still much to be done. First, a comprehensive conservation survey was performed to evaluate the condition of the collection and to determine priorities and schedules. Next, with support from the Sansom Foundation, three painting and two paper conservators were hired: Emilio Cianfoni, Rustin Levenson, and James Swope; Tom Schmitt and Lisa Hall. They spent endless hours returning the Glackens pieces to their original condition and correcting or stabilizing any deterioration. Their dedication and enthusiasm have been exemplary.

6. *Philadelphia Landscape,* 1893 (plate 5), is regarded as one of Glackens's earliest completed paintings. Also in the collection are what Ira identified as his last finished painting, *White Rose and Other Flowers,* 1937 (plate 130), and his final pochade—an untitled panel depicting three tubes of paint and a bottle of turpentine.

7. There are 91 paintings on canvas or panel by William Glackens in the collection, plus 248 works on paper, which range from Conté-crayon drawings to etchings. The rest of the collection comprises paintings, graphics, and a handful of sculptures by his contemporaries and his family.

8. In 1910 Glackens was a member of the selection committee for the *Exhibition of Independent Artists;* among the other panelists were George Bellows, Robert Henri, Walt Kuhn, Everett Shinn, and John Sloan. (Milwaukee Art Museum, *Painters of a New Century: The Eight and American Art* [Milwaukee, 1991], p. 100.) Three years later Glackens served as chairman of the committee in charge of choosing the American entries for the legendary Armory Show. (Glackens, *William Glackens and The Eight,* p. 181.) In 1917 Glackens's preeminence was acknowledged with his election as first president of the Society of Independent Artists; he served a one-year term and was succeeded by John Sloan. (Milwaukee Art Museum, *Painters of a New Century,* p. 97.) Glackens also served as adviser to Dr. Albert C. Barnes during the doctor's early years as art collector.

9. Edith Dimock Glackens bought Maurice Prendergast's *Landscape with Carriage* (also known as *Study*), c. 1912–13, at the Armory Show (a label handwritten by Ira states its provenance and calls it "their pride and joy"). Charles Prendergast's *Bounding Deer,* 1936 (cat. no. 412), has a label noting that it was once the property of Kraushaar Galleries, New York. Other pieces that were most likely purchased by one of the Glackenses are the sculptures by Jane Wasey and Antoine-Louis Barye and the drawings by Ronald Searle and Tom Hardy. Many of these works postdate William and Edith and were acquired by Ira.

10. Vincent John de Gregorio, in a doctoral dissertation done for

Ohio State University in 1955, after extensive correspondence with Ira Glackens (the Glackens Archives at the Museum of Art, Fort Lauderdale, includes some of these letters), identified three distinctive periods in Glackens's career. They are the "dark period" (1890s to 1905); the "transitional period" (1905–10); and the "bright period" (1910–38). (Vincent John de Gregorio, "The Life and Art of William J. Glackens," Ph.D. diss., Ohio State University, 1955, pp. 117–92.)

11. Glackens had an amazing memory for details and nuances. According to Everett Shinn, it was essentially unnecessary for Glackens to carry paper and pencil to his assignments; "One look was all that was required." (Everett Shinn, "William Glackens as an Illustrator," *American Artist* 9 [November 1945]: 23.)

12. The Glackens piece goes by the French title *Quatorze Juillet*; Henri's is called *Night, Fourteenth of July*. Both were probably done around 1895–96, but the date of Henri's canvas is problematic. In *Robert Henri: Painter*, a 1984 catalog published by the Delaware Art Museum, the canvas is assigned to 1898 (p. 43); Elizabeth Milroy has recently placed it in 1899 (in Milwaukee Art Museum, *Painters of a New Century*, p. 123). If either of those two dates were correct, it would mean that Glackens's version preceded his mentor Henri's by as much as three years; though possible, that is highly unlikely.

13. Henri encouraged his followers to work at great speed, capturing the magic of an instant, "rendering their work free from detail treatment and preserving that impression which first delighted the sense of beauty." (Quoted in Bennard B. Perlman, *Robert Henri: His Life and Art* [New York: Dover Publications, 1991], pp. 24–25.)

14. Matisse's influence on Glackens is clearly discerned in at least two other oils in the museum's collection: *The Pink Silk Trousers*, c. 1916–18, and *Back of Nude*, c. 1930s. In the former, the exotic theme and the disturbing eye makeup are Fauvist; in the latter the use of green for shadows on flesh also recalls the French artist's work.

15. The compositional development of some major and minor canvases can be traced through examples in the Glackens Collection; the process could be described, simplistically, as one of trial and error. In some cases a progression can be traced through graphite sketches, pastels, watercolors, and even several oil panels. Each stage would provide an opportunity to test, alter, and refine the basic design.

16. The Barnes Foundation in Merion Station, Pennsylvania, owns a different version of the Hindu theme, entitled *Krishna*. Their canvas is more symmetrical, more decorative, and blander. The seminude male figure is again depicted in the lotus position, framed by a rock; also repeated is the unclothed heavenly incarnation emerging from a cloud. The Fort Lauderdale painting, although unfinished, is more arresting, with a freer composition and execution.

17. In one of his books Ira described his mother as "anti-church" and "anti-clerical," and both she and William were buried without any memorial service. (Ira Glackens, *Ira on Ira: A Memoir* [New York: Writers and Readers Publishing, 1992], p. 8.) The Glackens household was agnostic; William and Edith concentrated their efforts on fighting discrimination and abuse. They were known as ardent suffragists, and according to Ira, they marched together in a parade along Fifth Avenue as early as 1913. (Glackens, *Ira on Ira*, p. 184.)

18. Glackens's first rendering of an antique subject—two Roman busts—appears first in a sheet in an early notebook, part of the Fort Lauderdale holdings (cat. no. 230). Another example is the undated *Orestes Pursued by the Furies*, owned by the Philadelphia Museum of Art. A small gouache-and-pencil work, it depicts a group of nude men and women in a landscape. Written on the verso is: "The composition does not consider the story literally but more as representing conscience in the abstract"—a statement that forthrightly proclaims Glackens's intention of exercising artistic freedom even within the confines of a mythological subject. The Pennsylvania Academy of the Fine Arts also possesses a canvas by Glackens rooted in a classical allegory; known as *Justice*, it was done in 1896 as part of a series of murals painted under the guidance of Henry Thouron.

19. It is very doubtful, considering the vulnerability of the medium, that Glackens would have reused a much earlier sheet. Furthermore, all of the studies, as well as the finished canvas for *The Breakfast Porch*, were done at a summer house at Samois-sur-Seine, not only near Fontainebleau, but also the Louvre, where the *Venus* is on display (de Gregorio, "The Life and Art of William J. Glackens," p. 264).

20. Rebecca Zurier, *Art for the Masses* (Philadelphia: Temple University Press, 1988), pp. 104–6. Dr. Zurier also cites the tango rage sweeping New York at that time and refers to an advertisement for dancing lessons at twenty-five dollars per hour, which the Sloan image was parodying.

21. The original card files of their inventory are part of the Archives of American Art, Smithsonian Institution, Washington, D.C.; a copy is at the Museum of Art, Fort Lauderdale. That inventory, though helpful, deals mainly with the oils on canvas; most of the oils on board and the watercolors are omitted.

22. "He mourned them when one was lost. They were more valued by him than his paintings." (Ira Glackens, *Drawings by William Glackens, 1870–1938* [Washington, D.C.: National Collection of Fine Arts, Smithsonian Institution, 1972], p. 27.)

23. Ira Glackens frequently described William as a man of few words. Nevertheless, he recounts that Albert Pinkham Ryder was "the only American painter whose work I remember my father ever specifically mentioning." (Glackens, *William Glackens and The Eight*, p. 183.)

24. Ibid., pp. 109, 114, 116.

25. Guy Pène du Bois, Leon Kroll, and Eugene Speicher acted as an advisory committee in selecting paintings for the *William Glackens Memorial Exhibition*, hosted by the Whitney Museum of American Art six months after his death. In the introduction to the show's catalog du Bois expressed the hope that one day Glackens would be as celebrated as Thomas Eakins, Winslow Homer, and Albert Pinkham Ryder. (Whitney Museum of American Art, *William Glackens Memorial Exhibition* [New York, 1938], p. 6.)

26. Mrs. Sloan's sentiments were expressed to me during a visit to her home in Wilmington, summer 1992.

27. The Glackens inventory includes numerous etchings and photogravures relating to Paul de Kock's books published in 1902–3. These are not all by Glackens; some are by George Benjamin Luks, James Moore Preston, and John Sloan.

CATALOG OF THE COLLECTION

Works by Glackens are organized in the catalog by date within the following sections:
Paintings, Watercolors and Gouaches, Drawings, Sketchbooks, Etchings and Drypoints, and
Photogravures and Lithographs. Works by other artists follow.
All dimensions are canvas or sheet sizes; height is followed by width.

ABBREVIATIONS FOR FREQUENTLY
CITED REFERENCES
Allyn and Hawkes: Allyn, Nancy E., and
Elizabeth H. Hawkes. *William Glackens:
A Catalogue of His Book and Magazine
Illustrations.* Wilmington: Delaware Art
Museum, 1987.

Glackens: Glackens, Ira. *William Glackens
and the Ashcan Group.* New York: Crown,
1957. Rpt. as *William Glackens and The
Eight: The Artists Who Freed American
Art.* New York: Writers and Readers Pub-
lishing, 1990.

Hawkes: Hawkes, Elizabeth H. *John
Sloan's Illustrations in Magazines and
Books.* Wilmington: Delaware Art
Museum, 1993.

FREQUENTLY CITED EXHIBITIONS
William Glackens Memorial Exhibition,
Whitney Museum of American Art, New
York, December 14, 1938–January 15, 1939;
Carnegie Museum of Art, Pittsburgh,
February 1–March 15, 1939.

William Glackens in Retrospect, City Art
Museum of Saint Louis, November 18–
December 31, 1966; National Collection
of Fine Arts, Washington, D.C., Febru-
ary 1–April 2, 1967; Whitney Museum
of American Art, New York, April 25–
June 11, 1967.

Selections from the Glackens Collection,
Museum of Art, Fort Lauderdale, Decem-
ber 19, 1991–August 21, 1992.

Touch of Glackens, Museum of Art, Fort Lau-
derdale, August 28, 1992–January 12, 1993.

*The Magic of Line: Graphics from the
Glackens Collection,* Museum of Art, Fort
Lauderdale, February 12–August 15, 1993.

*William Glackens: Portrait and Figure
Painter,* Museum of Art, Fort Lauderdale,
February 10–July 17, 1994.

WILLIAM GLACKENS (1870–1938)

Provenance of works by Glackens is as follows, unless otherwise indicated:
The artist; Ira Glackens; Museum of Art, Fort Lauderdale.

PAINTINGS

1. *Philadelphia Landscape,* 1893
Oil on canvas
17¾ x 24 in.
Accession no. 92.41
See plate 5

EXHIBITIONS
William Glackens in Retrospect, no. 1.

Touch of Glackens.

COMMENTS
One of Glackens's earliest canvases—
if not *the* earliest.

2. *Autumn Landscape,* c. 1893–95
Signed l.r.: *W. Glackens*
Oil on canvas
25 x 30 in.
Accession no. 94.68
See plate 8

3. *Girl with White Shawl Collar,* c. 1894
Oil on canvas
32 x 25½ in.
Accession no. 94.1
See plate 134

EXHIBITIONS
*William Glackens: The Formative
Years,* Kraushaar Galleries, New
York, May 8–June 8, 1991, no. 3.
*William Glackens: Portrait and
Figure Painter.*

4. *Quatorze Juillet,* 1895–96
Oil on canvas
25¼ x 30¼ in.
See plate 16
Accession no. 94.67

5. *In the Luxembourg,* c. 1896
Signed l.r.: *W. Glackens*
Oil on canvas

16 x 19 in.
Accession no. 91.40.66
See plate 14

PROVENANCE
The artist; Charles FitzGerald;
Ira Glackens; Museum of Art,
Fort Lauderdale.

EXHIBITIONS
Selections from the Glackens Collection.

COMMENTS
Glackens is known to have painted
four different versions of this subject;
the other three are in the Wichita Art
Museum, Wichita, Kansas; the Cor-
coran Gallery of Art, Washington,
D.C.; and the Munson-Williams-
Proctor Institute Museum of Art,
Utica, New York.

6. *Outside the Guttenberg Race Track (New Jersey),* 1897
Signed l.r.: *W. Glackens*
Oil on canvas
25½ x 32 in.
Accession no. 94.4
See plate 26

BIBLIOGRAPHY
Glackens, ill. after p. 50.

EXHIBITIONS
Seventieth Annual Exhibition of American Paintings, Watercolors and Sculpture, Pennsylvania Academy of the Fine Arts, Philadelphia, 1901, no. 539.

William Glackens Memorial Exhibition, no. 74.

Memorial Exhibition of Works by William J. Glackens, Department of Fine Arts, Carnegie Institute, Pittsburgh, 1939, no. 52.

William Glackens Memorial Exhibition, Arts Club of Chicago, 1939, no. 33.

The Art of William Glackens, University Art Gallery, Rutgers University, New Brunswick, New Jersey, January 10–February 10, 1967, no. 1.

William Glackens: The Formative Years, Kraushaar Galleries, New York, May 8–June 8, 1991, no. 6.

7. *Girl in Black Cape,* c. 1897
Signed l.r.: *W. Glackens*
Oil on canvas
32 x 25½ in.
Accession no. 94.2
See plate 31

EXHIBITIONS
William Glackens in Retrospect, no. 4.

William Glackens: Portrait and Figure Painter.

8. *Dancer in Pink Dress,* 1902
Oil on canvas
40½ x 24 in.
Accession no. 94.13
See plate 33

9. *Portrait of Charles FitzGerald,* 1903
Oil on canvas
75 x 40 in.
Accession no. 92.45
See plate 43

PROVENANCE
The artist; Charles FitzGerald; Ira Glackens; Museum of Art, Fort Lauderdale.

BIBLIOGRAPHY
Glackens, ill. after p. 50.

EXHIBITIONS
William Glackens in Retrospect.

William Glackens: The Formative Years, Kraushaar Galleries, New York, May 8–June 8, 1991.

William Glackens: Portrait and Figure Painter.

America around 1900: Impressionism, Realism, and Modern Life, Virginia Museum of Fine Arts, June 12–September 17, 1995; Museum of Art, Fort Lauderdale, Florida, October 27, 1995–January 14, 1996.

COMMENTS
FitzGerald was art critic for the *New York Evening Sun* and a strong supporter of Glackens's work. He married Glackens's sister-in-law, Irene Dimock.

10. *Tugboat and Lighter,* 1904–5
Oil on canvas
25 x 30 in.
Accession no. 91.40.154
See plate 53

BIBLIOGRAPHY
"Seventh Memorial Exhibition of Paintings by William Glackens." *Villager* (New York), November 1, 1945.

EXHIBITIONS
Third Exhibition, Edith Dimock Glackens residence, New York, November 13–December 14, 1941, no. 4.

The New York Scene. Seventh Annual Memorial Exhibition of the Paintings and Drawings of William Glackens, Edith Dimock Glackens residence, New York, November 2, 1945.

William Glackens in Retrospect, no. 14.

Selections from the Glackens Collection.

America around 1900: Impressionism, Realism, and Modern Life, Virginia Museum of Fine Arts, June 12–September 17, 1995; Museum of Art, Fort Lauderdale, Florida, October 27, 1995–January 14, 1996.

COMMENTS
The canvas has a Charles E. Prendergast frame made in 1917.

11. *Dancer in Blue,* c. 1905
Oil on canvas
48 x 30 in.
Accession no. 92.43
See plate 32

EXHIBITIONS
Touch of Glackens.

William Glackens: Portrait and Figure Painter.

COMMENTS
The blue-gray palette of this work is highly reminiscent of *Chez Mouquin* (plate 39) and *Tugboat and Lighter* (cat. no. 9, plate 53), two works that were completed in 1905—hence our tentative date.

12. *Study for "Flying Kites, Montmartre,"* 1906
Oil on panel
6 x 8 in.
Accession no. 91.40.1
See plate 63

EXHIBITIONS
Selections from the Glackens Collection.

COMMENTS
This is a study for a larger work in the collection of the Museum of Fine Arts, Boston.

13. *Café de la Paix* (also known as *Paris Café*), c. 1906
Signed l.r.: *W. Glackens*
Oil on canvas
15 x 18¼ in.
Accession no. 91.40.146
See plate 60

EXHIBITIONS
William Glackens Memorial Exhibition, no. 13.

The Fourth Annual Memorial Exhibition of the Paintings of William Glackens, Edith Dimock Glackens residence, New York, November 6–December 6, 1942, no. 2 (as *Paris Café*).

William Glackens in Retrospect, no. 19.

Selections from the Glackens Collection.

14. *Portrait of Ferdinand Sinzig* (also known as *Portrait of a Musician* and *Portrait of a Musician [Ferdinand Sinzig]*), c. 1906
Signed l.r.: *W. Glackens*
Oil on canvas

75¼ x 40 in.
Accession no. 92.38
See plate 48

EXHIBITIONS
William Glackens Memorial Exhibition, no. 10 (as *Portrait of a Musician [Ferdinand Sinzig]*).

The Fourth Annual Memorial Exhibition of the Paintings of William Glackens, Edith Dimock Glackens residence, New York, November 6–December 6, 1942, no. 31 (as *Portrait of a Musician*).

Selections from the Glackens Collection.

William Glackens: Portrait and Figure Painter.

COMMENTS
Ferdinand Sinzig, a noted German composer and musician, became a close friend of the Glackenses after he immigrated to the United States.

15. *Cape Cod Pier,* 1908
Signed l.r.: *W. Glackens*
Oil on canvas
26 x 32 in.
Accession no. 85.74
See plate 70

EXHIBITIONS
At the Water's Edge, Tampa Museum of Art, Tampa, Florida, December 9, 1979–March 4, 1990; Center for the Arts, Vero Beach, Florida, May 4, 1990–June 17, 1990; Virginia Beach Center for the Arts, Virginia Beach, July 8–September 2, 1990.

Selections from the Glackens Collection.

Touch of Glackens.

16. *Wickford Low Tide,* c. 1908
Oil on canvas
25 x 30 in.
Accession no. 94.69
See plate 153

17. *Twenty-three Fifth Avenue, Interior,* c. 1910
Signed on the reverse: *W. Glackens*
Oil on canvas
19½ x 24 in.
Accession no. 91.40.135
See plate 72

EXHIBITIONS
Summer's Lease, Corcoran Gallery of Art, Washington, D.C., June 13–August 31, 1972.

Selections from the Glackens Collection.

18. *Sledding, Central Park,* 1912
Signed l.r.: *W. Glackens*
Oil on canvas
23 x 31½ in.
Accession no. 91.40.150
See plate 81

EXHIBITIONS
William Glackens Memorial Exhibition, no. 90.

Fifth Annual Memorial Exhibition of the Paintings, Sketches, and Drawings of William Glackens, Edith Dimock Glackens residence, New York, November 6–December 5, 1943, no. 5.

William Glackens in Retrospect, no. 38.

Selections from the Glackens Collection.

19. *Self-Portrait,* c. 1912
Signed by Edith Glackens on the reverse: *W.G. by E.G.*
Oil on board
12 x 10 in.
Accession no. 91.40.9

EXHIBITIONS
Selections from the Glackens Collection.

William Glackens: Portrait and Figure Painter.

COMMENTS
This is one of only a handful of self-portraits by Glackens, probably painted when he was in his forties.

20. *Study for "Sledding, Central Park,"* c. 1912
Oil on panel
6 x 8 in.
Accession no. 91.40.2

EXHIBITIONS
Selections from the Glackens Collection.

COMMENTS
This oil sketch establishes the basic composition for the large canvas (cat. no. 18, plate 81) owned by the Museum of Art, Fort Lauderdale.

21. *Ira's Toy Witches,* c. 1913
Signed by Edith Glackens on the reverse: *W.G. by E.G.*
Oil on board
13 x 16 in.
Accession no. 91.40.17

19.

21.

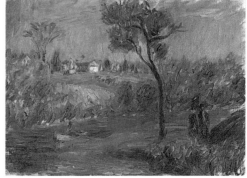

22.

22. *Cemetery by the River,* after 1913
Signed by Edith Glackens on the
reverse: *W.G. by E.G.*
Oil on board
12 x 15½ in.
Accession no. 91.40.58

EXHIBITIONS
Selections from the Glackens Collection.

*The Magic of Line: Graphics from the
Glackens Collection.*

23. *Children Roller Skating,* after 1913
Signed on the reverse: *W. Glackens*
Oil on canvas
18 x 24 in.
Accession no. 92.37
See plate 139

24. *Lenna at One Year,* 1914
Oil on canvas
15 x 12 in.
Accession no. 92.35
See plate 95

EXHIBITIONS
*Fifth Annual Memorial Exhibition
of the Paintings, Sketches, and Draw-
ings of William Glackens,* Edith
Dimock Glackens residence, New
York, November 6–December 5,
1943, no. 1.

Selections from the Glackens Collection.

25. *Mother and Baby, Washington
Square,* 1914
Signed l.r.: *W. Glackens*
Oil on canvas
14¼ x 17½ in.

Accession no. 91.40.137
See plate 78

EXHIBITIONS
Third Exhibition, Edith Dimock
Glackens residence, New York,
November 13–December 14, 1941,
no. 5.

Selections from the Glackens Collection.

26. *Roses in a Tobacco Jar,* after 1914
Oil on canvas
15 x 11½ in.
Accession no. 91.40.60

27. *Standing Girl in White Spats,* 1915
Signed l.r.: *W. Glackens*
Oil on canvas
29½ x 17½ in.
Accession no. 91.40.65
See plate 103

EXHIBITIONS
William Glackens in Retrospect, no. 50.

Selections from the Glackens Collection.

28. *The Picnic Island,* c. 1915
Signed by Edith Glackens on the
reverse: *W.G. by E.G.*
Oil on panel
12 x 16 in.
Accession no. 91.40.50

COMMENTS
Edith and one of the children are
shown by the water's edge.

29. *Study for "Walter Hampden as
Hamlet,"* 1916
Signed l.r.: *W. Glackens*

Oil on canvas
26 x 13½ in.
Accession no. 91.40.147
See plate 91

COMMENTS
Walter Hampden was an accom-
plished actor, best known for his
roles as Cyrano de Bergerac and
Hamlet. This is one of two large oil
sketches of the subject (the other is
in a private collection). The final
life-size version is in the National
Portrait Gallery, Smithsonian Insti-
tution, Washington, D.C. (see
plate 90).

30. *Buddha and the Maidens
(A Decoration),* c. 1916
Oil on canvas
48 x 30 in.
Accession no. 94.5
See plate 106

31. *Hindu Figure,* c. 1916
Oil on canvas
23¼ x 17¼ in.
Accession no. 91.40.313
See plate 143

32. *The Pink Silk Trousers,* c. 1916–18
Oil on canvas
25 x 18 in.
Accession no. 92.36

EXHIBITIONS
Selections from the Glackens Collection.

26.

28.

32.

33. *The Conservatory* (also known as *Lenna and Her Mother in the Conservatory*), c. 1917
Signed l.r.: *W. Glackens*
Oil on canvas
18 x 24 in.
Accession no. 91.40.116
See plate 92

EXHIBITIONS
William Glackens Memorial Exhibition, no. 32.

Fifth Annual Memorial Exhibition of the Paintings, Sketches, and Drawings of William Glackens, Edith Dimock Glackens residence, New York, November 6–December 5, 1943, no. 8 (as *Lenna and Her Mother in the Conservatory*).

Selections from the Glackens Collection.

Intimates and Confidants in Art: Husbands, Wives, Lovers and Friends, Nassau County Museum of Art, Roslyn Harbor, New York, February 28–May 23, 1993.

COMMENTS
This canvas was painted during one of the Glackenses' visits to the Dimock estate in West Hartford, Connecticut.

34. *Horse Chestnut, Washington Square,* c. 1917
Oil on canvas
9¾ x 10½ in.
Accession no. 91.40.13

35. *Nymphet Chasing Girl, No. 3,* c. 1917
Oil on canvas
20 x 24 in.
Accession no. 94.3
See plate 142

COMMENTS
The young girl being chased is probably Maisie, the model for *Maisie with Apple* (Kraushaar Galleries), done around the same time; she wears the same dress in both canvases.

36. *The Artist's Daughter in Chinese Costume* (also known as *Lenna in Chinese Costume, Lenna in Chinese Coat, The Artist's Daughter (Lenna in Chinese Costume), Girl in Oriental Costume,* and *Child in Chinese Dress*), 1918
Signed l.l.: *W. Glackens*

34.

39.

40.

Oil on canvas
48 x 30 in.
Accession no. 92.28
See plate 97

BIBLIOGRAPHY
Watson, Forbes. *William Glackens.* New York: Duffield and Company, 1923.

"A Memorial Exhibition." *New York Times,* December 17, 1938, p. 22.

"Annual Tribute Paid William Glackens." *Art Digest,* November 15, 1942, p. 11.

EXHIBITIONS
Catalogue of an Exhibition of Paintings by William J. Glackens, Kraushaar Galleries, New York, April 1–22, 1925, frontispiece (as *Child in Chinese Dress*).

Exhibition of Painting by William Glackens, Kraushaar Galleries, New York, February–March 1935, no. 7 (as *Child in Chinese Costume*).

William Glackens Memorial Exhibition, no. 26 (as *Child in Chinese Costume*).

Fifth Annual Memorial Exhibition of the Paintings, Sketches, and Drawings of William Glackens, Edith Dimock Glackens residence, New York, November 6–December 5, 1943 (as *Lenna in Chinese Coat*).

Paintings and Drawings by William Glackens, Kraushaar Galleries, New York, January 7–31, 1949, no. 39 (as *Girl in Oriental Costume*).

The Art of William Glackens, University Art Gallery, Rutgers University, New Brunswick, New Jersey, January 10–February 10, 1967, no. 22 (as *Lenna in Chinese Costume*).

Selections from the Glackens Collection.

Touch of Glackens.

COMMENTS
Glackens carved the frame for this painting.

37. *Lenna Painting,* c. 1918
Oil on canvas
12½ x 15½ in.
Accession no. 91.40.118
See plate 96

EXHIBITIONS
Selections from the Glackens Collection.

38. *Study for "Music Hall Turn"* (also known as *A Vaudeville Turn*), c. 1918
Oil on canvas
13 x 16 in.
Accession no. 91.40.151
See plate 84

EXHIBITIONS
William Glackens Memorial Exhibition.

Selections from the Glackens Collection.

COMMENTS
This canvas was exhibited at the *William Glackens Memorial Exhibition* and listed as having been completed around 1918. The composition is a detail from a drawing done by Glackens to illustrate a story by James L. Ford entitled "Our Melancholy Pastimes," which appeared in *Frank Leslie's Popular Monthly* in April 1904. The canvas depicts only the act seen on the stage, which occupies the background of the drawing.

39. *Nude in White Hat,* c. 1918
Oil on canvas
29¼ x 24¼ in.
Accession no. 91.40.314

EXHIBITIONS
William Glackens: Portrait and Figure Painter.

COMMENTS
This finished version of cat. no. 40 is quite faithful to it; the one obvious change is the depiction the model's left hand in the larger canvas.

40. *Nude Woman with Hat,* c. 1918
Oil on panel
12 x 10½ in.
Accession no. 91.40.139

EXHIBITIONS
William Glackens: Portrait and Figure Painter.

COMMENTS
On the reverse of this double-sided panel is an incomplete oil sketch for *The Artist's Daughter in a Chinese Costume* (cat. no. 36). This nude image was later repeated and amplified in a piece, also part of the Glackens bequest, with similar title (cat. no. 39).

41.

44.

45.

47.

41. *Study in a Garden,* c. 1918
Oil on canvas
12¼ x 15½ in.
Accession no. 91.40.28

42. *The Bandstand,* 1919
Oil on canvas (unfinished)
25 x 30 in.
Accession no. 92.29
See plate 89

EXHIBITIONS
Selections from the Glackens Collection.

43. *Home in New Hampshire,* c. 1919
Oil on canvas
22 x 32 in.
Accession no. 91.40.114
See plate 108

EXHIBITIONS
William Glackens Memorial Exhibition, no. 71.

Selections from the Glackens Collection.

44. *Sketch for "Head of Ira,"* c. 1919
Signed by Edith Glackens on the reverse: *W.G. by E.G.*
Oil on board
16 x 12 in.
Accession no. 91.40.34

EXHIBITIONS
William Glackens: Portrait and Figure Painter.

COMMENTS
This panel is a composite of unconnected images. In the center is a portrait of a pensive adolescent (Ira); most of the lower half is devoted to a sylvan landscape with ladies in white gowns. In several spots, there are traces of the artist's attempt to scratch off details.

45. *House in Conway,* 1920
Oil on canvas
18 x 24 in.
Accession no. 91.40.18

EXHIBITIONS
The Magic of Line: Graphics from the Glackens Collection.

46. *The Artist's Wife Knitting,* c. 1920
Signed l.l.: *W.G.*
Oil on canvas
24 x 30 in.
Accession no. 91.40.108
See plate 93

BIBLIOGRAPHY
"Ninth Annual Memorial Exhibition." *Villager* (New York), November 7, 1946.

EXHIBITIONS
Ninth Annual Memorial Exhibition (Featuring Portraits), Glackens residence, New York, November 7–December 1, 1946.

Selections from the Glackens Collection.

Intimates and Confidants in Art: Husbands, Wives, Lovers and Friends, Nassau County Museum of Art, Roslyn Harbor, New York, February 28–May 23, 1993.

47. *Bathing in Conway,* c. 1920.
Signed by Edith Glackens on the reverse: *W.G. by E.G.*
Oil on board
6 x 8¼ in.
Accession no. 91.40.128

48. *Hillside, New Hampshire,* c. 1920
Signed by Edith Glackens on the reverse: *W.G. by E.G.*
Oil on board
12 x 16 in.
Accession no. 91.40.32

49. *Lake Bathers, No. 2,* c. 1920
Signed by Edith Glackens on the reverse: *W.G. by E.G.*
Oil on canvas
12 x 15½ in.
Accession no. 91.40.110
See plate 135

EXHIBITIONS
Selections from the Glackens Collection.

50. *Untitled,* c. 1920
Oil on board
5¾ x 8 in.
Accession no. 91.40.90

COMMENTS
This image reappears in a few of Glackens's sketchbooks, and a larger version of it belongs to the Sansom Foundation.

51. *Portrait of Edith, Ira and Lenna in the Living Room,* c. 1920
Oil on canvas
59 x 69 in.
Accession no. 91.40.130

COMMENTS
This incomplete family portrait was executed in the same setting as *The*

48.

50.

51.

53.

Artist's Wife Knitting (cat. no. 46). The Sansom Foundation owns several oil sketches that relate to it and trace Glackens's attempts to arrive to an effective composition; in one of them a fourth figure was added, seated in the armchair on the right.

52. *Lenna with Rabbit Hound,* c. 1922
Signed l.l.: *W. Glackens*
Oil on canvas
26 x 32 in.
Accession no. 91.40.103
See plate 100

EXHIBITIONS
Selections from the Glackens Collection.

COMMENTS
Lenna is shown wearing the same striped skirt and sweater as in *Home in New Hampshire* (cat. no. 43). This scene was probably painted in Conway.

53. *Mount Washington from South Conway,* c. 1922
Signed l.r.: *W. Glackens*
Oil on canvas
12½ x 15½ in.
Accession no. 91.40.188

54. *Ira and Lenna's Egyptian Burial Ground,* 1923
Oil on canvas
13 x 16 in.
Accession no. 92.46
See plate 109

EXHIBITIONS
The Magic of Line: Graphics from the Glackens Collection.

55. *Nude in Green Chair,* after 1924
Oil on canvas (unfinished)
30 x 25 in.
Accession no. 92.33
See plate 104

EXHIBITIONS
Selections from the Glackens Collection.

56. *Breakfast Porch,* 1925
Oil on canvas
30 x 25 in.
Accession no. 92.30
See plate 126

EXHIBITIONS
Selections from the Glackens Collection.

An Ode to Gardens and Flowers, Nassau County Museum of Art,

58.

59.

60.

61.

64.

ished version of this composition (private collection) in which the back of a chair is introduced in the foreground; in the final version (private collection), Ira and his mother have been dropped from the composition, and Lenna has been shifted to the center.

57. *Flowers on a Garden Chair,* 1925
Signed l.r.: *W. Glackens*
Oil on canvas
20 x 15 in.
Accession no. 91.40.112
See plate 127

BIBLIOGRAPHY
"Tenth Memorial Exhibition of Paintings by William Glackens." *World Tribune Review,* November 1947.

EXHIBITIONS
William Glackens Memorial Exhibition, no. 45.

Fifth Annual Memorial Exhibition of the Paintings, Sketches, and Drawings of William Glackens, Edith Dimock Glackens residence, New York, November 6–December 5, 1943, no. 4.

Tenth Memorial Exhibition of Paintings by William Glackens, Edith Dimock Glackens residence, New York, November 2–30, 1947, no. 4.

Selections from the Glackens Collection.

58. *Lenna on a Donkey,* 1925
Oil on canvas
12 x 16 in.
Accession no. 91.40.7

EXHIBITIONS
Selections from the Glackens Collection.

COMMENTS
This panel was painted in Vence, during one of Glackens's frequent sojourns in France. This composition relates to *The Promenade* (plate 112), in the Detroit Institute of Arts.

59. *Untitled,* c. 1925
Signed by Edith Glackens on the reverse: *W.G. by E.G.*
Oil on panel
8¾ x 10½ in.
Accession no. 91.40.43

COMMENTS
This is probably a view of Vence, France, where the Glackenses vacationed in 1925 and 1930.

Roslyn Harbor, New York, May 10–August 9, 1992.

The Magic of Line: Graphics from the Glackens Collection.

COMMENTS
Painted at Samois-sur-Seine, near Fontainebleau, France, this canvas features Edith flanked by her two offspring. There is another, unfin-

60. *Woman in a White Blouse and a Black Skirt,* c. 1925
Oil on canvas
10 x 13¼ in.
Accession no. 91.40.127

61. *Woman in White Chemise,* c. 1925
Signed bottom center: *W. Glackens*
Oil on board
11½ x 9½ in.
Accession no. 91.40.182

62. *Along the Marne,* after 1925
Signed by Edith Glackens on the reverse: *W.G. by E.G.*
Oil on board
12½ x 15½ in.
Accession no. 91.40.107
See plate 114

EXHIBITIONS
Selections from the Glackens Collection.

The Magic of Line: Graphics from the Glackens Collection.

63. *Provençal Landscape,* after 1925
Signed by Edith Glackens on the
reverse: *W.G. by E.G.*
Oil on board
13 x 16 in.
Accession no. 91.40.21

64. *Villa Gardens,* after 1925
Signed by Edith Glackens on the
reverse: *W.G. by E.G.*
Oil on canvas board
12½ x 15½ in.
Accession no. 91.40.117

65. *Town of Vence,* c. 1925–26(?)
Signed by Edith Glackens on the
reverse: *W.G. by E.G.*
Oil on board
12½ x 16 in.
Accession no. 91.40.156
See plate 115

66. *English Ballet Girl,* 1926
Signed by Edith Glackens on the
reverse: *W.G. by E.G.*
Oil on canvas
18 x 15 in.
Accession no. 92.26

EXHIBITIONS
Selections from the Glackens Collection.

67. *Study for "Bal Martinique,"* 1926
Oil on canvas
19½ x 24 in.
Accession no. 92.32
See plate 120

EXHIBITIONS
Selections from the Glackens Collection.

COMMENTS
This composition was later reworked
by the artist on a larger scale; see
plate 119.

68. *Untitled (Trees),* c. 1927
Signed by Edith Glackens on the
reverse: *W.G. by E.G.*
Oil on canvas
12¾ x 15½ in.
Accession no. 91.40.82

COMMENTS
The subject of this painting is a
simple tree-lined road somewhere in
the south of France. This landscape
was incorporated in the background
of *The French Fair (Children's
Swings)* (John H. Surovek Gallery,
Palm Beach, Florida).

65.

66.

68.

69. *Bowlers, La Ciotat,* 1930
Signed l.l.: *W. Glackens*
Oil on canvas
25 x 30 in.
Accession no. 92.31
See plate 117

EXHIBITIONS
Selections from the Glackens Collection.

COMMENTS
The Sansom Foundation owns a
canvas similar to this one and
bearing the same title and date.

70. *The Ledges, South France,* 1930
Signed by Edith Glackens on the
reverse: *W.G. by E.G.*
Oil on board
13 x 16 in.
Accession no. 91.40.33

71. *Flowers in a Quimper Pitcher,* c. 1930
Signed l.l.: *W. Glackens*
Oil on canvas
24 x 18 in.
Accession no. 91.4.144
See plate 129

EXHIBITIONS
William Glackens in Retrospect,
no. 67, frontispiece of catalog.

Selections from the Glackens Collection.

72. *Bay Shore Creek,* 1931
Signed by Edith Glackens on the
reverse: *W.G. by E.G.*
Oil on board
11½ x 15 in.
Accession no. 91.40.124

73. *Outdoor Café,* c. 1932
Oil on canvas
14½ x 18 in.
Accession no. 92.40

EXHIBITIONS
*The Magic of Line: Graphics from the
Glackens Collection.*

COMMENTS
The Museum of Art also owns sev-
eral crayon drawings related to this
canvas. They are all done from the
same angle but some of the props
change. Initially a small black cat
was featured at the lower-right cor-
ner of this canvas; it was eliminated
from this composition but reappears
in Glackens's *Café de Pêcheurs*
(Kraushaar Galleries, New York).

74. *Route de Trajus, Cannes,* c. 1932
Signed by Edith Glackens on the
reverse: *W.G. by E.G.*
Oil on board
12½ x 14 in.
Accession no. 91.40.93

COMMENTS
This panel was most likely done
when William and Edith visited
Cannes in 1932.

70.

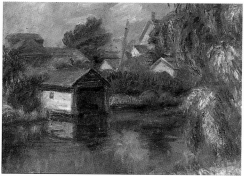

72.

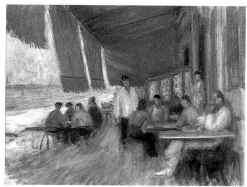

73.

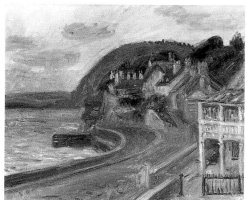

74.

75. *Baie St. Paul, Quebec, No. 2,* 1934
Signed by Edith Glackens on the
reverse: *W.G. by E.G.*
Oil on canvas
12½ x 15½ in.
Accession no. 91.40.68
See plate 122

EXHIBITIONS
Touch of Glackens.

COMMENTS
This panel illustrates Glackens's
technique of erasing mistakes or
deleting details by simply scraping
them off the painted surface; here
he erased sections of sky from the
upper registers of the panel.

76. *Baie St. Paul, Quebec, No. 4,* 1934
Signed by Edith Glackens on the
reverse: *W.G. by E.G.*
Oil on board
11½ x 15 in.
Accession no. 91.40.91

77. *Rockport, Massachusetts, No. 5,* 1936
Signed u.l.: *W. Glackens*
Oil on board
11¼ x 19½ in.
Accession no. 91.40.27
See plate 123

COMMENTS
This unfinished version was followed
by a larger, less elongated canvas
(Kraushaar Galleries, New York) that
Glackens also left incomplete.

78. *White Rose and Other Flowers,* 1937
Signed l.l.: *W. Glackens*
Oil on canvas
20 x 15 in.
Accession no. 91.40.148
See plate 130

PROVENANCE
The artist; Ira Glackens; Museum of
Art, Fort Lauderdale.

EXHIBITIONS
*William Glackens Memorial
Exhibition,* no. 83.

Selections from the Glackens Collection.

COMMENTS
According to Ira Glackens, this
was the last canvas that his father
completed.

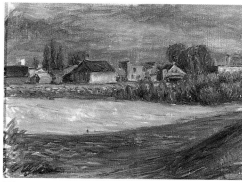

75.

79.

81.

79. *Untitled,* 1938
Oil on board
6¼ x 8½ in.
Accession no. 92.27

COMMENTS
According to Ira Glackens, this
was the last pochade his father
worked on.

80. *Back of Nude,* c. 1930s
Oil on canvas
30 x 25 in.
Accession no. 92.34
See plate 105

EXHIBITIONS
Selections from the Glackens Collection.

82.

83

85.

81. *Bread, Banana, and Grapes*, c. 1930s
Signed l.l.: *W. Glackens*; signed by
Edith Glackens on the reverse:
W.G. by E.G.
Oil on board
12½ x 15½ in.
Accession no. 91.40.125

82. *Calendula in Glass Pitcher*, c. 1930s
Signed by Edith Glackens on the
reverse: *W.G. by E.G.*
Oil on board
15¾ x 11½ in.
Accession no. 91.40.104

83. *Flowers in a Luster Pitcher*, c. 1930s
Signed by Edith Glackens on the
reverse: *W.G. by E.G.*
Oil on board
16 x 13 in.
Accession no. 91.40.126

84. *Fruit and a White Rose*, c. 1930s
Signed by Edith Glackens on the
reverse: *W.G. by E.G.*
Oil on board
13 x 16 in.
Accession no. 91.40.26
See plate 128

85. *Fruits, Grapes and Pears*, c. 1930s
Signed by Edith Glackens on the
reverse: *W.G. by E.G.*
Oil on board
8½ x 10½ in.
Accession no. 91.40.45

87.

88.

89.

86.

86. *Lily and Two Flowers,* c. 1930s
Oil on canvas
14 x 9¾ in.
Accession no. 91.40.102

87. *Pineapple,* c. 1930s
Oil on canvas
12¼ x 9½ in.
Accession no. 91.40.129

EXHIBITIONS
Selections from the Glackens Collection.

88. *Plums in a Saucer,* c. 1930s
Signed l.r.: *W.G.*
Oil on canvas
7¼ x 10½ in.
Accession no. 91.40.115

EXHIBITIONS
Selections from the Glackens Collection.

90.

89. *Red Berries and Yellow Leaves,*
c. 1930s
Oil on canvas
14 x 8¼ in.
Accession no. 91.40.20

EXHIBITIONS
*Fifth Annual Memorial Exhibition of
the Paintings, Sketches, and Drawings
of William Glackens,* Glackens resi-
dence, New York, November 6–
December 5, 1943.

*The Magic of Line: Graphics from the
Glackens Collection.*

91.

90. *Rose and Tulips in a Purple Vase,*
c. 1930s
Oil on canvas
13 x 10 in.
Accession no. 91.40.186

91. *Roses with Daisies,* c. 1930s
Oil on canvas
16 x 12 in.
Accession no. 91.40.123

92. *Two Roses,* c. 1930s
Signed by Edith Glackens on the
reverse: *W.G. by E.G.*
Oil on canvas
15½ x 12 in.
Accession no. 91.40.86

92.

93. *Tom Moore's Cottage,* c. 1892
Gouache on paper
7 x 4¾ in.
Accession no. 92.137

EXHIBITIONS
The Magic of Line: Graphics from the Glackens Collection.

COMMENTS
Tom Moore's cottage is one of the sites that Glackens frequented on his country excursions with his brother, Louis, and his friends—among them, John Sloan.

94. *Untitled,* c. 1892
Signed l.l.: *W. Glackens*
Gouache on paper
7½ x 5 in.
Accession no. 91.40.208

95. *Untitled,* c. 1892
Wash on wallpaper
3¼ x 5⅛ in.
Accession no. 91.40.321

96. *Barn Den,* c. 1892
Inscribed l.l.: *Barn Den*
Gouache on paper
7 x 4¾ in.
Accession no. 92.136

EXHIBITIONS
The Magic of Line: Graphics from the Glackens Collection.

COMMENTS
This appears to be a very early sketch done in the outskirts of Philadelphia.

97. *The Night after San Juan,* 1898
Watercolor, pen and black ink on paper
16 x 13 in.
Accession no. 91.40.67
See plate 19

BIBLIOGRAPHY
Glackens, ill. p. 25.

EXHIBITIONS
The Magic of Line: Graphics from the Glackens Collection.

A Century Ago: Artists Capture the Spanish-American War, Museum of Art, Fort Lauderdale, February 10–July 17, 1994.

COMMENTS
This gouache was done by Glackens in Cuba while recording the Spanish-American War for *McClure's Magazine.*

98. *"Did You Ever Hear of the Harbour-Master?" He Asked, Maliciously,* 1899
Signed l.l.: *W. Glackens*
Gouache on paper
9 x 12 in.
Accession number 91.40.25

Original drawing for: Robert W. Chambers, "The Harbor Master," *Ainslee's Magazine* 4 (August 1899): ill. p. 60.

BIBLIOGRAPHY
Allyn and Hawkes, cat. no. 28.

EXHIBITIONS
The Magic of Line: Graphics from the Glackens Collection.

99. *Plodding Far Behind in Pink Uniforms and Very Dejected,* 1899
Signed l.r.: *W. Glackens*
Gouache, charcoal, and wash on paper
6⅞ x 14 in.
Accession no. 91.40.98

Original drawing for: Arthur Colton, "The Portate Ultimatum," *Scribner's Magazine* 26, no. 6 (December 1899): ill. p. 716.

BIBLIOGRAPHY
Allyn and Hawkes, cat. no. 866.

EXHIBITIONS
Exhibition of Illustrations, Pennsylvania Academy of the Fine Arts, Philadelphia, 1936.

The Magic of Line: Graphics from the Glackens Collection.

100. *A Young Doctor, Especially during the Growth of His First Beard, Is Invariably a Music Lover,* 1900
Signed u.l.: *W. Glackens*
Gouache on paper

8½ x 11½ in.
Accession no. 91.40.77
See plate 20

Original drawing for: Marion Hill, "A Tune in Court: A Story of the Italian Quarter in San Francisco," *McClure's Magazine* 15, no. 2 (June 1900): ill. p. 174.

BIBLIOGRAPHY
Allyn and Hawkes, cat. no. 359.

EXHIBITIONS
The Magic of Line: Graphics from the Glackens Collection.

COMMENTS
On the reverse of this watercolor is a sketch for a book illustration in Thomas Nelson Page's *Santa Claus's Partner* (New York: Charles Scribner's Sons, 1899), 42. In this piece a warmly dressed man with top hat and umbrella is shown making his way carefully through the snow.

101. *Edouard,* 1903
Signed l.r.: *W. Glackens*
Watercolor, pen and black ink on paper
13 x 7 in.
Accession no. 91.40.153

Original drawing for: Charles-Paul de Kock, *Frère Jacques,* vol. 1. St. Gervais ed. (Boston: Quinby, 1903), ill. p. 191.

BIBLIOGRAPHY
Allyn and Hawkes, cat. no. 995.

COMMENTS
This was one of the countless drawings that Glackens made to illustrate the more than twenty volumes of translated stories by Charles-Paul de Kock that were published in 1902–4.

102. *Love Letter to Edith Dimock,* July 7, 1903
Ink and wash on paper
9½ x 7½ in.
Accession no. 92.133
See page 265

BIBLIOGRAPHY
Glackens, ill. p. 41.

93.

94.

96.

98.

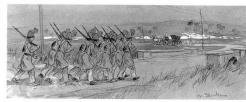

99.

101.

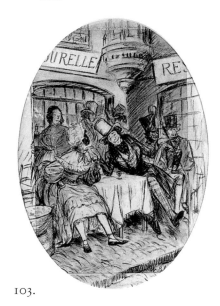

103.

104.

EXHIBITIONS
The Magic of Line: Graphics from the Glackens Collection.

COMMENTS
In this letter Glackens wrote: "I invoked your spirit and we had a fine time all by ourselves. . . . It was the next best thing to having you there." The words are accompanied by a drawing in which he converses with the ghost of Edith Dimock, whom he would marry in February 1904. The sketch not only includes a glimpse of the Manhattan skyline but also his straw hat flying off.

103. *The Greatest Happiness That a Grisette Can Experience Is to Make the Conquest of an Actor,* 1904
Signed l.r.: *W. Glackens*
Charcoal and wash on paper
5½ x 4 in.
Accession no. 91.40.92

Original drawing for: Charles-Paul de Kock, *Edmond and His Cousin, etc.* (Boston: Quinby, 1904), ill. p. 192.

BIBLIOGRAPHY
Allyn and Hawkes, cat. no. 1017.

Glackens, ill. p. 43.

104. *Each Spirit as It Passed Squealed and Kicked Backward at Sir Clement, Showing a Spectral Leg,* 1906
Gouache on paper
5⁹⁄₁₆ x 9½ in.
Accession no. 91.40.204

Original drawing for: Arthur Colton, "The Ghosts of Senzeille: A Christmas Adventure," *Collier's Weekly* (December 15, 1906), ill. p. 21.

BIBLIOGRAPHY
Allyn and Hawkes, cat. no. 110.

105. *Ira on a Rocket,* 1907
Signed l.r.: *W. Glackens;* inscribed on
bottom: *Fourth of July Celebration in
the Glackens home. Mother and Son
feeling very well*
Watercolor and graphite on board
12 x 8 in.
Accession no. 91.40.122
See page 266

PROVENANCE
The artist; Mr. and Mrs. L. Stinson;
Ira Glackens; Museum of Art, Fort
Lauderdale.

EXHIBITIONS
*The Magic of Line: Graphics from the
Glackens Collection.*

COMMENTS
This drawing, mailed to Mr. and
Mrs. Stinson, marked the birth of
Glackens's first child, Ira, on July 4,
1907. The child is shown, appropri-
ately, riding a firecracker over the
Washington Square arch.

106. *Curb Exchange, No. 3,* 1907–10
Gouache and Conté crayon on paper
26½ x 18 in.
Accession no. 92.44
See plate 22

EXHIBITIONS
*The Magic of Line: Graphics from the
Glackens Collection.*

COMMENTS
This is one of three known versions
of this scene. The other two are
owned by Arthur G. Altschul and
by the Georgia Museum of Art,
University of Georgia, Athens.

107. *Then Ouldsbroom, He Shouted Out
the Terrible News* (also known as
*'Tis Your Good Man's Done Away
with Himself. Sorry to Have to Tell
You),* 1909
Signed l.r.: *W. Glackens*
Graphite and wash with Chinese
white over blue pencil on board
10 x 13 in.
Accession no. 91.40.11

BIBLIOGRAPHY
Allyn and Hawkes, cat. no. 544.

Original drawing for: Eden Phill-
potts, "The Last Straw," *Putnam's
Monthly and the Reader* 6, no. 5
(August 1909): ill. p. 584.

EXHIBITIONS
*Drawings by William Glackens,
1870–1938,* National Collection of
Fine Arts, Smithsonian Institution,
Washington, D.C., February 25–
April 30, 1972, no. 31.

*The Magic of Line: Graphics from the
Glackens Collection.*

108. *Aha! Me Hated Rival! Unhand Her,
Villain, or Thy Life Be the Penalty!
Beside I Want a Ham and—,* 1912
Signed u.r.: *W. Glackens*
Charcoal and wash on paper
10 x 6 in.
Accession no. 91.40.84

BIBLIOGRAPHY
Allyn and Hawkes, cat. no. 131.

Original drawing for: May Brown,
"A Broad Prairie Mating," *Collier's
Magazine* 49, no. 24 (August 31,
1912): ill. p. 18.

EXHIBITIONS
*The Magic of Line: Graphics from the
Glackens Collection.*

109. *Christmas Shoppers, Madison Square*
(also known as *Fifth Avenue
Shoppers),* 1912
Signed l.r.: *W. Glackens*
Crayon and watercolor on paper
17½ x 31 in.
Accession no. 91.40.106
See plate 23

EXHIBITIONS
*William Glackens Memorial
Exhibition,* no. 125.

*The New York Scene. Seventh
Memorial Exhibition of the Paintings
and Drawings of William Glackens,*
Edith Dimock Glackens residence,
November 2, 1945 (as *Fifth Avenue
Shoppers*).

William Glackens in Retrospect,
no. 121 (as *Christmas Shoppers—
Madison Square*).

*Drawings by William Glackens,
1870–1938,* National Collection of
Fine Arts, Smithsonian Institution,
Washington, D.C., February 25–
April 30, 1972, no. 46 (as *Christmas
Shoppers—Madison Square*).

*Visions of New York City—American
Paintings, Drawings and Prints of
the Twentieth Century,* Tokyo Metro-
politan Art Museum, March 20–
May 24, 1981.

*The Magic of Line: Graphics from the
Glackens Collection.*

COMMENTS
The overfilled bus, seen at bird's-eye
view, counts among its passengers
the artist's son.

110. *Study for "Children Roller Skating
(A Decoration),"* after 1913
Watercolor on paper
15¾ x 21½ in.
Accession no. 92.42
See plate 141

EXHIBITIONS
*The Magic of Line: Graphics from the
Glackens Collection.*

111. *Go Let Them In,* before 1916
Signed l.r.: *W. Glackens*
Gouache and crayon on paper
12 x 10 in.
Accession no. 94.70

112. *Untitled (Hindu Series),* c. 1916
Watercolor and graphite on paper
13½ x 9¼ in.
Accession no. 94.71

113. *Untitled* (from *Nymphet Series*),
c. 1917
Watercolor and graphite on paper
17½ x 12¾ in.
Accession no. 94.72
See plate 144

114. *Suddenly He Let Drop His Glasses,
Grabbed the Wheel, and Pulled It
Hard toward Him,* 1918
Signed bottom center: *W. Glackens*
Charcoal and black ink wash
on paper
9¾ x 12¾ in.
Accession no. 91.40.35
Original drawing for: James B.
Connolly, "Flotilla Smiles," *Collier's*
61, no. 13 (June 8, 1918): ill. p. 14.

BIBLIOGRAPHY
Allyn and Hawkes, cat. no. 145.

EXHIBITIONS
*The Magic of Line: Graphics from the
Glackens Collection.*

107.

112.

116.

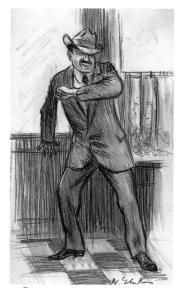

108.

114.

115. *When Her Stern Rises He Lifts His Feet and Shoots and Fetches Up— Bam!* 1918
Signed l.r.: *W. Glackens*
Charcoal and wash on paper
10¾ x 9 in.
Accession no. 91.40.41

Original drawing for: James B. Connolly, "Our Dauntless Destroyer Boys," *Collier's Weekly* 61, no. 14 (June 15, 1918): ill. pp. 8–9.

BIBLIOGRAPHY
Allyn and Hawkes, cat. no. 147.

EXHIBITIONS
The Magic of Line: Graphics from the Glackens Collection.

116. *Woman on a Couch,* c. 1920
Gouache and charcoal on paper
7½ x 9½ in.
Accession no. 91.40.46

EXHIBITIONS
The Magic of Line: Graphics from the Glackens Collection.

111.

115.

117. *Untitled,* before 1889
Signed: *Butts G—*
Ink on paper
6 x 2¼ in.
Accession no. 92.134

EXHIBITIONS
The Magic of Line: Graphics from the Glackens Collection.

118. *Untitled,* c. 1889
Signed: *W. J. Glackens*
Ink on paper
7½ x 5½ in.
Accession no. 92.141

COMMENTS
This image illustrates Glackens's propensity to alter his signature often and radically. This one is signed *W. J. Glackens.* He also signed his works in a variety of other ways, such as "Butts Glack," "Glack," "W. Glackens," "W. J.," or not even at all (as is the case with some of his best-known works).

119A–B. A: *Darby Creek,* c. 1892
B: *Untitled,* c. 1892
A: inscribed on side l.l.: *Darby Creek*
B: inscribed on side with color instructions
Graphite on paper
4½ x 7 in. each
Accession nos. 91.40.323.A–B

120A–C. *Untitled,* c. 1892
Inscribed with color instructions
Graphite on paper
4½ x 7 in. each
Accession nos. 91.40.322.A–C

121. *Untitled,* c. 1895
Pen and ink on paper
5¾ x 9 in.
Accession no. 94.79

122. *Sketch for "Facade of Royal Palace in Santiago de Cuba,"* 1898
Graphite and charcoal on paper (from sketchbook)
8¾ x 6¾ in., image; 15 x 12¼ in., framed
Accession no. 91.40.312

123A–B. A: *Sketch for "Scene of Embarkation at Port of Tampa,"* 1898
B: *Sketch for "Santiago de Cuba,"* 1898
Graphite on paper
7¼ x 9⅞ in. each
Accession nos. 91.40.225.A–B
A: see plate 136

124. *Untitled,* early 1900s
Inscribed l.r.: *Sept. 10th*
Ink on paper
7¼ x 5¼ in.
Accession no. 92.109

125. *How She Saved the General,* 1902
Signed l.r.: *W. Glackens*
Pen and black ink on paper
9¼ x 8½ in.
Accession no. 91.40.53

126. *Graft,* 1903
Signed l.l.: *W. Glackens*
Colored pastel on paper
10 x 8 in.
Accession no. 91.40.19
See plate 21

EXHIBITIONS
William Glackens in Retrospect, no. 97.

Drawings by William Glackens, 1870–1938, National Collection of Fine Arts, Smithsonian Institution, Washington, D.C., February 25–April 30, 1972, no. 11.

The Magic of Line: Graphics from the Glackens Collection.

127. *Scipio,* 1903
Ink on paper
11⅛ x 8⅞ in.
Accession no. 91.40.206

BIBLIOGRAPHY
Allyn and Hawkes, cat. no. 620.

Original drawing for: James L. Ford, "Our American Snobs: Mrs. Foxglove's Wedding," *Saturday Evening Post* 176, no. 4 (July 25, 1903): ill. p. 6.

EXHIBITIONS
The Magic of Line: Graphics from the Glackens Collection.

128. *Untitled,* 1903
Ink on paper
9½ x 7½ in.
Accession no. 91.40.203

COMMENTS
This drawing resembles *Scipio* (cat. no. 127) in medium, rendering, and paper stock.

117.

118.

121.

125.

129A.

122.

127.

129B.

124.

128.

129C.

130.

146.

149.

144.

147.

150.

145.

148.

151.

129A–C. *Portrait of William Glackens as a Small Boy to Satisfy a Lack,* c. 1903
Graphite on paper (triptych)
A, C: 6 x 4¼ in.; B: 5 x 3¼ in.
Accession nos. 91.40.181.A–C

130. *Untitled,* c. 1903
Charcoal on paper
5½ x 7½ in.
Accession no. 91.40.209

131. *Untitled,* c. 1903
Charcoal on paper
4½ x 5³⁄₁₆ in.
Accession no. 91.40.212

132. *Untitled,* c. 1903
Charcoal on paper
5⅛ x 4½ in.
Accession no. 91.40.213

133. *Untitled,* c. 1903
Charcoal on paper
4⁷⁄₁₆ x 5⅛ in.
Accession no. 91.40.214

134. *Untitled,* c. 1903
Charcoal on paper
5³⁄₁₆ x 4⅜ in.
Accession no. 91.40.215

135. *Untitled,* c. 1903
Graphite on paper
4½ x 5¼ in.
Accession no. 91.40.216

136. *Untitled,* c. 1903
Charcoal on paper
5³⁄₁₆ x 4⅜ in.
Accession no. 91.40.217

137A–B. A: *Untitled,* c. 1903
B: *Untitled,* January 22, 1888
A: Graphite on paper; B: ink on paper
A: 4⅜ x 5³⁄₁₆ in.; B: 6 x 2½ in.
Accession nos. 91.40.218.A–B

138. *Untitled,* c. 1903
Charcoal on paper
4½ x 6¼ in.
Accession no. 91.40.219

139. *Untitled,* c. 1903
Graphite on paper
4⁷⁄₁₆ x 5³⁄₁₆ in.
Accession no. 91.40.220

140. *Untitled,* c. 1903
Charcoal on paper
8 x 5 in.
Accession no. 91.40.221

Original sketch for: James L. Ford, "Our American Snobs: The Relation of Yellow Journalism to Its Own Creation, the Four Hundred," *Saturday Evening Post* 175, no. 41 (April 11, 1903): ill. p. 9.

BIBLIOGRAPHY
Allyn and Hawkes, cat. no. 590.

141. *Untitled,* c. 1903
Charcoal on paper
5 x 8 in.
Accession no. 91.40.222

142. *Untitled,* c. 1903
Charcoal on paper
8 x 5 in.
Accession no. 91.40.223

COMMENTS
This figure is a prototype for the drawing of a woman that appeared with the caption "Suddenly she stood on the platform with her skirt in her hand," accompanying William Dean Howells's "Letters Home," *New Metropolitan Magazine* 18, no. 4 (July 1903): 471.

143. *Untitled,* c. 1903
Graphite and ink on paper
8 x 5 in.
Accession no. 91.40.224

144. *Untitled,* c. 1903
Charcoal on blue paper
7⅞ x 4⅞ in.
Accession no. 92.83

145. *Untitled,* c. 1903
Charcoal on blue paper
8 x 5 in.
Accession no. 92.121

EXHIBITIONS
The Magic of Line: Graphics from the Glackens Collection.

146. *Untitled,* c. 1903
Charcoal on blue paper
8 x 5 in.
Accession no. 92.122

EXHIBITIONS
The Magic of Line: Graphics from the Glackens Collection.

147. *Untitled,* c. 1903
Charcoal on blue paper
8 x 5 in.
Accession no. 92.123

148. *Untitled,* c. 1903
Charcoal on blue paper
8 x 5 in.
Accession no. 92.124

149A–B. *Untitled,* c. 1903
Charcoal on blue paper
8 x 5 in. each
Accession nos. 92.125.A–B

150. *Untitled,* c. 1903
Charcoal on blue paper
8 x 5 in.
Accession no. 92.126

151. *Untitled,* c. 1903
Charcoal on blue paper
8 x 5 in.
Accession no. 92.127

152. *Untitled,* c. 1903
Charcoal on blue paper
8 x 5 in.
Accession no. 92.128

153. *Untitled* (study of seated woman), c. 1903
Charcoal on paper
7¾ x 4½ in.
Accession no. 92.65.1

154. *Untitled* (study of woman in a dark hat), c. 1903
Charcoal on paper
7½ x 4½ in.
Accession no. 92.65.2

155. *Untitled (Man with Walking Stick),* c. 1903
Charcoal on paper
7½ x 4½ in.
Accession no. 92.65.3

EXHIBITIONS
The Magic of Line: Graphics from the Glackens Collection.

156. *I Can't Do Mor'n Half of These Examples!* 1904
Signed bottom center: *W. Glackens*
Charcoal on paper
6¼ x 4 in.
Accession no. 91.40.83

153.

156.

159.

154.

157.

160.

161.

155.

158.

162.

Original drawing for: M. H. Carter, "The Parent," *McClure's Magazine* 24, no. 1 (November 1904): ill. p. 90.

BIBLIOGRAPHY
Allyn and Hawkes, cat. no. 428.

EXHIBITIONS
The Magic of Line: Graphics from the Glackens Collection.

157. *Monsieur Rouflard,* 1904
Charcoal on paper
5 x 4½ in.
Accession no. 91.40.176

Original drawing for: Charles-Paul de Kock, *Little Lise,* St. Gervais ed. (Boston: Quinby, 1904), ill. p. 86.

BIBLIOGRAPHY
Allyn and Hawkes, cat. no. 1027.

158. *Untitled,* c. 1905
Graphite and ink on paper
8½ x 7 in.
Accession no. 92.147

159. *Untitled* (sketch for a merry-go-round in Paris), 1906
Charcoal on paper
4 x 5 in.
Accession no. 92.55.1

160. *Untitled* (sketch for a merry-go-round in Paris), 1906
Charcoal on paper
4 x 5 in.
Accession no. 92.55.2

161. *Untitled,* c. 1906
Charcoal on paper
5 x 10 in.
Accession no. 91.40.171

162. *Untitled,* after 1906
Ink on paper
6¼ x 10½ in.
Accession no. 92.110

163. *Headpiece,* 1907
Charcoal on paper
9½ x 7½ in.
Accession no. 91.40.54

Original drawing for: Myra Kelly, "The Wiles of the Wooer," *McClure's Magazine* 29, no. 5 (September 1907): ill. p. 537.

BIBLIOGRAPHY
Allyn and Hawkes, cat. no. 454.

EXHIBITIONS
The Magic of Line: Graphics from the Glackens Collection.

164. *Untitled,* 1907
Charcoal on paper
7½ x 9¼ in.
Accession no. 91.40.30

Original drawing for: Myra Kelly, "The Wiles of the Wooer," *McClure's Magazine* 29, no. 5 (September 1907): ill. p. 546.

BIBLIOGRAPHY
Allyn and Hawkes, cat. no. 461.

EXHIBITIONS
The Magic of Line: Graphics from the Glackens Collection.

165. *Over Counter,* c. 1907
Graphite on paper
7½ x 9½ in.
Accession no. 91.40.29

EXHIBITIONS
The Magic of Line: Graphics from the Glackens Collection.

166. *Untitled,* c. 1908
Charcoal on paper
7¼ x 8½ in.
Accession no. 91.40.56

EXHIBITIONS
The Magic of Line: Graphics from the Glackens Collection.

167. *Nat Bickford Was Butler to the Squire,* 1909
Signed l.r.: *W. Glackens*
Charcoal on paper
8½ x 4 in.
Accession no. 91.40.97

Original drawing for: Eden Phillpotts, "The Practical Joke," *Putnam's Monthly and Reader* 7, no. 2 (November 1909): ill. p. 220.

BIBLIOGRAPHY
Allyn and Hawkes, cat. no. 545, p. 220.

EXHIBITIONS
William Glackens: Illustrator in New York, 1897–1919, Delaware Art Museum, Wilmington, March 15–April 28, 1985; Pennsylvania State University Museum of Art, University Park, June 30–September 8, 1985; Hudson River Museum, Yonkers, New York, September 15–November 24, 1985.

The Magic of Line: Graphics from the Glackens Collection.

168. *The North Platte Quartette,* 1910
Signed l.r.: *W. Glackens*
Pen and black ink on paper
10½ x 7½ in.
Accession no. 91.40.23

Original drawing for: Helen Green, "In Vaudeville," *McClure's Magazine* 33, no. 4 (February 1910): ill. p. 393.

BIBLIOGRAPHY
Allyn and Hawkes, cat. no. 474.

EXHIBITIONS
The Magic of Line: Graphics from the Glackens Collection.

169. *Self-Portrait,* c. 1910
Charcoal on paper
7½ x 4½ in.
Accession no. 92.59.A

EXHIBITIONS
William Glackens: Portrait and Figure Painter.

170. *Untitled,* c. 1910
Charcoal on brown paper
9 x 5 in.
Accession no. 91.40.162

171. *Untitled,* c. 1910
Charcoal and graphite on paper
6⅞ x 9½ in.
Accession no. 94.10

172. *Untitled,* c. 1910
Ink on paper
6½ x 4¼ in.
Accession no. 94.77

173. *Untitled,* c. 1910
Ink on paper
8 x 5 in.
Accession no. 94.78

163.

166.

169.

164.

167.

170.

165.

168.

172.

218

173.

174.

175.

177.

182.

174. *Untitled,* c. 1910
Graphite on paper
8⅜ x 5½ in.
Accession no. 94.80

175. *Untitled,* c. 1910
Red crayon on paper (probably
wallpaper)
8¾ x 12 in.
Accession no. 91.40.24

176. *Untitled* (sketch of a boy seen from
the rear and the side), c. 1910
Charcoal on paper
6½ x 5⅛ in.
Accession no. 91.40.317

177. *Untitled* (study of two ladies
strolling), c. 1910(?)
Charcoal on brown paper
9 x 8¼ in.
Accession no. 91.40.39

178. *Far from the Fresh Air Farm: The
Crowded City Street, with Its Dangers
and Temptations, Is a Pitiful Make-
shift Playground for Children,* 1911
Signed l.r.: *W. Glackens*
Crayon heightened with watercolor
on paper
24½ x 16½ in.
Accession no. 91.40.152
See plate 24

Original drawing for: *Collier's Weekly*
47, no. 16 (July 8, 1911): ill. cover,
p. 6.

BIBLIOGRAPHY
Allyn and Hawkes, cat. no. 115.

Glackens, p. 115.

EXHIBITIONS
The Art of William Glackens, Univer-
sity Art Gallery, Rutgers University,
New Brunswick, New Jersey, Janu-
ary 10–February 10, 1967, no. 58.

*Drawings by William Glackens,
1870–1938,* National Collection of
Fine Arts, Smithsonian Institution,
Washington, D.C., February 25–
April 30, 1972, no. 42.

*William Glackens: Illustrator in
New York, 1897–1919,* Delaware Art
Museum, Wilmington, March 15–
April 28, 1985; Pennsylvania State
University Museum of Art, Univer-
sity Park, June 30–September 8,
1985; and Hudson River Museum,
Yonkers, New York, September 15–
November 24, 1985, no. 42.

*The Magic of Line: Graphics from the
Glackens Collection.*

179. *A Large Distracted-Looking Woman
Sprang Forward,* c. 1911
Charcoal on paper
11 x 8 in.
Accession no. 91.40.87
See plate 150

EXHIBITIONS
*The Magic of Line: Graphics from the
Glackens Collection.*

180. *A Large Distracted-Looking Woman Sprang Forward,* c. 1911
Signed at the bottom: *W. Glackens*
Pen and black ink and graphite tracing on paper
11 x 7¼ in.
Accession no. 91.40.88
See plate 149

181. *Mother with Child,* c. 1911
Crayon on brown paper
9 x 4 in.
Accession no. 91.40.158

182. *Untitled,* c. 1911
Graphite on brown paper
11 x 8¾ in.
Accession no. 91.40.37

EXHIBITIONS
The Magic of Line: Graphics from the Glackens Collection.

183. *"Now, Yez Sheenie Matzo!" He Snapped His Fingers at the Other Two,* 1912
Signed l.r.: *W. Glackens*
Pen and black ink on cardboard
10¼ x 12 in.
Accession no. 91.40.44

Original drawing for: E. R. Lipsett, "Denny the Jew," *Everybody's Magazine* 27, no. 1 (July 1912): ill. p. 49.

BIBLIOGRAPHY
Allyn and Hawkes, cat. no. 185.

EXHIBITIONS
The Magic of Line: Graphics from the Glackens Collection.

184. *Washington Square, New York,* 1912
Signed on the reverse: *W. Glackens*
Graphite on paper
4½ x 6½ in.
Accession no. 91.40.178

185. *Untitled,* c. 1912
Charcoal on brown paper
10¼ x 5½ in.
Accession no. 91.40.55

EXHIBITIONS
The Magic of Line: Graphics from the Glackens Collection.

186A–B. *Untitled,* c. 1912
Colored pencil on paper
5 x 8 in. each
Accession nos. 91.40.207.A–B

187. *Sketch for "Children Roller Skating,"* after 1913
Conté crayon on paper
6 x 9¼ in.
Accession no. 94.73
See plate 140

COMMENTS
Cat. nos. 187 and 188 are studies for *Children Roller Skating* (plate 83), in the collection of the Brooklyn Museum.

188. *Untitled* (early sketch for *Children Roller Skating*), after 1913
Charcoal on paper
5 x 8¼ in.
Accession no. 94.11

189. *A Wild Man,* June 8, 1914
Inscribed l.l.: *A Wild Man W.G. June 8, 1914*
Graphite on paper
8½ x 5 in.
Accession no. 92.138
See plate 147

EXHIBITIONS
The Magic of Line: Graphics from the Glackens Collection.

190. *Untitled,* c. 1915
Charcoal on paper
12 x 9¼ in.
Accession no. 91.40.40

191. *Untitled,* c. 1915
Crayon on paper
5 x 8 in.
Accession no. 92.112

192. *Untitled,* c. 1915
Crayon on paper
5 x 8 in.
Accession no. 92.113

193. *Untitled,* before 1916
Signed l.r.: *WJG*
Ink on paper
6⁵⁄₁₆ x 6 in.
Accession no. 91.40.211

194. *Sketch for "Rye Beach,"* c. 1916
Charcoal on paper
7½ x 9½ in.
Accession no. 91.40.38

EXHIBITIONS
The Magic of Line: Graphics from the Glackens Collection.

195. *Study for "Two Nudes,"* c. 1916
Charcoal on paper
9⅞ x 7¼ in.
Accession no. 94.7

COMMENTS
This sketch is an early drawing for the nude on the left in the large canvas in a private collection.

196A–C. *This Is What Happened to a Bad Little Boy Named Oscar,* c. 1916
C: inscribed bottom center: *This is what happened to a bad little boy named Oscar, for Lenna from Daddy*
Graphite on paper
10½ x 8 in.
Accession nos. 91.40.316.A–C

PROVENANCE
The artist; Lenna Glackens; Ira Glackens; Museum of Art, Fort Lauderdale.

197. *Untitled (Hindu Series),* c. 1916
Graphite, crayon, and pastel on paper
14½ x 20 in.
Accession no. 94.74

COMMENTS
This is a drawing for an untitled wooden relief in the Sansom Foundation.

198. *Untitled (Hindu Goddess; Hindu Series),* c. 1916
Graphite on paper
15 x 16 in.
Accession no. 94.75

199. *Untitled,* c. 1917
Graphite on off-white paper
9¾ x 7½ in.
Accession no. 91.40.22

200. *Untitled,* c. 1918
Charcoal on paper
6 x 9¼ in.
Accession no. 91.40.52

201. *They Saw Her Slip, Almost Furtively, Stern Foremost, from Sight, and Flotsam Arose to Bob among the Crests,* 1919
Signed l.l.: *W. Glackens*
Charcoal on paper
13¾ x 17 in.
Accession no. 91.40.48
See plate 25

183.

190.

194.

185.

191.

195.

186.

192.

197.

193.

198.

221

199.

204.

208.

200.

205.

209.

202A.

202B.

206.

210.

203.

207.

211.

BIBLIOGRAPHY
Allyn and Hawkes, cat. no. 155.

Original drawing for: Roy Norton, "On the Beach," *Collier's Weekly* 63, no. 8 (February 22, 1919): ill. p. 13.

EXHIBITIONS
The Magic of Line: Graphics from the Glackens Collection.

202A–B. *Studies for "Lower East Side, New York,"* c. 1920
Charcoal on paper
A: 8 x 4½ in.; B: 8 x 5 in.
Accession nos. 92.54.A–B

EXHIBITIONS
The Magic of Line: Graphics from the Glackens Collection.

203. *Untitled,* c. 1920
Charcoal on paper
9½ x 14 in.
Accession no. 91.40.51

COMMENTS
The setting for this drawing is Mountain Lake, Conway, New Hampshire, near one of the Glackenses' summer retreats.

204. *Untitled,* c. 1920
Charcoal on paper
7⅞ x 4¾ in.
Accession no. 92.51.1

COMMENTS
This sketch is a view of the Lower East Side, New York.

205. *Woman on a Sofa,* c. 1920
Graphite and charcoal on paper
5¼ x 8 in.
Accession no. 91.40.36

COMMENTS
This casual drawing is an early prototype for Glackens's unfinished *Portrait of Edith, Ira and Lenna in the Living Room* (cat. no. 51). It shares with it the same angle chosen for the composition, the setting, and the basic relationship between the figures of Edith and Lenna.

206. *Untitled,* 1922
Graphite on postcard
3½ x 5½ in.
Accession no. 91.40.226

PROVENANCE
The artist; Lenna Glackens; Ira Glackens; Museum of Art, Fort Lauderdale.

207. *Dog,* c. 1922
Charcoal on paper
7¾ x 9½ in.
Accession no. 91.40.14

208. *Study for "The Dressing Table,"* c. 1922
Charcoal on paper
8½ x 11 in.
Accession no. 94.8

COMMENTS
This is a preliminary sketch for a canvas now on loan from the Sansom Foundation to the Snyte Museum of Art, Notre Dame University, Notre Dame, Indiana.

209. *Study for "Ira and Lenna's Burial Ground,"* 1923
Charcoal on paper
9½ x 13 in.
Accession no. 92.47

EXHIBITIONS
The Magic of Line: Graphics from the Glackens Collection.

COMMENTS
This is a study for *Ira and Lenna's Egyptian Burial Ground* (cat. no. 54).

210. *Portrait of Edith* (also known as *Sketch for the Head of Edith Dimock*), c. 1925
Pastel on paper
10 x 7¼ in.
Accession no. 91.40.42

EXHIBITIONS
The Magic of Line: Graphics from the Glackens Collection.

COMMENTS
This image was a study for the complex composition of the unfinished version of *Breakfast Porch* (see cat. no. 56, plate 126). Edith, then in her late forties, is portrayed as an ingenue.

211. *Tennelosa House,* c. 1925
Inscribed bottom center:
Tennelosa House
Graphite on paper
5¼ x 6½ in.
Accession no. 91.40.179

212.

213.

215.

212. *Untitled,* c. 1925
Charcoal on paper
8¼ x 5 in.
Accession no. 91.40.205

EXHIBITIONS
The Magic of Line: Graphics from the Glackens Collection.

213. *Untitled (Female Nude),* c. 1925
Charcoal on blue paper
10 x 7 in.
Accession no. 91.40.31

EXHIBITIONS
The Magic of Line: Graphics from the Glackens Collection.

214. *Venus of Cnidus,* c. 1925
Pastel on brown paper
11½ x 8½ in.
Accession no. 94.81
See plate 145

215. *Sketch for "Café de Pêcheurs,"* 1925–26
Charcoal on paper
5¼ x 8¼ in.
Accession no. 91.40.234

EXHIBITIONS
The Magic of Line: Graphics from the Glackens Collection.

COMMENTS
The Café de Pêcheurs is one of the themes that preoccupied Glackens for a considerable length of time. The museum owns several sketches that trace the development of his main image—an outdoor restaurant in l'Isle Adam, France. Some of the drawings show only the setting, others introduce different characters into the composition. The Sansom Foundation also owns two canvases entitled *Café de Pêcheurs* with related subjects.

216. *Sketch for "Café de Pêcheurs,"* 1925–26
Charcoal on paper
5¼ x 8¼ in.
Accession no. 91.40.235

EXHIBITIONS
The Magic of Line: Graphics from the Glackens Collection.

217. *Sketch for "French Fair (Children's Swings),"* c. 1927
Charcoal on paper
6½ x 8½ in.
Accession no. 91.40.232

EXHIBITIONS
The Magic of Line: Graphics from the Glackens Collection.

COMMENTS
The John Surovek Gallery in Palm Beach, Florida, owns a large canvas, *French Fair (Children's Swings),* that relates to this drawing and to cat. no. 218.

218. *Sketch for "French Fair (Children's Swings),"* c. 1927
Charcoal on paper
6½ x 8½ in.
Accession no. 91.40.233

EXHIBITIONS
The Magic of Line: Graphics from the Glackens Collection.

219. *Ned FitzGerald,* c. 1928
Signed l.l.: *W. Glackens*
Charcoal on paper
5 x 8 in.
Accession no. 91.40.85

EXHIBITIONS
The Magic of Line: Graphics from the Glackens Collection.

220. *Imp,* after 1928
Charcoal on paper
11½ x 8 in.
Accession no. 91.40.59

COMMENTS
Imp, a French poodle that was one of the Glackenses' most beloved pets, appears in many drawings and pastels as well as in some major canvases, such as *Lenna and Imp* (1930; James A. Michener Collection, University of Texas at Austin).

221. *Untitled,* c. 1929
Graphite on paper
4 x 5½ in.
Accession no. 92.139

COMMENTS
Glackens used the back of a scrap of a letter from Kraushaar Galleries, dated October 22, 1929, to render this view of a hillside town. The letter discusses the payment for the

216.

217.

218.

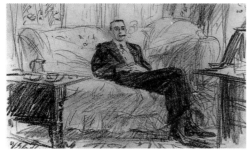

219.

221.

223.

220.

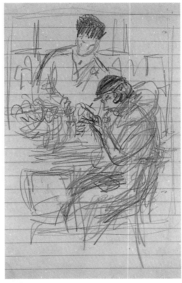

222.

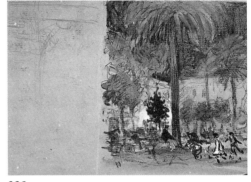

225.

sale of his painting *Bathers, Isle Adam,* which sold for $1,875 at an exhibition at the Carnegie Institute.

222. *Early Sketch for "The Soda Fountain,"* 1935
Graphite on lined paper
5 x 3½ in.
Accession no. 92.142

EXHIBITIONS
The Magic of Line: Graphics from the Glackens Collection.

COMMENTS
This is probably the initial sketch for *The Soda Fountain* (see plate 131). There is also a pastel that relates to it in a sketchbook in the museum's collection (cat. no. 242), as well as an oil sketch owned by the Sansom Foundation.

223. *Dog,* c. 1930
Charcoal on paper
11¼ x 8½ in.
Accession no. 91.40.15

224. *Untitled,* n.d.
Graphite with wash highlights on cardboard
5½ x 6¼ in.
Accession no. 91.40.324

225. *Untitled,* n.d.
Mixed media
5½ x 7⅛ in.
Accession no. 91.40.210

226. *Little Canvas,* 1893
Beige canvas book
6½ x 4½ in.
15 sepia sketches, some with wash or charcoal
Accession no. 92.48

COMMENTS
Also includes: European harbor scene titled "Bazaripiemontese R Secgo"; woman with hand to head; buildings; water scenes with people; park scene; man, holding a cane, resting in a chair with his hat on a table; woman and child under a tree; sketch for *Philadelphia Landscape,* 1893 (cat. no. 1, plate 5); rooftop with chimney smoke; stage with performer seen from audience; woman, wearing a hat, seen in half-view with her hands holding a drink on a table; cityscape; unfinished sketch of woman at a table.

227. *Spanish-American War,* 1898
Brown canvas-covered book
7 x 10 in.
35 graphite and charcoal sketches
Accession no. 92.63

COMMENTS
Includes: several war-related sketches, many unfinished—horses and donkeys, rifles, men with rifles; scene of women, seated and standing, with umbrellas; scenes (some unfinished) of ships—boarding troops and unloading cargo (these may be preliminary sketches for works like *Loading Horses on the Transports at Port Tampa,* 1898, The Library of Congress, Prints and Photographs Division, Washington, D.C.); a portrait; figure studies; a building (possibly a sketch for Fort Lauderdale's *Facade of Royal Palace in Santiago de Cuba*), 1898.

228. *Spanish-American War,* 1898
Brown canvas-covered book
7 x 10 in.
29 graphite and gouache sketches
Accession no. 92.64

COMMENTS
Includes: several war-related sketches, many unfinished—troops marching, troops at rest, campsites, cannons, broad landscapes with and without people, horses; two men walking; sketch titled "Rough rider killed" (signed "*W. Glackens*"); sketch titled "El Poso"; sketch of man sitting in a hammock.

229. *Gold Seal Notebook,* c. 1903
Cardboard-covered book
8 x 7 in.
4 charcoal sketches
Accession no. 92.65

COMMENTS
Includes: various drawings placed in book separately (cat. nos. 140–143). Includes: two figure studies (one male and one female); two crowd scenes (one with the notation "p. 37" underneath, perhaps an illustration for a story). The drawing of a young man, seated in a chair with his back turned toward us, is a sketch for an illustration in "Our American Snobs," a story by James L. Ford that appeared in *Saturday Evening Post* 175, no. 41 (April 11, 1903). The drawings placed separately are cat. nos. 132–139.

230. *Small Notebook,* 1905
Canvas-covered book
5 x 7 in.
21 graphite and wash sketches
Accession no. 92.61

COMMENTS
Includes: woman and child seated on a bench; man in profile; carriage scenes; street scenes; sketches of shadowed view of woman and child looking at a harbor scene (resembles an untitled etching in the museum's collection, cat. no. 265; very sketchy figure studies; multicolored wash of seated figure; studies of Greek or Roman busts; full-length sketch of woman holding a hat; the last page appears to be a grocery list.

231. *Paris,* 1906
Inscribed: *W. Glackens* Paris
Green book
8¼ x 5¼ in.
38 charcoal, graphite, ink, and pastel sketches
Accession no. 92.50

COMMENTS
Includes: very sketchy crowd scene; figure studies, including one of a woman holding an umbrella; dark restaurant scene; outdoor scene with closeup of figures; various sketchy scenes; written on one page, "21 Rue Duvivier"; studies of children; girl rolling hoop; sketches of seated man reading paper, girl bending over reaching for hoop (pose reminiscent of *In the Buen Retiro,* 1906, private collection); girl with jump rope; figures seated and standing; woman and man seated on bench; figure ascending an outdoor staircase surrounded by statues and plants; bullfights; carriages and buildings with man in foreground; seated woman resembling woman in *Café de la Paix,* c. 1906 (cat. no. 13, plate 60); unfinished café scenes; park scenes with buildings in background; woman carrying two chairs; colored sketch of beach scene; park sketch accented with ink; various park scenes with people.

232. *Untitled,* 1906
Inscribed on cover: *W. Glackens Paris*
Green book
4 x 5 in.
38 charcoal sketches
Accession no. 92.55

COMMENTS
Includes: preliminary sketches for a *Luxembourg Gardens* (1906; Wichita Art Museum, Wichita, Kansas); sketch of general scene and also sketch of girls bending over, park scene with woman walking dog in center, sketch of two people seated at outdoor café, crowded café scene with umbrella on right, girl holding rope, boy holding hoop, people in various poses, distant views of buildings and trees, sketches of seated women, two women seated in chairs with small child playing on ground next to them, building with tree on left and people in foreground, profile of elegantly dressed woman seated in a straight-back chair, variations of women seated in chairs, park scene with people and some with buildings in the background, people seated beneath trees, some unfinished sketches. These studies are possibly related to the Wichita *Luxembourg Gardens* or to *In the Buen Retiro,* 1906 (private collection).

226.

227.

228.

229.

230.

231.

232.

233.

233. *Paris,* c. 1906
Inscribed: *W. Glackens Paris*
Green book
8 x 5¼ in.
49 charcoal and graphite sketches
Accession no. 92.52

COMMENTS
Includes: city scene with carriages and light posts; unfinished sketches of unidentified scenes; studies of a woman's back; people dancing; woman running; dancers bowing and in "can-can" pose; preliminary sketch for *Café de la Paix,* c. 1906 (cat. no. 13, plate 60); sketch that appears related to *Gypsies Dancing, Gardens of the Alhambra,* 1906–12 (collection of Mr. J. C. Gutman) (the dancers in this sketchbook may relate to this work as well); sketches of woman on balcony with view of a city behind her; bullfight; sketches of people seated at table (possibly more studies for *Café de la Paix*); studies of young women; standing men and women; busy street scene with carriage and people; man and woman seated at a table; balcony with chairs.

234. *N.Y., Woman with Apple,* c. 1910
Inscribed: *W. Glackens N.Y. Woman with apple*
Blue book
8¼ x 5¼ in.
43 charcoal sketches
Accession no. 92.59

COMMENTS
Includes: many figure studies; head studies; sketch for streetlight; sketches for *Nude with Apple* (1910; see plate 71); street scenes; woman sitting on a couch with hand to face; beach scene; park scene. Most of the pages are devoted to studies of women in hats.

235. *Self-Portrait* (below smaller sketch of a head), c. 1910
Charcoal on paper
7½ x 4½ in.
Accession no. 92.59.A

COMMENTS
This is a sheet from cat. no. 234, above.

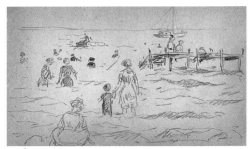

236.

239.

237.

240.

241.

238.

242.

236. *Bellport,* 1912
Inscribed: *W. Glackens Bellport 1912*
Blue book
8½ x 5½ in.
46 charcoal sketches
Accession no. 92.131

COMMENTS
Includes: primarily beach or boating scenes—possibly preliminary sketches for *Bathing at Bellport,* 1911 (the Brooklyn Museum, New York) or a similar painting, such as *At the Beach,* 1914 (Pennsylvania Academy of the Fine Arts, Philadelphia); boathouse with docks; house with trees; people sitting near and walking on a pier; people sitting on the beach and in the water; woman with baby carriage; child with dog; woman and child; woman and child sitting at dinner table; profile of woman reading; a chair.

237. *Conway,* 1920
Inscribed: *Conway 1920*
Green book
8¼ x 5¼ in.
30 charcoal and pencil sketches; several pages of notes
Accession no. 92.57

COMMENTS
Includes: pages of notes with prices of, conditions of, and sketches of works by artists such as Cézanne, Renoir, Sisley, and van Gogh; sketches of outdoor scene with hammock and chair in center; sketches of rabbit hound and child with dog; sketches of side of house and landscape—possibly sketch for *House in Conway,* 1920 (cat. no. 45); landscape scenes; three people walking down a path; four boats surrounded by foliage; outdoor scene with two animals at center; profiles of a child; studies of women playing sports.

238. *East Side,* c. 1920
Inscribed: *W. Glackens East Side*
Green book
8½ x 5¼ in.
45 charcoal, graphite, and sanguine sketches
Accession no. 92.51

COMMENTS
Includes: studies of men in hats; sketches of a child at a desk; sketches of columns; a bouquet of flowers; mountains, with boat in foreground;

houses and landscape; woman and child; head studies of men and women; studies of children; men and women in different poses; two women (one standing, one seated on a fence); front stoop and stores; sketches of a young girl eating from a bowl (possibly a study of Lenna for *Breakfast Porch,* 1925, cat. no. 56, plate 126); back views of two women walking; landscape; park scenes. A note in the sketchbook says "Ashcan city scapes," but it primarily comprises figure studies.

239. *N.Y.; 10 W. 9th St.,* c. 1920
Inscribed: *W. Glackens 10 W 9th St. N. Y. City*
Black-and-white book
10¾ x 8¾ in.
37 graphite and charcoal sketches, a few pages of notes, some pages have been torn
Accession no. 92.54

COMMENTS
Includes: sketch of house surrounded by trees; accurate preliminary sketch for *Breakfast Porch,* 1925 (cat. no. 56, plate 126); study of child eating; scene with well in center and car on right (rabbit in foreground); sketches of house and well-like structure on right (they all resemble *House in Conway,* 1920, cat. no. 45)—one with girl and one with hound in foreground; beach scenes, some with a diver; studies of cows; a few scenes of a crowded beach, with umbrella in foreground (resembles *Rye Beach,* c. 1920, John H. Suroveck Gallery, Palm Beach, Florida); sketches of seated woman in coat; various figure studies; studies of woman putting her hair up in different positions (resembles *Nude Arranging Her Hair,* 1914, private collection; *Two Nudes,* 1916, private collection; *Back of Nude,* c. 1930s [cat. no. 80, plate 105]); child blowing a horn; woman holding child on her lap; woman, wearing a hat, seated in a chair; young girl standing with hand on chair; very sketchy drawings of *Bal Martinique,* 1928–29 (see plate 119); woman seated at dressing table doing her hair; sketches of man and woman with heads together.

240. *Conway,* 1922
Inscribed: *Conway 1922*
Green book
8½ x 5 in.
46 charcoal sketches
Accession no. 92.49

COMMENTS
Includes: studies of child's head; sketchy versions of scene resembling *Breakfast Porch,* 1925 (cat. no. 56, plate 126); landscapes; sketch without people for *Home in New Hampshire,* c. 1919 (cat. no. 43, plate 108) or *House in Conway,* 1920 (cat. no. 45); studies of standing men and women; studies of cats; cityscape with two smokestacks; a building; some unfinished sketches; man and women walking down a path; sketches of houses and other buildings; street scenes; landscapes with people; landscapes with animals.

241. *Conway,* c. 1922
Inscribed: *Conway, W. Glackens*
Black-and-white book
7¾ x 5⅛ in.
53 graphite and charcoal sketches; 3 pages of notes
Accession no. 92.68

COMMENTS
Includes: sketch of foliage; very sketchy landscapes with many trees; unfinished sketches; sketch of trees with hammock; sketch of two people in hammock facing house; sketches of left side of house with trees; child's profile; women dancing on stage with a banner "OOH LA LA DANCERS"—resembles *Fryeburg Fair,* 1923 (Kraushaar Galleries, New York); studies of men and women; scene of people gathered around a gazebo; sketches of houses with trees; preliminary sketches for *Lenna with Rabbit Hound,* c. 1922 (cat. no. 52, plate 100); sketches of dogs; sleeping dog (rabbit hound?); sketchy interior; landscape with house on right.

242. *Conway,* 1923
Inscribed: *Conway 1923*
Green book
8 x 8⅛ in.
35 graphite and charcoal sketches
Accession no. 92.69

COMMENTS
Includes: very sketchy portrait of the Glackens family seated on a couch,

possibly study for *Family Portrait* (c. 1920, Museum of Art, Fort Lauderdale); street scene; bridge and telephone poles; sketches of columns, arches, and what appears to be stained glass (maybe interior of church); studies of seated women in different poses; a church; a plant and trees; many sketches of dogs and cows; cityscapes; studies of man standing with legs apart; outdoor scene with people and a gazebo at lower left; sketches of women and two children seated around a table with a vase of flowers (possibly sketches for *Breakfast Porch,* 1925 [cat. no. 56, plate 126]).

243. *Large Notebook,* c. 1925
Brown book
10 x 8¾ in.
14 charcoal and brown pencil sketches
Accession no. 92.66

COMMENTS
Includes: one loose small sketch page; numerous sketches of park scenes; several scenes of an outdoor café with a man and woman seated in the foreground under a large tree; figure bending over; woman seated on a chair (nude?); man sitting with legs pulled to body, looking at woman reclining with head propped on her arm.

244. *Samois sur Seine, Seine, Vence, and Isle Adam,* 1925–26
Inscribed on cover: *Samois sur Seine, 1925, Vence, Isle Adam, 1926*
Inscribed on inside cover: *William Glackens, Samois sur Seine, Rue Bas Samois, Mansion Daboncourt*
Yellow book
9¼ x 7½ in.
37 charcoal, wash, and graphite sketches; 1 pastel (signed); 2 pages of notes
Accession no. 92.53

COMMENTS
Includes: a chair; girl seated at a piano; four men seated at outside table (highlighted in wash); interior of room; unfinished sketch of men seated at outside café; houses and trees; studies of woman in different positions; dock with boats tied to it and trees; facade of building with trees in front; three people in a boat

on a river with a building at left and trees at right; three people in a boat; young girl seated in a chair with vase of flowers behind her; unfinished sketches, landscapes, and cityscapes—one in sanguine; woman's head; bathers and umbrellas; sketches of woman and girl sitting in chairs conversing; preliminary sketches for *The Soda Fountain,* 1935 (Pennsylvania Academy of the Fine Arts, Philadelphia; see plate 131)—two in pastel; preliminary sketch for *Promenade,* 1925 (Detroit Institute of Arts, see plate 112).

245. *Isle Adam (Landscapes and Figure Studies),* 1926
Inscribed: *Isle Adam*
Green book
9¼ x 6 in.
34 charcoal sketches
Accession no. 92.130

COMMENTS
Includes: scene with buildings; trees and people, some near a river (much like the sketch *Isle Adam—The Passerelle* in Glackens, p. 208); a few scenes with a carousel; detailed scenes of houses; studies of men and women sitting and standing; bathers; people seated at tables; sketches of man with a fishing pole; man and woman seated at a table; resort street scenes; person relaxing on a balcony looking over a sketchy unfinished scene.

246. *Isle Adam, Fair Swings,* 1928
Inscribed: *1928 Isle Adam, Fair Swings*
Green book
9 x 6 in.
30 charcoal sketches
Accession no. 92.60

COMMENTS
Includes: sketches for balcony and dancers in *Bal Martinique,* c. 1926 (Berry-Hill Galleries, New York); two sketches of street scene with large building; woman walking, wearing hat and trimmed coat; study of two children near fence—sketch for *French Country Fair, Children's Swing,* c. 1927 (John H. Surovek Gallery, Palm Beach, Florida); outdoor scene with train cars; scenes of people in a park; studies of men walking with canes and ladies with purses; couples strolling; outdoor café scene with

town in background; sketches of trees; houses; women with children; three children walking; detailed sketch of man walking with long stick; couple with baby carriage; couples strolling; study of man's back.

247. *Isle of Adam—Vence*
Inscribed on cover: *Ball Martinique, Isle Adam, Columbia Park,* 1928
Blue book
8 x 5 in.
32 graphite sketches
Accession no. 92.70

COMMENTS
Includes: notes written on the first few pages, including records of the temperature; studies of men and women; incomplete sketches; numerous sketches for *Bal Martinique,* c. 1926 (Berry-Hill Galleries, New York): scenes of an orchestra and people dancing; several sketches of buildings and landscapes in different variations (some with people in the foreground, some with more trees and fewer buildings or vice versa, some without buildings, etc.); park scenes; women seated at a café; a sketch resembling the painting *The Ledges, South France,* 1930 (cat. no. 70), which also has a tiered landscape.

248. *Rue de Bac, Marne,* 1929
Inscribed: *Rue De Bac, Marne*
Blue book
6¾ x 5 in.
21 charcoal sketches; 3 pages with numbers
Accession no. 92.62

COMMENTS
Includes: boating scene with buildings in the background; woman with baby on her lap; head studies; front of house with two trees; figure studies; outdoor café (view of the bar); sketches of open French doors looking out over a balcony; woman looking out French doors; man pushing a cart; landscape with people walking across bridge; back view of woman seated in a chair; landscape sketches; study of women reading; person in chair looking over a balcony; woman and child in chairs looking over a balcony; a poodle; lake with houses in background and trees on left.

249. *Cannes,* 1932
Inscribed: *Cannes, 1932*
Blue book
8 x 5¼ in.
40 sketches; 1 page with writing
Accession no. 92.56

COMMENTS
Includes: sketch inscribed "*W. Glackens Villa Des Orangiers Rue des Trisse Cannes*"; cityscapes—one with church in background; landscape with building at center; unfinished sketches; broad landscapes (including beach, buildings, people, and mountains); studies of people in various positions—one bending over, 1906; tree limb; sketches that resemble *Fête du Suquet,* 1932 (Whitney Museum of American Art, New York); scenes of buildings and trees; sketches of outdoor café scene with standing waiter and boats on left—resembles *Outdoor Café,* c. 1932 (cat. no. 73); studies of groups of people dancing. Many of the sketchbooks include, as this does, additional jottings—a sheet with names, numbers, addresses, or shopping lists.

250. *Cannes,* 1932
Inscribed: *Cannes 1932 Paris*
Blue book
8 x 5¼ in.
39 sketches; 1 page of numbers
Accession no. 92.58

COMMENTS
Includes: sketchy scene of trees and people; studies of women—some seated and reading; walking man seen from behind; scenes of large buildings with trees in right foreground; park scenes; sketch of old woman; unfinished sketches—some beach landscapes with mountains in background; various figure studies including people playing tennis; scenes of park with statues and building in background; sketches of couple walking with man's arm around woman; cityscape; restaurant scene; outdoor café scene—similar to *Outdoor Café,* c. 1932 (cat. no. 73)—with waiter standing and boats on left; beach scene with mountains in background; landscape with buildings in middle.

251. *Cannes,* 1932
Inscribed: *Cannes 1932*
Green book
10¾ x 8¾ in.
18 graphite and charcoal sketches;
a few pages with notes
Accession no. 92.67

COMMENTS
Includes: studies of groups of men;
landscapes with houses; restaurant
scene; interior with man at center;
crowded city street scene—resem-
bles *Fête du Suquet,* 1932 (Whitney

Museum of American Art, New
York; see plate 118); landscapes; head
studies; sketches of person (monk?)
in hat and robe with donkey; views
of buildings with palm trees re-
semble *Cannes, Le Suquet,* 1932
(private collection).

248.

249.

250.

245.

246.

247.

243.

244.

251.

252. *Schuylkill River,* 1894
Etching
5½ x 6⅛ in.
Accession no. 94.12

253. *Untitled,* 1894
Signed in the plate bottom center:
W. Glackens
Etching
3¾ x 4¾ in.
Accession no. 92.119

254. *Untitled,* 1897
Signed in the plate l.r.:
W. Glackens '97
Etching or drypoint
6¾ x 4¾ in.
Accession no. 91.40.169

255. *Untitled,* 1890s
Signed in the plate l.r.: *W. Glackens*
Etching
5 x 7 in.
Accession no. 91.40.173

256A–B. *Untitled,* 1900
Signed in the plate l.r.:
W. Glackens 1900
Drypoint
5¾ x 7¾ in. each
Accession nos. 92.117.A–B

257. *Untitled,* c. 1900
Signed in the plate l.l.: *W. Glackens*
Etching
5½ x 6 in.
Accession no. 91.40.164

258. *Untitled,* c. 1900
Signed in the plate: *W. Glackens*
Etching
3¼ x 4¾ in.
Accession no. 91.40.166

259A–B. *Untitled,* c. 1900
Etching
4 x 5¼ in. each
Accession nos. 91.40.168.A–B

260. *Untitled,* c. 1900
Signed in the plate l.l.: *W. Glackens*
Etching
2½ x 3¾ in.
Accession no. 91.40.172

261. *Untitled,* early 1900s
Signed in the plate bottom center:
W. Glackens
Etching
4 x 4¾ in.
Accession no. 92.115

262. *Untitled,* c. 1903
Etching
7 x 4¾ in.
Accession no. 92.146

263. *Trick . . . Came upon Mademoiselle
Pelagie beneath a Tree with a
Handsome Young Fellow,* 1904
Signed in the plate l.l.: *W. Glackens*
Etching
6 x 4¼ in.
Accession no. 91.40.170

BIBLIOGRAPHY
Allyn and Hawkes, cat. no. 1015.

Kock, Charles-Paul de. *Edmond and
His Cousin, etc.* St. Gervais ed.
Boston: Quinby, 1904, ill. p. 137.

264A–D. *By Jove! Everyone Was Fighting
and I Did Like the Others,* c. 1904
Signed in the plate l.r.: *W. Glackens*
Etching in different states
3¼ x 5¼ in. each
Accession nos. 91.40.174.A–D

BIBLIOGRAPHY
Allyn and Hawkes, cat. no. 1010.

Glackens, ill. p. 42.

Kock, Charles-Paul de. *Edmond
and His Cousin, etc.* St. Gervais ed.
Boston: Quinby, 1904, frontispiece.

EXHIBITIONS
*The Magic of Line: Graphics from the
Glackens Collection.*

265. *Untitled,* c. 1894
Signed in the plate l.r.:
W. J. Glackens
Etching
5 x 7 in.
Accession no. 91.40.161

266A–B. *Untitled,* c. 1905
Signed in the plate l.l.: *W. Glackens*
Etching; A: printed on China paper,
B: on rag paper
3 x 4½ in. each
Accession nos. 91.40.163.A–B

252.

253.

254.

255.

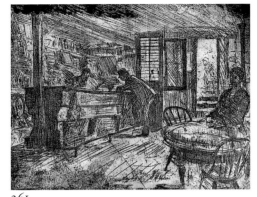

261.

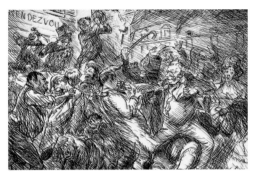

264A.

256A.

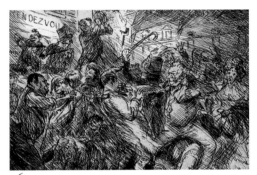

264B.

258.

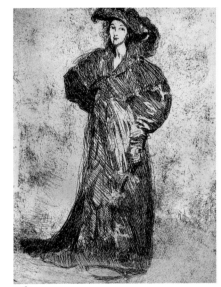

262.

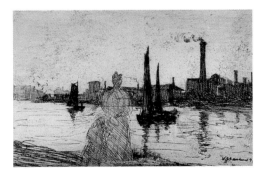

264C.

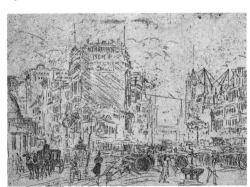

259B.

263.

265.

260.

266A.

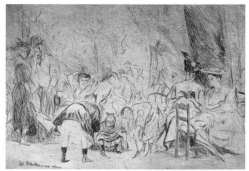

267A.

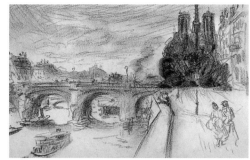

268A.

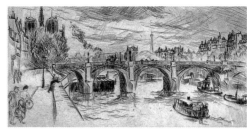

269B.

267A–C. *Luxembourg Gardens*, 1906
Signed in the plate: *W. Glackens '06, Paris*
Etching or drypoint
5 x 6½ in. each
Accession nos. 91.40.165.A–C

268A–E. *The Seine at Paris*, c. 1906
A: charcoal on paper; B–E: drypoint
3 x 5½ in. each
Accession no. 91.40.167.A–E

BIBLIOGRAPHY
Glackens, ill. p. 223.

EXHIBITIONS
The Magic of Line: Graphics from the Glackens Collection.

269A–C. *Untitled*, c. 1925
Drypoint
3½ x 5½ in. each
Accession nos. 91.40.175.A–C

270. *Cover of "The Fern Leaf,"* May 1891
Signed: *Butts G—*
Lithograph on green paper
10½ x 7½ in.
Accession no. 92.135
See plate 1

EXHIBITIONS
The Magic of Line: Graphics from the Glackens Collection.

271A–G. *Ah Quick! Let Us Fly!* 1902
Signed in the plate l.r.: *W. Glackens*
Photogravure
3½ x 5½ in. each
Accession nos. 92.74.A–G

BIBLIOGRAPHY
Allyn and Hawkes, cat. no. 907.

Kock, Charles-Paul de. *Monsieur Dupont.* Vol. 1. St. Gervais, ed. Boston: Quinby, 1902, ill. p. 94.

272A–D. *The Baron Will Come! He Calls Me Chambertin d'Allevard!* 1902
Signed in the plate l.l.: *W. Glackens;*
A, D: signed in the margin l.r.:

W. Glackens
Photogravure
5½ x 3½ in. each
Accession nos. 92.75.A–D

BIBLIOGRAPHY
Allyn and Hawkes, cat. no. 989.

Kock, Charles-Paul de. *Sister Anne.* Vol. 1. St. Gervais ed. Boston: Quinby, 1902, ill. p. 206.

273A–E. *Dubourg Drew from His Basket His Mechanical Syringe, Which He Had Filled with Barege Water,* 1902
Signed in the plate bottom center: *W. Glackens*
Photogravure; A: colored
3½ x 5 in. each
Accession nos. 92.92.A–E

BIBLIOGRAPHY
Allyn and Hawkes, cat. no. 90.

Kock, Charles-Paul de. *Sister Anne.* Vol. 2. St. Gervais ed. Boston: Quinby, 1902, frontispiece.

EXHIBITIONS
The Magic of Line: Graphics from the Glackens Collection.

274A–E. *To the Facts, Monsieur, If You Please,* 1902
Signed in the plate l.r: *W. Glackens;*
A, D, E: signed in the margin l.r.: *W. Glackens*
Photogravure
5 x 3½ in. each
Accession nos. 92.87.A–E

BIBLIOGRAPHY
Allyn and Hawkes, cat. no. 988.

Kock, Charles-Paul de. *Monsieur Dupont.* Vol. 1. St. Gervais ed. Boston: Quinby, 1902, ill. p. 121.

275A–E. *Edouard Swore and Raved Like a Madman* (published version), 1903
Signed in the plate: *W. Glackens;*
A: signed in the margin l.r.: *W. Glackens*
Photogravure
3½ x 5½ in. each
Accession nos. 91.40.310.A–E

271B.

273A.

275A.

272A.

274C.

BIBLIOGRAPHY
Glackens, p. 40.

EXHIBITIONS
The Magic of Line: Graphics from the Glackens Collection.

COMMENTS
This image was intended for reproduction in Charles-Paul de Kock, *Frère Jacques.* Vol. 2. St. Gervais ed. Boston: Quinby, 1903, ill. p. 31.

276. *Edouard Swore and Raved Like a Madman* (censored version), 1903
Photogravure
3½ x 5½ in.
Accession no. 91.40.311

BIBLIOGRAPHY
Allyn and Hawkes, cat. no. 997.

Glackens, ill. p. 40.

Kock, Charles-Paul de. *Frère Jacques.* Vol. 2. St. Gervais ed. Boston: Quinby, 1903, ill. p. 31.

EXHIBITIONS
The Magic of Line: Graphics from the Glackens Collection.

COMMENTS
The Quinby company, publishers of the Charles-Paul de Kock books, felt that Glackens's original version was too daring. They disapproved of the presence of the wife's lover, wearing a nightshirt, on the floor of her bedroom. He was replaced by an overturned chair.

277A–B. *He Noticed That He Was in Front of a Lottery Office,* 1903
Signed in the plate l.l.: *W. Glackens;*
B: signed in the margin l.r.:
W. Glackens
Photogravure
5 x 3½ in. each
Accession nos. 92.102.A–B

BIBLIOGRAPHY
Allyn and Hawkes, cat. no. 998.

Kock, Charles-Paul de. *Frère Jacques.* Vol. 2. St. Gervais ed. Boston: Quinby, 1903, ill. p. 63.

278. *Here Are Your Trousers,* 1903
Signed in the plate l.r.: *W. Glackens*
Photogravure
5 x 3 in.
Accession no. 92.98

BIBLIOGRAPHY
Allyn and Hawkes, cat. no. 1001.

Kock, Charles-Paul de. *Jean.* Vol. 1. St. Gervais ed. Boston: Quinby, 1903, ill. p. 7.

279A–B. *Here Is the Man with Two Heads, Gentlemen,* 1903
Signed in the plate l.r.: *W. Glackens;*
B: signed in the margin l.r.:
W. Glackens
Photogravure
3¼ x 5 in. each
Accession nos. 92.96.A–B

BIBLIOGRAPHY
Allyn and Hawkes, cat. no. 1007.

Kock, Charles-Paul de. *Jean.* Vol. 1. St. Gervais ed. Boston: Quinby, 1903, ill. p. 169.

280. *Jean . . . Wished to Show Her How He Made Love to the Ladies,* 1903
Signed in the plate l.r.: *W. Glackens*
Photogravure
5 x 3¼ in.
Accession no. 92.95

BIBLIOGRAPHY
Allyn and Hawkes, cat. no. 1008.

Kock, Charles-Paul de. *Jean.* Vol. 1. St. Gervais ed. Boston: Quinby, 1903, ill. p. 211.

281. *M. Durand . . . Arrived on the Scene,* 1903
Signed in the plate bottom center: *W. Glackens;* signed in the margin l.r.: *W. Glackens*
Photogravure
5 x 3 in.
Accession no. 92.106

BIBLIOGRAPHY
Allyn and Hawkes, cat. no. 1004.

Kock, Charles-Paul de. *Jean.* Vol. 1. St. Gervais, ed. Boston: Quinby, 1903, ill. p. 113.

282. *The Peasants Surrounded Maître Bonneau, While Fanfan Marched before Him Carrying the Famous Turkey,* 1903
Signed in the plate l.l.: *W. Glackens;* signed in the margin l.r.: *W. Glackens*
Photogravure
3¾ x 5¾ in.
Accession no. 92.103

BIBLIOGRAPHY
Allyn and Hawkes, cat. no. 994.

Kock, Charles-Paul de. *Frère Jacques.* Vol. 1. St. Gervais ed. Boston: Quinby, 1903, ill. p. 70.

283A–N. *Save Yourself; You Have Killed the Son of the King of Cochin-China,* 1903
Signed in the plate l.r.: *W. Glackens;*
A, D: signed in the margin l.r.:
W. Glackens
Photogravure
5¼ x 3½ in. each
Accession nos. 92.105.A–N

BIBLIOGRAPHY
Allyn and Hawkes, cat. no. 992.

Kock, Charles-Paul de. *The Barber of Paris.* Vol. 1. St. Gervais, ed. Boston: Quinby, 1903, ill. p. 44.

284. *Save Yourself; You Have Killed the Son of the King of Cochin-China,* 1903
Signed in the plate l.l.:
W. Glackens '03
Photogravure
6 x 4½ in.
Accession no. 92.120

285A–C. *The Stout Papa Shrieked at Receiving the Weight of Madam So Unexpectedly upon His Comfortable Expanse of Front,* 1903
Signed in the plate l.l.: *W. Glackens;*
C: signed in the margin l.r.:
W. Glackens
Photogravure
3½ x 5¼ in. each
Accession nos. 92.88.A–C

BIBLIOGRAPHY
Allyn and Hawkes, cat. no. 993.

Kock, Charles-Paul de. *Frère Jacques.* Vol. 1. St. Gervais ed. Boston: Quinby, 1903, ill. p. 22.

286A–C. *The Young Bachelor Allowed Himself to Be Led to a Chair,* 1903
Signed in the plate l.l.: *W. Glackens;*
A: signed in the margin l.l.:
W. Glackens
Photogravure
5 x 3½ in. each
Accession nos. 92.104.A–C

BIBLIOGRAPHY
Allyn and Hawkes, cat. no. 991.

Kock, Charles-Paul de. *The Barber of Paris.* Vol. 1. St. Gervais, ed. Boston: Quinby, 1903, ill. p. 264.

276.

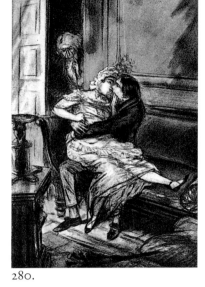

280.

283.

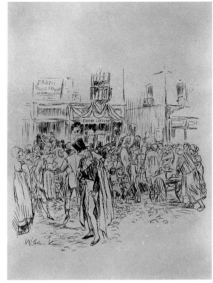

277A.

281.

284.

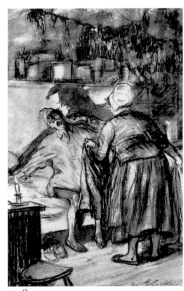

278.

282.

285.

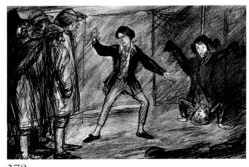

279.

286B.

289A.

292C.

287.

290.

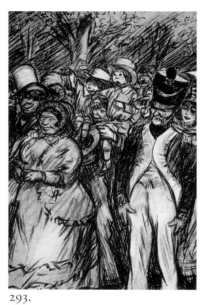

293.

288B.

291A.

Dinner New Society of Artists

294.

287. *Edmond Rose and Walked about the Room,* 1904
Signed in the plate l.r.: *W. Glackens*
Photogravure
3½ x 5 in.
Accession no. 92.97

BIBLIOGRAPHY
Allyn and Hawkes, cat. no. 1011.

Glackens, ill. p. 42.

Kock, Charles-Paul de. *Edmond and His Cousin, etc.* St. Gervais ed. Boston: Quinby, 1904, ill. p. 23.

288A–C. *The Fine Lady . . . Saw Lise, Who Was Seated in Front of Casimir,* 1904
Signed in the plate l.l.: *W. Glackens*
Photogravure
3½ x 5 in. each
Accession nos. 92.94.A–C

BIBLIOGRAPHY
Allyn and Hawkes, cat. no. 1031.

Kock, Charles-Paul de. *Little Lise.* St. Gervais ed. Boston: Quinby, 1904, ill. p. 172.

289A–E. *Go, by All Means, You Bad Boy, Kiss Me. I Shall See You Again, Presently,* 1904
Signed in the plate l.l.: *W. Glackens;*
E: signed in the margin l.r.: *W. Glackens*
Photogravure; A: colored
5 x 3½ in. each
Accession nos. 92.107.A–E

BIBLIOGRAPHY
Glackens, cat. no. 1026.

Kock, Charles-Paul de. *Little Lise.* St. Gervais ed. Boston: Quinby, 1904, ill. p. 74.

290. *He Knelt beside Constance's Bed,* 1904
Photogravure
3 x 5 in.
Accession no. 92.99

BIBLIOGRAPHY
Allyn and Hawkes, cat. no. 1014.

Kock, Charles-Paul de. *Edmond and His Cousin, etc.* St. Gervais ed. Boston: Quinby, 1904, ill. p. 105.

291A–B. *Mademoiselle, I Should Like to See Your Mark,* 1904
Signed in the plate l.r.: *W. Glackens;*
B: signed in the margin l.r.:
W. Glackens
Photogravure
5 x 3½ in. each
Accession nos. 92.89.A–B

BIBLIOGRAPHY
Allyn and Hawkes, cat. no. 1033.

Glackens, ill. p. 43.

Kock, Charles-Paul de. *Scenes of Parisian Life.* St. Gervais ed. Boston: Quinby, 1904, ill. p. 54.

292A–D. *Monsieur, I Will Have Satisfaction for All Your Insults,* 1904
Signed in the plate l.l.: *W. Glackens;*
D: signed in the margin l.r.:
W. Glackens
Photogravure
3¾ x 5 in. each
Accession nos. 92.93.A–D

BIBLIOGRAPHY
Allyn and Hawkes, cat. no. 1029.

Kock, Charles-Paul de. *Little Lise.* St. Gervais ed. Boston: Quinby, 1904, ill. p. 121.

293. *Papa, Carry Me—Take Me Up in Your Arms,* 1904
Signed in the plate l.l.: *W. Glackens;*
signed in the margin l.r.: *W. Glackens*
Photogravure
5 x 3½ in.
Accession no. 92.145

BIBLIOGRAPHY
Allyn and Hawkes, cat. no. 1018.

Kock, Charles-Paul de. *Edmond and His Cousin, etc.* St. Gervais ed. Boston: Quinby, 1904, ill. p. 226.

294. *Untitled,* c. 1920
Signed l.l.: *W.G.; Dinner New Society of Arts*
Lithograph
10½ x 6½ in.
Accession no. 91.40.89

295.

295. *Untitled*, n.d.
Ink wash on paper
8⅜ x 5½ in.
Accession no. 91.40.202

296. *Self-Portrait(?) of William Glackens,*
c. 1887
Graphite on paper
7 x 4⅝ in.
Accession no. 94.129.A

COMMENTS
This is from an early sketch book
attributed to Louis Glackens or
William Glackens.

296.

WORKS BY OTHER ARTISTS

ANTOINE-LOUIS BARYE (1796–1875)

297. *A Seated Cat: Bronze Figure,*
late 19th century
Signed: *Barye*
Bronze
Height: 3¾ in.
Accession no. 91.40.195

PROVENANCE
The artist; unknown; Ira Glackens;
Museum of Art, Fort Lauderdale.

298. *A Seated Figure of a Crouching
Rabbit,* n.d.
Signed: *Barye*
Bronze
Height: 2 in.
Accession no. 91.40.196

PROVENANCE
The artist; unknown; Ira Glackens;
Museum of Art, Fort Lauderdale

297.

298.

299. *Portrait of Daniel Logue Glackens,*
c. 1855
Signed or inscribed l.l.: [illegible]
Oil on canvas
15 x 12 in.
Accession no. 91.40.101

PROVENANCE
The artist; Daniel Logue Glackens;
William Glackens; Ira Glackens;
Museum of Art, Fort Lauderdale.

299.

EDITH DIMOCK (1876–1955)

300. *Self-Portrait,* 1900
Oil on canvas
9 x 7 in.
Accession no. 91.40.10

PROVENANCE
Unless otherwise indicated, the
provenance for all works by Edith
Dimock in the museum's collection
is: The artist; Helen Farr Sloan;
Ira Glackens; Museum of Art,
Fort Lauderdale.

EXHIBITIONS
Selections from the Glackens Collection.

301. *The Old Snuff Taker,* 1912
Signed u.l.: *E. Dimock;* signed on the
reverse: *Edith Dimock*
Watercolor on paper

7 x 7 in.
Accession no. 91.40.3
See plate 132

EXHIBITIONS
*The Magic of Line: Graphics from the
Glackens Collection.*

302. *New Shoes,* c. 1915
Signed l.l.: *E. Dimock*
Watercolor on paper
6½ x 8 in.
Accession no. 91.40.94

303. *Rain,* c. 1915
Signed l.l.: *E. Dimock*
Watercolor on paper
6½ x 8 in.
Accession no. 91.40.95

EXHIBITIONS
*The Magic of Line: Graphics from the
Glackens Collection.*

304. *Untitled,* c. 1915
Signed on label affixed to the reverse:
Edith Glackens
Watercolor on paper
8¼ x 5½ in.
Accession no. 91.40.6

305. *Untitled,* c. 1915
Watercolor on paper
5½ x 10½ in.
Accession no. 91.40.76

EXHIBITIONS
*The Magic of Line: Graphics from the
Glackens Collection.*

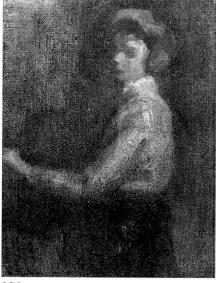

300.

302.

303.

304.

305.

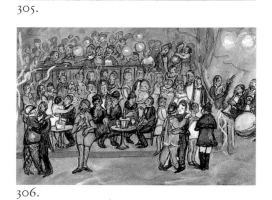

306.

309.

310.

311.

312.

313.

314.

315.

316.

317.

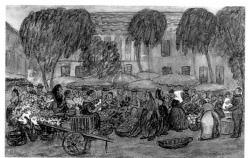

318.

319.

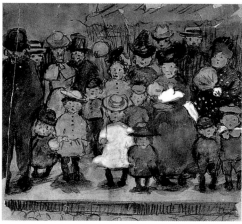

320.

322.

306. *Untitled,* c. 1915
Signed l.r.: *E. Dimock*
Watercolor on paper
7 x 10½ in.
Accession no. 91.40.177

307. *Untitled,* c. 1920
Signed l.l.: *E. Dimock*
Gouache on paper
9½ x 8½ in.
Accession no. 91.40.64

308. *Untitled,* c. 1920
Watercolor on paper
9 x 8 in.
Accession no. 91.40.73

309. *Epicerie,* 1925
Signed l.l.: *E. Dimock 1925*
Watercolor on paper
7 x 9¼ in.
Accession no. 91.40.200

310. *At an Art Gallery,* c. 1925
Signed l.r.: *E. Dimock*
Watercolor on paper
7¾ x 10½ in.
Accession no. 91.40.5

EXHIBITIONS
The Magic of Line: Graphics from the Glackens Collection.

311. *Italian Fish Market,* c. 1925
Signed u.r.: *E. Dimock*
Watercolor on paper
8¾ x 8½ in.
Accession no. 91.40.78

EXHIBITIONS
The Magic of Line: Graphics from the Glackens Collection.

312. *Mrs. Roosevelt at Klein's, No. 4,*
c. 1925
Watercolor on paper
9¾ x 8¾ in.
Accession no. 92.77

313. *Untitled,* c. 1925
Signed l.r.: *E. Dimock*
Watercolor on paper
8 x 10½ in.
Accession no. 91.40.79

314. *Untitled,* c. 1925
Signed l.l.: *E. Dimock*
Watercolor on paper
6¼ x 8 in.
Accession no. 91.40.99

EXHIBITIONS
The Magic of Line: Graphics from the Glackens Collection.

315. *Widow,* 1926
Signed l.r.: *E. Dimock 1926*
Watercolor on board
7½ x 9½ in.
Accession no. 91.40.133

316. *Trying-on Room, Klein's, Union Square,* c. 1926
Signed bottom center: *Edith Dimock*
Watercolor on paper
10 x 15 in.
Accession no. 91.40.75

317. *Untitled,* c. 1926
Watercolor on paper
11 x 8 in.
Accession no. 91.40.4

318. *Untitled,* 1930
Signed l.r.: *E. Dimock 1930*
Watercolor on paper
12 x 17 in.
Accession no. 91.40.191

319. *W.G. and E.G. Watching the Wreck,*
c. 1930
Graphite on postcard
3½ x 5½ in.
Accession no. 91.40.227

PROVENANCE
The artist; Ira Glackens; Museum of Art, Fort Lauderdale.

BIBLIOGRAPHY
Glackens, ill. p. 256.

320. *Untitled,* n.d.
Watercolor on paper
8½ x 9 in.
Accession no. 91.40.18

321. *Untitled,* n.d.
Signed l.l.: *E. Dimock*
Watercolor on paper
5½ x 10 in.
Accession no. 91.40.183

322. *Untitled,* n.d.
Watercolor on paper
11 x 8½ in.
Accession no. 92.73

EXHIBITIONS
The Magic of Line: Graphics from the Glackens Collection.

GUY PÈNE DU BOIS (1884–1958)

323. *Untitled,* 1905
Signed l.r.: *Guy Pène du Bois 1905*
Pen and black ink and wash on paper
11 x 8¼ in.
Accession no. 91.40.100

PROVENANCE
The artist; unknown; Ira Glackens; Museum of Art, Fort Lauderdale.

EXHIBITIONS
The Magic of Line: Graphics from the Glackens Collection.

324. *Pets,* 1927
Signed l.l.: *Guy Pène du Bois '27*
Oil on canvas
21½ x 18½ in.
Accession no. 91.40.134
See plate 155

PROVENANCE
The artist; Kraushaar Galleries(?), New York; Ira Glackens; Museum of Art, Fort Lauderdale.

EXHIBITIONS
Guy Pène du Bois: Artist about Town, Corcoran Gallery of Art, Washington, D.C., October 10–November 30, 1980.

Selections from the Glackens Collection.

325. *At an Exhibition,* 1938
Signed: *Guy Pène du Bois '38*
Watercolor, pen and black ink on paper
15½ x 12½ in.
Accession no. 91.40.189

PROVENANCE
The artist; unknown; Ira Glackens; Museum of Art, Fort Lauderdale.

EXHIBITIONS
Guy Pène du Bois: Artist about Town, Corcoran Gallery of Art, Washington, D.C., October 10–November 30, 1980.

The Magic of Line: Graphics from the Glackens Collection.

326. *Portrait of Nancy Glackens,* 1952
Signed l.l.: *Guy Pène du Bois '52*
Oil on canvas
30 x 25 in.
Accession no. 91.40.141

PROVENANCE
The artist; Ira and Nancy Glackens; Museum of Art, Fort Lauderdale.

EXHIBITIONS
Selections from the Glackens Collection.

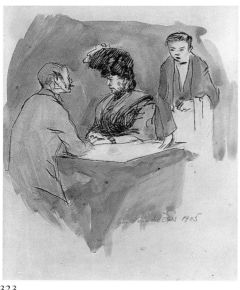

323.

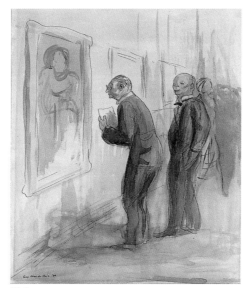

325.

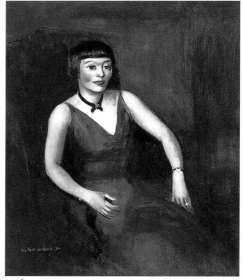

326.

LENNA GLACKENS (1913–1943)

327. *The Dream Ride,* 1920
Crayon on paper
9½ x 10½ in.
Accession no. 92.144

PROVENANCE
Unless otherwise indicated, the provenance for all works by Lenna Glackens in the museum's collection is: The artist; Ira Glackens; Museum of Art, Fort Lauderdale.

328. *William Glackens and Imp,* c. 1930
Oil on canvas
11¼ x 15¼ in.
Accession no. 91.40.12

BIBLIOGRAPHY
Glackens, ill. after p. 174.

EXHIBITIONS
Selections from the Glackens Collection.

329. *Triptych,* n.d.
Signed bottom center: *LG*
Mixed media
7¼ x 11 in.
Accession no. 94.9

330. *Triumph of Bigotry,* n.d.
Signed l.l.: *Lenna Glackens*
Oil on canvas
25 x 35 in.
Accession no. 91.40.201

BIBLIOGRAPHY
"Tenth Memorial Exhibition of
Paintings by William Glackens."
World Tribune Review, November
1947.

EXHIBITIONS
*Tenth Memorial Exhibition of Paint-
ings by William Glackens; Also a
Group of Drawings and Paintings by
Lenna Glackens,* Edith Dimock
Glackens residence, New York,
November 2–30, 1947.

331. *Untitled,* c. 1920(?)
Graphite and crayon on paper
5 x 8 in.
Accession no. 91.40.320

327.

328.

330.

LOUIS GLACKENS (1866–1933)

332. *Under the Old Boot-Tree Tabby,* 1907
Signed l.l.: *L. M. Glackens*
Crayon, pen and black ink on paper
12½ x 16½ in.
Accession no. 91.40.160

PROVENANCE
Unless otherwise indicated, the
provenance for all works by Louis
Glackens in the museum's collection
is: the artist; Ira Glackens; Museum
of Art, Fort Lauderdale.

333A–B. *Untitled,* c. 1915
Graphite on paper
8 x 5 in. each
Accession nos. 91.40.229.A–B

334. *Untitled,* c. 1915
Graphite on paper
5 x 8 in.
Accession no. 91.40.230

335. *Untitled,* c. 1915
Graphite on paper
9 x 7 in.
Accession no. 91.40.231

336. *Untitled,* c. 1915
Graphite on paper
9 x 7 in.
Accession no. 91.40.236

332.

333.

334.

337. *Untitled*, c. 1915
Graphite on paper
5 x 8 in.
Accession no. 91.40.237

338. *Untitled*, c. 1915
Graphite on paper
5 x 8 in.
Accession no. 91.40.238

339. *Untitled*, c. 1915
Graphite on paper
5 x 8 in.
Accession no. 91.40.239

340. *Untitled*, c. 1915
Graphite on paper
8 x 5 in.
Accession no. 91.40.240

341. *Untitled*, c. 1915
Green pencil on paper
8 x 10 in.
Accession no. 91.40.241

342. *Untitled*, c. 1915
Graphite on paper
5 x 8 in.
Accession no. 91.40.242

343. *Untitled*, c. 1915
Graphite on paper
8 x 5 in.
Accession no. 91.40.243

344. *Untitled*, c. 1915
Graphite on paper
8 x 5 in.
Accession no. 91.40.244

345. *Untitled*, c. 1915
Graphite on paper
8 x 10 in.
Accession no. 91.40.245

346A–B. *Untitled*, c. 1915
A: ink on paper; B: graphite on paper
12½ x 8 in. each
Accession nos. 91.40.246.A–B

347. *Untitled*, c. 1915
Graphite on paper
5½ x 9 in.
Accession no. 91.40.247

348. *Untitled*, c. 1915
Graphite on paper
5½ x 9 in.
Accession no. 91.40.248

345.

347.

348.

349.

350.

349. *Untitled*, c. 1915
Graphite on paper
8 x 10 in.
Accession no. 91.40.249

350. *Untitled*, c. 1915
Graphite on paper
5 x 8 in.
Accession no. 91.40.251

351. *Untitled*, c. 1915
Graphite on paper
5 x 8 in.
Accession no. 91.40.252

352. *Untitled*, c. 1915
Graphite on paper
5 x 8 in.
Accession no. 91.40.253

353. *Untitled*, c. 1915
Graphite on paper
5 x 8 in.
Accession no. 91.40.254

354. *Untitled*, c. 1915
Graphite on paper
5 x 8 in.
Accession no. 91.40.255

355. *Untitled*, c. 1915
Graphite on paper
5 x 8 in.
Accession no. 91.40.256

356. *Untitled*, c. 1915
Graphite on paper
8 x 5 in.
Accession no. 91.40.257

357. *Untitled*, c. 1915
Graphite on paper
8 x 5 in.
Accession no. 91.40.258

358A–B. *Untitled (Headache . . .)*, c. 1915
Graphite on paper
5 x 8 in. each
Accession nos. 91.40.259.A–B

359. *Untitled*, c. 1915
Graphite on paper
5 x 8 in.
Accession no. 91.40.260

360. *Untitled*, c. 1915
Graphite on paper
5 x 8 in.
Accession no. 91.40.261

363.

364.

365.

366.

361. *Untitled*, c. 1915
Graphite on paper
8 x 5 in.
Accession no. 91.40.262

362. *Untitled*, c. 1915
Graphite on paper
8 x 5 in.
Accession no. 91.40.263

363A–B. *Untitled (Candy, Cake and Pies),*
c. 1915
Graphite on paper
8 x 5 in. each
Accession nos. 91.40.264.A–B

364. *Untitled*, c. 1915
Graphite on paper
5 x 8 in.
Accession no. 91.40.265

365. *Untitled*, c. 1915
Graphite on paper
5 x 8 in.
Accession no. 91.40.266

366. *Untitled*, c. 1915
Graphite on paper
5 x 8 in.
Accession no. 91.40.267

367. *Untitled*, c. 1915
Graphite on paper
5 x 8 in.
Accession no. 91.40.268

368A–B. *Untitled*, c. 1915
Graphite on paper
9 x 7 in. each
Accession nos. 91.40.269.A–B

369A–B. *Untitled*, c. 1915
Graphite on paper
5½ x 9¹³⁄₁₆ in. each
Accession nos. 91.40.270.A–B

370. *Untitled*, c. 1915
Graphite on paper
8 x 10 in.
Accession no. 91.40.271

371. *Untitled*, c. 1915
Graphite on paper
10 x 8 in.
Accession no. 91.40.272

372. *Untitled*, c. 1915
Graphite on paper
8 x 10 in.
Accession no. 91.40.273

373. *Untitled*, c. 1915
Graphite on paper
8 x 10 in.
Accession no. 91.40.274

374. *Untitled* (studies for heads of
animals), c. 1915
Graphite and green crayon on paper
8 x 9¾ in.
Accession no. 91.40.275

375. *Untitled*, c. 1915
Graphite on paper
10 x 8 in.
Accession no. 91.40.276

376. *Untitled*, c. 1915
Graphite on paper
8 x 5 in.
Accession no. 91.40.277

377. *Untitled*, c. 1915
Graphite on paper
5 x 8 in.
Accession no. 91.40.278

378. *Untitled*, c. 1915
Graphite on paper
8 x 5 in.
Accession no. 91.40.279

379. *Untitled*, c. 1915
Graphite on paper
8 x 5 in.
Accession no. 91.40.280

380. *Untitled*, c. 1915
Graphite on paper
5 x 8 in.
Accession no. 91.40.281

381. *Untitled*, c. 1915
Graphite on paper
5 x 8 in.
Accession no. 91.40.282

382. *Untitled*, c. 1915
Graphite on paper
6¾ x 9 in.
Accession no. 91.40.283

383. *Untitled*, c. 1915
Graphite and red pencil on paper
5 x 8 in.
Accession no. 91.40.284

384. *Untitled*, c. 1915
Graphite on paper
5 x 8 in.
Accession no. 91.40.285

378.

379.

380.

381.

382.

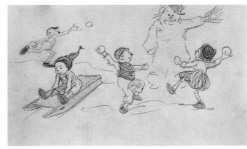

383.

384.

385.

385A–B. *Untitled*, c. 1915
Charcoal on paper
8½ x 13½ in. each
Accession nos. 91.40.286.A–B

386. *Untitled*, c. 1915
Graphite on paper
8 x 5 in.
Accession no. 91.40.287

387. *Untitled*, c. 1915
Graphite on paper
8 x 5 in.
Accession no. 91.40.288

388. *Untitled*, c. 1915
Graphite on paper
8 x 5 in.
Accession no. 91.40.289

389. *Untitled*, c. 1915
Graphite on paper
8 x 5 in.
Accession no. 91.40.290

390. *Untitled*, c. 1915
Graphite on paper
5¾ x 9 in.
Accession no. 91.40.291

391. *Untitled*, c. 1915
Graphite on paper
5¾ x 9 in.
Accession no. 91.40.292

392. *Untitled*, c. 1915
Graphite on paper
5¾ x 9 in.
Accession no. 91.40.293

393. *Untitled*, c. 1915
Graphite and red pencil on paper
8 x 5 in.
Accession no. 91.40.294

394. *Untitled*, c. 1915
Graphite on paper
8 x 5 in.
Accession no. 91.40.295

395. *Untitled*, c. 1915
Graphite on paper
9 x 5¾ in.
Accession no. 91.40.296

396.

397.

398.

400.

401.

402A.

403.

404.

396. *Untitled*, c. 1915
Graphite on paper
9 x 5¾ in.
Accession no. 91.40.297

397. *Untitled*, c. 1915
Graphite on paper
8 x 5 in.
Accession no. 91.40.298

398. *Untitled*, c. 1915
Graphite on paper
5¾ x 8¾ in.
Accession no. 92.78

399. *Untitled*, c. 1915
Graphite on paper
5 x 8 in.
Accession no. 92.79

400. *Untitled*, c. 1915
Graphite on paper
8 x 5 in.
Accession no. 92.80

401. *Untitled*, c. 1915
Graphite on paper
5 x 8 in.
Accession no. 92.91

402A–B. A: *Chestnut Street, Saturday
Afternoon*, 1929
B: *No Bartholemew, It's Your Turn*
Ink on paper
5½ x 7 in. each
Accession nos. 91.40.301.A–B

EXHIBITIONS
*The Magic of Line: Graphics from the
Glackens Collection*

403. *But I'll Try*, n.d.
Ink on paper
5½ x 7 in.
Accession no. 91.40.300

404. *Corpulent or Complacent Cow That
Gives Everybody a Ride*, n.d.
Graphite on paper
5 x 8 in.
Accession no. 91.40.250

405. *Father I Cannot Tell a Lie. I Did It
with My Little Hatchet*, n.d.
Inscribed in graphite u.l.: *Smashed
Village of Primitive Man*; inscribed
bottom center: *Father I Cannot Tell a
Lie, I Did It With My Little Hatchet*
Graphite, pen and ink on paper
9½ x 12 in.
Accession no. 91.40.299

405.

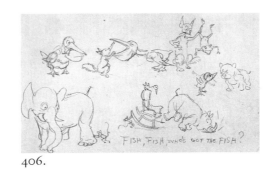

406.

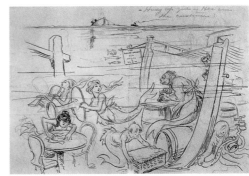

407.

EXHIBITIONS
The Magic of Line: Graphics from the Glackens Collection.

406. *Fish, Fish, Who's Got the Fish?,* n.d.
Graphite on paper
5 x 8 in.
Accession no. 91.40.228

407. *Hurry Up Girls—Here Comes the Customers,* n.d.
Inscribed u.r.: *Hurry Up Girls— Here Comes the Customers*
Graphite, pen and ink on paper
8½ x 11¾ in.
Accession no. 92.132

EXHIBITIONS
The Magic of Line: Graphics from the Glackens Collection.

TOM HARDY (B. 1921)

408. *Wet Hen,* 1974
Signed l.l.: Tom Hardy 1974
Graphite on paper
10¼ x 14½ in.
Accession no. 91.40.74

PROVENANCE
The artist; Kraushaar Galleries, New York; Ira Glackens; Museum of Art, Fort Lauderdale.

408.

ROBERT HENRI (1865–1929)

409. *Portrait of a Lady,* n.d.
Oil on canvas
19¼ x 15 in.
Accession no. 92.39

409.

PROVENANCE
The artist; William and Edith Dimock Glackens; Ira Glackens; Museum of Art, Fort Lauderdale.

EXHIBITIONS
Selections from the Glackens Collection.

ERNEST LAWSON (1873–1939)

410. *Nancy's Cove,* n.d.
Signed l.r.: *Ernest Lawson*
Oil on canvas
15½ x 19½ in.
Accession no. 91.40.149

PROVENANCE
The artist; Edith Dimock
Glackens(?); Ira Glackens; Museum
of Art, Fort Lauderdale.

411. *Spring on the Hudson,* n.d.
Oil on canvas
20 x 24½ in.
Accession no. 91.40.143

PROVENANCE
The artist; Edith Dimock Glackens;
Ira Glackens; Museum of Art, Fort
Lauderdale.

EXHIBITIONS
Ernest Lawson, National Gallery of
Canada, Ottawa, 1967, no. 37.

411.

412.

412. *Untitled,* n.d.
Signed l.l.: *E. Lawson*
Oil on board
9 x 11½ in.
Accession no. 91.40.111

PROVENANCE
The artist; Edith Dimock Glackens;
Ira Glackens; Museum of Art, Fort
Lauderdale.

413. *Windblown Tree,* n.d.
Signed l.l.: *E. Lawson*
Oil on board
9 x 9 in.
Accession no. 91.40.315
See plate 151

PROVENANCE
The artist; unknown; Ira Glackens;
Museum of Art, Fort Lauderdale.

RICHARD HAYLEY LEVER (1876–1958)

414. *Beachy Head,* 1912
Signed l.l.: *Hayley Lever 1912;* signed
on the reverse: *Hayley Lever 1912*
Oil on board
7 x 10 in.
Accession no. 91.40.138

PROVENANCE
The artist; unknown; Ira Glackens;
Museum of Art, Fort Lauderdale.

414.

EXHIBITIONS
Retrospective, Bernard Block Gallery
of Paintings, Sculpture and Antiques,
September–October 1961, no. 10.

GEORGE BENJAMIN LUKS (1867–1933)

415A–C. *Untitled,* c. 1902
Signed u.r.: *G. B. Luks*
Etching
4¾ x 3½ in. each
Accession nos. 92.108.A–C

PROVENANCE
The artist; unknown; Ira Glackens;
Museum of Art, Fort Lauderdale.

416. *Ah, You've Come at Last, Young Man,*
1902–3
Charcoal and wash on brown paper
10 x 6½ in.
Accession no. 91.40.57

Original drawing for a story by
Charles-Paul de Kock, 1903.

PROVENANCE
The artist; unknown; Ira Glackens;
Museum of Art, Fort Lauderdale.

EXHIBITIONS
*The Magic of Line: Graphics from the
Glackens Collection.*

417. *Ostriches,* 1904
Charcoal on paper
7½ x 9¾ in.
Accession no. 91.40.185

PROVENANCE
The artist; unknown; Ira Glackens;
Museum of Art, Fort Lauderdale.

EXHIBITIONS
*The Magic of Line: Graphics from the
Glackens Collection.*

418. *Girl in Blue,* n.d.
Signed l.r.: *Luks*
Oil on canvas
20 x 16 in.
Accession no. 91.40.132

415.

416.

417.

418.

PROVENANCE
The artist; Kraushaar Galleries,
New York; Ira Glackens; Museum of
Art, Fort Lauderdale.

EXHIBITIONS
Selections from the Glackens Collection.

419. *The Night Rolled On and Nothing
Happened,* n.d.
Signed l.l.: *G.B.L.*
Gouache on paper
6¼ x 9¼ in.
Accession no. 91.40.49

PROVENANCE
The artist; unknown; Ira Glackens;
Museum of Art, Fort Lauderdale.

EXHIBITIONS
*The Magic of Line: Graphics from the
Glackens Collection.*

420. *The Night Rolled On and Nothing
Happened,* n.d.
Signed in the plate l.r.: *George Luks*
Etching
3½ x 5 in.
Accession no. 92.81

PROVENANCE
The artist; unknown; Ira Glackens;
Museum of Art, Fort Lauderdale.

421. *Untitled,* n.d.
Oil on panel
32½ x 19¾ in.
Accession no. 94.76

419.

420.

421.

JAMES WILSON MORRICE (1865–1924)

422. *Untitled,* n.d.
Signed l.l.: *J. W. Morrice*
Oil on board
6 x 5 in.
Accession no. 91.40.187

PROVENANCE
The artist; unknown; Ira Glackens;
Museum of Art, Fort Lauderdale.

BIBLIOGRAPHY
Wattenmaker, Richard. *Maurice Prendergast.* New York: Harry N. Abrams in Association with the National Museum of American Art, Smithsonian Institution, 1994, ill. pp. 24, 26.

422.

ETHEL MYERS (1881–1960)

423. *Grace Morgan,* c. 1913
Bronze, 1/17
Height: 9 in.
Accession no. 91.40.194

PROVENANCE
The artist; unknown; Ira Glackens;
Museum of Art, Fort Lauderdale.

423.

JEROME MYERS (1867–1940)

424. *The Old Quarter,* n.d.
Signed l.l.: *Jerome Myers*
Etching
9½ x 11 in.
Accession no. 91.40.159

PROVENANCE
The artist; Lenna Glackens(?);

424.

Ira Glackens; Museum of Art,
Fort Lauderdale.

EXHIBITIONS
The Magic of Line: Graphics from the Glackens Collection.

MARJORIE ORGAN (1886–1930)

425. *Portraits of Henri, Yeats, and Sloan,* n.d.
Signed l.l.: *Marjorie Organ*
Gouache, pen and black ink on paper
19½ x 12¼ in.
Accession no. 91.40.61

PROVENANCE
The artist; unknown; Ira Glackens; Museum of Art, Fort Lauderdale.

425.

BIBLIOGRAPHY
Berman, Avis. *Rebels on Eighth Street: Juliana Force and the Whitney Museum.* New York: Atheneum, 1990, ill. p. 127.

COMMENTS
These are portraits, by Robert Henri's second wife, of the two Ashcan School artists and the poet and painter John Butler Yeats (father of the poet William Butler Yeats).

CHARLES E. PRENDERGAST (1868–1948)

426. *Bounding Deer,* 1936
Signed l.l.: *C. Prendergast*
Oil and gesso embossed on board
15 x 19¼ in.
Accession no. 91.40.105

426.

PROVENANCE
The artist; C. W. Kraushaar Art Galleries, New York; Ira Glackens; Museum of Art, Fort Lauderdale.

BIBLIOGRAPHY
Wattenmaker, Richard J. *The Art of Charles Prendergast.* Greenwich, Conn.: New York Graphic Society, 1968, ill. p. 68.

EXHIBITIONS
The Art of Charles Prendergast, Museum of Fine Arts, Boston, October 2–November 3, 1968; University Art Gallery, Rutgers University, New Brunswick, New Jersey, November 17–December 22, 1968; Phillips Collection, Washington, D.C., January 11–February 16, 1969.

Selections from the Glackens Collection.

427. *Box,* n.d.
Incised and painted wood
2 x 6½ x 3 in.
Accession no. 91.40.193

PROVENANCE
The artist; William and Edith Dimock Glackens; Ira Glackens; Museum of Art, Fort Lauderdale.

427.

MAURICE BRAZIL PRENDERGAST (1859–1924)

428. *Ladies in the Rain,* c. 1893–94
Signed l.l.: *M. B. Prendergast, Boston*
Watercolor and graphite on paper
14 x 6 in.
Accession no. 91.40.131

PROVENANCE
The artist; Charles FitzGerald; Irene Dimock FitzGerald; Ira Glackens; Museum of Art, Fort Lauderdale.

BIBLIOGRAPHY
Wattenmaker, Richard. *Maurice Prendergast.* New York: Henry N. Abrams in association with the National Museum of American Art, Smithsonian Institution, 1994, ill pp. 20, 24.

EXHIBITIONS
Currier Gallery, Manchester, New Hampshire, 1969, no. 73.

Selections from the Glackens Collection.

429. *The Lady with Dog—Primrose Hill,* c. 1895–1900
Signed with monogram l.r.: *MBP;* inscribed in plate across the bottom: *The Lady with Dog Primrose Hill*
Monotype on paper with graphite additions
8 x 8 in.
Accession no. 91.40.136

PROVENANCE
The artist; Charles E. Prendergast, 1924; Lenna Glackens; Ira Glackens; Museum of Art, Fort Lauderdale.

BIBLIOGRAPHY
The Monotypes of Maurice Prendergast: A Loan Exhibition. New York: Davis and Long Company, 1979, ill. p. 46.

EXHIBITIONS
The Monotypes of Maurice Prendergast. New York: Davis and Long Company, 1979, no. 12.

The Magic of Line: Graphics from the Glackens Collection.

430. *Apples and Pear on the Grass,* 1912
Signed l.l.: *Prendergast*
Oil on panel
9½ x 13 in.
Accession no. 91.40.109

PROVENANCE
The artist; William and Edith Dimock Glackens, 1912; Ira Glackens; Museum of Art, Fort Lauderdale.

BIBLIOGRAPHY
Glackens, p. 120.

Wattenmaker, Richard. *Maurice Prendergast.* New York: Harry N. Abrams in Association with the National Museum of American Art, Smithsonian Institution, 1994, ill. pp. 106, 109.

EXHIBITIONS
Currier Gallery, Manchester, New Hampshire, 1960.

431. *Ira Glackens at Five,* c. 1912
Signed in green, l.l.: *Prendergast*
Oil on canvas
20 x 16 in.
Accession no. 91.40.142
See plate 74

PROVENANCE
The artist; William and Edith Dimock Glackens, c. 1912; Ira Glackens; Museum of Art, Fort Lauderdale.

EXHIBITIONS
Selections from the Glackens Collection.

432. *Landscape with Carriage* (also known as *Study*), c. 1912–13
Signed in black ink l.r.: *Prendergast*
Watercolor and graphite on paper
14¾ x 21¾ in.
Accession no. 91.40.16
See plate 154

PROVENANCE
The artist; Edith Dimock Glackens, 1913; Ira Glackens; Museum of Art, Fort Lauderdale.

EXHIBITIONS
International Exhibition of Modern Art (Armory Show), New York, February 17–March 31, 1913, no. 899 (as *Study*).

Selections from the Glackens Collection.

433. *Nanhant* (also known as *Landscape with a Carriage*), c. 1912–13
Signed in black, l.l.: *Prendergast;* signed in ink l.r.: *Prendergast*
Watercolor and graphite on paper
14¾ x 21½ in.
Accession no. 91.40.155
See plate 75

PROVENANCE
The artist; Charles E. Prendergast, 1924; Mrs. Charles E. Prendergast, 1948; Ira Glackens; Museum of Art, Fort Lauderdale.

BIBLIOGRAPHY
Mathews, Nancy Mowll. *Maurice Prendergast.* Williamstown, Mass.: Williams College Museum of Art; Munich: Prestel, 1990, ill. p. 29.

EXHIBITIONS
Maurice Prendergast Memorial Exhibition, Kraushaar Galleries, New York, 1925, no. 4.

Selections from the Glackens Collection.

434. *Bathers on a Beach,* c. 1912–15
Watercolor, pastel, and graphite on paper
9¾ x 12¾ in.
Accession no. 91.40.157

PROVENANCE
The artist; Charles E. Prendergast, 1924; Mrs. Charles E. Prendergast; Kraushaar Galleries, New York; Ira Glackens; Museum of Art, Fort Lauderdale.

EXHIBITIONS
Selections from the Glackens Collection.

428.

429.

430.

434.

JAMES MOORE PRESTON (1873–1962)

435.

435A–C. *Untitled,* 1903
Photogravure
5 x 3¾ in. each
Accession nos. 92.100.A–C

PROVENANCE
The artist; unknown; Ira Glackens;
Museum of Art, Fort Lauderdale.

436. *A Church, Château-Thierry,
France,* n.d.
Charcoal on paper
6 x 7½ in.
Accession no. 91.40.70

PROVENANCE
The artist; unknown; Ira Glackens;
Museum of Art, Fort Lauderdale.

436.

MARY (MAY) WILSON PRESTON (1873–1949)

437. *Untitled,* 1926
Signed: *May Wilson Preston '26*
Oil on canvas
12 x 16 in.
Accession no. 91.40.145

437.

PROVENANCE
The artist; William and Edith
Dimock Glackens; Ira Glackens;
Museum of Art, Fort Lauderdale.

EXHIBITIONS
Selections from the Glackens Collection.

RONALD SEARLE (B. 1920)

438.

438. *River Boat,* n.d.
Signed l.l.: *Ronald Searle*
Pen and black ink on paper
16 x 12½ in.
Accession no. 91.40.190

PROVENANCE
The artist; unknown; Ira Glackens;
Museum of Art, Fort Lauderdale.

439. *A-Hunting-We-Will-Go,* n.d.
Signed l.r.: *Ronald Searle;* inscribed
l.l.: *Dog's Ear Book 35 pp. 60–61*
Pen and black ink on paper
8 x 12½ in.
Accession no. 91.40.192

PROVENANCE
The artist; unknown; Ira Glackens;
Museum of Art, Fort Lauderdale.

439.

EVERETT SHINN (1876–1953)

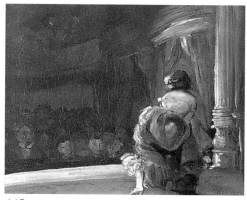

440.

440. *Curtain Call*, n.d.
Signed l.r.: *E. Shinn*
Oil on canvas
10 x 12 in.
Accession no. 91.40.140

PROVENANCE
The artist; unknown; Ira Glackens;
Museum of Art, Fort Lauderdale.

BIBLIOGRAPHY
DeShazo, Edith. *Everett Shinn, 1876–1953: A Figure in His Time.*
New York: Clarkson N. Potter, 1974, ill. pp. 46–47.

Glackens, ill. after p. 174.

EXHIBITIONS
Selections from the Glackens Collection.

POSSIBLE ATTRIBUTION TO EVERETT SHINN

441. *Portrait of William Glackens*, n.d.
Graphite on paper
10 x 7½ in.
Accession no. 94.29

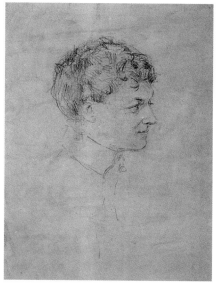

441.

FLORENCE SCOVEL SHINN (1869–1940)

442. *Portrait of John Sloan*(?), 1895
Signed l.r.: *FS '95*
Pen and black ink on paper
10½ x 6⅛ in.
Accession no. 91.40.318

PROVENANCE
The artist; John Sloan; unknown;
Ira Glackens; Museum of Art,
Fort Lauderdale.

COMMENTS
This could be a portrait of James
Moore Preston, rather than Sloan.

443. *Portrait of William Glackens*, 1895
Signed l.l.: *F.S. 1895*
Pen and black ink on paper
7¼ x 5¼ in.
Accession no. 91.40.199

PROVENANCE
The artist; William Glackens;
Ira Glackens; Museum of Art,
Fort Lauderdale.

EXHIBITIONS
*The Magic of Line: Graphics from the
Glackens Collection.*

444. *Portrait of Edith Glackens*, c. 1905
Signed l.r.: *Florence Scovel Shinn*
Gouache, pen and black ink on
paper
14½ x 11 in.
Accession no. 91.40.62

PROVENANCE
The artist; Edith Dimock Glackens;
Ira Glackens; Museum of Art, Fort
Lauderdale.

443.

444.

445. *Portrait of William J. Glackens,* c. 1905
Signed l.r.: *Florence Scovel Shinn*
Gouache, pen and black ink on paper
12 x 17 in.
Accession no. 91.40.63

PROVENANCE
The artist; William Glackens; Ira
Glackens; Museum of Art, Fort
Lauderdale.

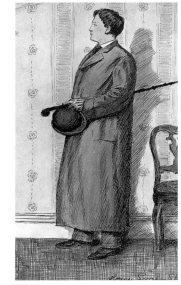

445.

JOHN SLOAN (1871–1951)

446. *The Branding of Edouard,* 1902
Signed in the plate l.r.: *John Sloan*
Photogravure
4¾ x 3½ in.
Accession no. 91.40.309

PROVENANCE
The artist; unknown; Ira Glackens;
Museum of Art, Fort Lauderdale.

BIBLIOGRAPHY
Hawkes, cat. no. 673.

Kock, Charles-Paul de. *Frère Jacques.*
Vol. 2. St. Gervais ed. Boston:
Quinby, 1902, facing p. 124.

COMMENTS
The caption reads "The eyes of the
unfortunate man met hers. It was
Edouard; it was her husband."

447. *Dupont's Ride* (also known as
*In Vain Did Dupont Shout,
"Stop! Stop!"*), 1902
Signed in the plate l.r.:
John Sloan 1902
Photogravure
5 x 3½ in.
Accession no. 92.85

PROVENANCE
The artist; unknown; Ira Glackens;
Museum of Art, Fort Lauderdale.

BIBLIOGRAPHY
Hawkes, cat. no. 663.

Kock, Charles-Paul de. *Monsieur
Dupont.* Vol. 2. St. Gervais ed.
Boston: Quinby, 1902, ill. facing
p. 224.

448. *The Row at the Picnic,* 1902
Signed in the plate l.r.: *John Sloan*
Photogravure
4⅞ x 4⅝ in.
Accession no. 91.40.307

PROVENANCE
The artist; unknown; Ira Glackens;
Museum of Art, Fort Lauderdale.

BIBLIOGRAPHY
Hawkes, cat. no. 660.

Kock, Charles-Paul de. *Monsieur
Dupont.* Vol. 1. St. Gervais ed.
Boston: Quinby, 1902, frontispiece.

COMMENTS
The caption reads "Poor Bidois,
who had been drawn into the midst
of the tumult, . . . received upon

446.

447.

448.

his nose the blow intended for the toymaker."

449. *The Serenade,* 1902
Signed in the plate l.r.: *John Sloan*
Photogravure
4¾ x 3½ in.
Accession no. 91.40.306

PROVENANCE
The artist; unknown; Ira Glackens; Museum of Art, Fort Lauderdale.

BIBLIOGRAPHY
Hawkes, cat. no. 662.

Kock, Charles-Paul de. *Monsieur Dupont.* Vol. 2. St. Gervais ed. Boston: Quinby, 1902, frontispiece.

COMMENTS
The caption reads "The violin mounted the counter, the hunting-horn seated himself upon the loaves of sugar, the clarinet upon a keg of glue, and the fife upon a barrel of molasses."

450. *Sleepwalker and Hypnotist,* 1902
Signed in the plate l.r.: *John Sloan*
Photogravure
4¹³⁄₁₆ x 3⁵⁄₁₆ in.
Accession no. 91.40.308

PROVENANCE
The artist; unknown; Ira Glackens; Museum of Art, Fort Lauderdale.

BIBLIOGRAPHY
Hawkes, cat. no. 670.

Kock, Charles-Paul de. *Frère Jacques.* Vol. 1. St. Gervais ed. Boston: Quinby, 1903, frontispiece.

COMMENTS
The caption reads "He passed his hand several times before my face, and put his index finger to the end of my nose."

451. *The Donkey Ride,* 1903
Signed in the plate l.r.: *John Sloan 1903*
Photogravure
3½ x 5¼ in.
Accession no. 92.118

PROVENANCE
The artist; unknown; Ira Glackens; Museum of Art, Fort Lauderdale.

BIBLIOGRAPHY
Hawkes, cat. no. 675.

Kock, Charles-Paul de. *The Gogo Family.* Vol. 1. St. Gervais ed. Boston: Quinby, 1903, frontispiece.

COMMENTS
The caption reads "Her mount decided to take to a gallop and bore off his rider."

452. *Monsieur Gerval Returns,* 1903
Signed in the plate l.r.: *John Sloan*
Photogravure
4¾ x 3½ in.
Accession no. 92.101

PROVENANCE
The artist; unknown; Ira Glackens; Museum of Art, Fort Lauderdale.

BIBLIOGRAPHY
Hawkes, cat. no. 674.

Kock, Charles-Paul de. *Frère Jacques.* Vol. 2. St. Gervais ed. Boston: Quinby, 1903, ill. facing p. 192.

COMMENTS
The caption reads "M. Gerval was obliged to make a sign to the villagers to withdraw themselves."

453. *Some Gendarmes and a Police Officer Came into the Room,* 1903
Signed in the plate l.r.: *John Sloan*
Photogravure
5 x 3½ in.
Accession no. 92.86

PROVENANCE
The artist; unknown; Ira Glackens; Museum of Art, Fort Lauderdale.

BIBLIOGRAPHY
Hawkes, cat. no. 672.

Kock, Charles-Paul de. *Frère Jacques.* Vol. 2. St. Gervais ed. Boston: Quinby, 1903, frontispiece.

454A–C. *Lucille's English Lesson,* 1904
Signed in the plate l.r.: *John Sloan 1904*
Photogravure
5¼ x 4 in. each
Accession nos. 92.90.A–C

PROVENANCE
The artist; unknown; Ira Glackens; Museum of Art, Fort Lauderdale.

BIBLIOGRAPHY
Hawkes, cat. no. 708.

Kock, Charles-Paul de. *André the Savoyard.* Vol. 2. St. Gervais ed. Boston: Quinby, 1904, ill. facing p. 26.

COMMENTS
The caption reads "Ah, how pretty—kiss me—stay, I can say that quite readily."

455. *Connoisseurs of Prints,* 1905
Signed in the plate l.l.: *John Sloan;* signed in the margin l.r.: *John Sloan*
Etching on wove paper, ed. 105
5½ x 7½ in.
Accession no. 91.40.72

PROVENANCE
The artist; unknown; Ira Glackens; Museum of Art, Fort Lauderdale.

456. *Fifth Avenue Critics* (also known as *Connoisseurs of Virtue* and *Une Rue à New York*), 1905
Signed in the plate l.r.: *John Sloan*
Etching on France watermarked paper, ed. 110
5 x 6⅞ in.
Accession no. 91.40.80

PROVENANCE
The artist; unknown; Ira Glackens; Museum of Art, Fort Lauderdale.

EXHIBITIONS
The Magic of Line: Graphics from the Glackens Collection.

457. *Fun, One Cent,* 1905
Signed in the plate l.r.: *John Sloan 1925;* signed in the margin l.r.: *John Sloan*
Etching on laid paper, ed. 60
5½ x 7¼ in.
Accession no. 91.40.71

PROVENANCE
The artist; unknown; Ira Glackens; Museum of Art, Fort Lauderdale.

EXHIBITIONS
The Magic of Line: Graphics from the Glackens Collection.

458. *Man Monkey,* 1905
Signed in the plate l.r.: *John Sloan*
Etching on laid paper, ed. 100
5 x 7 in.
Accession no. 91.40.88

PROVENANCE
The artist; Ira Glackens; Museum of Art, Fort Lauderdale.

449.

452.

455.

450.

453.

456.

457.

451.

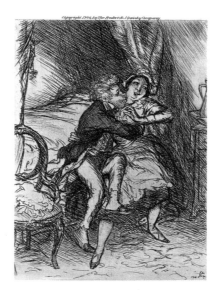

454.

458.

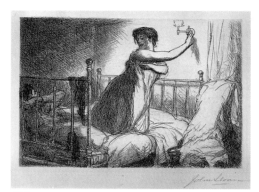

459.

460.

461.

462.

459. *Turning Out the Light,* 1905
Signed in the plate l.r.: *John Sloan*
Etching on wove Rives watermarked
paper, ed. 110
5½ x 7½ in.
Accession no. 91.40.81

PROVENANCE
The artist; unknown; Ira Glackens;
Museum of Art, Fort Lauderdale.

EXHIBITIONS
*The Magic of Line: Graphics from the
Glackens Collection.*

460. *Eubetilebethare,* 1909
Signed l.r.: *J.S. 3/18/09;* inscribed
bottom center: *Eubetilebethare*
Pen and black ink on paper
4¾ x 8 in.
Accession no. 91.40.180

PROVENANCE
The artist; William and Edith
Dimock Glackens; Ira Glackens;
Museum of Art, Fort Lauderdale.

BIBLIOGRAPHY
Glackens, ill. p. 139.

EXHIBITIONS
*The Magic of Line: Graphics from the
Glackens Collection.*

461. *The Rag Pickers,* 1913
Signed in the plate l.l.: *John Sloan
'13;* inscribed in the margin:
*New Year Greetings from Dolly
and John Sloan*
Etching
2¾ x 3½ in.
Accession no. 91.40.302

PROVENANCE
The artist; William and Edith
Dimock Glackens; Ira Glackens;
Museum of Art, Fort Lauderdale.

EXHIBITIONS
*The Magic of Line: Graphics from the
Glackens Collection.*

462. *New Year Greeting,* 1915
Signed in the plate: *New Year
Greeting 1915 From Dolly and
John Sloan*
Etching
4⅝ x 2½ in.
Accession no. 91.40.303

PROVENANCE
The artist; William and Edith
Dimock Glackens; Ira Glackens;
Museum of Art, Fort Lauderdale.

EXHIBITIONS
*The Magic of Line: Graphics from the
Glackens Collection.*

463. *Calf Love,* 1916
Signed in the plate l.l.: *John Sloan
1916;* inscribed in the margin: *Dolly
and John Sloan wish you a Happy
New Year 1917*
Etching
4³⁄₁₆ x 2¾ in.
Accession no. 91.40.304

PROVENANCE
The artist; William and Edith
Dimock Glackens; Ira Glackens;
Museum of Art, Fort Lauderdale.

EXHIBITIONS
*The Magic of Line: Graphics from the
Glackens Collection.*

464. *Untitled,* n.d.
Signed in the plate l.l.: *John Sloan
'17(?)* [date difficult to read]
Etching
2⅜ x 3⅝ in.
Accession no. 91.40.305

PROVENANCE
The artist; William and Edith
Dimock Glackens; Ira Glackens;
Museum of Art, Fort Lauderdale.

463.

464.

EXHIBITIONS
The Magic of Line: Graphics from the Glackens Collection.

465. *Easter Eve, Washington Square,* 1926
Signed in the plate l.r.: *John Sloan 1926;* signed in the margin l.r.: *John Sloan;* inscribed l.l.: *Easter Eve*
Etching and aquatint on wove paper, ed. 60, 100 proofs
9⅞ x 7⅞ in.
Accession no. 91.40.69

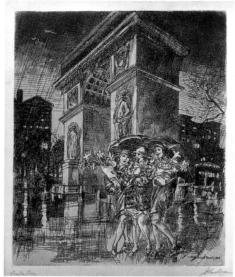

465.

PROVENANCE
The artist; unknown; Ira Glackens; Museum of Art, Fort Lauderdale.

EXHIBITIONS
The Magic of Line: Graphics from the Glackens Collection.

JANE WASEY (1912–1993)

466.

466. *Four Llamas,* n.d.
Signed on the base: *Wasey*
Bronze
Height: 9 in.
Accession no. 91.40.198

PROVENANCE
The artist; unknown; Ira Glackens; Museum of Art, Fort Lauderdale.

467. *Woodchuck,* n.d.
Signed on the back of the base: *Wasey*
Stone
Height: 9½ in.
Accession no. 91.40.197

PROVENANCE
The artist; unknown; Ira Glackens; Museum of Art, Fort Lauderdale.

467.

ARTIST UNKNOWN

468. *Portrait of George Lewis Middlebrook,*
c. 19th century
Oil on canvas
19 x 16 in.
Accession no. 91.40.120

PROVENANCE
The artist; George Lewis Middlebrook; May R. Middlebrook; Mrs. I. Leengran; Ira and Nancy (Middlebrook) Glackens; Museum of Art, Fort Lauderdale.

469. *Portrait of Margareta Middlebrook,*
c. 19th century
Oil on board
18¼ x 15 in.
Accession no. 91.40.119

PROVENANCE
The artist; Margareta Middlebrook; May R. Middlebrook; Mrs. I. Leengran; Ira and Nancy (Middlebrook) Glackens; Museum of Art, Fort Lauderdale.

COMMENTS
The sitters for this work and for cat. nos. 468 and 470 were forebears of Nancy Glackens (Ira's wife and William's daughter-in-law).

468.

469.

471.

470. *Portrait of Mrs. Henshaw Middlebrook*, 1825(?)
Inscribed with circular monogram upper center: *R;* inscribed below the monogram: *25*
Oil on canvas
30 x 24 in.
Accession no. 91.40.121

PROVENANCE
The artist; Mrs. Henshaw Middlebrook; Ira and Nancy (Middlebrook) Glackens; Museum of Art, Fort Lauderdale.

470.

471. *Sketch for "Tom Moore's Cottage,"*
c. 1883
Graphite on paper
7 x 4⅝ in.
Accession no. 92.137

COMMENTS
This is from an early sketch book attributed to Louis Glackens or William Glackens.

CHRONOLOGY

HOLLY J. HUDSON

1870

March 13—William James Glackens is born at 3214 Sansom Street, Philadelphia, to Samuel Glackens and Elizabeth Cartwright Finn Glackens. His ancestors, of Irish, English, and Pennsylvania Dutch descent, had lived in and around Philadelphia for many generations. William is the youngest of three children. His brother, Louis M. Glackens (born 1866), became a well-known illustrator for *Puck, Argosy,* and other magazines; his sister, Ada (born 1869), lived at home.

1890

February—Graduates from Central High School, Philadelphia, with a Bachelor of Arts degree; presents valedictorian address at his commencement. John Sloan and Albert C. Barnes are students with him there.

1891

March—becomes an artist-reporter on the *Philadelphia Record.* One of his first published illustrations, signed "Butts G—," is on the cover of the May issue of *The Fern Leaf.*

1892

Leaves the *Philadelphia Record* and joins the staff of the *Philadelphia Press* and then the *Philadelphia Public Ledger.* At the *Press,* renews his acquaintance with Sloan

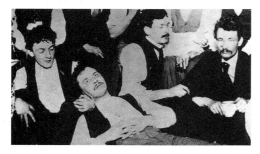

William Glackens (extreme left) with Robert Henri, c. 1892

and meets George Luks, James Preston, and Everett Shinn. Attends evening classes at the Pennsylvania Academy of the Fine Arts, studying with Henry Thouron and, briefly, with Thomas Anshutz, who was a student of Thomas Eakins. At the Academy, Sloan introduces him to Robert Henri.

Glackens, at the top of the pyramid, cavorting with friends

1893

With Sloan and others, organizes the short-lived Charcoal Club, which meets twice a week to draw from the nude model. Paints *Philadelphia Landscape* (plate 5).

1894

Fall—shares a studio with Henri at 1717 Chestnut Street (through spring 1895). December—participates in his first exhibition, the sixty-fourth annual of the Pennsylvania Academy of the Fine Arts.

1895

Has his first major book illustration published, in *Through the Great Campaign*

with Hastings and His Spellbinders, by George Nox McCain (from 1899 to 1913 he illustrates thirteen more books). June—relinquishes his job and sails to France. With Henri and the Canadian painter James Wilson Morrice, makes sketching trips around Paris, outside the city, and in the Forest of Fontainebleau. August—with Henri, possibly Morrice, and the painter Elmer Schofield, takes a bicycle trip to Brussels, Antwerp, The Hague, Rotterdam, and Amsterdam. October—rents a studio at 6, rue Boissonade, in Montparnasse.

1896

In Europe, bicycles through Northern France, Belgium, and Holland with Henri and Elmer Schofield to study the Dutch masters. One of his paintings of Luxembourg Gardens is shown at the Salon of the Société Nationale des Beaux-Arts. Fall—returns to Philadelphia, then settles in New York and rents a studio in the Holbein Studio Building, 139 East Fifty-fifth Street. His first job on a New York newspaper is drawing comics for the *New York World.*

1897

Works on staff as artist-reporter at the *New York Herald;* his last drawing ap-pears there in September. Becomes a freelance illustrator for various magazines. August—his first magazine illustrations, for "Slaves of the Lamp" by Rudyard Kipling, appear in *McClure's Magazine.* Continues painting and trying to get his work shown.

1898

Early in the year—returns to the *New York World;* stays only one month. Spring—with news correspondent Stephen Bonsal travels from Tampa, Florida, to Cuba to report on the Spanish-American War for *McClure's Magazine,* eventually complet-

ing some three dozen or more drawings, of which twelve are published. After returning from Cuba, he never works as an artist-reporter again but establishes a career as a magazine illustrator, receiving assignments from *Ainslee's, Century, Collier's Weekly, Harper's Bazar, Harper's Weekly, McClure's, Munsey's,* the *Saturday Evening Post,* and *Scribner's.*

Glackens at age 28

1899

Moves to a studio at 13 West Thirtieth Street.

Glackens, c. 1898

1901

April—with Henri, Ernest Fuhr, Alfred Maurer, Sloan, and others, exhibits paintings at the Allan Gallery, 14 West Forty-fifth Street, New York, where his work is well reviewed by Charles FitzGerald, critic for the *New York Evening Sun.*

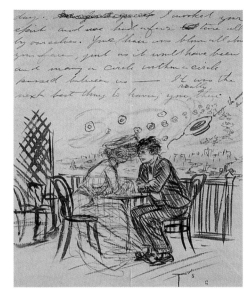

LOVE LETTER TO EDITH DIMOCK, 1903
Ink and wash on paper
9½ x 7½ in.

1903

August—with Fuhr, travels to Saint Pierre, off the coast of Newfoundland. Receives a major commission to illustrate a number of volumes of the collected stories of the nineteenth-century French writer Charles-Paul de Kock; Luks, Preston, and Sloan also contribute to this series of illustrations.

1904

January 19—group show organized by Henri at the National Arts Club on Gramercy Park in New York opens, with Arthur B. Davies, Glackens, Henri, Luks, Maurice Prendergast, and Sloan. February 16—marries Edith Dimock, an artist, in West Hartford, Connecticut. Summer—they move to 3 Washington Square North, and Glackens establishes a studio at 50 Washington Square South. Wins silver medal for painting and bronze medal for illustration at the Louisiana Purchase Exposition in Saint Louis.

The Dimock family residence on Vanderbilt Hill, Hartford, Connecticut

1905

Paints *Chez Mouquin* (plate 39), which receives honorable mention at the Carnegie Institute, Pittsburgh, from a jury that includes Eakins and J. Alden Weir.

1906

April—becomes an associate of the National Academy of Design when it merges with the Society of American Artists. April—on a belated honeymoon, travels in Spain (Gibraltar, Granada, Seville, and Madrid); June—goes to Paris and Chezy-sur-Marne, France, possibly visiting Maurer. Goes to London and then returns to New York at end of the summer.

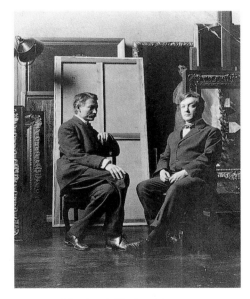

Henri and Glackens, c. 1905

1907

Submits several paintings to the spring exhibition of the National Academy; all but one are rejected. Sloan and Henri plan an exhibition of their own group. July 4—son, Ira, is born.

1908

February—Davies, Glackens, Henri, Ernest Lawson, Luks, Prendergast, Shinn, and Sloan, subsequently known as "The Eight," hold an exhibition at the Macbeth Gallery, 450 Fifth Avenue, New York; the show travels to Philadelphia; Chicago; Toledo, Ohio; Detroit; Indianapolis; Cincinnati; Pittsburgh; Bridgeport, Connecticut; and Newark,

IRA ON A ROCKET, 1907
Watercolor and pencil on board
12 x 8 in.

New Jersey. The Glackens family moves to 23 Fifth Avenue. William acquires a studio at 50 Washington Square South. Summers in Dennis, Massachusetts, on Cape Cod.

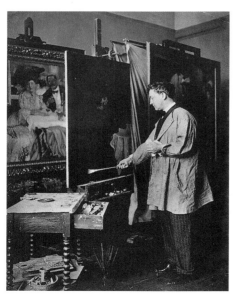

Glackens touching up a canvas, c. 1908

1909

Summers in Wickford, Rhode Island, near Narragansett Bay.

1910

April—with Henri, Sloan, Davies, Walt Kuhn, and others, organizes the *Exhibition of Independent Artists* at 29 West Thirty-fifth Street, New York, the first "no jury-no prizes" exhibition held in America; it includes *Nude with Apple* (plate 71). Summers near Chester, Nova Scotia, on Mahone Bay (southwest of Halifax). Glackens's palette becomes increasingly colorful and Renoiresque.

1911

Summer—rents a cottage at Bellport, Long Island, on Great South Bay (spends the following five summers there as well). Moves to 29 Washington Square West. December 19—Association of American Painters and Sculptors holds its first meeting, with Glackens as a charter member; the group organizes the Armory Show (formally, the *International Exhibition of Modern Art*) in 1913.

1912

February—goes to Paris with Maurer on a buying trip for Barnes, who is by this time a doctor as well as a successful inventor and manufacturer. Returns with canvases for the Barnes collection by Edouard Manet, Edgar Degas, Auguste Renoir, Paul Cézanne, Vincent van Gogh, Paul Gauguin, and Henri Matisse. March—

Glackens with son, Ira, c. 1911

Dr. Albert Barnes (left) with Glackens

first one-artist show opens, at the Madison Art Gallery, 305 Madison Avenue, New York. From about this date, becomes increasingly identified as a figurative rather than a landscape artist.

1913

February 13—the Armory Show opens in New York; Glackens is chairman of the Committee on Domestic Exhibits. March—second one-artist show held, at the Folsom Gallery, New York. Illustrates three short stories by Theodore Dreiser for *Century,* which are later published in the book *A Traveler at Forty.* December 6—daughter, Lenna, is born. December—moves to the new Daniel Gallery, at 2 West Forty-seventh Street.

1914

Begins devoting himself entirely to painting. Old friends Maurice and Charles Prendergast move from Boston to occupy a studio above his at 50 Washington Square South.

1916

Summer—because of an epidemic of infantile paralysis, leaves Bellport for a house in Brookhaven, Long Island.

1917

January—has his first and only one-artist show at the Daniel Gallery. February—begins to exhibit at the Bourgeois Galleries, New York. Elected first president of the newly formed Society of Independent Artists. April 10—the society's *Exhibition of Independent Artists* opens at Grand Central Palace, New York. May—Edith's parents die, and the Glackens family spends much of the year in West Hartford.

1918

Summers in Pequot, near New London, Connecticut.

1919

Illustrates his last story, "On the Beach" by Roy Norton, for *Collier's Weekly;* after this, devotes all his time to painting. Acquires a house at 10 West Ninth Street. Summers in Gloucester, Massachusetts.

Glackens, Edith Dimock Glackens, and Florence Scovel Shinn at the beach

1920

Summers on a lake near Conway, New Hampshire.

1922

Has small one-artist show at the Whitney Studio Club.

Lenna Glackens, accompanied by a friend, hugs a donkey

1924

Receives the Temple Gold Medal from the Pennsylvania Academy of the Fine Arts for the painting subsequently known as the *Temple Gold Medal Nude* (Dr. J. Edward Taylor).

1925

April—has first one-artist show at C. W. Kraushaar Art Galleries, 680 Fifth Avenue, New York; they have remained his primary dealer to the present. Summers in Samois-sur-Seine, France; spends winter (1925–26) at Les Pivoines, a villa in Vence, France. Fall—Art Institute of Chicago acquires *Chez Mouquin* (plate 39). Travels frequently abroad (until 1931), particularly France, painting in Paris and its suburbs, the south of France, and his New York studio. Health begins to deteriorate.

1926

May 1—tours Italy: Naples, Pompeii, Sorrento, Rome, Orvieto, Perugia, Siena, Assisi, Florence, and Venice. Spends summer at l'Isle-Adam, France, and winter (1926–27) at 51, rue de Varenne, Paris.

1927

Summers in Isle Adam. Fall—returns to New York.

1928

March—returns to Paris, before his one-artist show opens at Kraushaar Galleries that month. Summers in l'Isle-Adam. Possibly winters in Vence, and New York.

1929

Early spring—returns to Paris; lives at 110, rue du Bac. Summers at the fishing village of Saint-Jean-de-Luz on the Spanish frontier. November—returns to Les Pivoines; remains through the winter (1929–30).

1930

May—travels to Paris from Vence via Arles, Nîmes, Orange, Avignon, Aix-en-Provence, and Beaune. Summers at Villa des Cytharis in La Ciotat, France. October—returns to New York.

1931

April—one-artist show held at Kraushaar Galleries. Spring—returns to Paris; summers at Villa des Orangers in Le Suquet, near Cannes, France. October—returns to New York; his traveling after this gradually becomes less extensive.

1932

Spring—returns to Paris; spends August and September in Cannes. Winter—visits Ernest Lawson in Coral Gables, Florida.

1934

Summer—visits Vermont and Baie Saint Paul, Canada, near Quebec.

1935

February—one-artist show held at Kraushaar Galleries. Paints *The Soda Fountain* (plate 131); the soda jerk is a portrait of his son, Ira.

1936

Visits England and France; returns to New York in midsummer. Spends rest of summer in Rockport, Massachusetts.

1937

Receives the Grand Prix at the Paris Exposition for *Central Park, Winter* (The Metropolitan Museum of Art, see plate 56). Summers near Stratford, Connecticut. Paints *White Rose and Other Flowers* (plate 130), his last completed canvas.

1938

May 22—dies suddenly of a cerebral hemorrhage, while visiting Charles and Eugenie Prendergast in Westport, Connecticut. December—memorial exhibition opens at the Whitney Museum of American Art, New York, and travels to the Carnegie Institute, Pittsburgh, in February 1939. A smaller version of the show travels to Chicago; Los Angeles; San Francisco; Saint Louis; Louisville, Kentucky; Cleveland; Washington, D.C.; and Norfolk, Virginia (until March 1940).

INDEX

PHOTOGRAPHY CREDITS

The photographers and the sources of photographic material other than those indicated in the captions are as follows:

Geoffrey Clements: plate 79; Copyright © 1994 Detroit Institute of Arts: plate 112; The Metropolitan Museum of Art, New York: plate 30 (copyright © 1994), plate 56 (copyright © 1992), plate 77 (copyright © 1989); Copyright © 1994 Board of Trustees, National Gallery of Art, Washington, D.C.: plates 69 and 152; Terra Museum of American Art, Chicago: plate 9 (copyright © 1995), plate 116 (copyright © 1994); Copyright © 1995 Whitney Museum of American Art: plates 37, 79, and 118; Courtesy of Richard York Gallery, New York: plate 86.